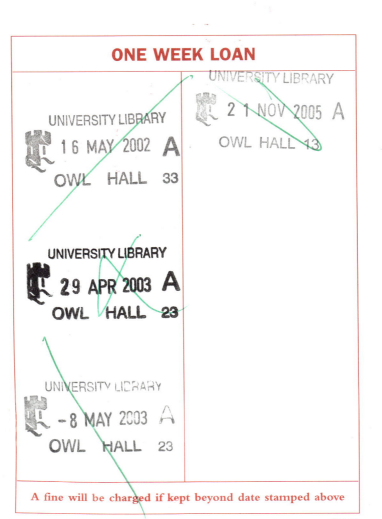

ONE WEEK LOAN

UNIVERSITY LIBRARY

2 1 NOV 2005 A

OWL HALL 13

UNIVERSITY LIBRARY

1 6 MAY 2002 A

OWL HALL 33

UNIVERSITY LIBRARY

29 APR 2003 A

OWL HALL 23

UNIVERSITY LIBRARY

- 8 MAY 2003 A

OWL HALL 23

A fine will be charged if kept beyond date stamped above

10013

Body, Place, and Self in Nineteenth-Century Painting

Around the middle of the nineteenth century, painters, novelists, playwrights, and theorists of architecture seized upon the interior as a metaphor for selfhood. This book shows how and why the painted domestic interior, with figures positioned in provocative, and even disturbing, manners figured so prominently in contemporary visual culture. In these expressive images, the notion and limits of identity were debated rather than resolved. *Body, Place, and Self in Nineteenth-Century Painting* begins in the 1840s and examines the new ways of imagining and describing interior spaces. It ends in the years around World War I, when the devastations of the war left countless people with their private interiors either nakedly exposed or totally destroyed. Wide-ranging analyses of key individual works, including Edgar Degas's *Interior,* John Singer Sargent's *Daughters of Edward Darley Boit,* Edouard Vuillard's *Mother and Sister of the Artist,* and Walter Sickert's *Ennui* form the core of this study.

Susan Sidlauskas is Assistant Professor of Art History at the University of Pennsylvania. A scholar of nineteenth-century art, she has contributed to *The Art Bulletin* and the *Art Journal.*

Body, Place, and Self in Nineteenth-Century Painting

SUSAN SIDLAUSKAS

University of Pennsylvania

CAMBRIDGE
UNIVERSITY PRESS

PUBLISHED BY THE PRESS SYNDICATE OF THE UNIVERSITY OF CAMBRIDGE
The Pitt Building, Trumpington Street, Cambridge, United Kingdom

CAMBRIDGE UNIVERSITY PRESS
The Edinburgh Building, Cambridge CB2 2RU, UK http://www.cup.cam.ac.uk
40 West 20th Street, New York, NY 10011-4211, USA http://www.cup.org
10 Stamford Road, Oakleigh, Melbourne 3166, Australia
Ruiz de Alarcón 13, 28014 Madrid, Spain

First published 2000

Printed in the United States of America

Typeface Sabon 10.25/13.5 pt. *System* QuarkXPress [CS]

A catalog record for this book is available from the British Library.

Library of Congress Cataloging in Publication Data
Sidlauskas, Susan.
 Body, place, and self in nineteenth-century culture/Susan Sidlauskas.
 p. cm.
 Includes bibliographical references and index.
 ISBN 0-521-77024-6 (hb)
 1. Painting, Modern – 19th century – Themes, motives. 2. Space (Art) 3. Personal space.
4. Identity (Psychology) in art. I. Title.

 ND190.S475 2000
 759.05—dc21 99-050140

ISBN 0 521 77024 6 hardback

Publication of this book has been aided by a
grant from the Millard Meiss Publication Fund
of the College Art Association.

Contents

Illustrations

Prologue: The Body in Place

Definitions

"*Interiority*" – "a visceral sense of insideness," the sense of self carried within.[1] The idea, which overlaps with more general modern notions of subjectivity and identity, assumed a very particular cast during the nineteenth century, when its most potent expression became the provocative dispersal of figures within the image of the interior. As Michel Foucault has observed, the idea of a "self" certainly was not new to modernity; but the sense that the self was something held *inside* was.[2] Several themes have shaped this book: the urgency with which the metaphor of the interior was seized upon by painters, novelists, playwrights, theorists of architecture and of vision and spatiality; the conflicts – psychological and pictorial – that surfaced and entwined when body was made to interact with place; and finally, the discovery that the painted interior did not function, ultimately, as a sign of safety, but instead became a deeply contested terrain where the very nature and limits of identity were debated rather than resolved.

My study begins around the mid-nineteenth century and ends in the years around World War I, a time frame that might be said to mark the origin, the consolidation, and the decline of the modern bourgeois imagination. Yet it is not a development per se that I chart through these chapters, but rather a series of successively more conflicted variations on a theme. Or, to put it another way, I identify the dawning of the possibility that subjectivity *could* be represented through the juxtaposition of figure and space; examine the rich, often contradictory permutations that followed; and, lastly, analyze why and how the viability of such an image ended. The demise of the pictured domestic interior as a metaphorical vessel for the self coincided roughly with the actual devastations of World War I, an event that left countless private interiors either nakedly exposed to view or totally destroyed. Around the same time, a new theorization of the self coalesced most powerfully, and influentially, in the work of Sigmund Freud, who held that the mind itself was divided into

discrete, only partially penetrable, chambers.[3] My chapters chart the historical, conceptual, and visual conditions for selfhood that preceded Freud, and are focused upon, in succession, Horace Lecoq de Boisbaudran – drawing teacher and theorist – and his colleague César Daly – architect, reformer, and editor – along with the painters Edgar Degas, John Singer Sargent, Edouard Vuillard, and Walter Sickert, whose work concludes the story I will tell.

I shall argue that conceptual and historical shifts were not simply reflected in painting; they were *enacted* within its very structures. It is by now a commonplace that new content demands a new form. During the second half of the nineteenth century, new visual forms and strategies of beholding made an almost abstract content *representable*. At times, in the paintings we shall examine, figures seem to be at war with their surroundings. Sometimes they are nearly overwhelmed by a space that appears dauntingly empty; at other times, the setting seems excessively animated and congested. Figures teeter at the edges of voids or, alternately, threaten to disappear into walls. In another variation, figures appear to have absorbed into their very bodies the spaces around them, producing sensations of airless constriction. Such oscillations between body and place, figure and ground, are inseparable from the achievements of modernism.

I originally imagined this as a different kind of book, one that would expand upon an earlier inquiry into what I had called "the expressive interior."[4] The inquiry could have moved outward, casting an ever-widening net to encompass more artists, writers, and theorists. And indeed, many other figures could be included. To the cast of characters I mentioned above could be added artists such as James Tissot, James McNeill Whistler, William Merritt Chase, Pierre Bonnard, Edward Tarbell, James Ensor, Jacques-Emile Blanche, Vilhelm Hammershøi, and Edvard Munch – all of whom were concerned at one time or another with the psychological expressivity of the painted interior and its inhabitants.[5] Sheer numbers would have cemented my argument.

But instead I have chosen a different, perhaps riskier, path. As the project progressed, I decided to reduce the number of images I was looking at, and to expand the depth of my analysis. Each image, and eventually each chapter, demanded a different range of methods and sources. This approach might seem quixotic or, at best, idiosyncratic, but it is necessary to bring out most fully what I thought the paintings could reveal. I selected these images not only because they were concerned in an obvious way with the theme of interiority, but because this theme was embedded directly in, and accessible through, their very structures. Each of the artists I discuss tackled a profound question – how are the self and its relation to the world pictured? – with all their aesthetic, intellectual, and emotional might, and did so in an economical and accessible way. Not surprisingly, no one painted an *answer* to the question; but each artist struggled with such intensity that the depth and texture of the quest remain palpable, with an immediacy that connects us to history. We are cognizant that nine-

teenth-century notions of self were different from our own and can never be fully reexperienced. But these paintings compel the spectator to imagine vividly, and to respond deeply to, historically distant constructions of the self.

Perhaps surprisingly, this book will not reaffirm the by now conventional opposition between the private and public realms of early modern culture. Instead it will identify the signs of their interpenetration. Also, while I discuss, even emphasize, gender issues throughout the book, I do not position a "feminine" domestic interior against a "masculine" public domain. Instead, I plumb the internal, often gendered, conflicts that took place within, leaving neither male nor female particularly victorious. To paraphrase the words of Richard Shiff, interiority is something made, not found.[6]

From the Body of Space to the Space of the Body

The first chapter establishes historical and conceptual foundations for my premise that subjectivity *could* be pictured through a calculated marriage of figure and space – as these ideas were enunciated, and given a practical application, in drawing instruction and architectural criticism. I map the simultaneous emergence in several fields of the conception of the *mise-ensemble:* the idea that a figure and its surroundings comprised one dynamic, expressive whole. The central actors in this section are Horace Lecoq de Boisbaudran, a modest but influential teacher and theorist of drawing, and César Daly, whose writings on architecture inaugurated new practices of engaging the spectator in spatial representation.

Each of the chapters that follows elucidates a different aspect of interiority in representation and charts both the internal limits and the external pressures generated by the very *need* to represent something as private, opaque, and resistant to visualization. Chapter 2 concerns sexuality and intimacy, and the irresolvable conflict between autonomy and desire. A reinterpretation of Degas's *Interior* (ca. 1868–69) (Fig. 1 and Plate I), sometimes known as *The Rape,* anchors the theme to the ideology and imagery of Realist painting. Degas paints the loss of self that can occur in the throes of sexual desire.

Sargent, too, is concerned with loss, and the third chapter tells of the loss of the historical, innocent self that was captured for the nineteenth century in the figure of the child. Sargent imagines interiority as a form of personal history. A void at the center of his painting, *The Daughters of Edward Darley Boit* (1882) (Fig. 31 and Plate III), the subject of this chapter, threatens to compromise the bodily autonomy of the girls who stand at its periphery. Chapter 4 charts the costs of forging a female self within the constricted familial interior. In Vuillard's *Mother and Sister of the Artist* (ca. 1893) (Fig. 36 and Plate VII), the self is conceived as a series of multiple, shifting representations that are alternately performed and withheld. New staging practices in the Symbolist

theater – enigmatic gestures and generalized, almost abstract, settings – illuminate both the bodily constitution and the enlivened setting of Vuillard's portrait, in which his sister and mother enact a number of roles – for their audience and for one another.

Finally, Chapter 5 considers the phenomenon I write about as it comes to an end, when hired models performed self-absorption in an interior rented for the occasion. Walter Sickert's *Ennui* (ca. 1914) (Fig. 47 and Plate VIII), the subject of this section, is evidence of a skepticism that interiority could even *be* represented. Sickert's resistance to imagining, let alone painting, the actual interior life of his subjects was not an isolated act, but part of a much more general hesitation about trusting the representational powers, and stability, of the phenomenal world. Virginia Woolf wrote eloquently about Sickert's work in an essay inflected by her perceptions about the war, and about the notions of privacy and self it had destroyed.

Method and Meaning

My method throughout this book is Janus-faced, by necessity and design. On one hand, I historicize the strategies of making and viewing that produced the paintings discussed here, but I also insert these images and ideas into current theoretical debates about representation and response. In this way, a variety of nineteenth-century conceptions articulating the relation of the body to space (theories of visuality, empathy, innovations in stage design and decoration, drawing pedagogy, and architectural presentation) are integrated with more recent considerations of space as a site for the construction of subjectivity. History provides much evidence about the material conditions in which the works of art under discussion here were first imagined and produced, but it stops short of articulating the nature of the human response that they continue to activate. Thus, contemporary theory helps to explain how and why these images still compel attention and resist easy interpretation.

In a recent study, Anthony Vidler adapted Sigmund Freud's conception of the uncanny to a kind of architectural space that seems disturbingly, even eerily, animated.[7] Locating the origin of such psychotropic effects in the romantic tales of E. T. A. Hoffman and the mysteries of Edgar Allan Poe, Vidler finds a more recent expression in the stark, forbidding spaces of the postmodern city center. He writes: "Space, in most contemporary discourse, as in lived experience, has taken on an almost palpable existence. Its contours, boundaries, and geographies are called upon to stand in for all the contested realms of identity, from the national to the ethnic; its hollows and voids are occupied by bodies that replicate internally the external conditions of political and social struggle, and are likewise assumed to stand for, and identify, the sites of such struggle."[8] Vidler finds the first visual manifestations of the architectural

uncanny in film, where an expressive, often forbidding, architecture could be enlivened, quite literally, through the movement of the film, an animation obviously not possible in the static form of built architecture. I contend, however, that something akin to the architectural uncanny had an even earlier manifestation in certain nineteenth-century paintings of domestic interiors. Kirk Varnedoe once posited that the compositional anomalies of Degas's paintings anticipated, rather than reflected, the structural manipulations of photographic composition; I argue that the expressively configured interiors discussed here *anticipated* the innovations of later architectural and cinematic space.[9] These painterly compositions might in fact be characterized as *precinematic,* activated not by the moving frame of the filmic image, but by the complicity of the spectator.

Any study concerned with psychological content in the modern era must acknowledge the work of Freud. As I suggested earlier, the images and ideas I probe might be called pre-Freudian, or proto-Freudian, for they draw upon the same collective insights of neuroscience, biology, philosophy, history, and literature from which Freud drew his early conceptions of the unconscious. For example, Freud depended upon the pioneering works of the physician William Preyer and the psychologist James Sully, who wrote about children's development – works that I employ to understand more fully Sargent's *The Daughters of Edward Darley Boit* in Chapter 3.[10] Also, Freud was deeply impressed – and troubled – by Jean-Martin Charcot's theories and practical demonstrations of neurological disorders, ideas that are relevant to interpreting the distorted figurations of Edouard Vuillard's *Mother and Sister of the Artist* in Chapter 4.[11] At other times, I use a Freudian theoretical insight to explore an image because it seems to offer the most plausible explanation for what I see. For example, some of Freud's findings – however wrong-headed they may have been in the case of the young woman known as "Dora" – illuminate aspects of Degas's *Interior,* which concerns in part the link between sexual anxiety and the unconscious, a theme expressed in paint years before it was fully theorized in psychoanalysis.[12]

My approach is interdisciplinary – a book about the representation of the self would demand nothing less – but I am writing first and foremost about images, and about the rewards of deep, even obsessive, looking. As we struggle in the throes of the "linguistic turn" within the humanities, I wonder if we as art historians are as adept as we could be about explaining how our work is both singular *and* rigorous. This book represents my attempt to grapple with, if not resolve, the problem. Images are so omnipresent in our culture that it is possible to overlook, or to underestimate, their subtle contradictions and masked revelations. I try to expose these and, in so doing, to extract meanings that are shored up by historical change and theoretical insight. Although nineteenth-century ways of interior world-making cannot be fully retrieved, I believe that – through these paintings – they can be reimagined.

Acknowledgments

This book has been many years in the making, and so has incurred many debts. I thank John McCoubrey, Emeritus Professor at the University of Pennsylvania, who supervised its earliest beginnings, and the fellow students who saw it through: Teresa Louw Ashton, Jeff Cohen, Michael Lewis, Constance McPhee, and Peter Reed. The Society of Fellows at Columbia University and the Getty Foundation supported the next stages of research and writing. Colleagues in the Art History and Archaeology Department at Columbia – Hilary Ballon, Richard Brilliant, Johanna Drucker, David Freedberg, David Rosand, John Russell, Alan Staley, and Janis Tomlinson – were also sources of criticism and encouragement. At an early stage, illustrations were partially supported by a research grant from the University of Pennsylvania Research Foundation; the final year of writing was enabled by a grant from the American Association of University Women. Others who helped with specific tasks – pictures, references, translations – are thanked in the text. I do want to thank Emily Eisenstein, Stephanie Ruiz, and Bett Schumacher for crucial help with research and photographs.

Portions of the manuscript were tested out before various audiences, including those at the Institute of Fine Arts, NYU, Yale University, Bryn Mawr College, the Buell Center for American Architecture at Columbia University, Rutgers University, and the University of Pennsylvania's Friday Colloquiums. Beatrice Rehl at Cambridge University Press lent encouragement at an early stage, and guided the manuscript through its final transformation. Barbara Folsom did the copyediting with grace and care. A Millard Meiss grant from the College Art Association made possible the inclusion of color plates.

After years as a student at the University of Pennsylvania, I found a second home here as a faculty member. I thank both my colleagues and my students for enabling such a smooth transition. David Brownlee and Renata Holod both had roles in guiding the original dissertation, and are now valued friends. Leo Steinberg, now Emeritus Professor, contributed much by the example of his intellectual boldness and breadth. John McCoubrey has remained one of

my most acute critics and an abiding source of support. Elizabeth Johns continues to teach me a great deal by the example of her generosity of spirit and intellectual rigor. Christine Poggi has been a generous collaborator, and Larry Silver has become an invaluable sounding board. Sue Ann Prince, who taught for me while I was on leave, was a great source of encouragement. I also thank the colleagues, past and present, who have contributed not only their warmth and support, but stimulating observations on a range of subjects and methods: Malcolm Campbell, Lothar Haselberger, Ann Kuttner, Suzanne Lindsay, Charles Minott, Holly Pittman, Cecil Lee Striker, and Paul Watson. Elyse Saladoff and Darlene Jackson provided more help than they realize, as well as some much-needed perspective. I also thank my M.A. and Ph.D. students, for the discoveries they have shared and the faith they have had: Juliet Bellow, Judith Dolkart, Maria Gindhart, Heather Grossman, James Hargrove, Claudia Heilbrunn, Mark Levitch, Janine Mileaf, Nicholas Sawicki, Gretchen Sinnett, Isabel Taube, and Matthew Witkovsky.

I have been especially lucky in my circle of friends, and want to thank those who have listened and lent support over the years: Teresa Cader, Elizabeth Childs, Sarah Cohen, Marcia Lind, Michelle Marcus, Merrill Mason, Joanne Olivier, Carole Paul, Joan Zukas, and Susan Taylor-Leduc, whose presence in Paris has done nothing to limit the generosity and timeliness of her support. Susan Leduc and Sarah Cohen read various portions of the manuscript and offered critical suggestions. I am also grateful to be part of a reading group whose members have become essential to my sense of what art history is and can be: I thank Elizabeth Bartman, Ülkü Bates, Anne Lowenthal, Lucy Oakley, and Lisa Vergara for their collective acuity and generosity. Lucy Oakley edited the first version of the manuscript, working gracefully and with fierce concentration under very difficult circumstances. Claudia Heilbrunn generously took on the index. Life at home would have been far more difficult without the friendship and support of Alan and Sheelagh Vietze, Julie Alderson, Beth Laurano, and Mildred Moskowitz. My correspondence with Rudolf Arnheim was an unexpected gift.

My last words of thanks are for my family. I thank my sister Nancy O'Hara for her constancy, and I thank my father, who did not live to see this book finished, for his ability to make contagious the excitement of ideas. My husband Ken Safir's unwavering faith, toughness of mind, and, not least, his black humor, were quite simply essential. Our daughters, Emma and Miranda, forced me to sharpen my concentration, but in the process made the perpetual juggle of family and work seem eminently worthwhile, if never easy.

Finally, this book is dedicated to the memory of my father, Francis W. Sidlauskas, who taught me the great value of locating the rewarding even though arduous path, and to the memory of my father-in-law, Marshall Safir, whose optimism in the face of difficulty I continue to admire.

Plate I. Edgar Degas, *Interior*, ca. 1868–69. Philadelphia Museum of Art, The Henry McIlhenny Collection in Memory of Frances P. McIlhenny

Plate II. Edgar Degas, *Interior* (detail of left side of painting)

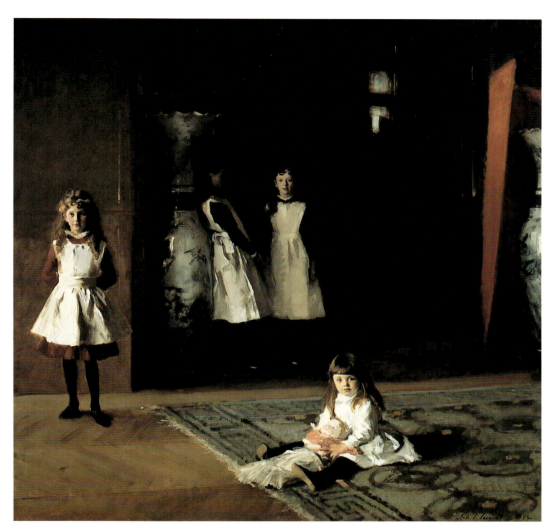

Plate III. John Singer Sargent, *The Daughters of Edward Darley Boit*, 1882. Boston, Museum of Fine Arts. Gift of Mary Louisa Boit, Julia Overing Boit, Jane Hubbard Boit, and Florence D. Boit in Memory of their Father, Edward Darley Boit. Courtesy, Museum of Fine Arts, Boston. Photo: © 1999 Museum of Fine Arts, Boston.

Plate IV. John Singer Sargent, *The Daughters of Edward Darley Boit* (detail of Julia)

Plate V. John Singer Sargent, *The Daughters of Edward Darley Boit* (detail of Mary Louisa)

Plate VI. John Singer Sargent, *The Daughters of Edward Darley Boit* (detail of Florence, left, and Jane, right)

Plate VII. Edouard Vuillard, *Mother and Sister of the Artist,* ca. 1893. New York, Museum of Modern Art. Gift of Mrs. Sadie A. May. Photo: © 2000 The Museum of Modern Art

Plate VIII. Walter Sickert, *Ennui*, ca. 1914. London, The Tate Gallery. Presented by the Contemporary Art Society, 1924. Photo: © 2000 Artists Rights Society (ARS), N.Y./DACS, London

Introduction

A Short History of the Interior and Interiority

"The nineteenth-century, like no other, was addicted to the home." So wrote Walter Benjamin in 1936, and his elaborations on the theme surface in most accounts of the urban, middle-class life of this period.[1] According to Benjamin, the domestic interior was nothing less than "the universe for the private citizen."[2] The visual evidence seems to bear him out, for the image of the interior flooded not only French, but also British and American architectural journals, pattern books, photography albums, and manuals, which advocated interior decoration as a form of self-expression.[3] In popular illustrations of the new apartment house, or *maison à loyer,* facades were sheared off in order to demonstrate that the social class of the occupants was inversely proportionate to their height from the street (Fig. 5). In the new domestic melodramas, a naturalistic setting virtually assumed the stature of a protagonist.[4] Social practices of identity construction were concentrated around the interior as well. Members of the bourgeois class were anxious to define both their new status and their newly conceptualized interior lives through an expressive, and legible, relation to their intimate surroundings.[5] The calculated juxtaposition of the body to the house through the mediums of architecture, decoration, furniture arrangement, and the somatic expressions of gesture, posture, and personal adornment constituted nothing less than the enactment of a private identity, a new notion in the culture, which, not surprisingly, demanded a new pictorial expression.

Across nineteenth-century urban culture, then, the domestic interior would seem to have become a transparent, even inevitable, metaphor for bourgeois identity, a metaphor ratified through the sheer multiplicity and diversity of its expression – a simple way to understand how psychic space is related to physical space in representation.[6] But the matter is not simple at all. The role of advanced painting in the rise of the interior – and of the visualization of interiority – was at once more equivocal and more dynamic.

Interior is commonly, even essentially, defined as "opposed in all senses and in all uses to *exterior*" (*Oxford English Dictionary*, 1971). But the dynamic interaction I am concerned with here took place not between an "inside" and an "outside," but between two different *kinds* of interiors: the body and the inner chambers of the house. In her book *On Longing,* Susan Stewart argues that the imaginative relation between the body and its surroundings must always be in doubt: "The Body presents the paradox of contained and container at once. Thus our attention is continually focused upon the boundaries or limits of the body: known from an exterior, the limits of the body as object; known from the interior, the limits of its physical extension into space."[7] I believe that the instability described by Stewart pervaded the culture's manner of imagining the interior, and that the advanced paintings I consider in this book provide one of the most potent expressions of this mental picture.

The images considered here consistently strain structural and imaginative distinctions between container and contained, body and space. In so doing, they counter the usual expressive dominance of figure over ground. Consider these apparent anomalies: the yawning emptiness that divides the man and woman of Degas's *Interior* (Fig. 1 and Plate I); the almost palpable gloom that ebbs around the asymmetrically arranged young subjects of Sargent's *The Daughters of Edward Darley Boit* (Fig. 31 and Plate III), the overly lively wallpaper and telescoped perspective of Vuillard's *Mother and Sister of the Artist* (Fig. 36 and Plate VII); and the awkward compression of figures and furnishings in Walter Sickert's *Ennui* (Fig. 47 and Plate VIII).[8]

At first glance, the visual structures of these paintings seem random and idiosyncratic, even aberrant. Yet, in fact, they conform to a fairly predictable mix of asymmetry, imbalance, and distortion – precisely the features that have come to be identified with modernity in painting. Identifying the formal strategies that shape these paintings is the first step toward understanding how they *mean* what they do. For instance, one must struggle to describe the "content" of a picture of four young girls adrift in a cavernous hallway (as in Sargent's *The Daughters of Edward Darley Boit*), or of an image of an enervated woman who seems about to be absorbed into the wallpaper surrounding her (Vuillard's *Mother and Sister of the Artist*). What material and theoretical conditions – of making and spectatorship – made these works possible? And how do they remain intelligible to us even now?

These images do not *narrate* stories of psychological discomfort, alienation between the sexes, or the isolation of children. Rather, they *act out* their effects through figural and spatial arrangements calculated to provoke a bodily empathy on the part of the viewer.[9] Conventions for perceiving and describing space in these years suggest that when spectators viewed painted figures stranded on opposite reaches of a gaping space, pressed into a corner, or subsumed into the furniture around them, they were cued to experience a visceral response, a

bodily empathy, for the discomfort of their protagonists. The visual provocations to unease and disorientation were thus translated into an imagined experience of another's psychological state. In architectural treatises, manuals on decoration, descriptions of theatrical settings, and novels, readers/viewers were encouraged to project themselves imaginatively into whatever space was described or represented. One didn't merely *see* space; one experienced it through a visceral response to the imagined effects of light and shade, proportions, perspective, and scale. In all the paintings I analyze here, space is as palpable and as vivid a presence as any sentient being. These interiors are not neutral vessels designed to contain or protect; they are animate entities, highly responsive to, even shaped by, the psychological currents that flowed within them.

These images exploit the interior's accessibility as a sign, even as they subvert its commonplace associations with comfort and safety. Contradictions are inherent in the interior, as Benjamin noted early on. On the one hand, the private interior was a sanctuary from which the world could be safely observed – a "box in the world theater," as Benjamin put it; on the other, it was a stage for the acting out of one's most intimate feelings with great authenticity.[10]

Spatial Identities

In *The Production of Space,* Henri Lefebvre argued that every culture possesses its own characteristic "spatial codes."[11] These are no less real for being difficult to retrieve, particularly when they must be extracted from the mediated world of representation. Lefebvre's notion of "representational spaces" is most relevant here; these are spaces that embody "complex symbolisms, sometimes coded, sometimes not, linked to the clandestine or underground side of social life, as also to art (which may come eventually to be defined less as a code of space than as a code of representational space)."[12] Spatial codes are acted out through the body; thus, the question that I am raising is this: how does the bodily core of the nineteenth-century actor perform in the spatial field of the interior?

Anthropologists use such terms to describe the ritualized spatial practices of certain cultures. People can delimit spaces through the actions of their own bodies, through markings that are part of the shared knowledge of the group, even though they may be invisible to outsiders. Nancy Munn has written about the spatial practices of the Aborigines living in the Australian interior: "Since a spatial field extends from the actor, it can also be understood as a culturally defined, corporeal-sensual field of significant distances stretching out from the body in a particular stance or action at a given locale or as it moves through locales . . . the bodily core of the actor's spatial field stretches out to

become one with, to construct, the space of [symbolic] importance."[13] What Munn's subjects are looking for, she argues, are "identifying centers from which a space with uncertain or ambiguously defined limits stretches out."[14]

At times, the nineteenth-century bodies pictured in this book seem to generate the space around them; at other times, the trajectory is reversed, and the space appears to define, even impinge upon, the figure. In other instances, figure and space are fused as one, with signs of resistance indicated in the instability of the fusion. Munn argues that Aboriginal people imprint their environment by marking spatial borders, as if they were imposing their bodies directly onto the land.[15] This strategy is not unlike the nineteenth-century bourgeoisie's need to leave material traces of their presence on their intimate environment: corporeal markers of "activity, introspection, and intimacy." Benjamin explained that "To live is to leave traces. . . . In the interior these are emphasized. An abundance of covers and protectors, liners and cases is devised, on which the traces of objects of everyday use are imprinted. The traces of the occupant also leave their impression on the interior."[16]

Actual touch is disallowed in painting; but the provocations to touch are myriad, as are the invitations to project oneself into the painterly space constructed by the artist. This strategy is employed in all the works I consider, and its emergence coincided with new mid-century conventions for imagining, and vicariously experiencing, architectural space. César Daly, who will be discussed at greater length in the first chapter, was contributing to a larger nineteenth-century attempt to combine aesthetics and science when he formulated his roster of "aesthetic geometry," a series of shapes that were thought to elicit predictable physiological responses in the responsive viewer. "Movement of Lines! Equilibrium of masses!" Daly proclaimed. "Is there not, in effect, in the universality of these figures, the proof that at the base of human instinct exists the conscience of a permanent symbolic relation between, on the one hand, certain considerations of lines, and on the other hand, the static and dynamic condition of bodies?"[17]

The mental animation of architectural forms, and the voids they enclosed, enjoyed a general currency in the early writings that made up the nascent field of art history. Heinrich Wölfflin used the psychological notion of empathy to characterize the sentient viewer's response to art and architecture. In 1886, he wrote that "our own bodily organization is the form through which we apprehend everything physical." These judgments take place, he argued, through a "process of unconscious endowment of animation," in which architecture as an "art of corporeal masses, relates to man as a corporeal being."[18] Wölfflin explicitly linked symmetrical compositions to positive responses. "Likewise," he concluded, "it is also known that a severe injury to the equilibrium can have a depressing effect. We ourselves feel fear and anxiety when the restful effect of balance cannot be found."[19]

If we extend both Daly's and Wölfflin's formulations about the animism of physical space to the painted interior, we might imagine that any figure represented within that space becomes a surrogate for the spectator's own empathic response: a substitute through which the viewer can vicariously experience the imagined comfort of a space too compressed or too attenuated, a furniture arrangement too confining, or another figure too near or too far away. Of course, the nature of response differs with each historical viewer; nonetheless, a quality of heightened engagement or curiosity consistently characterizes many viewers' responses to these paintings.

T. J. Clark recently applied the notion of empathy to the peculiarly resistant bodies of Paul Cézanne's *Bathers* of 1895. He writes, "Because in the case of bodies (to make the point about empathy again, slightly differently), *we are* what fills, or reaches out to, the space another body occupies."[20] Something like this happens in the paintings by Degas, Vuillard, Sargent, and Sickert under examination here. But the space the body imaginatively reaches out to fill is not the luminous, apparently infinite, landscape of a Cézanne *Bathers*, but the far more limited, and uncannily familiar, space of the domestic interior.

Chapter One

Body into Space

Lecoq de Boisbaudran and the Rhetoric of Embodiment

Lecoq's List

In the collection of the Archives Nationales in Paris, there is a list penned by the teacher and theorist of drawing composition Horace Lecoq de Boisbaudran.[1] Here, Lecoq set down the necessary items for his new class at the Ecole Gratuite de Dessin, or the "Petite Ecole," as it was familiarly known – largely to distinguish it from that bastion of the "grand style," the Ecole des Beaux Arts.[2] Lecoq projected the cost for draperies, plants, and life models – the customary requirements for any drawing class. But toward the end of the list he enumerated the furnishings he needed. These last – chairs, tables, lamps, plants – were seldom seen in the austere drawing classrooms of the Petite Ecole. If Lecoq did not intend to supply his students with domestic comfort, why did he include items more appropriate to a bourgeois parlor? Because these mundane furnishings had become *subjects for drawing,* as critical to Lecoq's classroom exercises as the life models he hired.

A drawing teacher's list may seem like a minor bit of administrative housekeeping, but Lecoq's importation of domestic furnishings into an institutional drawing class signaled a new way to conceptualize and represent the relation between the human figure and the material and spatial worlds it navigated.[3] Today, Lecoq is best known for his technique of "memory drawing." Students memorized what was before them, then turned away from their subjects and drew their *observation conservée.* Pertinent aspects of this highly influential program are discussed below.[4] For now, let us turn our attention to the general theory of expression developed by Lecoq during the 1850s and 1860s, a theory which stipulated that the figure was formally and conceptually inseparable from the objects and spaces around it.[5] Lecoq's phrase for this expressive fusion of parts was *la mise en place ou la mise ensemble,* and its resemblance to the theatrical "mise-en-scène" is not accidental for, like his counterparts in the evolving Realist theater, Lecoq assumed that the setting was as animate and as expressive as the figures that moved within it.[6]

Writing just two years after Lecoq's first publication in 1847, the Realist playwright Victorien Sardou likened an informally arranged cluster of chairs in a drawing room to a group of "personnages," who turn toward one another as if they are chatting among themselves.[7] Sardou's and Lecoq's shared conviction about the expressive agency of the setting and the objects and structures that defined it – furnishings, draperies, rugs, mirrors – also shaped Edgar Allan Poe's nearly contemporaneous meditation on the significance of decor, *The Philosophy of Furniture* (1840); Louis-Edmond Duranty's comical short story *Bric-à-Brac* (1876) about the interchangeability of people and their possessions; and Honoré de Balzac's novels *Eugènie Grandet* (1833) and *Père Goriot* (1834), whose grim atmosphere strategically depends upon the author's detailed evocation of the characters' shabby settings.[8] These literary conjurors of place were concerned not only with the static realism of the settings they described but also with capturing what they believed to be the revelatory *interactions* between their protagonists and their immediate surroundings. Clues to subjects' motivations, even anticipations of plot turns, could be embedded in the way someone slumped at a table or sat too erect in a chair. Balzac, Emile Zola, Gustave Flaubert, the brothers Goncourt all took pains to describe how a character handled a wine glass, lingered in a doorway, or grasped the drapery at a window. Meaning lay in the juxtaposition of figure to setting and was founded on the more general assumption that no protagonists – fictive or otherwise – could be severed from his or her setting without disrupting both the authenticity, and the appeal, of the presentation. Hippolyte Taine parlayed this assumption into a more general argument about the primacy of environment as a shaper of individual temperament and extended it to explain the collective forces that motivated the evolution of an artistic style.[9]

Although the lamps, chairs, and tables in Lecoq de Boisbaudran's classroom may not have borne the same imaginative burden as Sardou's stage props or Balzac's battered kitchen tables, the affinities among all three affirm that a more fundamental, and widespread, subversion was at work. By mid-century, skepticism arose in a number of domains concerning people's capacity – both in representation and in life – to dominate the world around them. Put another way, there was some doubt that the bodily core of the actor in the early modern world was sufficiently oriented within his or her spatial field.

The Animated Field and the Social Self

When liveliness is projected onto what previously had been assumed to be inanimate objects and irrelevant spaces, the incontestable primacy of the human inhabitants is cast into doubt. Around mid-century, even the conventionally "dead" spaces of a stage set or a painterly composition – the remote corners, the gaps between furniture, the empty recesses – were understood to be

dynamic parts of an animated whole. Acceptance of such a wholly animated field raises challenging questions about the very utility of the boundaries that conventionally define, and defend, the self from the world outside the self. Distinctions between the two were elided in the literary, theatrical, and pictorial worlds of these years. It became increasingly difficult to articulate, and to represent, the place where the self ended and the world began. Social identity was crafted not through an autonomous self, but through a body that was imaginatively and materially extended *into* the world through a dense network of structures, possessions, spaces – and other bodies.

Articulating, and demonstrating, just how to *represent* that network was at the heart of Lecoq's enterprise as a teacher and theorist. A generation of young artists eagerly heeded the teacher's advice to incorporate all the apparently disparate elements before them into a unified ensemble.[10] His emphasis on the primordial connectedness of objects and bodies to the world around them to some degree did mirror contemporary experiments by Realist playwrights such as Sardou, Louis Montigny, and Alexandre Dumas *fils*. But there was a critical difference between the two modes of expression. Whereas an actor could build up a desired effect over time, depending upon an unfolding narrative and an accumulation of gestures, drawing and painting were static media. Lecoq's task was to identify – and to *teach* – an analogous strategy, one that would allow artists to preserve the specificity of individual relationships between figure and setting without compromising the integrity of the whole. His lessons were absorbed not only by the aspiring artists, architects, and artisans who attended his classes at the Ecole Gratuite, but also by those who read his tracts or simply heard secondhand about the *mise-ensemble*.[11]

While an audience can watch an actor walk stiffly or stride confidently across the stage, the movements of painted or drawn figures must be inferred. Lecoq believed that the quality of animation he imaginatively bestowed on figures and on all other components of a setting had to be embedded somehow in the very structure of the composition. He sought a method to convey, without recourse to anecdote or melodrama, the sensation of a movement arrested, or the unexpected way a figure was enframed during its passage through an architectural form, or the manner in which an arm lingered over the back of a chair. Lecoq was influential precisely because he offered a variety of pragmatic strategies for forging meaning out of these subtle, newly significant juxtapositions. In so doing, he shed light on the problem of how to construct an authentic, yet expressive, link between what his students imagined and what they experienced in the world. Central to Lecoq's teachings was the conviction that any representational structure – perspective, in particular – had to be flexible enough to accommodate, indeed to proclaim, the subjectivity of the maker, and to actively engage the response of the viewer. Lecoq's approach to composing the figure in space, distilled in his advocacy of a "perspective of feeling," the marriage of geometry and sentiment, was radical. His methods, how-

ever, were in concert with the overall philosophy of the Ecole Gratuite, whose faculty collectively elevated and conjoined two distinct, but ultimately interdependent, concerns: artistic subjectivity and the expressive primacy of spatial relationships.

Traditional pedagogy, still securely in place at mid-century, favored drawing the elements of the human body in isolation and in sequence – first the head, then the torso or a limb, for instance – as if the figure could be known only in increments. Further reinforcing a sense of displacement from nature, these studies were often based on plaster models of human body parts, a removal at third hand from the original source.[12] At the Ecole Gratuite, students followed a progression from the "simple" to the "composé," a strategy of successively greater integration that replaced the usual practice of relating parts in sequence to a whole, which was the basis for most academic teaching.[13]

New compositional techniques were practical manifestations of the central question Lecoq wanted his students to address: how does an artist bridge the space between one thing and another or reconcile the seemingly irreconcilable – a model with the nearby furniture, or a moving figure with the surrounding architectural space? Literary scholar and critic Elaine Scarry recently asked the same question, in more general terms: how do people create their imaginative bridges to the world around them? In her study of bodily subjectivity, *The Body in Pain,* Scarry argues that people have a profound need to bridge mentally the gap between "themselves" and what is external to them. One way they achieve this is by projecting into the objects around them a kind of animism, a strategy Scarry thinks is essential to feeling oriented in the world. She believes that "human beings project their bodily powers and frailties into external objects such as telephones, chairs, gods, poems, medicine, institutions and political forms, and then those objects in turn become the object of perceptions that are taken back into the interior of human conception of oneself."[14] During the nineteenth century, the practice of animating one's immediate surroundings began as material inspiration and came to constitute a mode of configuring identity. This identity depended not simply on the existence of the private home as a container or mirror for the psychic interior, but further upon the interrelations, the attachments, the acts of resistance and withdrawal, that were enacted there. Identity was dynamic and contingent, the self an ever-shifting imbrication of psychic and physical structures. Both were insecurely bounded.

New modes of acting within space are admittedly difficult to identify with any precision, let alone to historicize. Furthermore, novel corporeal styles can be distorted, misremembered, or even wholly invented, when they are cast through representation. Actions in the world are never transparently recorded through representation, whether literary, pictorial, or theatrical. Even film, which might seem to constitute a more reliable form of evidence, offers a highly stylized and idiosyncratic version of contemporary body types,

postures, and expressions. To identify what Lefebvre calls the "spatial codes" of nineteenth-century culture, and to understand as fully as possible how they were distilled in the structures of representation, we must consider a range of evidence. Not all the sources are pictorial; all, however, are concerned with spatial relationships as they were sensed through and with the body. And all testify to a distinct restructuring in the way space and figure became bearers of meaning.

Around mid-century, literary descriptions of space, architectural analyses and their accompanying illustrations, pictorial space as it was imagined through drawing exercises, and commentaries on vision collectively defined a moment that would from then on unsettle the relation of body to place, figure to ground. New strategies for emphasizing the connections among things emerged in tandem with new modes of perceiving those interrelations. Speaking about the "mental constructions of space," Scarry has wondered how the reader imaginatively "enters" Marcel Proust's childhood interiors, or empathically wanders across the expansive fields of Thomas Hardy's *Tess of the d'Urbervilles*.[15] I pose an analogous question about the foundations for a new, interactive mode of spatial perception. Around 1850, what I term a "rhetoric of embodiment" colored a range of discourses concerned with the expressive signification of space. I have already suggested how, in the visual and literary cultures of mid-century, corporeal qualities were projected onto household objects and furnishings; supposedly empty spaces were thought to emanate a sensation of sometimes uncanny *presence;* architectural structures were described as if they pulsed with life; and theatrical props seemed to inhabit the stage with an unsettling liveliness more commonly – and more plausibly – associated with human actors.

Nineteenth-century writers on architecture described buildings as if they were bodies, but not in the way that architectural theorists and their successors had earlier understood the orders as analogues for the human figure. Rather, the structures *themselves* were described as moving forward, ascending upward, swelling, and contracting. The expressivity of the ensemble depended upon equally expressive, and integrated, parts and, not least, upon the finely tuned response of the spectator, whose spatial awareness was invoked in visceral terms.

Lecoq's ideas about the expressivity of pictorial space had their architectural analogue in the writings of César Daly, architect and founding editor of the *Revue Générale de l'Architecture* and an enthusiastic promoter of the teaching methods at the Ecole Gratuite. In describing the experience of visiting a medieval church, Daly insisted that "vital fluid circulated through the stones" and the walls and pillars became positively animated under the concentrated gaze of imaginative visitors.[16] In another article, Daly insisted that a church was not merely a pile of stones, but "something living, animated, that speaks to me and stirs in me an indefinable feeling."[17] Daly believed that both the building and

the voids it enclosed became successively more enlivened as the activity of look-ing was more precisely directed and self-consciously attended to.

For Daly, any description of a structure that did not imagine the flow of fig-ures within was necessarily incoherent. In so imagining, he employed a lan-guage of corporeality. The well-ordered building possessed a "central body" that acted much like the backbone of a skeleton; it was the heart of a building's circulatory system and the "marrow" for its nervous system.[18] Even the voids framed by these architectural structures were invested by Daly with an expres-sive force, a force that was, in turn, available to the spectator through his or her *own* bodily sensations.[19]

As I mentioned earlier, Daly's preoccupation with the mental animation of architectural forms, as well as the voids they enclosed, anticipates the preoccu-pations of early art historians such as Heinrich Wölfflin. Like Daly before him, Wölfflin posited an almost seamless relationship between the sentient body and the architectural forms surrounding it, as if architecture and space were themselves agents of perceptual effects. Consider Wölfflin's characterization of a building's portico: "Powerful columns energetically stimulate us; our respira-tion harmonizes with the expansive or narrow nature of the space. In the for-mer case we are stimulated as if we ourselves were the supporting columns; in the latter case we breathe as deeply and fully as if our chest were as wide as the hall." Wölfflin concluded by invoking Goethe's belief that an architectural im-pression, "far from being some kind of reckoning by the eye, is essentially based on a direct bodily feeling."[20]

Daly's projection of animism into space and structure was not uncommon at mid-century. Analogous strategies emerged in the writings of Hippolyte Taine, for example. While Daly described buildings in corporeal terms, Taine charac-terized the body in architectural terms. For him, a modified geometric struc-ture acted as a bridge between body and architecture, just as it did in Lecoq de Boisbaudran's "perspective of feeling." In his *Lectures on Art,* Taine wrote, "There is an architecture of the body, and to the organic connections which tie together its living parts we must join the mathematical connections which de-termine the geometrical masses and its abstract contour." Taine believed that nearly every composition could be reduced to a "panel of space in which the human assemblage forms an edifice."[21]

The Viewing Subject

Preoccupation with the bodily share of spatial experience also surfaced in con-temporary writings about vision. By the 1840s a series of novel conceptions about the nature of visuality emerged in France and Germany. These empha-sized what Jonathan Crary has identified as "the corporeal subjectivity of the observer." He writes, "The human body, in all its contingency and specificity,

generates 'the spectrum of another colour' and thus becomes the active producer of optical experience."²² Maine de Biran, a colleague of Goethe's, outlined a "sense in time" to characterize more precisely the internal experience of seeing. Biran posited "the emergence of a restless, active body whose anxious *motilité* [willed effort against felt resistance] was a precondition of subjectivity."²³ Ultimately, this approach to visuality caused observation to become "increasingly exteriorized," as Crary argues. "For both Goethe (who devised his own camera obscura) and Maine de Biran, subjective observation is not the inspection of an inner space or a theater of representations . . . the viewing body and its objects begin to constitute a single field on which inside and outside are confounded."²⁴

Biran's emphasis on the agency of the subject anticipates the concerns of both Daly and Lecoq, who imagined that the human subject did not simply *perceive* space and its structural components but, rather, actively experienced them as an extension of the body. Daly's drive for greater aesthetic expressivity mingled with his appetite for social reform, as he beseeched architects to provide their clients with more engaging and congenial designs. He strongly believed in the spatial intuitions of the everyday viewer and felt that they could be activated by inviting designs. In an essay called "Du symbolisme dans l'architecture," Daly proposed his own "theory of instinctive symbolism," which emphasized the importance of a "natural language" of form through which the vigor of great art could be conveyed and understood. "Minor" and "major" combinations of geometric structures could be orchestrated like a symphony for the gratification of the audience.²⁵

It is no coincidence that Daly's theory of instinctive symbolism resonates with Lecoq's idea about the importance of a perspective of feeling. Both believed that a softening of geometric structure was essential to produce the conditions for expressing the maker's subjectivity and engaging the spectator's response. For each, expressivity was to be enhanced within the constraints of his domain. For Lecoq, the pictorial composition should be authentic, that is, visibly linked to the phenomenal world, an impulse inseparable from the emerging movement of Realism. While Daly advocated a more fluid approach to geometry in architectural composition, Lecoq labored to reform the teaching of perspective to young artists, most often, as an arid mathematical subject that bore no apparent relation either to nature in general or to irregular and animate human forms in particular. Slavish devotion to the symmetries of perspective would produce only the dreaded pyramid of academic composition – a pictorial structure that preempted subjectivity.²⁶

Clearly, Lecoq anticipated some of Lefebvre's insights about the dynamism of space. Victor Burgin describes Lefebvre's central project in terms that resonate with Lecoq's concern about the dreaded power of geometry: "to reject the conception of space as 'a container without content'. . . an abstract mathematical/geometrical continuum, independent of human subjectivity and agency."²⁷

Lecoq taught his students to build – in two dimensions – a space that contained *themselves*.

The Spaces of Subjectivity

That figures should be visually and symbolically integrated with their settings was an idea as old as linear perspective.[28] Traditionally, settings in history paintings were designed to frame the significant action, to serve as inanimate, geometrically arranged backdrops for the animate – though often, likewise, geometrically arranged – human subjects.[29] Despite the acknowledged need for sympathy between figures and surrounding structures, rarely was there any question of challenging the distinctions between them. Each was kept in its place, so to speak, through the geometric rules of perspective; those rules, in themselves, were in part an expression of the "decorum" that was deemed essential to the true history painting.[30]

By and large, genre painting followed suit. Although informality is ostensibly favored, there is little ambiguity about the figure's supremacy over his or her environment, and rarely any significant deviation from the rules of symmetry and balance that filtered down from history painting. Symmetrical arrangements and balanced apportioning of light and shadow are generally the rule. In the great majority of these paintings – and one can think of countless examples – walls and floors seem perfectly stable, furnishings suitably anchored, and objects reliably inanimate. Aside from a few rare exceptions (in the work of Turner, Zoffany, and Piranesi, for example) figures clearly dominate the settings and are distributed relatively evenly throughout the spaces.[31]

In challenging the presumptions of this tradition, Lecoq gave his students both the technical means and the mental attitude to construct a new *space of subjectivity*. Such a space necessarily had to look different from those made according to more codified rules. The signs of subjectivity had to be somehow embedded directly in the lineaments of compositional structure. Daly believed that the same principle could be applied to architectural drawing.[32] He wanted architects to be as self-conscious as painters and draftsmen about developing strategies for evoking human response through built form. For Daly, nothing less than the quality of life was at stake. In the *Revue Générale,* he queried, "Isn't man composed of a mind, a sensibility, a heart? Is he not thoughtful, sensitive, and affectionate? That being true, how is it possible to exhaust the study of the relations between man and form, or in other terms, between man and geometry (which contains the principles of all forms)?" Each aspect of the human character had a distinct relation to geometric form, Daly argued.[33] Activating such new conceptual structures between body and building would engender a new kind of spectatorship, one both more emotional and more analytical. What was needed, Daly believed, was an "aesthetic geometry," the

study of physiological responses to various shapes, a human science akin to acoustics or optics.[34]

Something much like Daly's insistence on aesthetic geometry shaped Lecoq's directives to his students, especially when he reminded them to heed their own reactions and experiences when casting the world before them into two-dimensional form. Lecoq felt so strongly about nurturing his young charges' artistic liberty that he refused to illustrate his books – a significant departure from convention.[35] In fact, Eugène Viollet-le-Duc, a colleague and friend of Lecoq's, praised the freshness of Lecoq's students' drawings, noting especially their "absence of *chic,* of conventional poses, of calculated effects." He applauded the students' ability to convey "truth without triviality."[36] If Lecoq was teaching his students to produce a vision of their own subjectivity, how could such a thing be recognized? What visual form would it take? Although the very idea of a formula was antithetical to Lecoq's thinking, it is clear that, to his mind, picturing subjectivity involved refuting the signs of order, balance, and symmetry. If subjectivity had a shape, it was clearly an asymmetrical one.

In order to express this newly imagined equivalency between body and place, animate and inanimate, Lecoq advocated incorporating "the accidents of perspective," reductions of scale, foreshortenings, and shifting sightlines.[37] Representing the accidents of perspective directly within the composition offered a way to acknowledge that disparate entities – space and figure – were being joined together on a flat surface. This was an affirmation of the anti-illusionistic nature of painting that was fundamental to the Realist enterprise, with which Lecoq was deeply sympathetic. (Lecoq actually enrolled in Gustave Courbet's short-lived atelier class.) He believed that the young artist was entitled to manipulate the proportions, perspective, and scale of what he saw, all in the name of creating a truer ensemble on the canvas or paper surface. These subtle adjustments, even deviations, from nature were legitimate not only because they constituted a form of personal signature, but because the visual integrity of the image was a metaphor for nature's intrinsic unity. While nature could not be copied exactly, a parallel form of expression with its own independent visual logic could be devised. In other words, truth to the self did not preclude truth to nature. Ultimately, Lecoq's method licensed a kind of *reasoned distortion,* in which it was precisely those deviations from a perfect geometry that affirmed an image's authenticity.

The idea that distortion might enable a more authentic expression was also gaining currency in contemporary architectural drawing. In *Le Temps,* Charles Blanc applauded the drawing style of Viollet-le-Duc: "He has made a particularly fortuitous use of *perspective cavalière* which enables bird's-eye views, allowing the viewer to determine from a very reduced surface the arrangement of the whole."[38] Viollet's *perspective cavalière* and Lecoq de Boisbaudran's *perspective de sentiment* were visual provocations to the spectator to project him- or herself into the space represented or described. A conventional pyra-

midal composition or, in architectural drawing, a lateral section, could instruct or inform, while dramatically skewered orthogonals, tilting floor planes, and quickly retreating vanishing points invited the engagement, the curiosity, and, ultimately, the *bodily empathy* of the spectator.

Lecoq advocated distortion if it served expression. He believed that the young artist's task was not to represent exactly what was before him, but "to choose, to diminish, to augment, to abstract, to accentuate, to embellish." Students were to look for "interpretations, equivalents, abstractions, and explain, in sum, less the thing than its spirit."[39] The ultimate purpose was "to represent not only the things that one sees, but more importantly, those things that one thinks and invents, and thus to give to the conceptions of the imagination a clarity and precision which places them, in a way, under the eye and at the disposition of the artist."[40]

To exhort young, unformed artists to represent what they *imagined* as well as what they *saw* was to take a radical position at mid-century. Conventional academic teaching stipulated that an art student needed a strong foundation in technical skills before attempting individual creativity. Lecoq believed that most conventions that could be taught were of little use to his students. He wanted them to develop "their own conception, their own ideal." If young practitioners could develop greater confidence in their own resources, they would naturally invent conventions of their own and cease to depend on abstract geometric formulas.[41] Rules were made to be manipulated. There were no real rules of composition, Lecoq insisted, only conventions, which students could accept, or not, at their discretion.[42] Symmetry was fine for a world where power relations were transparent, where objects stayed in their place, where people always dominated their settings. But just after mid-century, a roster of what we might call counterconventions – asymmetry, distortion of perspective or scale, manipulation of proportion – emerged to express a relation of body to place that no longer seemed either predictable or orderly.

These ideas unfolded within the fictive domesticity of Lecoq's classroom, laying the groundwork for the expressive interiors of the next generation. But the teacher also thrust his students deliberately into "real life," taking them first to the countryside – a move that may have inspired Edouard Manet's *Déjeuner sur l'Herbe*.[43] He also installed them in the ample and, at the time, empty, interiors of the Palais de Justice. There, he instructed his pupils to draw figures as they moved through the vast open areas of the building, isolating for study the affective and structural relations between the ambient models and the surrounding architectural structures and spaces.[44] Lecoq believed that it was here that his students learned to effect "the compromise between style and the rigor of principles that one calls 'the perspective of feeling.' "[45]

In this schema, every interaction of body and place generated an entirely new picture, whose expression demanded its own abstractions, distortions, and manipulations. Lecoq's pragmatic insights anticipated what perceptual psycholo-

gists have discovered about how the mind and eye perceive spatial relationships. In his classic study of the senses, J. J. Gibson described the process: "For every translation of a body in space, there is a corresponding transformation of its figure in the field of view, and the same is true for every rotation of a body in space. All these can be called *perspective* transformations."[46]

Without access to the apparatus of twentieth-century cognitive psychology, Lecoq taught his students that spatial relations were relative; that their structure, and thus, their meaning, altered with each movement. For the younger generation of avowedly Realist painters who would be influenced by Lecoq's ideas – Fantin-Latour, Legros, Degas, Whistler, Tissot, and later, Vuillard and Sickert – such assumptions about the contingency of meaning generated the compositional tools to picture such affective phenomena as instability, imbalance, and uncertainty, all of which could be achieved by delicately calibrating the multiple, shifting relations between body and place, figure and ground. Lecoq conceded that these revelatory but fleeting relationships could not always be captured. How, then, could the most expressive interactions, the most engaging juxtapositions, be identified and preserved? The answer lay in the best-known aspect of Lecoq's pedagogy, *la mémoire pittoresque*.

Memory and the Structure of Absence

In 1955, Gibson identified the limitations of the standard theory of memory:

The trouble with the classical theory of memory as applied to apprehension over time is that it begins with passive sensations in a supposedly discrete series. It presupposes that the observer gets only a series of *stimuli*. . . . The idea that "space" is perceived whereas "time" is remembered lurks at the back of our thinking. But these abstractions borrowed from physics are not appropriate for psychology. Adjacent order and successive order are better abstractions, and these are not found separate.[47]

In his own fashion, Lecoq anticipated some of these ideas – not in scientific terms, of course, but in terms that emphasized memory as an active agent of imagination, with the body moving through space the means for its visualization. Lecoq construed memory not as a passive receptacle but as an active creative agent. Memory was no "living warehouse of actions, dates, prose and verse." Its proper use *depended* upon the imagination, for it was the imagination that chose the images to be memorized in the first place, that synthesized them, and that ultimately transposed them into an intelligible expression. Lecoq believed that bad results were not due to an exaggerated dependence on the memory – as was occasionally suggested – but to the poor choice of subjects on the part of the imagination. A limited imagination generated a faulty memory, not the other way around. In response to the criticism that memoriz-

ing the same group of images made for uniformity among students, Lecoq scoffed that all students had the same master, after all – nature – and each practitioner's interpretation would look different from every other.[48]

Lecoq's memory training was hailed by colleagues, administrators, and students alike not only because it developed young artists' visual acuity, but because it was believed to foster general intelligence. The teacher advised that memory training should become a part of every school curriculum and pointed out the practical applications for artisans; as craftsmen usually worked without the benefit of models, those trained in his method could rely on a mnemonic inventory for ornamental forms.[49]

The relevance to ornament went right to the heart of the intense rivalry during these years between England and France, which vied to produce the most aesthetically advanced, and economically produced, ornament. Hillaire Belloc, the head administrator of the Ecole during most of Lecoq's tenure there, pointed out how Lecoq's method would help France to triumph over Great Britain in the decorative arts (the rivalry was at its height with London's Great Exposition of 1851, followed four years later by the Paris Exposition) and would also guarantee for the school a few prizes, the receipt of which was duly recorded in Daly's *Revue Générale de l'Architecture*.[50]

The Ecole Gratuite's emphasis on ornament was another facet of the institutional elevation of what might be called "the spaces between." Degas would later use a similar language to explain what he considered the fundamentals of decoration. Around 1870, he wrote in his notebooks: "ornament is the space between one thing and another. One fills that interval through a relation between the two things, and there is the source of ornament."[51]

Lecoq trained his students to give structure to what was materially *absent* but imaginatively *present*. He invoked what he called "the interior view of memory" and believed that by combining this with observation the artist could create something greater than the sum of its parts. He likened the process to a chemical reaction, in which familiar elements are combined in novel ways to produce a new whole.[52] For many young artists, memory would become the key to subjective expression. Georges Jeanniot quotes Degas as saying: "It is all very well to copy what you see, but it is much better to draw only what you still see in your memory. This is a transformation in which imagination collaborates with memory. Then you only reproduce what has struck you, that is to say the essential, and so your memories and your fantasy are freed from the tyranny which nature holds over them."[53] Henri Matisse would later repeat a very similar sentiment to his own students. He told them that fidelity to nature was not enough: "To copy the objects in a still-life is nothing . . . one must render the emotion they awaken in one . . . Close your eyes and hold the vision, and then do the work with your own sensibility." He continued, "Thus, if I close my eyes, I see objects better than with my eyes open."[54] Lecoq wanted his students to extrapolate from their lived experience, to shape that

experience with their memories, and to structure its visual form by using the "perspective of feeling." In so doing, they could realize the expression of their own subjectivity.

A structure, or a series of structures, invented to visualize what is present in the mind but not obviously present in the observable world could be used in a variety of ways. Absence could be, simply, an empty space in a composition – an unexplained gap between figures. Or the application could be more subtle and indirect. The Ecole's entire emphasis on attachments and the interrelations between things (appropriate for aspiring artisans of the Second Empire building campaigns) created a climate that made significant the refusal of those attachments. If the eye and mind were being trained to locate the expressive possibilities of a body leaning against a door frame or seated at a table, then the denial of such interactions could and did open up a new expressive vocabulary: one figure stranded across the room from another, a gesture withheld or masked, an eye averted, a posture contracted, a body turned away – all of which could be conveyed through the delicate structural calibrations advocated by Lecoq. These images' effectiveness depended on their ability to engage the spectator. When the empathy of the viewer was provoked, meaning seemed reciprocal. The spectator was cued not only to see but to sense a gesture withheld, a posture constrained, furniture abandoned, and objects dispersed. An entire range of meanings – states of mind, modes of relating – thus became *representable* within the constraints of Realism. These are explicitly non-narrative meanings, and the viewing practices that animated them depended, not on allegory or anecdote, but on spatial ambience and bodily empathy, and on a constant assessment of how the two were entwined. When these strategies were applied within the domestic interior, meaning revolved around the affect and effects of intimate relations among siblings and between couples, and mothers and daughters. As I will demonstrate in the following chapters, such newly charged formal relationships distilled a novel kind of psychological content: the enactment of, and resistance to, interiority.

Conclusion: To the Interior

The theme of life in the domestic interior preoccupied Daly throughout the 1860s and 1870s. His lavishly illustrated book, *Architecture Privée* (1864), bridged the worlds of architecture and representation, applying his earlier ideas on "intuitive symbolism" to the actual conditions of bourgeois domestic life. As for Lecoq de Boisbaudran, his ideas were adapted by many outside the circle of his students and were applied in a variety of ways. But the critic Louis-Edmond Duranty was perhaps the first to recognize the social possibilities of Lecoq's emphasis on the expressive fusion of figure and space.[55] Duranty adapted the idea to the social program of early Realism, which held that

modern men and women were psychologically, morally, and socially insepara-ble from their settings. Realism also prescribed that the authentic portrayal of contemporary life demanded compositions that were as distinct from those of their precursors as was the new subject matter. Duranty himself later linked the new painterly conventions – such as those of Degas, Whistler, Tissot, and Manet – with Lecoq's ideas. In a review of a drawing exhibition by the students of Charles Cazin, Lecoq's prize pupil, Duranty applauded the efforts of the young artists. The review quickly turned to an enthusiastic endorsement of Cazin's mentor, whom Duranty called "the most interesting teacher of our time." He added that what was truly remarkable about Lecoq's students was that each of them was encouraged to develop his own style. Most students, Duranty contended, learned to do one thing in their ateliers – to duplicate the style of the master. In his celebrated apologia for Impressionism, *La Nouvelle Peinture,* Duranty cited Lecoq as one of its direct ancestors.[56]

Lecoq had devised a method of conveying expression through composition while remaining true to nature. But it was left to a younger group of painters to inflect his ideas with the moral and psychological concerns that so preoccu-pied the latter half of the nineteenth century. When Degas painted his *Interior,* Sargent *The Daughters of Edward Darley Boit,* Vuillard his *Mother and Sister of the Artist,* and Sickert *Ennui,* each directly or indirectly incorporated the assumptions distilled by Lecoq and Daly. Subjectivity became *interiority* when it was staged in the space that was identified with its most intense, authentic expression: the domestic interior.

Chapter Two

Degas and the Sexuality of the *Interior*

Introduction

For the generation that came of age during the 1850s and 1860s, subjectivity was thought to be most authentically imagined and experienced in relation to one's intimates – intimacy being "a nineteenth-century invention."[1] The visual, literary, and theatrical cultures of these years attest that the relation of body to place – still the measure of private identity – was negotiated through sometimes complementary, sometimes competing, interactions with yet *another* body, or bodies – often, but not necessarily, of the opposite sex. Not surprisingly, that interaction most often took place within the private interior, which by 1860 had become a stage for the enactment of an entire range of affective, intimate dramas. Subjectivity was not simply pictured within the domestic interior; it was here that it *came into being*. With the painting *Interior* (Fig. 1 and Plate I), Degas fashioned a new kind of content by marrying the two-dimensional fusion of space and subject advocated by Lecoq de Boisbaudran to an anxiety about how the lived, sexual body was both exposed and constrained within its intimate world.[2]

Degas's *Interior* dramatizes the fraught, wordless aftermath of some kind of sexual encounter between a man and woman who have retreated to opposite sides of a sparsely furnished room. The apocryphal, but nonetheless persistent, informal title of the work, *The Rape,* is sensational rather than explanatory: there is no visual or narrative evidence that a rape has occurred.[3] Nonetheless, the designation captures something of the painting's initial effect, which might best be described as a potent sensation of sexual menace.

The man stands nearly erect, while the woman is huddled in a self-protective curve, suspended somewhere between sitting and crouching. In contrast to her companion's impeccable *haut bourgeois* costume, she is clothed only in a chemise, which has fallen – or been made to fall – to expose her left shoulder and the curve of her back. The mass of purplish drapery lying limply in her lap may be her discarded dress. Her facial expression is indecipherable, lost in the

1. Edgar Degas, *Interior*, 1868–69. Philadelphia Museum of Art, The Henry McIlhenny Collection in Memory of Frances P. McIlhenny

shadows around her. The combination of bared shoulder and shadowed face makes the woman seem simultaneously more exposed and more remote than her companion. The man's physiognomy, on the other hand, is starkly apparent and eerily irradiated by a dull yellow glow. Early critics focused on the so-called bestiality of his features, for this fueled the story of violation they saw in the painting – most often, in their telling, the story of a virginal servant girl who has been brutally assaulted by her upper-class employer.[4] Degas kept this painting largely hidden in his studio until 1905, when he decided to end thirty-five years of solitary possession and offer it for sale at the Galérie Durand-Ruel.[5]

Elsewhere, I have challenged *Interior*'s long-standing status as a narrative work and offered another way to understand its pictorial and thematic ambiguities, arguing that Degas's confounding of narrative clarity – and his subversion of its pictorial structures – act to intensify the work's disturbing psychological effect and to provoke the viewer's engagement.[6] In this chapter I want to deepen and expand my discussion, situating *Interior* within the historical and theoretical framework of the body in place that I have just set out in the preceding chapter. Although Degas's *Interior* remains in many ways mysterious, I believe that it offers one of the richest and most revelatory intersections of subjectivity and space in nineteenth-century visual culture.

There is no conventional "solution" to *Interior* (though viewers will doubtless continue to look for one), but I believe that the painting possesses a dominant theme: the strains and failures of bourgeois sexuality. Moreover, this theme is wrought in explicitly spatial terms. Degas visualized sexual desire *confounded,* and he did so by embedding the uneasiness of the encounter within the very structure of the composition. Any prior volatility between the man and woman is thereby suppressed and remains unresolved. Degas's own sexual anxieties may have played a role in shaping at least the outlines of this enigmatic scenario. But if so, his preoccupations resonated with those of his generation, as did the means he used to explore them. Georges Bataille has suggested that spatial transformation possesses a fundamental eroticism of its own. Degas's painting implies that eroticism suppressed or frustrated *also* generates a particular spatial transmutation, one that, in turn, shapes the bodily constitution of those who experience it.[7]

Anthony Vidler invokes Bataille's remark in relation to a fragment called *The Little House (La Petite Maison),* written by Jean-François Bastide around 1770. Bastide tells the story of a man's wish to seduce a learned, and reluctant, lady. His beautifully proportioned, elegantly decorated villa serves as the vehicle of seduction. The lord's female visitor, wary at first, moves through the rooms in growing awe and admiration. Eventually, it is the architecture *itself* that she desires, rather than the man who owns it. The little house becomes "the subject of a sublimated sex drive."[8] Degas's *Interior* is a space whose structure, figural arrangements, proportions, scale, and atmospheric effects have all been calculated to disallow or preempt any acts of seduction. Its distorted perspective, asymmetric arrangements, and irrational lighting effects shape a pictorial field of sexual despair, in which the pleasure in looking and touching is prohibited. As surrogates for the viewer, these stranded, withdrawn figures elicit a bodily empathy that is intensified by their spatial isolation from one another, an isolation that is effectively cemented by their heightened visual interdependence with the room in which they are confined. This conflict between affective and spatial isolation, on the one hand, and visual fusion, on the other, generates a sensation of acute strain, a tense equipoise felt – by extension – in the spectator's own body, a tension that resists dissipation. Sexual tension does not simply run beneath the surfaces of *Interior,* as it arguably did in the daily life of the French bourgeoisie; it is embedded in its very constitution.

The Intimate Life of the Bourgeoisie

The sexualized fusion of body and place on which *Interior* depends reflects a widespread contemporary preoccupation with how the bourgeoisie lived in

their domestic spaces. The discussion about domesticity was carried on within many venues, from the loftiest of architectural volumes to the illustrated pages of the daily press. In the first category, César Daly led the way. Beginning around 1860, he directed his long-standing interest in people's response to space and structure toward life in the private "habitat," as he called it. In his opus, *Architecture Privée* (1864), he defined the house as "the clothing of the family. It is in effect destined to serve as an envelope for them, to shelter them and to yield to all their movements."[9] Daly was one of the first to insist that the "aesthetic geometry" of domestic architecture did not simply reflect the tenor of family life; its structures and spaces could actually *determine* its psychological quality – for good or ill: "According to the appearance of the house, its lines, its exterior and interior decoration flatter or offend the taste of anyone who inhabits it, it is for him a pleasure or a pain each day; for certain dispositions, it is an occasion of triumph or of permanent humiliation."[10] When properly housed, the aesthetically balanced family could relate appropriately and constructively to the world outside. The usual habits and chores of domestic life could be carried out either "easily or with pain," depending upon the congeniality of the environment. Internal rapport was necessary before a family could function well outside the walls of the domestic sanctum.[11] Daly's writing was prescriptive as well; he had definite ideas about what constituted the proper encasement for family life. He believed that the ideal house's decor consisted of "delicate and harmonious details, and well-balanced lines." Everything should "caress the eye and satisfy the affections."[12]

Degas's *Interior* adamantly defies the architectural and decorative conventions for ensuring family harmony. Few harmonious elements grace the room's architecture. The man and woman are both placed at a distance from the table – that anchor for family togetherness. The flowered wallpaper (which Degas may have touched up around 1895) seems almost a mockery of the despairing scene. Surely, Daly would not have approved of such a space for *any* family, for there is little to caress the gaze or satisfy the spirit. The softening surface coverings so commonplace in nineteenth-century bourgeois decor – and so prominent in Walter Benjamin's analysis of the interior – are nearly absent, except for the skimpy rug that emphasizes the bareness of the floor. There are no draperies, as called for by Daly, because there are no windows (although one may be discernible in the unrevealing mirror reflection) and the only egress – the door on the right – is securely closed.

Degas may not have known Daly's publications directly, but he was certainly aware of the popular prints that promulgated a cruder visualization of the same belief: that there was an inextricable tie between the decor and structure of the habitat and the quality of private life. By the 1860s, Parisians were accustomed to categorizing images of domestic interiors by signs of class so conventional that they amounted to a visual code. Even the casual observer

3. Cross section of a Parisian house about 1850 showing the economic status of tenants varying by floors. (Edmund Texier, *Tableau de Paris*, Paris, 1852, I, 65.)

2. Edmund Texier, cross-section of a Parisian House, ca. 1850. From *Tableau de Paris*, 1852, I, 65, in David Pinkney, *Napoleon III and the Rebuilding of Paris* (Princeton, N.J.: Princeton University Press, 1972)

became adept at assessing class affiliation according to the relative height of ceilings, the lavishness or spareness of decor, and the comparative scale of windows and doors.[13] Some new multifamily dwellings consisted of a variety of *appartements-à-loyer*: adjacent, discontinuous rooms let to boarders, often with a commercial enterprise on the street level (Fig. 2). For these city-dwellers, class was inversely proportionate to height from the street. Spacious bourgeois dwellings were situated just above the shop, and middle-class quarters were on the level just above that. In both classes of apartments, the family's most private rooms (the bedrooms) were farthest away from the street, and thus most remote from light and air. At the top of the building were the grim garrets that housed the Second Empire's marginal citizens: the starving actor, the struggling artist and writer, the seamstress, and the prostitute.[14]

Could Degas's room represent such a garret? While the room as painted is certainly modest, with its low ceiling, bare floor, and thin rug, it is not unequivocally lower-class. Consider the refinements in the decor: the gold-framed mirror and the glass-shaded lamp – elements more at home in a bourgeois parlor or sitting room. The small framed images distinguish the room from the grim topmost quarters of Texier's 1852 *Tableau de Paris* (Fig. 2), for instance, although it shares its drab decor with the rooms just below. In addition, the lace collar and thread on Degas's pedestal table, along with the embroidery hoop visible inside the box, suggest the sewing activities of a gentle needlewoman rather than a seamstress-for-hire. And if Degas intended the woman to be a prostitute, why has her "client" lingered, in the aftermath of what was obviously an unsatisfactory encounter? Perhaps *Interior* depicts a more *public* private space – a room in a ho-

tel, for instance. Otherwise, why have the bonnet and cloak been tossed on the bed, apparently in haste, rather than hung on a coatrack in the foyer or downstairs at the entrance? The question remains to a large degree unanswerable, for while the reductive setting and scattered clothing imply that this is a transient place, the sewing box is planted on the table like a domestic fixture. Presumably, such an object would be an unwieldy accompaniment to a quick assignation.

It is impossible to establish with certainty *Interior*'s class or location, and even the identity, and thus the gender, of its primary inhabitant. This is a room that was "built" for expressive effect. Indeed, the room itself is clearly an *agent* of effect, as Daly contended was the case with any domestic setting. Daly's belief that a house should envelop, should virtually *clothe,* the family within, was a metaphorical turn of phrase, to be sure. But his musings confirm, nonetheless, the nineteenth-century obsession with the material sensuality of the surfaces and objects that constituted the private interior. Benjamin believed that the need to "leave traces," as he put it, was a defining feature of the bourgeois's living habits.¹⁵ All those antimacassars, runners, and upholstered surfaces doubled the sensation of touch and served as material evidence of the multiple acts of physical possession by which middle-class identity was constructed and represented. These tactile surfaces served as repositories for the inhabitants' visceral connection to their intimate surroundings, a liminal space where body actually verged into place.

The impact of Degas's *Interior* depends in part on a thematics of touch or, more precisely, on the consequences of the refusal or suppression of touch. Not only are surface coverings scarce, but the fire is remote and the bedstead is metal. The space is chilly and barren – overdetermined, it would seem, for domestic *dis*harmony. Paradoxically, this sensation of touch withheld or rejected was constructed through a delicately modulated fusion of figure to ground. Sexual aversion is conjured through the pressure of a successively greater pictorial integration. As Degas adjusted the woman's proportions to recede more seamlessly into the room's distorted perspective; as he distanced her farther from the table and the sewing box upon it; as he stiffened her companion's body and submerged his legs into murky shadow, he dramatized the sexual and psychological abyss between them. Pictorial integration exacted a psychological price, a strategy that operates in all the paintings I discuss in this book. As the animacy of the shifting surfaces, enlivened objects, and expressive furniture became subtly heightened in the course of Degas's studies for the picture, the figures became more fixed, locked into space in a way that gives visual form to the sensations of futility and defeat. In the visual and psychological interdependence of these phenomena is embedded the inseparability of sexual and spatial identity in nineteenth-century culture.

The Engendering of Space

The domestic interior is generally considered, in both historical and contemporary discourse, to be an overwhelmingly feminine space, one conventionally opposed to the masculine, public realm. Jürgen Habermas's model for this division prevails. While his ideas do provide a valuable framework for understanding many modern institutions, Habermas's analysis has sometimes been applied wholesale to visual representations.[16] Certainly, actual historical conditions dictated many women's confinement within the home. Women bore the principal responsibility for child-rearing and education, for hiring servants and running and decorating the house, and for negotiating and preserving the social connections prized by any middle-class family. Countless works of scholarship provide convincing arguments that such was the case.[17] I am not disputing the historical realities, or the social conditions they engendered. But the usual polarities between the masculine and feminine realms of the nineteenth century, as they are employed to interpret images, must be tempered somewhat. Recently, feminist scholars have begun to urge that women's public lives must be considered in tandem with their intimate experiences; that men were not the only ones who navigated the public world of the Second Empire.[18] I would add that *men's* interior lives must be considered as well – especially those of men whose most searching reflections appear to have occurred either at home (in the case of Vuillard), or within the private interiors of friends (as in Sargent's work and life), or inside the extended home of their studios (as with Degas). In Degas's *Interior,* neither protagonist enjoys a privileged position – despite initial impressions to the contrary. The anxieties and preoccupations of a man *and* a woman (which are presented as being very different) collide and intermingle. Degas painted this work at a critical juncture in his career and, I would venture, at a pivotal moment in the evolution of his own masculine identity. The waning years of the Second Empire saw much confusion about men's and women's public and private roles, and, in particular, about the fortunes of their intimate relations. Many wondered how an authentic intimacy might be identified, how it should be acted out and preserved. What were its psychological and social costs?[19]

Degas's *Interior* is neither entirely feminine nor masculine, although it contains signs of both. There is, on the one hand, the flowered wallpaper, the sewing box, the lace collar, and the corset collapsed on the floor. On the other hand, there is the man's top hat and the map just above it. The right corner of the room might be construed as "feminine," with its small framed images, single pillow, and delicate tones in the towels beside the bed. Yet this is precisely the side of the room in which the man stands – the realm he seems, at first, to command. Likewise, the male "attributes," the map and top hat, penetrate what might be understood initially as the woman's territory.[20] This room is

neither a woman's space nor a man's. It is rather a place where the social and sexual signs of *both* femininity and masculinity are constrained and imperiled.

A Family Portrait

I have said earlier that *Interior* visualizes the strains and failures of bourgeois sexuality. This suggests a familial tie, that this man and woman are already intimately known to each other; they could be a couple – perhaps even a married couple – in extremis. The characterization may seem far-fetched at first, for sexual alienation hardly seems the conventional subject for a "family portrait," as we usually understand it. But a variety of evidence supports such a claim, beginning with Degas's own name for *Interior*: "my genre painting." The title indicates that the artist imagined a broader framework for his painting, a more general interpretation of this seemingly private and obsessive theme. His designation does raise the question, however, of how such a theme ever came to constitute a plausible scene from "everyday life." Whose everyday life do we see represented here? And why *this* particular moment from that life?[21]

Degas did seem to harbor a personal skepticism about the possibilities for domestic happiness, but the theme of alienation between men and women, within and without marriage, was very common during these years, inspiring countless novels, plays, illustrations, and paintings.[22] Conjugal violence, the specter of divorce, marriages of convenience, and victimized working girls flooded mid-century domestic dramas such as Alexandre Dumas *fils*'s *La Femme de Claude, La Question d'Argent,* and *Le Fils Naturel.*[23] Characteristic of such plays is the following vision of marriage; in one scene of the first play, the protagonist Claude says to his wife: "I don't know who you are. There is only a bondage between us. There is nothing more than the chain which the law imposes on us."[24] In the literature of Degas's own generation, examples of sexual misalliances are legion. Duranty's *Combats de Françoise Du Quesnoy* (1873) was actually the first suggested literary source for the *Interior.* In Emile Zola's *Thérèse Raquin* (1867), the most often mentioned "source" for the painting, the grim fate of the protagonists, Thérèse and Laurent, is prefigured by their murder of her husband, Camille. In *Madéleine Férat* (1868), Zola's heroine's destructive affair with Jacques leads ultimately to her suicide. The Goncourts charted the violence between the painter Coriolis and his model Manette Salomon in their novel of that name (1867), a novel that we know deeply preoccupied Degas around this time.[25] At the center of Flaubert's *L'Education Sentimentale* (1869) is the doomed affair between Frédéric and Madame Arnoux. Not surprisingly, most of these relationships' culminating intimate scenes were staged in *interiors,* decorated either sparingly or lavishly to enhance the effect.

3. Augustus Leopold Egg, *Past and Present, No. 1, 1858*. London, The Tate Gallery. Presented by Sir Alec and Lady Martin in Memory of their Daughter, Nora. Photo: The Tate Gallery, London/Art Resource, N.Y.

The consequences of alienation between the sexes even surfaced in history books. In his tract on the decaying morals of modern life called *L'Amour*, Jules Michelet posited that the crumbling family was a consequence of modern progress and warned that "the strongest cultures are monogamous."[26] He introduced an eccentric but influential theory that a woman's child, no matter who his father was, would bear the physical imprint of her first lover. (Zola appropriated this deterministic notion as the basis for *Madéleine Férat*.)

There were many visual representations of strain between the sexes. Most were serial images, such as those published by the prolific Eugène Sue, or sentimental genre paintings. (Degas's very "title" for *Interior* seems to insist upon the difference between his interpretation and the usual fare.)[27] Serial tales, often illustrated, told of young country lasses who found dishonor, and sometimes even death, in the dangerous modern city. Following in the footsteps of William Hogarth, English painters such as Augustus Leopold Egg and William Holman Hunt painted the once devoted wife or innocent working girl who falls into a life of vice – often at the hands of an immoral married man.[28] French depictions of illicit love tended to be coquettish rather than didactic. In James Tissot's *Les Adieux* (1871; Bristol, City Museum), a maid takes leave of her lover at the back

4. William Holman Hunt, *The Awakening Conscience,* 1853. London, The Tate Gallery. Photo: Tate Gallery, London/Art Resource, N.Y.

door of the establishment where she works, bowing her head demurely, the tools of her working-class trade clearly visible. As Tissot is the only artist known to have commented on *Interior* during its production, the differences between his and Degas's approach to the theme of illicit attraction are instructive.

In most of these representations, signs of sexuality and dishonor were carefully codified. A painting might contain unmistakable signs of past indiscretions: for example, the pile of French novels on which the children of the disgraced wife in Egg's *Past and Present, No. I* (1858) (Fig. 3) build their house of cards, or the scene of a shipwreck on the rear wall of the same painting. But it was just as likely to include a scene hinting at future redemption, such as the open door and welcoming greenery reflected in the mirror of Hunt's *The Awakening Conscience* (1853) (Fig. 4). Sexuality was never expressed dynamically in the compositions themselves, however, which were by and large extremely static. Consider the pedestal table sitting squarely, even obdurately, in

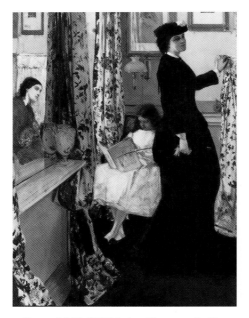

5. James McNeill Whistler, *Harmony in Green and Rose: The Music Room,* ca. 1860–61. Washington, D.C., Freer Gallery of Art. Photo: Courtesy of the Freer Gallery of Art, Smithsonian Institution, Washington, D.C.

the middle of Egg's *Past and Present, No. I,* and the centralizing arc over Hunt's soon-to-be-estranged couple in *The Awakening Conscience.*

Degas's *Interior* may have been the first of its kind, but it did not exist independently of a larger contemporary context. It was made at a moment of tremendous anxiety about involuntary expressions of feeling within the family, an anxiety that generated acute self-consciousness. Richard Sennett has contended that "the principle of personality created instability in a domain – the family – people were resolved to fix into a tableau."[29] Egg's enforced pyramid, which encompasses the diagonal of the collapsed wife, and Hunt's neatly symmetrical moment of revelation testify to this urge toward containment.

6. Sir William Quiller Orchardson, *Le Mariage de Convenance,* 1883. Glasgow Museums: Art Gallery and Museum, Kelvingrove

7. Edouard Vuillard, *Married Life*, ca. 1894. Private collection

Degas's close friend Duranty believed that the subject of intimate family re-
lations need not be confined to the less elevated genres, precisely *because* of its
intensity. He claimed that themes which revealed what he called the "moral
machinery of men," their "small, interior changes," could inspire a new, ambi-
tious, Realist painting, a viable and vital alternative to history painting, a form
far more appropriate to the moral complexities of modern life.[30] The subjects
that would best realize the formal and social goals of the new Realism were to
include "a vast series of kinds of people of the world – priests, soldiers, peas-
ants, workers, judges, merchants; they would be represented in the course of
all their usual customs: scenes of marriage, baptism, communion," and – most
relevant to the present discussion – *"family interiors."*[31]

Walter Sickert, the English painter who was friendly with Degas during the
1880s and 1890s, believed that this was exactly what the older painter had
had in mind for *Interior*. In the margins of one of his two copiously annotated
copies of Paul Jamot's *Degas*, published in 1924, he disagreed vehemently with
the author's interpretation of the painting as a scene of the sexual humiliation
of a servant girl. In the margins, Sickert penciled in an emphatic "non!" and

8. Edgar Degas, *The Bellelli Family,* ca. 1859–60. Paris, Musée d'Orsay. Photo: Giraudon/Art Resource, N.Y.

then inscribed that what Degas had been after was "un portrait de famille."[32] Certainly, the genre was much represented in the works of Degas's own circle, and related works depend also on a similarly charged interaction between body and place. Tissot's *Too Early* (1873; London, Guildhall Art Gallery), for example, as well as Whistler's *Harmony in Green and Rose: The Music Room* (1860–61) (Fig. 5), are exemplary works that Duranty would later cite (anonymously) in the *New Painting.*[33]

The explicit sexual charge of Degas's *Interior* separates it from these works at the very same time that it anticipates the works by a slightly younger generation of artists who would also express the tensions between intimates through exaggerated intervals between two figures: John Singer Sargent's *Robert Louis Stevenson and His Wife* (1883; private collection); William Quiller Orchardson's *Mariage de la Convenance* (1883) (Fig. 6); and Edouard Vuillard's *Married Life* (ca. 1894) (Fig. 7). As a family portrait, *Interior* would seem to be a highly subversive one. We prefer, to this day, that our familial im-

ages appear less strained, more reas-
suring – a conventional vision that
has never, in fact, reflected what actu-
ally goes on inside a house. As Beatriz
Colomina has put it: "As we all
know, but rarely publicize, the house
is a scene of conflict. The domestic
has always been at war. The battle of
the family, the battle of sexuality . . .
the battle for cleanliness, for hygiene
. . . and now the ecological battle."[34]

The conventional bourgeois family
of the nineteenth century expended
an enormous amount of energy in
suppressing the overt expression of
any potentially damaging emotion.
Suppression is the subtext of Degas's
magisterial *The Bellelli Family* (1860)
(Fig. 8), which he began around
1858.[35] In this work, the young
painter demonstrated an especially

9. Edgar Degas, *Edmondo and Thérèse Mor-
billi*, 1867. Boston, Museum of Fine Arts.
Gift of Robert Treat Paine II. Photo: © 1993,
Courtesy Museum of Fine Arts, Boston

acute eye for the affective and bodily signs of familial strain. He is remarkably
alert to the emasculating effects of disharmony on the ostensible patriarch of
the family. Baron Gennaro Bellelli, who was married – unhappily – to Degas's
beloved aunt, Laura, standing at the left, is trapped in a chair turned away
from the viewer and boxed in by the molding of the fireplace mantle, which
rises to fuse with the frame of the mirror. The table wedged between him and
Laura further isolates him from the rest of his family. The baron's shoulder is
contracted and strained, as if he is attempting, futilely, to rise from his chair.
His wife is regally contained and commanding, pyramidal in her sober black
drapery – an acknowledgment of the recent death of the Degas family patri-
arch, René. Her triangular form provides a fulcrum for the two daughters who
are positioned on either side of her, but her engagement with them is re-
strained: the fingers of her left hand flexed *toward*, but not touching, Giulia,
who in turn looks toward, but not *at*, her father. The Bellellis' collective dis-
comfort is signaled in their spatial confinement. They seem a family of soli-
taries pressed into enforced proximity.

When Degas painted his sister and her husband, *Edmondo and Thérèse
Morbilli* (1867) (Fig. 9), he mined a more tightly edited range of contrasts to
suggest division or imbalance: the contrasting tones and textures of the back-
grounds behind Thérèse and Edmondo; her pliancy versus his hauteur; and her
pallor versus his robustness. Here, the husband dominates the space. Thérèse's

large, sad eyes – their melancholy aspect echoing Degas's own – are widened in helplessness. One of her hands clasps her husband's shoulder like a claw; the other clings limply to her cheek. Sexual strain seems to underpin both family portraits.

The War between the Sexes

The theme of sexual conflict was staged most overtly in the works the young Degas called his "history paintings." But their idiosyncrasies of form and meaning, and their explicit sexual content, placed them well out of range of Salon success. In *Young Spartans Exercising* (ca. 1860–62) (Fig. 10), a group of adolescent girls aggressively confronts a cluster of diffident young men. The two camps are divided by a field of parched grass, traces of a dried riverbed perhaps, and by the diminutive figures of adults who stand many yards in the distance. Although the work is most commonly interpreted as a scene of aggressive challenge between the protagonists, it may be a marital selection rite, as Carol Salus has contended.[36] An androgynous – and possibly male – figure appears to be fondling the left breast of one of the young women on the far right of her group. Even if Salus is right, the aggression of the most prominent girl on the left is unmistakable, as is the sexual posturing of the nearest male youth. The shock of his display of frontal nudity is first mitigated, then complicated, by the much reduced size of his genitals relative to earlier studies. The postures of his companions are enigmatic: the blond boy in the foreground crouches like an animal, the youth second from the right swoons without apparent provocation. Also disturbing are the smallish heads and truncated features of all the young men, as if, as Nancy Miller has argued, Degas had deliberately primitivized these agents of uncertain but aggressive sexuality.[37]

Scene of War in the Middle Ages (ca. 1863–65) (Fig. 11) is an even more disturbing painting about sexual conflict, representing as it does a number of inexplicably nude women who are being pursued and attacked by men (soldiers?) on horseback. The women's postures are histrionic, with their flailing limbs, arched backs, and theatrically waving manes of hair. The androgynous hatted figure in the center was originally drawn from a female nude; it offers a distinct contrast to its more muscular blond companion.[38] The scorched, barren setting acts to defuse the sexual conflict that one would normally extrapolate from a vision of nude, prostrate women being pursued by armed soldiers. But the public (and too obviously *invented*) site is inconsistent with the private (i.e., sexual) nature of the conflict, making this a difficult painting to respond to or understand. It was the last "history painting" Degas would produce.

10. Edgar Degas, *Young Spartans Exercising*, ca. 1860–62. London, National Gallery. Photo: © National Gallery of Art

11. Edgar Degas, *Scene of War in the Middle Ages*, erroneously called *The Misfortunes of the City of Orléans*, 1863–65. Paris, Musée d'Orsay. Photo: Giraudon/Art Resource, N.Y.

Interior Melodramas

When Degas staged a more contemporary sexual conflict within an interior, he drew upon that space's identification with family privacy. In so doing, he unmasked the fragility of the interior as a sanctum. Writing about cinematic melodrama, Laura Mulvey has argued that "the family is the socially accepted road to respective normality, an icon of conformity, and at one and the same time, the source of deviance, psychosis and despair. In addition to these elements of dramatic material, the family provides a physical setting, the home, that can hold a drama in claustrophobic intensity and represent, with its highly connotative architectural organization, the passions and antagonisms that lie behind it."[39]

Discussing the same cinematic devices, Thomas Elsaesser contrasts the intense psychological conflict on which melodrama depends to the more "theatrical" gestures of an epic form such as the Western. In melodrama, Elsaesser writes, "the social pressures are such, the frame of respectability so sharply defined, that the range of 'strong' actions is limited. The tellingly impotent gesture, the social gaffe, the hysterical outburst replaces any more directly liberating or self-annihilating action and the cathartic violence of a shoot-out or chase becomes an inner violence, often one which the characters turn against themselves. . . . The dramatic configuration, the pattern of the plot makes them, regardless of any attempt to break free, constantly look inwards, at each other and themselves."[40] With certain adjustments, this could be a telling description of Degas's *Interior*, in which the viewer is drawn in, again and again, to speculate about a conflict that has no obvious resolution. *Interior* contains *some* signs of the world exterior to its limited space – the outer garments of both the man and the woman, the map, and the framed pictures. But nearly all architectural clues to the space external to the room have been studiously expunged. The room is turned back on itself. There is no light, except for the artificial glow of the glass oil lamp; there is no air; nor is there a window to relieve the room's claustrophobia. The spectator both projects and absorbs this sensation of entrapment, which is intensified with every look.

By the 1860s, the practice of imaginatively projecting oneself into an architectural setting described or represented was relatively commonplace. César Daly continued to coax his readers into the domestic spaces he wrote about. In one article on the villa, which was, to his mind, the exemplary upper-bourgeois dwelling, Daly spoke almost intimately to his imagined reader: "What do you think, Madame, and you, reader, of the 'House' which we are going to visit together? Was I not right to tell you about this true nest of refined people?"[41] Daly did not simply invite his readers in; he *demanded* that they mentally enter the spaces he described. Degas's invitation to his audience is a more equivocal one, for he simultaneously solicits and foils imaginative entry into his pictorial space. The space between his protagonists acts as what

Wolfgang Kemp has called a "constitutive blank," a site for the projections of the spectator.[42] Yet the intimate nature of the encounter that Degas pictures serves as a prohibition to the viewer; to enter *Interior* is to insert oneself directly between the alienated protagonists – an uncomfortable position, it would seem. In addition, an effect of disorientation strikes most who look at the painting, for the immediate foreground is plunged into shadow and threatens to fall away beneath the observer who comes too close.

There are other disturbing spatial anomalies that viscerally affect the spectator. *Interior*'s foreground recedes too rapidly toward the distant wall and the ceiling that descends to meet it. With its combination of widened floor and lowered ceiling, the space seems at once claustrophobic and unprotected: the man and woman seem both too near and too far away. The painted floorboards, which act as schematic orthogonals, underscore the impression that the figures are stranded on either side of an abyss. Objects and figures are crowded into the left side of the composition, while the space on the right seems to yawn, an effect that intensifies the general sense of destabilization, as does the figures' uncertain attachment to the tilting floor. The glow of the hearth appears at the perspectival vanishing point, but its orange light seems futile and remote; Degas subtly exaggerated the distance between the foreground and the far wall by compressing the rear plane disproportionately to make it seem even farther away.

The spectator is almost unconsciously implicated in this spatial distension and perspectival retreat. Heinrich Wölfflin argued that "to interpret the spatial form aesthetically we have to respond to this movement vicariously through our senses, share in it with our bodily organization. . . . The extension and movement of our body is associated with a feeling of pleasure or displeasure, which we interpret as the experience characteristic of the form itself."[43] Adapting Wölfflin's generalizations to the space of the *Interior,* the painting clearly inspires discomfort. The room is structured rationally enough to remain recognizable as an entirely plausible – even a "realistic" – interior space. But the spatial distortions employed by Degas are allied to what Victor Burgin has called "psychical space." Burgin borrows from Freud's definition of fantasy or dream to define a space "between perception and consciousness." For Burgin, the psychical mise-en-scène, as he calls it, is a "non-Euclidean" space, one in which the rationality of geometry is jettisoned for the unreality of the condensed, distorted spaces of fantasy and projection.[44] I would modify Burgin's observation somewhat, for I believe that in Degas's *Interior,* Euclid's geometry remains the template. The memory of its rational order is subtly evoked, then denied, by a new, deliberately distorted, structure. This consciousness of perspectival order displaced operates as nostalgic longing for the elusive, orderly interior as sanctum.

In attempting to clarify the impact of Balzac's tawdry interiors, Peter Brooks has written that "meaning is ever conceived as latent; description of surface

will not necessarily and of itself give access to the inner world of significance. Hence the 'pressure' applied to the surfaces of the real, the insistence of the recording glance, striving toward that moment where . . . view becomes vision."[45] The active pressure that Degas applies to his interior is evident in the "reasoned distortions" he employed, distortions that actualize Lecoq's recipe for the envisioning of subjectivity through the charged relations of body to place, figure to ground. Like the room's skewed perspective and telescoped rear plane, *Interior*'s dramatic projections into light and recessions into shadow are greatly exaggerated.[46] Light seems to emanate *from* the opened sewing box – for reasons I will explore later – and the shadow cast on the door behind the man displays the silhouette and force of an independent entity. Neither effect can be accounted for entirely by the only source of strong illumination, the glass oil lamp, whose light spills directly, and impossibly, onto the mirror reflection behind.[47]

I claimed earlier that, in *Interior*, Degas wrought the visceral effect of sexual alienation through a successively tighter integration of body and place. The process can be traced in Degas's studies, which reveal the evolving, anchoring asymmetry of the fused table, lamp, and mirror frame; the shift of the angle of the box, which was originally pivoted toward the viewer, and which now faces the woman's back; the shrinking of the table's proportions and the near-dissolution of its legs; the transformation of the bed from a cumbersome wooden box to an elegant, if simple, metal frame (Fig. 12). The change exaggerates the bed's spatial retreat, as does the widened pillow, which suppresses the bed frame as it meets the rear wall.

Figural changes were made in concert with these shifts. Early on (as in Fig. 13), the table is large and the woman, who sits just behind it, is even larger. By shrinking the table's proportions and moving the woman away from it, Degas made her seem even more vulnerable in the painting. She is at once visually stranded from the single material anchor in the painting's foreground and isolated from a symbol that had become, in both contemporary theater and painting, a virtual cliché for the family gathering. Degas's table has an emblematic quality. When the theater director Louis Montigny first thrust a pedestal table downstage during the 1850s, the move was hailed as a harbinger of the new Realist theater. The presence of the table in Degas's painting marks it as an unmistakable sign of modern life. The table's meaning was more charged in Degas's time than it might seem to us now. Sennett has argued that nineteenth-century audiences, rather paradoxically, went to the theater to *find* authenticity. The idea was that life itself was far too confusing, but a convincing illusion could be relied upon to deliver discernible clues about how life should be lived.[48] Emile Zola and the brothers Goncourt never failed to include a table in the stage settings for their domestic melodramas and depended on that prop – almost always a pedestal table such as the one Degas painted – to inspire a range of mundane activities intended to reveal the psychology of

12. Edgar Degas, *Study for Interior,* detail of right-rear corner of the room, ca. 1868. Location unknown

the characters. Degas's distancing of both figures from the table is thus thematically, as well as visually, significant.[49]

The first study Degas made for the seated female figure (Fig. 14) showed a cowering model whose upper body was crudely exposed. In a later study, the woman is contemplative rather than cowed (Fig. 15); her chair is suppressed, and we concentrate more fully on her affect, which is decidedly melancholy and withdrawn.[50] In the painted version (Plate II), the woman's integration into the space and atmosphere around her appears to be seamless. The isolation of her reverie, and of her likely humiliation, is enacted in her retreat into the surrounding shadows. To clarify this retreat, Degas exaggerated the woman's tilt away from the viewer while shrinking the size of her head and enlarging her lower body. As a result, she recedes into space as rapidly as the orthogonals beneath her.[51] Although almost cruelly exposed, she is rendered unavailable, both to the viewer and to her companion. Her fixedness in this distancing space and the apparent ease of her spatial retreat make her seem even farther away. Yet, her seeming inattention to her surroundings intensifies the engagement of those who gaze upon her, as if her trajectory could at least be understood, if not interrupted. Her visceral defeat and her exposure inspire a bodily empathy in the spectator, not simply a detached appraisal, such as

13. Edgar Degas, *Study for Interior,* ca. 1868. Pencil on paper. Paris, Musée d'Orsay. Photo: Giraudon/Art Resource, N.Y.

that directed at, say, Egg's prostrate wife in *Past and Present, No. 1* (Fig. 3). Earlier, I cited T. J. Clark's characterization of how bodily empathy is provoked by Cézanne's *Bathers* of 1895. The viewer imaginatively "fills, or reaches out to" the space occupied by one of Cézanne's figures. Clark continues, "the space gets multiplied by our imagined acts, by the plurality of our own experience of our body getting beyond us."⁵² In Degas's *Interior*, the bodily depletion and psychological shame of what appears to be sexual humiliation is enacted through spatial compression and retreat. It is an economical solution, and its success depended on Degas's rejection of other, more distracting scenarios.

In an early oil study, a woman is poised at the threshold of a room, greeted by the man, who is dressed and positioned much as he will be in the final painting (Fig. 16). But here he leans against a door that he has apparently just opened to admit his guest. The woman is fully dressed in a contemporary bourgeois street costume decorated with black trim along with a veiled hat and muff.⁵³ Perhaps Degas originally envisioned a very different scene: an affluent but unmarried couple desperate for an anonymous retreat. But this decorous, anecdotal subject was jettisoned for the painting, as was a far more melodramatic representation: a full-length frontal figure, shown nude from

14. Edgar Degas, *Le Modèle*, ca. 1868. Pencil on paper. Location unknown

15. Edgar Degas, *Study of a Seated Woman*, ca. 1868–69. New York, The Pierpont Morgan Library. Photo: Courtesy, The Pierpont Morgan Library, New York. 1985.38

the waist up, who clutches a garment or cloak to herself in a self-protective pose reminiscent of a Venus Pudica (Fig. 17). Her left arm is thrust out, as if she were gesturing in agitation or has just thrown something away (her corset perhaps)?[54] Another oil sketch (Fig. 18), probably made at the same time, appears to show the same model – likely Emma Dobigny, one of Degas's favorite models of these years, and the model for the painting *Sulking* (1868–69; New York, Metropolitan Museum of Art). In the sketch, she stretches her neck downward and to the left and gazes past a shoulder bared by a fallen chemise. Her mouth looks slightly open, as if she is speaking, and her brow is creased with a faint scowl. Pentimenti attest to Degas's multiple experiments with the positioning of the model's arms. They are alternately thrust straight out, raised as if in protest, or contracted as if to resist. These choices all preempt the viewer's involvement, for different reasons. The first version is too anecdotal; the second two are dependent on near-histrionic gestures not unlike those found in Degas's *Scenes of War in the Middle Ages*. None of these versions achieves the sexual tension that permeates the final work, whose power

16. Edgar Degas, *Man's Portrait (Study for Interior)*, 1868–69. Private collection. Photo: Courtesy of Jean Sutherland Boggs

17. Edgar Degas, *Young Woman at Her Toilette*, 1866–68. Basel, Oeffentliche Kunstsammlung Basel, Kunstmuseum. Photo: Oeffentliche Kunstsammlung Basel, Martin Bühler

18. Edgar Degas, *Standing Woman*, 1868–69. Pastel and pencil on paper. The Molly and Walter Bareiss Family Collection of Art

is drawn from the calculated suppression of both overt volatility and clear narrative.

Animism

As Degas successively restrained the gestures of both protagonists, fusing bodies more completely to setting, the components of that setting became, in turn, more dynamic. Both Daly and Wölfflin, writing out of a shared conviction about the animacy of architectural form, might have described the ceiling not simply as "low," but as "actively descending." The floor tilts and expands; the walls contract and recede. Not only do space and structure exert agency in this painting; so too do the objects and furnishings that adhere, with varying degrees of stability, to its surfaces. The table, the lamp, the corset, and above all, the open sewing box are rendered with little detail. Yet, they exude the presence of human actors. The sensation of unfinish that clings to each of the

objects and furnishings – the ill-defined legs of the table, the indistinctness of the map, the thinness of the corset and the rug – integrate them more fully into the ensemble, displaying the disintegration of boundaries between animate and inanimate that had been prescribed by Lecoq.

The nineteenth-century bourgeoisie carried on ambivalent relationships with their ever-present "bibelots." Their drawing rooms were notorious for the proliferation of surface coverings, upholstered chairs, and "knickknacks." Edmond de Goncourt dubbed the taste for crammed rooms and cosseted furniture "bricàbracomania." Although such objects and coverings were presumably selected and arranged by their owners, their sheer profusion called the primacy of human inhabitants into doubt. Duranty's short story *Bric-à-Brac* (1876) is a humorous account of a family of collectors whose limbs are indistinguishable from the legs of their oversized furniture. According to both Charles Baudelaire and Edgar Allan Poe, the wrong furniture, or an unpleasing arrangement of it, could positively ruin a room.[55] And in the writings of Guy de Maupassant, furniture could even come alive – to the susceptible imagination, at least.[56]

Sexual attraction was believed to heighten the imagined animacy of objects even further. In 1858, this commentary about the vitality of matter appeared in the periodical *L'Artiste*: "The sister-molecules, separated by the arbitrary force of man, yield spontaneously only to the sweet law of attraction. . . . Living a life of their own, animated by an individual spirit, they obey only one law: the law of love."[57] These comments anticipate by over a century Elaine Scarry's emphasis on the importance of animism as a practice for orienting the self in the world. She writes, "it is the work of the imagination (rather than the object) to make the inanimate world animate-like, to make the world outside the body as responsible as if it were not oblivious to sentience."[58]

Degas achieves something very close to this: he fosters the *expectation* of animacy by staging a series of dynamic oppositions between objects and bodily configurations that are gendered as masculine or feminine, rather than by using an accumulation of anecdotal clues. In *Interior*, certain obvious emblems of gender, such as the sewing box and the top hat, are contrasted through the associations they inspire; the openness of the sewing box might stand for a certain feminine vulnerability, for instance, while the map suggests a world of masculine adventure. Yet postures, gestures, physiognomies, and costume are directly opposed within the structure of the painting itself. Even in these more explicit oppositions, the meaning of each object or gesture is never discrete, as would be the case with more conventional attributes – such as the half-eaten apple in Egg's *Past and Present, No. 1* or the unraveling embroidery in Hunt's *Awakening Conscience* – but, rather, relative to its structure within the composition. In other words, Degas painted not just a sewing box, but a sewing box that serves as a pivotal point from which the body of a woman turns away; a

corset cast down between the couple; and a top hat that rests at the opposite side of a room from its putative owner.

"The interior structure of the object has been attended to because it contains the material record of the interior of this invisible action," according to Scarry. A chair, for instance, can be "recognized as mimetic of sentient awareness. . . . The chair is therefore the materialized structure of a perception; it is sentient awareness materialized into a freestanding design. . . . not the act of perception, but the structure of the act of perception visibly enacted."[59] Extending Scarry's formulation, we might imagine that each object Degas painted for *Interior* materializes the sensation of sexuality denied, or frustrated. Despite its apparent spareness, *Interior* is dense with visualizations of desire confounded and of touch denied: the sewing box opened but abandoned, the tools of handiwork set aside, the garments cast off and strewn carelessly over the bed frame. The exposed flesh of the woman's shoulder embodies touch as an act of violation, as does her corset, that most intimate of bodily encasements, now collapsed unceremoniously at midpoint between the couple.

The corset's condition and its distance from the woman's body testify to the volatility of the earlier encounter.[60] Like the rug, the corset is thinly painted, almost ghostly in its immateriality, with its laces spilling toward the viewer. The ephemerality of its form contradicts its loaded meaning, for no corset can be dismissed, no matter how reductively it is painted. One early critic, Georges Grappe, called it "a symbol of powerful restraint," evidence that the woman was forcibly undressed.[61] But as we have seen, the painting is far more ambiguous than this. The corset's equidistance from both man and woman raises the unanswerable question of how it fell to the floor in the first place. Did the woman cast it away of her own volition, all the while knowing its abandonment would be a sure prelude to female dishonor?[62] Or was it included as an assurance of the realism of the image?

Just over a decade later, Degas would advise his young friend Henri Gervex to plant a corset in the foreground of the latter's *Rolla* (1879; Bordeaux, Musée des Beaux-Arts), a scene of an elite young man's debauchery inspired by the novel by Alfred de Musset. "You must make it plain that the woman is not a model. Where is the dress she has taken off? Put a pair of corsets on the floor nearby," Degas is said to have instructed Gervex.[63] The corset in *Rolla* looms into the foreground like a large baffle that the viewer must negotiate in order to attain the languid young woman on the bed. It seems less a sign of eroticism than a show of the artist's knowledge of the latest fashion in women's undergarments. At the time of the painting's exhibition, the corset aroused intense indignation among critics, because it highlighted the so-called female identification problem: how to tell who was virtuous, and who was not.[64] Of course, Degas himself was explicitly concerned with the dress and undress of his

19. Edgar Degas, *Little Dancer of Fourteen Years*. After the wax executed in 1880. Bronze, tulle, and silk. Philadelphia Museum of Art, The Henry P. McIlhenny Collection in Memory of Frances P. McIlhenny

subjects. As Carol Armstrong has pointed out, his ballerinas constantly rearrange their skirts, readjust their toe shoes, straighten their chokers, and smooth their hair. Degas's *Little Dancer of Fourteen Years* (1880–81) (Fig. 19) might be considered the apotheosis of this activity, as he dressed the figure's waxen body – quite literally – in a gauze tutu, satin corselet, horsehair wig, and fabric slippers.[65]

Marcia Pointon has described nineteenth-century painting as "littered with cast-off garments," a condition of disarray that confuses the historical status of the female nude as an allegory for male creativity.[66] Degas's corset does not function as an allegory but, in concert with the fallen chemise, the abandoned outer garments, and the sewing box, as one of a chorus of fragmentary signs of female sexuality that attains its coherence through the presence and, in particular, through the gaze of, the male protagonist.[67] Other signs of femininity dispersed throughout the painting include the woman's jeweled ear, the lace collar on the table, the embroidery hoop, the flowered glass lamp, and the patterned wallpaper. Most powerful of all is the sewing box, which forms the radiant perceptual center of the painting. Its small but riveting interior reflects, in concentrated form, all the tensions and contradictions of the larger interior that encompasses it. Degas labored long and hard over the scale, position, and conspicuousness of this sewing box. A note from Tissot found in Degas's studio suggests the difficulties he confronted. Tissot warned him, "the sewing box [*sic*] too conspicuous, or rather not vivid enough."[68]

Pandora's Box

For early critics of *Interior,* the sewing box confirmed the asymmetry of the protagonists' respective class status and reinforced the bestiality of the man. The woman, according to Georges Grappe, was "the little worker," whose employer has "lost his head . . . his composure returning as he contemplates his grief."[69] Camille Mauclair, a well-known Symbolist critic, concurred in 1924, bemoaning the agony of the "little victim," with her "embroiderer's work basket," sobbing in the aftermath of the "brutal struggle." The man, who has "satisfied his lust, is once more composed, but mournfully so."[70]

Some authors have argued that the box on the table is a valise, pointing to its commodious proportions and conspicuous presence.[71] Indeed, a box of approximately this size *could* function as a general index for femininity, for it resembles a milliner's case, as well as a traveling seamstress's workbox. But Degas seems relatively indifferent to the actual details of sewing and embroidery as activities, as he was to their customary moralizing associations. The scissors, ball of thread, lace collar, and embroidery hoop do not collectively serve as implements for a project. Instead, they act as a cumulative inventory of references to the significance of the *act* of sewing.

Historically, sewing had been represented as a virtuous activity. Practitioners ranged from the Virgin Mary to the beneficent matron pictured in Jacques-Louis David's *The Marquise de Pastoret and her Son* (ca. 1792; Chicago, The Art Institute). Nineteenth-century popular illustrations are full of seamstresses working alone in their damp, ill-lit garrets. Working-class seamstresses were vulnerable to the predatory bourgeois, who is represented in some illustrations as a menacing, top-hatted silhouette lurking just outside the seamstress's shop.[72]

Disengagement from the signs of sewing or embroidering could serve as a sign for honor lost, just as the discarded corset did. In Jean-Baptiste Greuze's *A Young Woman Who Has Broken Her Mirror* (1763) (Fig. 20), a disconsolate woman bends toward her looking glass, which lies broken on the floor, and toward the baubles on her vanity. In so doing, she turns away from her sewing box. The loosened laces of her corset indicate that vice has triumphed over virtue.[73] In Fragonard's *The Stolen Kiss* (1780; St. Petersburg, The State Hermitage Museum), a woman is snatched away from her sewing table into the fervent embrace of her seducer. In a futile attempt to maintain her composure, she grips some fabric as spools of thread spill out. The moralistic opposition between sewing and the abandonment of needlework was codified in a diptych by Charles Marchal that Degas probably saw in 1868: *Pénélopé* and *Phryné.* Wearing a demure dove-gray dress, *Pénélopé* (Fig. 21) is absorbed in her needlework as she stands beside her husband's picture, while her companion, *Phryné,* preens before her vanity in a daring black evening dress, as jewels spill out of a box below.[74]

20. Jean-Baptiste Greuze, *A Young Woman Who Has Broken Her Mirror*, 1763. London, The Wallace Collection. Photo: Reproduced by Permission of the Wallace Collection, London

Degas's early sketches indicate unmistakably that he had originally opened the sewing box toward the viewer (Fig. 22). By facing it toward the woman, he emphasized her turning away from it and from the innocence it represents.[75] As Nathaniel Hawthorne wrote, "And when the work falls in a woman's lap, of its own accord, and the needle involuntarily ceases to fly, it is a sign of trouble quite as trustworthy as the throb of the heart itself."[76] A painting of around the same time by the Macchiaioli artist Adriano Cecioni, called *Interior with Figure* (ca. 1867) (Fig. 23), includes a similar juxtaposition, but without the sexual connotations.[77] There a woman appears kneeling in grief, turned away from the sewing that lies abandoned in her lap. Represented with more economy and intensity, Degas's female protagonist appears to endure the humiliation of her compromised virtue.

The sewing box serves not only as the visualization of virtue longed for but lost, but also as the materialization of sensual, female flesh. This was precisely

the claim made in the catalogue of the
Degas retrospective organized by the
Musée d'Orsay and the Metropolitan
Museum of Art in 1988, where the
author of the entry on *Interior* as-
serted that "there had not been a
more expressive symbol of lost virgin-
ity than that gaping box, with its pink
lining glaringly exposed in the lamp-
light." The writer adds the rather
breathtakingly offhand suggestion
that "the open box may suggest a
hasty search for some jewel that was
hidden there."[78]

Earlier in the 1860s, Degas had em-
barked on a search for essential wom-
anly traits. In his notebook, he in-
structed himself to "think of a trait of
ornament for women, or for *the*
women. Made after observing their
ways, their deportment, their affecta-
tions and combine . . . think of their
toilette, dressing table, costume,
grooming, all their things."[79] Con-
temporary notebook drawings show
a woman's dressing table, with a
closed box prominently centered. Ap-
proximately the same size as the box
in the *Interior,* it sits amid a collection
of various accessories and vessels.
The skirt of the table is trimmed with
a lavish ribbon. It is tempting to
imagine that Degas has virtually
dressed the object, much as he would

21. Charles-François Marchal, *Pénélopé*,
1867. New York, The Metropolitan Museum
of Art. Gift of Mrs. Adolf Obrig in Memory
of Her Husband, 1917 (17.138.2). Photo:
Metropolitan Museum of Art, New York

later clothe the *Little Dancer of Fourteen Years*.[80]

For the *Interior,* Degas opened the box, and therein lies the crucial differ-
ence. Luminous rose tones seem to pulse from the box's interior. A constella-
tion of pink and red hues – the woman's rosy cheek, the red stripes of the rug,
the red- and pink-flowered sprigs on the glass chimney – coalesce around the
box to cement its unambiguous association with the woman. In *The Poetics of
Space,* Gaston Bachelard described the small chest as an "interior within an in-
terior." Its relation to the larger space it inhabits is equivocal, depending en-
tirely on whether it is open or closed. "Chests, especially small caskets, over

22. Edgar Degas, *Study for Interior,* ca. 1868. Pencil on paper. Notebook 22, p. 98. Paris, Bibliothèque Nationale. Photo: Giraudon/Art Resource, N.Y.

23. Adriano Cecioni, *Interior with Figure,* ca. 1867. Rome, National Gallery of Modern Art. Photo: Alinari/Art Resource, N.Y.

which we have more complete mastery, are objects *that may be opened*. When a casket is closed, it is returned to the general community of objects; it takes its place in exterior space. But it opens! . . . a new dimension – the dimension of intimacy – has just opened up."[81]

Ludmilla Jordanova links the closed object containing a hidden interior with female sexuality and thus with the danger of the secrets that might be revealed. And secrecy is seductive. She writes: "Women and their secrets have a decidedly ambiguous status, being both desired and feared. . . . Men desire to possess both women and knowledge, and they pay a cost for both."[82] That Degas felt acutely the perilous nature of this dual possession is suggested in his pronouncement about the difficulties of making art: "Art is vice. You don't marry it, you rape it. Whoever says art says artifice."[83] For Degas, the metaphorical possession of the female body that was a necessary prelude to transmuting it into art was fraught with anxiety, and perhaps even with shame.

The best-known box in the modern history of sexuality belonged to Freud's patient "Dora." As Janet Malcolm has put it: "The case rattles with boxes; you practically trip over one wherever you turn. There is a jewelry box in the first dream . . . there are two boxes in the second dream . . . and there is the . . . reticule, which Dora pokes her finger in and out of."[84] Freud himself recorded his comments to Dora after she recounted for him a dream in which she was offered a jewel case. "Perhaps you do not know that jewel-case [*Schmuckkastchen*] is a favourite expression for the same thing that you alluded to not long ago by means of the reticule you were wearing – for the female genitals, I mean."[85]

Freud's analysis of Dora was a notorious failure, largely because he was unable to cope with the countertransference inspired by this intelligent, challenging, young woman.[86] Malcolm asks, "Who could Dora be but Pandora? . . . the authoress of all our ills," a combination of "great beauty and a bad character."[87] As for the Pandora myth itself, according to Elaine Showalter, it is "a parable of defloration."[88] Less literally, the myth is also about the dangers of satisfying one's curiosity, "a reification and displaced representation of female sexuality as mystery and threat."[89] If Pandora's box distills the fear of women's secrets, of their hidden anatomy, and their potential treacheries, then Degas's open sewing box evokes both the seductions and the dangers of an erotic encounter. Indeed, the idea that female sexuality presented a distinct threat to masculine autonomy was a commonplace in Degas's day, one acutely felt within his own circle. Roy McMullen has pointed out that many of Degas's friends and colleagues remained unmarried, while others delayed the "march to the altar." McMullen also notes that Degas was deeply absorbed in Edmond and Jules de Goncourt's volatile tale of sexual obsession, *Manette Salomon,* at the end of 1867, just when he began the sketches for *Interior*. The novel tells of a wealthy and talented painter, Coriolis, who succumbs to the erotic charms of Manette, an illiterate Jewish model. Coriolis's obsession with

Manette dissipates his drive to create and destroys his career. Degas identified *Manette Salomon* as a "direct source" for his "new perception" of painting.[90] If *Interior* exemplifies this new approach to his work, then Degas himself, at the age of thirty-four, seems to have possessed a deeply conflicted understanding of the role of masculine authority, as well as a significant confusion about the proper response to those who might challenge it.

When Freud's analysis of Dora came to its unexpected end, the psychoanalyst nonetheless boasted to his friend Wilhelm Fliess that "the case has opened smoothly to my collection of picklocks," a comment that depends quite obviously on metaphors of penetration. Such penetration could be simply psychoanalytic – the obdurate dreams and fantasies yielding to the insightful powers of Freud's technique. But we know that Freud himself associated the key, or picklock, with male sexuality.[91] The word that Dora used for box, *Schachtel,* was also a deprecatory word for woman. As Freud mused, " 'Where is the *key*?' seems to me to be the masculine counterpart to the question 'Where is the *box*?' "[92]

Honor

Degas may not have represented the key itself in *Interior,* but he did represent the lock plate. In an early oil sketch (Fig. 16) – the same study that shows the fully dressed woman about to enter the room – the man leans heavily against the opened door. Below his elbow is a conspicuous rectangular lock plate with a keyhole at its center – a striking detail given the provisional nature of the study. In the final painting, the man's body occludes the keyhole, but the connotation of privileged entry is preserved in the bold red color and clear rectangular contour of the lock plate. Both lock and keyhole are now absorbed directly into the masculine body that presses against the (now) closed door; the visible portion of the lock plate acts less as an accessory or attribute than as a partially hidden body part. Degas certainly understood the sexual significance attached to the lock plate or latch, as seen in paintings such as Fragonard's *The Bolt* (ca. 1778; Paris, Musée du Louvre), in which a man overcomes the objections of his lover (or rather, his victim) by sliding the bolt across the doorjamb. Degas's own collection of prints by Gavarni included an image of a man conspicuously sliding back the bolt of a lock to secure his privacy.[93] The partial obscuring of the lock in *Interior* is but one aspect of Degas's envisioning of a contemporary man fixed in a position that is both compromising and compromised. Degas pictured a masculine subjectivity that seems without authority, without freedom and, above all, without honor.

Degas's male protagonist is in many ways more enigmatic than his female counterpart. His class identity seems at first to echo the artist's own, for he is garbed much as Degas himself dressed during these years. In his last painted

24. Edgar Degas, *Self-Portrait, Degas Lifting His Hat,* ca. 1863. Lisbon, Calouste Gulbenkian Foundation. Photo: The Gulbenkian Foundation

25. Anonymous, *Edgar Degas.* Photograph printed from glass no. 31. Paris, Bibliothèque Nationale. Photo: Giraudon/Art Resource, N.Y.

self-representation, *Self-Portrait, Degas Lifting His Hat* (ca. 1863) (Fig. 24), the young artist pictures himself as a straight-laced bourgeois, as he also does in a *carte-de-visite* of around the same time (Fig. 25). While it is possible that a painting about sexuality and despair would have drawn upon the artist's own fantasies and fears, *Interior* is not a confessional painting. Degas did not reveal himself directly in his works. He proceeded by indirection, painstaking reformulation, and charged juxtapositions. If his own sexual preoccupations were implicated – perhaps unwittingly – in *Interior,* the painting's power stems in great part not from its personal revelations, but from the fact that Degas gave figural and spatial form to a far more general uncertainty about the nature and appearance of masculine authority. There is a strategic difference between "solving" a complex painting and striving to understand the more general significance of its complexities. It is true that the interior state of a man who lingers in the aftermath of a failed sexual encounter is something that a high-strung, unmarried man of thirty-four may well have speculated about.[94] We shall never know. Nor do we need to, for Degas's *Interior,* despite the persistence of our ignorance about its "origin" in the mind of the artist, demonstrates that, in the nineteenth century, spatial identity – how and where a man stood in relation to the milieu and the figures around him – *was* sexual identity.

26. Edgar Degas, *Study for Interior,* ca. 1868. Pencil on paper. Location unknown

Degas's male protagonist underwent a process of reformulation as protracted as that of his female companion. In an early study for the painting (Fig. 26) he possesses greater physical confidence and projects a robust, sensual presence. His posture is relatively relaxed, and his hands are clasped behind his back rather than encased in his pockets. His vitality is implied in his body's freedom from confinement by the door frame, and his handsome head is angled *toward* the woman, as if he is engaging her in conversation. He wears not the formal *haut-bourgeois* coat and pants, but the relatively informal "lounge suit" – a more casual ensemble of loose jacket and roomy pants sewn out of the same fabric that was worn only in private family settings.[95] Degas made notes directly on the drawing, jotting down desired changes in sartorial details. In several studies that follow and, most importantly, in the final painting. Degas replaced the casually cut jacket with a formal topcoat and the loose-fitting trousers with close-fitting striped pants. A starched white collar and stiff cuffs complete an ensemble whose *haut bourgeois* pedigree is ratified by a hint of bright blue in the cravat, a well-tailored waistcoat, and a faintly visible, but unmistakable, gold watch fob.

Clothes made the man in nineteenth-century France. As Robert Nye has observed, by mid-century "people's personalities came to be seen in their appearances, [and] facts of class and sex thus became matters of real anxiety. The world of immanent truths is so much more intense and yet so much more problematical than the public world of the *ancien régime* in which appearances were put at a distance from the self."[96] When Degas fashioned his protagonist's costume, he reimagined his masculinity, which, in these years, was never, as scholars have argued, wholly interiorized.[97] Such an exteriorized masculinity depended above all on the formal suit, which, according to Stephen Schindler, served two purposes: "to protect against women and against men's own unconscious and oppressed femininity."[98] As Degas formalized his subject's costume, he stiffened his posture, so that body and garb are completely coextensive. This fusion was not simply a pictorial invention; it

was a manifestation of a recognized social convention about bourgeois masculinity. The suit was understood to provide a smooth, uninterrupted encasement for the body. Anne Hollander writes that "the suit does not constrict the body . . . but it hides the body's whole surface quite thoroughly, and it usually offers its ensemble of lines, colors, and shapes with discretion."[99] The discreet containment of the suit proclaimed the restraint and sang-froid of the man who wore it, and it also suggested his resistance to any kind of sexual or social dependency. The gradually more emphatic intactness of the man's costume, as Degas imagines it, along with the evolving restraint of his posture, deepens the contrast between male and female protagonists. The woman's bodily signs are all in pieces, scattered, lacking in coherence, while her companion remains sheathed, seemingly undisturbed. Even his top hat has been placed carefully across the room, with a precision that implies that its owner possessed the virtue of patience, the luxury of time, and the privilege of access to the room.

If we mentally restore the top hat to the crown of the man's head, he looks like nothing so much as a *flâneur* – that detached, ambulatory spectator of modern life, the man who observes without becoming engaged. It is as if the ambient *flâneur* has become trapped in the interior.[100] His hands-in-pockets gesture might signal well-being if he were shown outdoors, as, say, Manet was in Degas's study of him at the races (*Manet at the Races*, ca. 1870; New York, Metropolitan Museum of Art). In *Interior*, the hands lodged in pockets seem to signal constraint, even impotence, rather than amused detachment. The "passive silence" and withdrawal that characterize the *flâneur* in public become acts of refusal when staged within the private domestic interior.[101] The nineteenth-century man could roam the streets, observing life with detached amusement, but he was also free to penetrate the domestic interior, as long as he assumed his proper role of provider. The responsible husband and father was both a man of honor and a powerful member of the French nation. Nye points out that, "for bourgeois men, there was a far less dramatic rupture between public and private life than was the case for women; a single code regulated both domains of a man's life, permitting him to cross his threshold without feeling he had passed into a wholly different world."[102]

Degas's male protagonists are, in general, only equivocal authorities within their respective domains. Even flanked by his family, Gennaro Bellelli seems to sit alone in the rented rooms of his exile in Florence. His isolation is reinforced by a roster of humiliating details: the awkwardly contracted shoulder, the ineffectual half-rise from the averted chair, the cruel revelation of the bald spot beneath the thinning hair. In his *Portrait of James Tissot* (ca. 1867–66; New York, Metropolitan Museum of Art), Degas shows his friend leaning in a chair that is only tenuously anchored to the floor beneath. His too-long upper legs; his almost sullen, quizzical gaze; the leglessness of his easel – all conspire to create a sensation of unease. Degas's *Collector of Prints* (1866; New York, Metropolitan Museum of Art) is hemmed in, rather than amplified, by his possessions;

27. Edgar Degas, *Portrait of Michel-Lévy* (*The Man and the Mannequin*), 1879. Lisbon, The Calouste Gulbenkian Foundation. Photo: The Gulbenkian Foundation

and in a later portrait, Duranty is nearly overwhelmed by the literary attributes of his profession (*Edmond Duranty*, 1879; Glasgow, The Burrell Collection). In the *Portrait of Henri Michel-Lévy* (1879) (Fig. 27), the artist who may have served as the model for *Interior*'s protagonist, who was a genre and landscape painter, appears barricaded in the corner of his studio, pressed back by a paintbox bristling with brushes and by a disturbingly angled female mannequin that is collapsed at his feet. His sullen demeanor is reinforced by his hands, which are jammed into his pockets.[103] When Degas locates his male subjects in more public spaces, they tend to linger at the margins, in the liminal spaces of the wings of the rehearsal stage, the foyer of the concert hall, and the area outside the rehearsal hall or dressing room. By the same token, Degas's representations of the exclusively masculine domains of business seem curiously privatized. Armstrong has pointed out the near-domestic hominess of the *Portraits in an Office* (*New Orleans*) (1875; Pau, Musée des Beaux Arts), and in the *Portraits at the Stock Exchange* (ca. 1878–79) (Fig. 28), financial transactions are made to seem surreptitious, secretive, even illicit.[104]

In mid-century France, two characteristics were essential to the preservation of masculine honor: the mastery of involuntary or indecorous emotion, and sexual potency. Propagating the species was a solemn duty of the exemplary French citizen, and "only a man who was sexually potent could live in and through the heirs who received both his good name and the imprint of his person." He who departed from the standard "dishonored himself and brought shame to his family – a judgement applied with equal severity to both the bachelor and the homosexual."[105]

Degas's common designation as the "celibate" bears repeating here. A life-long bachelor, his sexuality has been the subject of much inconclusive debate and discussion, as it was during his own lifetime.[106] But, as his biographer McMullen has pointed out, bachelorhood was not uncommon for a member

of the artist's class and social aspiration, although his apparent celibacy was rather unusual. Yet it is important to remember that Degas grew up surrounded by bachelor uncles and by a widowed grandfather and father (his mother died when he was thirteen). Like many other ambitious artists of his generation, he evidently believed that family life was incompatible with a successful career.[107]

In Degas's day, much bourgeois effort was directed toward mastering emotion or involuntary urges within the interior. The male's "unshakeable sang-froid," according to Nye, "not only promoted social mobility, but conferred, it would appear, a selective advantage on the men who possessed it in the highest degree."[108] The male protagonist of *Interior* initially appears to be the very picture of self-possession. He is contained and aloof; moreover, Degas exaggerates

28. Edgar Degas, *Portraits at the Stock Exchange,* ca. 1878–79. Paris, Musée d'Orsay. Photo: Giraudon/Art Resource, N.Y.

his bodily presence. He extends the length of his legs by fusing them with the shadows they cast on the floor, and he amplifies the force of his body with a nearly independent shadow on the door behind him. But this effect of dominance is subtly undermined, not only by the hands encased in pockets, but by his physiognomy and the startling manner in which it is lit. His face is distinctly unappealing. He is not grotesque or bestial – as early critics insisted – but his features are aberrant enough to warrant attention.[109] His physiognomy was carefully shaped in a series of studies, in which Degas discarded the handsome face and engaged demeanor of the earlier version for a man whose forehead is too narrow, nose too large, eyes too small, and eyebrows too close together. A sizable fleck of white paint fills the man's left eye and, most unsettling of all, the man's ear seems ever-so-slightly pointed.

The relative subtlety of such dissonance is confirmed by comparison with the earlier, more sinister features that Degas rejected. These include a man with fierce and penetrating eyes, a heavy dark brow, a drooping moustache, and an overly large ear (Fig. 29), a visage that anticipates Cesare Lombroso's imagery of criminal physiognomy.[110] Another drawing (ca. 1868–69) (Fig. 30) is a sensitive treatment of the man's head and a more schematic rendering of his upper body. The subject has a furrowed, almost scowling, brow, and Degas

29. Edgar Degas, *Head of a Man (Profile)*, ca. 1868. Charcoal on paper, no. 35. Paris, Bibliothèque Nationale. Photo: Giraudon/Art Resource

carefully sketched dark shadows around his left eye – a suggestion of melancholy and weariness that is more understated in the final painting. As Theodore Reff has pointed out, the features may have been inspired collectively by a variety of sources; Lombroso's theories, which were disseminated in public lectures years before they were published, may well have inspired the man's low forehead and closely spaced eyes, while we know from Degas's own notebooks that the white glint was evidently an homage to the acting teacher François Delsarte, who taught his students how to emote on stage. I would add that the ear may have been inspired by Caspar Lavater's features for the satyr, a creature of unquenchable sexual appetites.[111] Keeping in mind Degas's characteristic conjoining of sexual and aesthetic appetites, consider as well Honoré Daumier's print of 1844, in which this favorite of Degas's used a pointed ear to suggest the lust of an art collector as he contemplates his classical bust.[112]

Degas's protagonist is probably not a criminal, although it should be noted that forcible rape was one of the few crimes punishable by the Napoleonic code.[113] But he is a man whose masculine honor has been compromised. His sang-froid has been shaken – perhaps more by a recognition of his own lapse than by any actual harm he has inflicted on the woman who crouches before him. More than any other feature, the flash of white paint in the man's eye aroused the animosity of early critics. (As Grappe put it: "A lewd fire burns in his gaze – oh, that white point on his pupil!")[114] It is unsettling but ambiguous, because even as it rivets the spectator's attention to the male gaze, it conceals both its direction and expression. Armstrong has argued that the man's gaze, and its deflection by the woman's back, is the central theme of the painting, a supposition reinforced to some degree by the conventional understanding of male sexuality in these years. Nye writes: "Males alone were believed capable of a subjective orientation toward sexuality; women, though they were regarded as eminently capable of subjectivity, were simply the objects of this

gaze."[115] But Degas's man gazes without pleasure or authority. His face supplies little evidence of the "bestial" creature critics saw; instead, it is a site of emotion masked, emptied, or restrained.

The man's gaze and his constrained posture suggest what may be another theme within the *Interior*: the mutual endurance of sexual shame. The picture's protagonists seem forever trapped in a space that at once suffocates and divides them. The relinquishing of self under the press of desire has consigned each character to an unending, and unbreachable, isolation. The signs of humiliation are more overt in Degas's female protagonist: the dishevelment of her dress, the dispersal of both her inner and her outer garments, the reflexive curve of her body, the dramatic exposure of the sewing box's interior. But she is not the only character to have lost honor. Her male companion is stranded too, fixed by perspective,

30. Edgar Degas, *Study for Interior,* ca. 1868–69. Pencil on paper. Private collection. Photo: Courtesy of Jean Sutherland Boggs

proportion, and atmosphere – by *paint* – in a space riven by irreparable tensions.[116]

Interior envisions how sexual identity – for men and women – was imagined during a most unstable period in the history of private life. Mark Wigley has argued that, in the nineteenth century in particular, "identity theory is necessarily spatial theory. . . . Sexuality in the age of psychoanalysis is the sexuality of the interior."[117] While much of the art I examine in this book preceded Freudian psychoanalysis by two decades, the kinds of sexual tensions it claimed to elucidate were first visualized in works such as Degas's painting. Because the artist's protagonists are visually fused to a space that acts out their sexual alienation, their conflict is reimagined – and *felt* in the body – by every viewer who stands before them. Perhaps this is why everyone who sees the painting tries to invent a convincing solution to its mystery. Irresolution may be the truest stance toward *Interior,* but it remains an uncomfortable one, even for the late-twentieth-century viewer.

Robert Nye has claimed that "we cannot easily penetrate the veil that cloaks private sexual experience and identity in the past, but the representations in

the surrounding culture to which they are dialectically bound have left abundant traces in the public record."[118] Degas's *Interior* provides just such a trace, a trace which, moreover, invites the responsive spectator to experience viscerally an exceptionally strained and intimate encounter, the kind of encounter that, in life, would have no witnesses. While we are not admitted, exactly, into the metaphorical interior of Degas's own sexual anxieties, we are given a glimpse of the larger stage on which those anxieties may have been imagined, masked, or, in the language of the post-Freudian age, repressed. Traces of renunciation and paralysis are embedded in *Interior*'s very form, but can be pried out, can be *seen* and *felt,* through a process of immersion that preserves the enigma of Degas's sexuality but delivers the viewer to the very brink of a revelation about the unvoiced but abiding bonds that, at one and the same moment, connected *and* isolated bourgeois men and women of the nineteenth century.

Chapter Three

John Singer Sargent's Interior Abysses

The Daughters of Edward Darley Boit

Introduction

If Edgar Degas's *Interior* embodied the confrontation of one self with another
in terms of the starkest and most exclusionary intimacy, then John Singer Sar-
gent's *The Daughters of Edward Darley Boit* (Fig. 31 and Plate III) envisions
an interiority that appears more available to representation and simpler to
penetrate: the subjectivity of the child. The work itself, made in Paris about
fourteen years after *Interior* was painted, initially prompts this expectation:
three out of Sargent's four young subjects – sisters ranging in age from four to
fourteen – address themselves to the beholder rather than to one another. The
foreground is bright with sunlight that streams in from the left, beyond the
frame. The area directly before us is wide and open – a public area within a
private home, an area suitable for display. The family has admitted the specta-
tor into its interior and, presumably, into something of the interior life that is
lived within its walls.[1]

Yet Sargent's painting, like childhood itself, is far from transparent. Neither
his politely attentive subjects nor the wide-open spaces they inhabit are as
forthcoming as they appear. The space is oddly proportioned and inadequately
framed, near-Piranesian in its overscaled proportions and in the centrality, and
intensity, of the darkness beyond. The sisters seem adrift and alone, "lost in
space," as one scholar has put it.[2] Barely discernible in the shadowy room be-
yond the threshold is a mirror whose surface reflects a window elsewhere in
the room – the only explicit reference to a source of natural light. The mirror
hangs above a large, unlit fireplace crowned by at least two, if not three, ele-
gantly proportioned urns – recapitulations in miniature of the monumental
Japanese vases that frame the doorway into the room. These vases, while cer-
tainly decorative, add no warmth to the space; they are architectural in scale
and almost corporeal in presence. Except for the vases, the fringed carpet and
the red folding screen on the right – a planar form rather than a sculptural
presence – the area that opens before the spectator is virtually empty.

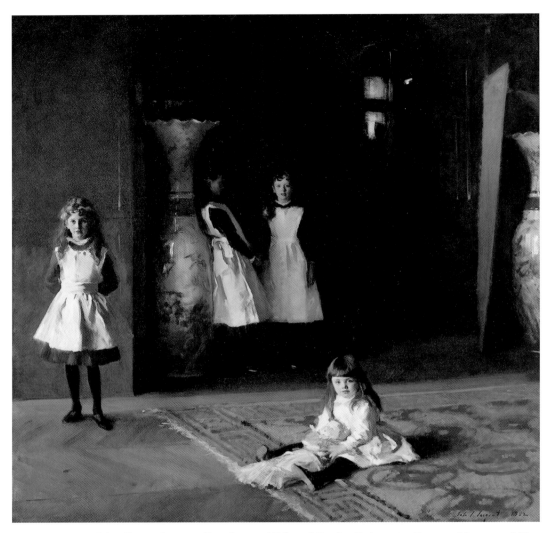

31. John Singer Sargent, *Daughters of Edward Darley Boit,* 1882. Boston, Museum of Fine Arts. Gift of Mary Louisa Boit, Julia Overing Boit, Jane Hubbard Boit, and Florence D. Boit in Memory of Their Father, Edward Darley Boit. Courtesy, Museum of Fine Arts, Boston. © 1999, Museum of Fine Arts, Boston. All rights reserved.

This space is not only austere; it is prefatory. Its raison d'être depends on its relation to *other* spaces, spaces whose proportions and limits we cannot judge with any confidence. Many critics assumed that Sargent had painted the family's drawing room; but this "rich, dim, rather generalized French interior," as Henry James called it, is an oversized foyer, its scale not uncommon in the palatial *appartements-à-loyer* that filled the new buildings on the avenue de Friedland in Paris, where the Boits leased their quarters.[3] Although very different in scale and class associations from Degas's *Interior,* the space Sargent painted shares an important characteristic with that work: like Degas's fictive

interior, Sargent's rendering of the Boits' grand hall provokes, simultaneously, sensations of confinement and exposure. The claustrophobic exclusion of any sources for the natural light in the foreground, and the impenetrability of the dark space that dominates the composition, tensely counterbalance the daunting scale and the distended intervals between the girls.

The following passage in *The American Scene* by Henry James might have been penned about this apartment:

This diffused vagueness of separation between apartments, between hall and room, between one room and another, between the one you are in and the one you are not in, between place of passage and place of privacy, is a provocation to despair which the public institution shares impartially with the luxurious "home." . . . Thus we see systematized the indefinite extension of all spaces and the definite merging of all functions; the enlargement of every opening, the exaggeration of every passage, the substitution of gaping arches and far perspectives and resounding voids for enclosing walls, for practicable doors, for controllable windows, for all the rest of the essence of the room-character, that room-suggestion, which is so indispensable to occupation and concentration.[4]

James was describing turn-of-the-century American domestic architecture, perhaps the kind of house the Boits inhabited in Newport or Boston when they traveled "home" to the States (like Sargent himself, they were expatriates living in Paris). But James's description uncannily captures the "resounding void" at the core of the Boit interior. In Sargent's painting, incompatibility between public and private life – between the fragile but binding ties of family and its ostensible opposite, societal exposure – is embodied in the very structure of the painting. The conflict is also acted out in the subtle but revelatory interactions between each subject and the "spatial envelope" she inhabits.[5] Puzzling out the meaning of these interrelations, understanding the conditions under which they *possess* meaning, leads us to the larger question of how much the adult can ever penetrate the interiority of the child.

Interiority and the Child

The adult's sense of familiarity with the child – particularly with the historical child – is largely an illusion. Childhood is not a human constant accessible to anyone who has experienced it. Eighteenth- and nineteenth-century concepts of the "natural child" have only recently been replaced by what psychologists and sociologists call the "invented child," according to which the child is considered as much a social and psychological construct as a biological and developmental entity.[6] The notion of the invented child underpins much recent research in psychology and other branches of cognitive science, as well as history, sociology, and anthropology.[7]

Every adult was once a child, of course. But childhood itself is irretrievable, making the adult both complicit in, and forever exiled from, the state of being a child.[8] Adults wishing to paint children are faced with a challenge unique to the genre of portraiture. The artist must conjure up a "state of otherness" from which he is permanently excluded.[9] As the child was represented in portraiture during the nineteenth century, so too the figure of the child became a kind of representation in itself, a symbol for interiority – more precisely, for the interiority of the *adult*.[10] In large part, this happened because the sheer number of biological, psychological, and cognitive discoveries about human beings multiplied during these years. People thus became ever more preoccupied with the profound significance of growth being studied in the science of physiology, and with the human figure who best exemplified the trajectory of growth – the child. While there was intense interest in the child's actual cognitive and psychological development, physical abilities, and social training, the symbolic importance of the figure of the child rested on how he or she mirrored back to adults their essential, original selves – the selves that were now lost and gone, "the child as interiority, privacy, the deepest place inside: not to be found."[11] As the inevitable outcome of any organic development was death, the child, so close to the origins of life, also came to stand for its end and for loss in general, a recognition that only exacerbated the nineteenth century's realistic fears about childhood mortality. This preoccupation with loss was borne out in the writings, the memories, and the artifacts collected during this period: "Mourning pictures, tragic love stories, and fears of the gradual decline of the human species were common fare."[12]

Thus, conceptions of interiority and loss were conjoined and concentrated in the figure of the child, as they are in Sargent's *The Daughters of Edward Darley Boit*. Sargent's reliance on the expressivity of *absence* – of adequate light throughout the space, of proximity, of comfort – may have a great deal to do with his own childhood, and with the more general dislocations of his post–Civil War, expatriate culture. If childhood was considered "the deepest place inside," then Sargent's hollowed-out interior, at once brightly lit and deeply shadowed, leads the spectator in but disallows final penetration.[13] In varying degrees, the four sisters invite and deflect attention as well as empathy. The viewer remains suspended somewhere between discovery and exclusion, with the location on that continuum shifting as he or she confronts each subject in turn. In the staging of the various roles, light and dark play against expectation. The spatiocorporeal relationships that *appear* to be most clearly defined, and most comprehensible, prove somewhat resistant to understanding, while those relationships that seem more opaque or obscured ultimately reveal, and engage, *more*. In Sargent's *The Daughters of Edward Darley Boit,* the supreme difficulty of penetrating the interiority of the child is both acknowledged and defied.

Because of the indistinct boundaries of the foyer, and the almost overwhelming concentration of darkness at the center of the composition, it is not immediately apparent that the space represented in the painting is deeply divided. Mary Louisa and Julia, the two youngest, occupy an area that functions much like a brightly lit stage proscenium – that liminal space where actors come forward to address the spectators directly. Only several feet away, but a world apart, the older girls, Jane and Florence, seem to teeter on the edge of an abyss. Through a series of oppositions – of light to dark, of projection to retreat, of physical robustness to corporeal discomfort – Sargent staged not only two different states of interiority, he painted the limits of our access to them.

Preparations in Paint

The radical asymmetries of Sargent's earlier Venetian paintings, and his painstaking copy of Diego Velázquez's *Las Meniñas* (1656; Madrid, Prado) had laid the groundwork for the formal problems encountered in the Boit portrait. All these works situate multiple figures apparently at random in a large shadowy space.[14] Sargent's audience was not inexperienced at responding to the expressive potency of such a space. In fact, for those who favored advanced strategies in painting, such compositions carried a positive charge. Sargent's friend R. A. M. Stevenson, a fellow studio mate at Carolus-Duran's atelier, a shrewd critic, and a cousin of Sargent's future portrait subject Robert Louis Stevenson, described the effect of dark space in *Las Meniñas*. His remarks recall those of Lecoq de Boisbaudran, whose book, along with Stevenson's, was to become immensely popular at the Slade School in London around the turn of the century:

These fields of vibrating space, this vast shadowed top, wonderfully modeled as it recedes from the eye, are no more empty and useless around the figures than the landscape itself, which was so long withheld as uninteresting wasted space. . . . The vast gloomy top of *Las Meniñas,* the empty foreground of a Whistlerian etching, or the darkness of a mysterious Rembrandt forms an essential part of a picture and controls the force of colours and definitions, explains the lighting and emphasizes the character of the sentiment which invests the figures. In fact the surroundings of such pictures are as much part of the impression as the figures themselves.[15]

By proclaiming the primacy of *Las Meniñas* as an influence – a work exemplary both for its radical inventiveness and its historical pedigree – Sargent could appeal simultaneously to both avant-garde and more conservative audiences (and potential clienteles), a calculated dual position that Marc Simpson has perceptively identified as having been fundamental to the artist's early career.[16]

In fact, the meaningful expanse of empty space, radical in 1868 when Degas painted the *Interior,* had become by 1880 a recognizable strategy for conveying disturbance or discomfort, sensations that carried an especially potent charge when the figure at the periphery of the space was a child. Here is a critic writing about J. Bertrand's painting *Marguerite of Faust* (1878; location unknown) at the time of its exhibition at the International Exposition of 1878:

The reader will observe the peculiar composition which the artist has used, the focus of the scene being quite vacant, and the personages arrayed centrifugally around the edges; this blank emptiness of his stage gives our painter a very appropriate expression of austerity, of cheerlessness, of desolation. In his arrangement, too, the hopeless infant lies directly under the descending weight of Time.[17]

If Sargent was already adept at the spatial maneuvers necessary to produce the Boit portrait, his delineation of the children who inhabited the space was unprecedented in his own work. Sargent *had* painted the children of friends before in *Portraits de M.E.P. . . . et de Mlle. M.-L.P. (Portrait of Edouard and Marie-Louise Pailleron)* (1881) (Fig. 32).[18] Marie-Louise later complained that Sargent had required her to sit for him more than eighty times. Even in spite of this, she remembered the artist fondly as a man who threw himself with unselfconscious gusto into children's games. Despite the warmth that evidently colored their personal relations with the artist, as painted subjects Marie-Louise and Edouard appear sour and disdainful. They look down slightly upon the viewer with pinched, skeptical expressions. Both are formally attired, and their lavish costumes – especially Marie-Louise's jeweled, lace-trimmed, satin frock – intensify the sensation of restraint. Although Edouard's twisted body and curled fingers lend some dynamism to the centralized arrangement, the composition is finally compressed and static. The siblings' gazes are aggressively penetrating, incongruously harsh for children of this age. Marie-Louise's body seems stiffly confrontational; her hands are firmly planted on both sides, as if she is ready to spring forward to defend herself. The young Paillerons' forbidding demeanor mimics that of adults, an inauthenticity of affect that is enhanced by the hothouse setting fabricated by Sargent: an elevated chaise or bench covered with a carpet and a luxurious throw. The variegated red background looks as artificial as the temporary backdrop in a *carte-de-visite* photographer's studio.[19]

By comparison, the Boit sisters are modestly dressed and studiously well-mannered (with the possible exception of Florence, who turns away from the viewer). Julia, the youngest, is dressed in a high-collared, fluffy white dress, while her sisters, Mary Louisa, Florence, and Jane, are garbed in schoolgirl frocks, white pinafores, and black wool winter stockings – the uniform of upper-class girls who were schooled at home. After lessons, the girls might have gone out visiting with their mother or to dancing lessons, activities for which they would have donned walking costumes suitable for girls who had

32. John Singer Sargent, *Portraits de M.E.P. . . . et de Mlle. M.-L.P.* (*Portrait of Edouard and Marie-Louise Pailleron*), 1881. Des Moines, Iowa, Des Moines Art Center. Purchased with funds bequeathed by Edith M. Usry in memory of her parents, Mr. and Mrs. George Franklin Usry, and funds from Dr. and Mrs. Peder T. Madsen and Anna K. Meredith. Des Moines Art Center Permanent Collection, 1976.61. Photo: Michael Tropea, Chicago

not yet come out into society. The pinafores underscore the insularity of the girls' lives and the tightly edited range of their interactions with the world outside. The costumes are reminiscent of the garb worn by Degas's young cousins, Giulia and Giovanna, in *The Bellelli Family* (Fig. 8).[20]

Despite the apparent informality of the Boit sisters' distribution, their asymmetric isolation from one another is as calculated as the centralized focus and aggressive gazes of Edouard and Marie-Louise Pailleron. The Paillerons assume an adversarial relation to the spectator; they close ranks and stare disdainfully out of the painting. But the Boits activate a more reciprocal exchange. Their respective strategies of recognition of, and resistance to, the spectator's intrusion are more subtly encoded and more decorously executed. We sense their vulnerability first; they seem to be captive to the dilated spaces that isolate them from one another and diminish both their individual and their collective identities.

If Sargent did not follow his own prior model for his portrait of the Boit sisters, he also ignored conventional historical precedents (*Las Meniñas* excepted). Thomas Gainsborough, Joshua Reynolds, and William Hogarth had often used garden or landscape settings in their child portraits; Hogarth also incorporated games as a pretext for representing the "natural" child at play.[21] Nor did Sargent choose to emulate the examples of his own peers. Thomas Eakins and Mary Cassatt had represented children playing unselfconsciously, either alone or in the presence of a benignly inattentive adult.[22] Around the same time Sargent painted the Boit portrait, James Tissot produced genre paintings called *Le Blanc de Jardin* (1822; private collection) and *La Soeur Ainée* (ca. 1881; Collection of D. C. Dueck), in which the children of a family root around the chairs of a parlor while the adults sit reading.[23] Although the demands of genre painting were different from those of formal portraiture, for over a century many children's portraits had appropriated the ostensible informality of genre: such an unpretentious format seemed appropriate to the "naturalism" of the child. Yet Sargent chose a presentational style that is the opposite of informal. The lack of distractions – the absence of an appealing garden, the rejection of the sentimentality of a child's game – focuses attention on the subtleties of each girl's affective and corporeal presentation to the spectator. Let us remember that the original spectator was Sargent himself, whose own childhood may have in part provided the optic through which he constructed the politely wary girls before him.

Preparations in Life

While neither a parent nor (yet) an indulgent uncle, Sargent was the son of a general-practice physician who was "passionately interested in his family."[24] Fitzwilliam Sargent, whose talented son was his great pride and joy, continued to write on matters of medical interest long after he prematurely retired from his successful Philadelphia practice to follow his wife to the spas and art centers of Europe. From his immediate family experience, Sargent would have known a great deal about childhood ailments and the strategies used to avoid or ameliorate them. His own sister Emily, who was a year younger, was often ill. The victim of an early accident, she suffered from a deformity of the shoulder and spine. Her brother would have seen her strapped to a spring-loaded panel placed on top of her carriage and tied into her bed at night to prevent movement. Emily crawled at five and walked at six. Her arrested development may have been a source of some shame to the Sargents. In the nineteenth century, all persons within a family were understood to suffer collectively for the deficiency of one member.[25] The firstborn son of the family had died before John was born, and another sister, Minnie, would succumb to pleurisy after her fourth birthday. According to Stanley Olson, Sargent's biographer, tragedy

and temperament conspired to render the Sargent family deeply preoccupied with impending illness and possible death. Their restless itinerary was in great part determined by Mrs. Sargent's frequent pregnancies and undiagnosable, but lingering, illnesses: "[Mr. and Mrs. Sargent] had no friends, few acquaintances, no occupations, in fact nothing apart from themselves and their children to monopolize them. Time weighed heavily upon them, and they awarded themselves every justification to plunge into an unnatural preoccupation with health."[26]

But if Sargent was only as conversant in the nuances of child-rearing as a solicitous brother of his time could be, then his patron, Edward Boit, was positively steeped in the daily business of family life. A wealthy Boston Brahmin, Boit wed a woman even wealthier, whose portrait Sargent would paint in 1888 *(Mrs. Edward Darley Boit [Mary Louisa Cushing])* (Fig. 33). In 1868, Boit abandoned a career in law to become a landscape painter. (Today he is best known for his evocative watercolors.) Boit's letters, diaries,

33. John Singer Sargent, *Mrs. Edward Darley Boit (Mary Louisa Cushing)*, 1887–88. Boston, Museum of Fine Arts. Gift of Miss Julia Overing Boit. Photo: Courtesy Museum of Fine Arts, Boston. © 1999, Museum of Fine Arts, Boston

and biography suggest that he was the rare modern father who took a vigorous interest in his children's mental and physical health, at just the time when the relationship between the child's soma and psyche was becoming the subject of much speculation by experts in a variety of fields.[27] His diary entries of the 1880s demonstrate an intimate acquaintance with the well-being of his two younger daughters, in particular, whose illnesses he monitored assiduously and whose health he personally ensured by taking them out walking on the Boston Common.[28] As his wife, Mary Louisa, left no written records, it is impossible to chart her involvement in her daughters' early lives. (We do know that she closely supervised Jane's debut into Boston society four years later.) Henry James fondly remembered Mrs. Boit's "exceptionally high spirits" and "merry laugh." Her nephew, Robert Apthorp Boit, later enigmatically described her as "a great, noble-hearted woman, whose foibles and eccentricities added to her charms."[29]

Her husband was characterized as unfailingly generous and intolerant of class snobbery, unusual in a man who had been born into one of Brahmin Boston's finest families and married into another even more celebrated.[30]

An 1887 etiquette book described the typical contact between upper-class children and their father: "After breakfast, Father asks to see the small children – their coming to say good morning and goodbye is a delight when children are carefully reared. . . . A girl who is not 'out' is not considered sufficiently intelligent to be interesting to her elders among her own sex, and certainly not worldly-wise enough to associate with gentlemen. . . . As for the younger children, they are never to visit the drawing room except for birthdays or weddings, and even then if they are 'over-hilarious,' out they go."[31]

Boit, on the other hand, would have been applauded by the new generation of psychologists and scientists who had begun to see the father's role as pivotal in the healthy development of a child. Social psychologist James Mark Baldwin wrote in 1894: "You [parents] can be of no use whatever to psychologists – to say nothing of the actual damage you may be to the children – unless you *know your babies through and through*. Especially the fathers! They are willing to study everything else. They know every corner of the house familiarly, and what is done in it, *except the nursery*. A man labors for his children ten hours a day, gets his life insured for their support after his death, and yet he lets their mental growth, the formation of their characters, the evolution of their personality, go on by absorption – if no worse – from common, vulgar, imported and changing, often immoral, attendants!"[32]

Hence, among upper-class men, and perhaps even middle-class men, Boit was quite exceptional. But then, few men commissioned a portrait of their young daughters on such a grand scale. While it is true that many a patriarch over the years has commissioned a representation of the children who would extend his identity and cement his immortality, the group portrait Sargent painted is neither celebratory nor conventionally ingratiating. Aside from the obvious fact that a significant income was required in order to inhabit rooms of this proportion and to collect – and transport – vases of this scale, signs of wealth and success are otherwise understated. What *were* the terms of this commission?

The Commission

"Children do not commission portraits," Marcia Pointon reminds us, "and their presence in them is the result of negotiated relationships in the adults' world designed, consciously and unconsciously, to produce a set of explicit and implicit meanings."[33] Some writers have made much of the two paternal authorities who together "made" the children we see – a formulation that excludes entirely the agency of the four young subjects, and a choice I will show

is a strategic mistake.³⁴ Sargent's authority in relation to *both* his wealthy patron and the daughters he painted was likely to have been rather tenuous. Boit was sixteen years older than Sargent, a gap of years large enough to constitute the difference of a generation. In fact, Sargent was only twelve years senior to Florence, and Jane, at twelve, was the same age as Violet, the artist's younger sister. In age and experience, Sargent was suspended somewhere between the father and his daughters, a position that is itself akin to the transitional stage of adolescence. He needed to please Boit (who apparently was pleased), and to pacify (or intimidate) Boit's daughters long enough to paint them. But he also needed to garnish his reputation with a stunning salon success, which, by and large, he did.

Henry James, a friend of the Boits, applauded Sargent's effort but was also alert to its idiosyncrasies: "The treatment is eminently unconventional. And there is none of the usual symmetrical balancing of the figures in the foreground."³⁵ Another critic writing in the *Gazette des Beaux-Arts* was so impressed by the size of the vases that he dubbed the work "la famille de potiches."³⁶ Approbation was not unanimous, however. Some criticized the asymmetric composition; others were distressed at the austerity of the setting. The *Gazette des Beaux-Arts* critic called it "a space that is rather too large and at times rather bare."³⁷ Critics also commented on the girls' isolation from one another. One writer asserted that "the figures might almost be cut out and framed separately."³⁸ Henry James agreed. "The place is regarded as a whole," he observed, "it is a scene, a comprehensive, impressive . . . yet none the less do the little figures in their white pinafores . . . detach themselves and live with a personal life."³⁹

Indeed, each Boit sister appears to inhabit her own spatial territory, which is adjacent to, rather than continuous with, that of its neighbor. This is true even when the girls are proximate. Jane and Florence are just inches away from one another, but each appears to be oblivious of the other's presence. The spareness of the setting and the visual isolation of the figures demand that the spectator appraise them one by one. The Boits' collective identity as a family seems far more fragile than each girl's force as a singular entity.

Figures in Space

Sargent may not have been asked to reflect upon the individual personalities of his subjects. He may not even have been much interested in them. Nonetheless, each girl is figured at a distinct stage of cognitive, physical, and emotional development, differences that are dramatized by their detachment.⁴⁰ The baby of the family, four-year-old Julia (Plate IV), seems implanted on the rug in the foreground; her doll, Popau, is nestled between sturdy legs that are unselfconsciously rotated inward. Mary Louisa (Plate V), at eight, is fixed in a pose that

encapsulates the emerging socialization of the older female child; she possesses a gravity of demeanor and a sense of containment that ages her beyond her years. She alone is dressed in a deep-berry-red frock under the same kind of white pinafore worn by her older sisters. Jane (Plate VI), Mary Louisa's elder by four years, stands slackly at the center of the painting, her black dress dissolving into the deep shadow around her. The viewer's awareness of her apparent corporeal and psychic discomfort is intensified by the primacy of her position. She is – quite literally in Sargent's placement of her – poised at the threshold of adolescence. Florence (Plate VI), at fourteen the oldest of the sisters, is closest to the state of womanhood that will exile her from the children's world of her sisters. She leans stiffly against one of the pair of monumental vases that reportedly traveled sixteen times across the Atlantic Ocean.[41]

James wrote that the Boits' foyer "encloses the life and seems to form the happy play-world of a family of charming children."[42] The children are indeed charming, but the "play-world" seems far from happy; the space is ill suited to any kind of play. With the exception of Julia's doll, there is no evidence that children routinely occupy this place; there are no architectural or material accommodations to a child's scale, activities, or preoccupations. In fact, the near-public foyer is the architectural antithesis of the children's private quarters in the most remote rooms of the apartment. It is as if, still wearing the schoolgirl pinafores that would have been worn in the nursery (and rarely outside its walls), the girls have been thrust into a space that they do not customarily occupy (even though Boit may have been more indulgent than the average patriarch). What did this barren foyer make *representable* that a more habitable and congenial space could not?

Dark Space

Some might claim that Sargent was simply representing the Boits' grand apartment on the avenue Friedland as it *really was*, inflected perhaps by the artist's desire to emulate the shadowy recesses of *Las Meniñas*. This is certainly possible, but it serves as only a partial explanation, given what we know about the patron's taste in decorating. For one thing, Boit disliked bare floors and unadorned surfaces in general. His letters from London and Paris home to his parents in the early years of his marriage tell of daily trips to local shops to purchase wall coverings, furnishings, and objets d'art for their Newport home, whose every wall seems to have been covered with some variety of striped damask, accompanied by draperies and upholstery designed to match. Almost uniformly, the floors were covered with carpets that left no more than eighteen inches of bare floor around their borders (Boit's stipulation was quite emphatic).[43]

Even if Boit's taste changed radically or was limited by the impermanence of his tenancy in Paris, it seems likely that the family's apartment was actually altered before it was constructed in paint. The rug may well have been pulled back to expose a greater expanse of floor; perhaps pictures were removed from the walls, for even a series of rented rooms would have been properly decorated by a family of the Boits' class and artistic inclinations. Also, if Boit disliked bare floors, he was positively depressed by dark spaces. His journals are filled with irritated, melancholy critiques of various dark rooms he has visited – a friend's house, a barbershop, the gloomy galleries of a nearby museum. (When the portrait was first loaned to the Boston Museum of Fine Arts, Boit was particularly gratified by the lighting; he had been concerned that dimness would render it difficult to see.)[44] Boit's intuitive recoil from darkness is echoed in the writings of contemporary psychologists, who believed that a dark home could generate ill effects within the young mind. Psychologist James Sully wrote that "painful states of feeling are occasioned in certain cases by the want of an appropriate stimulus. This is illustrated to some extent in the effect of darkness. Prolonged darkness gives rise to a craving for light, which in part seems connected with the circumstances that the organ is ready for activity, but wants the necessary stimulus." If a child was frightened in a dark room, the memory could be indelible: "A child may conceive a lasting antipathy to a room where something dreadful has occurred."[45] César Daly, who continued to publish in the *Revue Générale* until his death in 1888, concurred. He himself possessed just such a "lasting antipathy" to dark spaces and undoubtedly would have disapproved of the jarring, even dehumanizing, proportions of Sargent's painted space. Daly believed that an abundance of natural light was crucial for the collective health of the family. In fact, he claimed that "shadow is the house of the savage."[46] In *The Daughters of Edward Darley Boit,* even the force of the sunlight that irradiates Mary Louisa's pinafore, whitens Julia's dress, and gleams in rays that skim the doorway mouldings, is eclipsed by the darkness within.

Given the association between darkness and disturbance within the family interior, what did Sargent gain by constructing such a dominant dark space? And how is the meaning of that space inflected because the subjects at its periphery are children – children shown without their parents? I believe that Sargent leapt beyond the bounds of portraiture to give shape to the power of the uncanny within the very space designed to exclude it – the family interior. Despite their living presence, the Boit sisters inhabit a house that is already haunted.[47]

The expressive power of Sargent's composition depends upon what Anthony Vidler has called "a spatial phenomenology of darkness," which he summarizes as follows: "Equally, space is assumed to hide, in its darkest recesses and forgotten margins, all the objects of fear and phobias that have returned with

such insistency to haunt the imaginations of those who have tried to stake out spaces to protect their health and happiness. Indeed, space as threat, as harbinger of the unseen, operates as medical and psychical metaphor for all the possible erosions of bourgeois bodily and social well being."[48]

The sensation that Vidler describes originated in the visionary designs of Etienne Boullée and was elaborated to great effect in Giovanni Battista Piranesi's interior abysses.[49] As Vidler writes, "Boullée invented, if not the first architectural figuration of death, certainly the first self-conscious architecture of the uncanny, a prescient experiment in the projection of 'dark space.' "[50] The eerie abandoned cottages and haunted houses found in the works of Victor Hugo and Edgar Allan Poe provide a literary analogy. In a Poe-like short story, *The Jolly Corner* (1909), Henry James forced his protagonist to confront the terrifying dark spaces of his own childhood home: "The house, withal, seemed immense, the scale of space again inordinate; the open rooms to no one of which his eyes deflected, gloomed in their shuttered state like mouths of caverns."[51] The man discovers the heart of a terror that he cannot articulate, a position analogous to that of a child who senses more than she can understand.

The "great gaps and voids," to paraphrase James's phrase in *The American Scene,* between what the child sees of the adult world and what she understands, is the subject of the same author's *What Maisie Knew* (1897):

Only, even though it is her interest that mainly makes matters interesting for us, we inevitably note this in figures that are not yet at her command and that are nevertheless required whenever those aspects about her and those parts of her experience that she understands darken off into others that she rather tormentedly misses.[52]

Edith Wharton believed that upper-class children were particularly ignorant of their parents' activities, and a doctor writing some years later agreed: "The children of the poor have a better chance to get things straight. They live in closer contact with their neighbors and cannot be kept from a knowledge of fundamental things. They cannot be coddled and pampered as are children better off and there is therefore less danger that they will think too highly of themselves."[53]

William Merritt Chase's painting *Hide and Seek* (1888) (Fig. 34) seems to materialize the sensation that Henry James would later describe in *What Maisie Knew.* The painting, which was evidently influenced by both *Las Meniñas* and *The Daughters of Edward Darley Boit,* shows two girls fixed at either end of a diagonal vector that crosses a vast empty space. The girl in the lower lefthand corner, whom we see from the back, is a robust, substantial presence, with near-sculptural golden curls and a luminous white dress. She peers around what seems to be a curtain and gazes across the empty space to her playmate, whose form seems to disintegrate as she moves farther away.

34. William Merritt Chase, *Hide and Seek*, 1888. Washington, D.C., The Phillips Collection. Acquired 1923. Photo: Courtesy The Phillips Collection

The girl in the foreground might be looking at a *picture* of the companion who is so profoundly dematerialized.[54] In pictorial composition, a large space without incident inevitably acts like a "blank" toward which the spectator can direct his or her projections.[55] In *The Daughters of Edward Darley Boit*, as in Chase's painting, the blank assumes an almost material presence that acts upon both the figures represented, and upon the viewer whose curiosity they arouse. Spectatorial empathy for the figures at the perimeter of the space balks before a darkness whose limits cannot be discerned. The Russian filmmaker Sergei Eisenstein, who has been called "the first theorist of the blank," identified a similar impulse at work in the apparently limitless spaces of Piranesi's *Carceri*, in which the gaping darkness of ruins both beckons and terrifies the viewer.[56]

Piranesi's subjects are the ruined monuments of lost civilizations; his architectural sublime testifies to the grandeur of history and to the transitory nature of human participation in it. Sargent's painting offers a concentrated domestic sublime that is no less daunting to the correspondingly diminished subjects

who live in it. For the Sargent portrait is *also* about history: the history of the father who is rendered immortal through his children and of the artist whose personal experiences and artistic alliances shaped his interpretation. The architectural structures that frame the young girls will outlast them. So will the finely wrought and painted vases. Today those vases stand before the painting at the Museum of Fine Arts in Boston, embodying the phrase *ars longa, vita brevis.* And if life is short, childhood is even shorter.

The "Shadow World"

Sargent's own childhood is described in metaphors that equate loss and dislocation with darkness. According to Olson, "John Sargent's extreme youth began as it would continue for nearly twenty years, in a household that quivered on the brink of gloom. Everyone around him possessed a chilling aura of impending doom, of either waiting to be ill or struggling to recover."[57] Sargent's success in Paris did not seem to diminish the family's sense of dread, for unfortunately, after feigning maladies for years, his mother became seriously ill. Olson writes: "Emily became her mother's nurse, and Violet was incapable, at the age of twelve, of combating the gloom. John's success, the very thing they had longed for, struggled for, spelt their decline."[58]

Although Edward and Mary Louisa Boit had a greater appetite for life than Fitzwilliam and Mary Sargent, their elevated class and energy did not insulate them from terrible losses. We know that the couple lost at least two children before Florence's birth and, most likely, several after. Their biographer, Boit's nephew Robert, refers to the daughters Sargent painted as "the four living daughters of this marriage."[59] For both the Sargent and the Boit families, then, the loss immanent in the figure of the child was not an abstraction or a bit of arcane knowledge but a part of lived experience.

Sargent endured yet another kind of absence during his youth: the lack of a stable home. His family's wanderings dictated that they move from leased quarters to hotels and back again, watching their finances carefully all the while. They had just enough of a private income to avoid real employment. They lived in a "shadowy expatriate world" without stability or occupation. They were "intimately acquainted with the superficial, enjoying long friendships built on fleeting encounters."[60] The Boits, in contrast, had been raised in New England comfort and lived fairly conventional upper-class lives. But after 1870 they committed themselves to an expatriate existence, shuttling between Paris, London, Boston, and Newport. Their peripatetic lives isolated their children even more. In an early letter to his parents, Boit himself complained of the ennui that descended upon him when he was not in transit, apologizing to them for the lackluster accounts of his daily existence, which varied only when they were on the move.[61]

Dark space – a pictorial shape for loss and dislocation – hollows out the Boit sisters' temporary home in Paris. If meaning in this painting lies in large part in how each young subject's body interacts with the void at the painting's core, then there are four distinct interactions: moving from the youngest to the oldest, these are indifference, self-containment, submersion, and retreat. Each stance encapsulates the child's recognition of her own interiority and charts the construction of an acceptable foil to the public – with differing degrees of self-consciousness and success. Each subject interacts with her spatial envelope in a way that sums up her individual role in the family, that fragile collectivity about which Sargent knew so much.

Pairings: In the Light

Despite their proximity to the viewer, the two younger sisters deflect, rather than satisfy, curiosity. This derives partly from their self-contained demeanor and partly from the elaborated surfaces of which they are made. The figures of Julia and Mary Louisa are sharply delineated – dramatically lit and sumptuously painted. Burnished, colored, irradiated, each is cast as a precious object of display. The practice of considering children as familial possessions has not been uncommon throughout history and still persists today.[62] Sargent painted the two younger Boits with an aggressive and conspicuous virtuosity. Some passages of paint are almost obtrusively prominent: the slash of crimson that skims the white bib of Mary Louisa's pinafore; the scarlet streaks that edge the softly jagged hem of her dress; the frosty blue-white shadows of Julia's dress, and the comically pink cheeks and rosebud mouth of her doll. It is as if glossy pigment materializes the barrier between the children's interior life and what an adult can know of it. Sargent paints what he cannot know, and the highly saturated, gleaming surfaces suggest the strain of the effort.

Sargent's near-fetishistic attention to the surfaces of Mary Louisa's and Julia's costumes, hair, and skin concentrates the spectator's attention upon their bodies. This is fitting, for the interiority of the child resides in the body. That is, very young children cannot usually articulate the character of their interior lives through language; their bodies are the principal agents of their own visceral sense of insideness. The inner sense of self is coextensive with the *bodily* sense of self. The younger the child, the more inseparable are the two sensations, and the less available to adult comprehension. This brings us to the figure of Julia (Plate IV).

Julia

Costumed in a white dress with a high lace collar, Julia is planted rather unceremoniously on the soft blue carpet.[63] The convincing unselfconsciousness of

her body is compromised slightly by the preternaturally frank gaze on her face, which is painted like a mask. Her bangs skim her forehead diagonally to form a shieldlike shape that appears to float, as if detached, *over* her flowing hair. Her face thus seems to project out, rather than to draw the spectator in. Sargent identifies her with the doll she holds, whose cheeks, pink jacket, and golden curls lend it a decidedly feminine aspect, despite its masculine name (Popau was named for Paul de Cassagnac, a family friend). Julia's hair flows into the doll's; her fingers press weblike against the doll's costume, their roseate color merging with the crimson of the doll's jacket. Both sport the same pink cheeks, although the doll's are of a deeper hue, their color intensified by contrast with the chalk-white of what is probably an expensive bisque head.

David Lubin has described "J" (as he calls Julia) as "both the star of the family and its most powerless member. In this sense she is a paradigm for the Victorian child, and indeed, for the Victorian woman: on a pedestal but unempowered."[64] While I do not dispute Julia's preciousness here, I want to offer a different assessment of her orientation in space. In our informal age, the sprawl of a young child's legs seems entirely appropriate. But within most nineteenth-century upper-class households, such a posture would have been deemed indecorous, especially in this most public area of the private home. Children of Julia's age were usually confined to the nursery, and were expected to observe the prevailing rules of behavior when they were allowed to venture outside of it. While there are obvious practical advantages to installing a potentially restless four-year-old on the floor, we can assume that the artist who required the Pailleron children to pose more than eighty times was not overly sensitive to the comfort of his young subjects.

Julia's *plantedness* is emphasized by the ink-black shadow cast directly behind her. Its elliptical shape forms the third arm of a tripartite structure (her black-stockinged legs acting as the other two) that pins her in place on the carpet, whose cool gray-blue tones match the shadows of her white dress, as if the child were continuous with the ground on which she sits. Julia's fundamentally *bodily* sense of self is also expressed in the careful arrangement of her dress, which radiates around her stout little legs to stabilize her upper body. Her legs are curiously formless, as if they were not quite evolved enough to serve as reliable supports; the unblemished matte ochre of her shoe soles adds to the impression that the legs are somehow inadequate (or indifferent) to the sophisticated task of walking. Julia's posture dramatizes childhood as a "natural state," the primitive origins of humankind that parents of the nineteenth century both honored and feared.

Until the 1830s, parents were loath to allow their babies to crawl on the ground, for it was considered that such a position reduced the child to an animal. To be human was to be erect, and to achieve this status, whether or not

the child was ready for it, families relied upon devices such as the "standing stool," a cagelike contraption for babies who could not yet stand on their own. Some parents even threaded "leading strings" through the sleeves of their children's costumes so they could hold their progeny up like marionettes. Thickly padded headgear called "puddings" cushioned the inevitable falls.[65]

By the last decades of the nineteenth century, parents generally subscribed to a more sentimental view of childhood, which was now considered a vital prefatory stage on the way to adulthood rather than simply a deficient stage of life. Nonetheless, the link between the primitive being and the child persisted and inflected even the more sophisticated writing on children's behavior. As W. B. Drummond wrote in his seminal work of 1907, *Introduction to Child Study*, "child study marks the introduction of evolutionary thought into the human soul . . . the anthropologist, unable to discover a living specimen of primitive man, turns to the child as his nearest representation."[66] Tips for civilizing unruly behavior still dominated child-rearing manuals. Up until the first decades of the twentieth century, parents depended on "soothing syrups" – elixirs laced with opium derivatives or alcohol – to quiet the restive temperaments of their little ones.[67]

As children – born innocent but vulnerable to the vices of society – were believed to be simultaneously good and evil, so too were the dolls they played with.[68] Although the location of the doll between her legs bestows upon Julia a kind of precocious motherhood, the fact is that dolls were actually rather equivocal objects. Dolls did offer both girls and boys an opportunity to mimic the social rituals of daily life; they went visiting with their owners, had tea parties, and attended – and sometimes starred in – elaborate weddings. More often, however, dolls played the lead roles in their own funerals.[69] Most French bisque dolls, like the one Julia holds in her lap, came equipped with a full set of mourning clothes. It was far more common for a French father to construct a coffin than a dollhouse.[70] Also, girls were often very aggressive with their dolls, "hurling them through space, burying them, dismembering them." The doll could thus represent a "subversion of authority and of conventions of femininity."[71] In other words, dolls were the objects of feelings that children needed to express but could not fully articulate or understand: a displacement from one vulnerable body to another even more vulnerable.

The Psychology of Children

In a stream of books that began to appear just before 1880, authors from a variety of fields struggled to identify with precision what of and how a child understood the world and his or her place in it. The child-rearing manuals that preceded these studies had offered solutions to behavioral problems, and tips on

furnishing the nursery and feeding the child. Now professionalized tracts systematically analyzed a new subject: the interaction between the child's body and mind. Psychiatrists, psychologists, general practitioners, pediatricians, sociologists, and educators all speculated about children's cognitive abilities and their capacity for feeling. They offered theories about how children construct a sense of self, and identified variations on how the child relates – psychologically, perceptually, socially – to the setting around her. Also, for the first time, writers began to draw a developmental distinction between the child and the adolescent, a difference that Sargent – perhaps unintentionally – figured in his painting.

In his seminal book *The Mind of the Child,* William Preyer contended that the child's sense of self in relation to the world around it rested entirely in the body. Here Preyer describes the intensely felt corporeality of the very young child. "In the bath . . . the child sometimes looks at and feels of *his own skin* in various places, evidently taking pleasure in doing so. Sometimes he directs his gaze to his legs, which are bent and extended in a very lively manner in the most manifold variety of positions."[72] James Sully, a psychologist and educator, had anticipated these claims in his *Outlines of Psychology* of 1885: "[The child's] pleasure and pains are largely bodily feelings" – which is one reason the child cannot articulate what he feels. Sully continues: "The young have of course some little knowledge of their feelings, but this is of a very vague character. The reason for this is that they cannot attend to their mental states in themselves and apart from the objects which excite them and the bodily organism with which they are connected. . . . Thus the antithesis of self and not-self, the internal mind and external things, is imperfectly developed in the first years of life."[73] Most physicians and psychologists agreed that the young child's sense of spatial orientation originates in the sensation of touch, in the ability to interact physically with the world: "In this way an inseparable coalescence of signs and significates takes place at a period of life too far back for any of us to recall it."[74]

In *The Production of Space,* Henri Lefebvre described the critical shift that occurs in the growing child's relation to her surroundings: "Like (supposedly) primitive peoples, the child, who, doubtless on account of its unproductive and subservient role, is mistakenly viewed as a simple being, must make the transition *from the space of its body to its body in space.*"[75] The trajectory that Lefebvre describes is embodied in the movement from Julia's childish sprawl to the poise of Mary Louisa's, on the left.[76]

Mary Louisa

Mary Louisa's gracefully constrained posture suggests a self-conscious assent to another's authority (Plate V).[77] Her awareness of her audience is borne out by a slightly averted gaze, as if she is waiting calmly but knowingly while judg-

ment is passed.[78] It is impossible to recover fully the directive for her pose (as well as for her poise) – whether it was shaped by her internal sense of what was "right" or configured in response to the authority of the painter (or the father) who stood before her. As Maurice Merleau-Ponty pointed out, "it is always very difficult to distinguish between what is considered to be the childhood behavior and behavior that actually depends on our adult presence."[79]

Mary Louisa's carefully calibrated balance illustrates a developmental milestone that is widely known to scientists today. Not until around the age of eight can a child balance in space without recourse to the visual and kinesthetic stimuli needed by smaller children like Julia, who will fall if they stand in a room with a wall that tilts toward them.[80] Mary Louisa appears to be *performing* the action of posing for an audience whose approval she has not yet completely secured. Nineteenth-century child actors or dancers, for instance, were not usually complicit in facilitating the adult meanings that the audience attached to their performances. In fact, adult recognition and enjoyment depended upon the child's seeming lack of contrivance.[81]

To some degree, every portraitist of children is expected to conceal the contrivances that compel them to pose in the first place. The painter must create the fiction of the child's temporary stillness, even as he is expected to capture her native liveliness. In the figure of Mary Louisa, Sargent collapsed the distinction between artifice and obedience. The question of Mary Louisa's "performance" is further complicated by the resemblance of her pose to that of Edgar Degas's sculpture *The Little Dancer of Fourteen Years* (1880–81) (Fig. 19), which Sargent almost certainly saw at the Impressionist exhibition of 1881.[82]

Although Mary Louisa's form shows none of the strain that defines Degas's adolescent dancer, her legs appear to be arrested in a movement from second to fourth position. Her left toe points elegantly on a diagonal that parallels the oblique pattern of the wooden floor. Her arms are clasped behind her back, resting just below her waist. While certainly not flexed like those of Degas's dancer, neither are they entirely relaxed. Sargent evidently took pains over the delicately chiseled contours of her legs (the legs also being the main focus for a young ballerina's admirers). Both artists' figures demonstrate a recognition of what is expected of them within their respective domains. Degas's model meets at least some of the demands of a ballet audience. And Mary Louisa exemplifies the decorum of a young girl of her class who presents herself to the tightly edited range of visitors who are allowed to penetrate the family interior. Anthropologist Paul Connerton has analyzed the "incorporating practices" by which societies preserve their collective identities. He believes that "memory is sedimented, or amassed, in the body." A girl such as Mary Louisa would have been taught by her elders how to stand and sit decorously. "In all cultures, much of the choreography of authority is expressed through the body." So,

presumably, is the choreography of deference. Connerton writes, "Culturally specific postural performances provide us with a mnemonics of the body."[83] Mary Louisa's body enacts the deference of her class and age, and acknowledges the training that enabled it.

She seems alone in her spatial envelope, an isolation underscored by the unadorned panel behind her and the bare floor beneath her feet. D. W. Winnicott believed that "the child is alone only in the presence of someone." He contended that "the place where cultural experience is located is in the *potential space* between the individual and the environment." Potential space is a space "outside the individual, but it is not the external world."[84] Mary Louisa occupies just such a space – neither inside, nor outside. Of all the sisters, she most clearly embodies the contradictions that arise when private meets public.

Exactly *how* the older female child should relate to the world was a subject of some debate at this time. Around 1871, one doctor commented ironically on the tendency to treat girls as etherealized, unearthly creatures: "as a matter of fact, girls *do* step on the ground just like boys. I have frequently walked behind them to test this point, and have noticed that when the ground is soft, they make tracks, and thus demonstrate the existence of an actual, material body."[85] Mary Louisa incarnates such an "actual, material body." She is in the prime of girlhood. Her pinafore is almost sculptural in form, standing out more crisply than either of her older sisters', its shape amplifying her own. Psychologists recognized that clothing was a crucial means for children to integrate themselves into the world: "self-feeling dilates with the spread of clothing outside the body."[86]

Given these emphases, it is not surprising that Mary Louisa seems the most conventionally "feminine" of the sisters. She is certainly the most sensually painted. Her golden curls are rendered in an impasto that lifts them off the surface. Their radiance is enhanced by the deep, saturated red of her dress, a tone that seeps throughout her costume and features. Her lips are a burnished crimson, her cheeks flushed with a delicate rose. Red pigment rims the hollows of her luminous eyes and defines the contour of her ear. Even the deep folds of her dazzling white pinafore are red in tone. Particularly prominent is a wedge-shaped area of reddened shadow that coincides almost exactly with Mary Louisa's genital area, a shape that is echoed, amplified and inverted, in the arrow-like scarlet screen poised across from her by the right door frame. The severely angled screen panel hovers like a mute but slightly menacing sentry at the edge of a cave – perhaps an allusion to the hazards of fully entering into a world shaped by female subjectivity. Mary Louisa seems almost womanly in relation to her older siblings, rehearsing for a role that she cannot yet fully assume or understand. Her figure suggests that Sargent could only fully embrace and represent female sensuality when it could be held at a temporal distance. Mary Louisa anticipates the position – and the isolation – of the beautiful

woman in the public space of society. The unadorned background behind the eight-year-old girl is a prologue to the social stage to come.[87]

Pairings: In the Dark

Jane

Mary Louisa's crisp white pinafore and artfully posed body could not offer a greater contrast to the strained posture and indistinct contours of her older sister Jane (Plate VI). Multiple formal links between the two sisters emphasize the differences, as Julia's childish sprawl dramatized Mary Louisa's poise. One muted white reflection at the dark threshold indicates that Jane's left foot is extended along a diagonal in front of her, much like Mary Louisa's. Jane's curls also tumble attractively onto her forehead, but her hair possesses none of

35. Jean-Antoine Watteau, *Pierrot,* also known as *Gilles,* 1718–19. Paris, Musée du Louvre. Photo: Foto Marburg/Art Resource, N.Y.

the bright gleam or springy sensuality of her younger sister's. While Mary Louisa's pinafore is a light-reflecting white, Jane's is a sullied-looking, muted gray.

Jane stands stiffly, with her shoulders thrust slightly forward, as if she is responding correctly but unenthusiastically to a request for attention. Hands that Sargent paints almost crudely hang limply by her sides. One arm appears shorter than the other (an asymmetry that recalls Emily Sargent's deformed shoulder). Jane appears to be wary without being entirely alert. Her eyes are fixed, but not focused. In fact, each of her eyes seems to be directed at a slightly different point in space, which complicates the already unstable relation of her gaze to the beholder. Her lips are parted, as if speech has been stilled or forcibly arrested. Though Jane's lips are symmetrical, the white of her teeth has been painted *over* them at a light diagonal, underscoring the oddness of her face.

Jane's fixed posture, so lacking in confidence, is reminiscent of that of another, more public performer, Watteau's *Pierrot,* also called *Gilles* (1718–19) (Fig. 35), a painting that Sargent would have seen many times in the Louvre. Sarah Cohen argues that Gilles represents for Watteau the "unartful body,"

the performer all dressed up with no place to go.[88] Jane's comparably unartful body acts out the corporeal and psychic discomfort of adolescence, a new subject for the scientists and educators of the late nineteenth century. Around 1880, the same psychologists and educators who were preoccupied with charting the cognitive and corporeal changes of childhood began to identify adolescence as a period in which volatile physical changes collided with the "mental anarchy" of the expanding imagination.[89]

The self-absorption generated by this anarchy was akin to a dream state, as G. Stanley Hall, one of the first American doctors to publish on adolescence, described it:

Puberty is the birthday of the imagination. This has its morning twilight in reverie . . . in many sane children, their own surroundings not only shrivel but become dim and shadowy compared with the realm of fancy . . . the youth is rapt, apart, perhaps oblivious of his environment, and unresponsive to its calls, because his dreams have passed beyond his nascent and inadequate power of control and become obsessions.[90]

This exclusionary dream life was often manifested in a listless, apparently inert body, "a unique lethargy that often distresses both parents and teachers."[91] However, many observers of social mores felt that passivity was desirable in adolescent girls. In fact, the robust physicality that Mary Louisa exemplifies was explicitly discouraged – even, on occasion, medicinally suppressed.[92] There was a general fear of adolescent female sexuality. Conservative writers advised girls that they should greatly restrain their physical activities once they reached puberty, "for fear of betraying some portion of the general system which gives to woman her peculiar prerogative, as well as her distinctive character."[93]

The sensibility of the adolescent girl was, in short, a delicate one, susceptible to even further disruptions by external stimuli. These could range from "clothing to the larger space of the world." Sully believed that the connection between mind and body was intensified at adolescence: "An uneasy attitude of body, the pressure or chafing of a garment, or the chilliness of a limb, is quite enough to depress the mental powers, to induce irritability of temper, a disposition to peevishness, and to outbreaks of angry passion."[94]

The adolescent felt stranded in the larger space of the world. Psychologists of Sargent's time agreed that the very young child – the child of Julia's age – made no particular distinction between the animate and inanimate worlds. Both were understood as equally lively and interesting places – extensions of, even reiterations of, their own bodies. The sense of continuity between self and world was sensed as a coexistence among multiple, equal entities.[95] For the adolescent, however, what was defined as *outside* the divided container of body and mind was perceived as vast but undifferentiated. In its most extreme

instantiation, that exterior was a void that held the power to compromise the autonomy of the self.

The Daughters of Edward Darley Boit exhibits some uncertainty about where Jane ends and the setting around her begins. Only the faint glimmer at the threshold suggests the location of her otherwise invisible left foot (her right must be lodged farther back in the darkness). The contours of both her legs and her arms are lost in the blackness around her; even the edges of her hair and her dark frock are indistinct. Because the room Sargent paints behind (or, more precisely, *around* Jane) is exceedingly difficult to penetrate, the spectator is confronted with an empty space that seems, paradoxically, materially present. Jane's dematerialized body vies for primacy with a physicalized void. In Chapter 1, I suggested that a "rhetoric of embodiment" emerged around mid-century, a discourse in which bodily properties were projected onto spaces, and vice versa. Sargent's painting posits an analogous reciprocity, but to very different effect: a vacated presence is placed in tension with a *present* absence.

Sargent's almost palpable space exerts a force analogous to that found in Expressionist film, in which space took on, as critic Herman Scheffauer described it, "something dynamic and daemonic, demanding not only attention but tribute from the soul." The impact of this cinematic space on the film's protagonists is similar in character to that of Jane's partial submersion into the darkness that surrounds her. "Against this obliterating firmament," Scheffaur writes, "this sponge of darkness, the players move, merge into it, emerge out of it. In order that they may not be visually lost, their hands, faces and the outlines of their clothing are relieved by means of highlights carefully applied."[96] Jane's body seems porous in relation to the dark space around it. In such a setting, an actor might feel as if he had lost his own corporeality. He would stand in a place where "primeval darkness rules, perspective is engulfed, life and action transpire in a world of breadth and height."[97]

In psychiatry, the patient's perception of space as an antagonistic force is a telling symptom of pathology, most particularly of schizophrenia. Eugène Minkowski described how one of his patients imagined the darkness around him as having a material presence that, in the patient's words, "touches me directly, envelops me, embraces me, even penetrates me completely, passes through me, so that one could almost say that while the ego is permeable by darkness it is not permeable by light."[98] Minkowski's description applied principally to his adult patients. But the disrupted boundary between self and surroundings was perceived as a recurring problem in adolescence. Adolescent girls, in particular, were subject to what was called "pubertal insanity." Boys were subject to melancholy; girls, not surprisingly, to hysteria.[99] Even stable girls lost their bearings during puberty, many doctors believed. In 1887, a Dr. C. B. Burr wrote on "The Insanity of Pubescence," in which he explained the propensity of even stable girls to become unhinged during this time: "The

tendency to emotional disturbances is also more strongly marked among females. Crying and laughter are indulged in without cause. A patient formerly under treatment was subject to outbursts of hysterical laughter. Another female was subject to uncontrollable fits of screaming."[100]

During the late-nineteenth century, then, the dawning of female sexuality was understood as a moment threatening to both body and mind. Jane Boit does not appear obviously histrionic in Sargent's representation of her, but her demeanor is subtly disturbed, and disturbing. She is arrested at a point between confrontation and retreat, stranded awkwardly between private and public, ignorance and knowledge. In Jane's figure is embodied the question of how a young woman can incorporate the knowledge of sexuality without becoming paralyzed by it. How does one acknowledge and, at the same time, *incorporate* one's interiority? Jane seems alone in her endeavor. D. W. Winnicott once described the erratic emotional and physical growth of adolescents: "Growth is not just a matter of inherited tendency, it is also a matter of highly complex interweaving with the facilitating environment." Jane's "facilitating environment" seems to have failed her.[101]

Florence

Florence (Plate VI), at fourteen, is established in adolescence in a way that Jane is not. Yet at this still tender age she is in retreat from those around her; she has receded from the position of authority that being the oldest surviving child would ordinarily confer. Formal similarities between her figure and Julia's – the same blue-white highlights and crispness of line in their costumes – underscore the affective differences. Julia's engaged gaze contrasts with Florence's inaccessible one. Florence's closest companion is not her sister Jane (who appears oblivious to her presence), but the monumental Japanese vase that supports her, the vase that Henry James described as seeming "to partake of the life of the picture."[102]

Not all critics approved of the monumental scale of the vases. Some felt that their gigantic size distracted from what should have been the central emphasis of the painting, the "living objects" of the household.[103] What did Sargent hope to achieve by the juxtaposition? Some have interpreted the interdependence of girl and vase as a fertility symbol. Florence is "the Female Child transformed into the Young Wife," or even the "Expectant Bride," given the swelling outward of the supporting vase, a vessel that symbolizes the womb.[104] Though I agree that Sargent was deliberately alluding to female sexuality here, I also believe that the artist painted a sexuality *effaced* or displaced rather than simply celebrated.

Sargent seems to have taken pains to suppress any physical signs of Florence's sexuality. A thick strip of white paint tinged with coral and gray forms

a stiffened pinafore bib. The bib thrusts out slightly more than seems neces-
sary; no breasts interrupt its downward planar slide. In fact, the vase behind
her has more budding curves. Her figure seems large but unformed, oversized
for a child but lacking the corporeal and spatial command of an adult. Flo-
rence's sensual presence is thereby reduced. While her pinafore does possess a
greater material presence than that of Jane beside her, her body and face are
otherwise almost featureless. Her brow is a shadowy indentation; her right eye
is invisible; the nose a schematic isosceles triangle, the mouth barely dis-
cernible. Even the neck is completely in shadow. One is reminded of the re-
mark made about Nanda, the protagonist of Henry James's novel *The Awk-
ward Age:* "She has no features. No, not one."[105] Florence's ear – an inverted
red wedge framed in ochre – mirrors, upside down, the contour of her nose.
The conspicuous redness of the ear's interior is reiterated in Florence's crudely
painted hands, an unexpected fleshiness in this otherwise dephysicalized body.
Her legs are almost entirely subsumed into the same dark shadows that absorb
Jane's; her hair is a dark curve that separates her body from the vase she leans
against.

 Florence's shoulders strain backward to touch the throat of the vessel. Sar-
gent exaggerated slightly the outward swell of the vase's bottom half to pro-
vide a kind of shelf for her to lean upon; yet the posture still seems awkward.
The fragility of the actual vases is evident today in their installation before the
painting. The delicate fluting rimming their wide mouths is much mended, and
it is obvious that one of the top-heavy vessels would not provide stable sup-
port for the full weight of a young woman's body. Florence's near-fusion with
this prized possession of her father's is an exaggeration of the interdependence
Louis-Edmond Duranty chronicled in his short story "Bric-à-Brac," in which
furniture legs become indistinguishable from the limbs of the family who owns
them.[106] The vase Sargent painted, however, confounds the usual expecta-
tions about the nature of possessions. Objects acquired and arranged to ratify
nineteenth-century bourgeois identity could generally be held in the hand.
Large pieces of furniture also expressed one's taste and temperament, to be sure,
but they were less easily fondled, grasped, or relocated. Instead, Boit's vases
assume the status of competing bodies. This sensation is acute in the dynami-
cally organic presence of the vases themselves. Slight but unmistakable swell-
ings mark each shift of the vase's surface, and subtle variations affect their
contours. The original vases are far more profusely decorated and highly glazed
than Sargent's representations of them; his edited versions draw attention to
their suggestively corporeal forms rather than to their mirrorlike surfaces.[107]

 In childhood, objects loom larger than they really are. The vases actualize
that disparity, as if memory alone had enhanced their scale. In the character
of Florian in *The Child in the House,* Walter Pater cited the visceral nature
of children's memories of their home, and "the law which makes the material

objects about them so large an element in children's lives . . . had actually be-
come a part; inward and outward being woven through and through each
other into one inextricable texture."[108] The fact that the Boits' vases were
transported at least sixteen times across the Atlantic (according to family leg-
end) suggests that they were the unlikely markers of "home" for their expatri-
ate owners. The vases' association with domesticity is ironic (aside from the
obvious difficulties posed by their scale and transport costs) because, as luxury
items manufactured in Asia, they constituted signs of the exotic, or the Other –
precisely the opposite of home. The vases were made in Japan explicitly for a
Western audience. Such Orientalist possessions would fascinate by virtue of
their "anteriority." Estrangement from the original culture and an emphasis
on display value were crucial for the desired effect.[109] The scale of the Boit
vases certainly excludes the possibility of use value, although they may have
been enlargements of an existing, and possibly more useful, type of vase – a
vase monumentalized expressly for wealthy American and European collec-
tors. These vases were manufactured *to be big*, to announce the privilege of
those who could afford to acquire them. That there are *two* of them – even
though the other is present only as a fragment in Sargent's portrait – makes the
air of privilege even more emphatic. Such exotic acquisitions, transported
through the imperialist whims of a wealthy collector, can activate other associ-
ations as well. The ostensibly "primitive" object – as even the most sophisti-
cated Asian products were labeled – is also, by extension, analogous to "that
radical otherness which is the possessor's own childhood."[110] If Florence –
indeed, all the Boit daughters – are to varying degrees sites of projection for an
adult's vision of childhood, then the vases can refer to something even more
general: the childhood of humanity.

Florence is allied with an *object* in her father's home; indeed, she becomes
almost one with it. Given the organic form and female associations of the
overscaled vessel, it is not far-fetched to imagine that Sargent deliberately
sought to draw an analogy between the objecthood of the vase and the object-
hood of the young woman as a possession of her family. Of all the sisters, Flo-
rence's interiority is the most difficult to imagine. With her averted profile, ab-
sent gaze, and unyielding body, she has adamantly removed herself – or has
been removed – from the possibility of revelation. Perhaps she has transcended
the corporeal and psychological instability that seems to paralyze her sister
Jane; but she has not yet attained the privileges of womanhood. Indeed, in the
painting, she is trapped between her sister's inert figure and the unyielding
porcelain of the body-vase. Retracted from her human companion, Florence
cleaves to the inanimate other. She is gazing across the doorway (we presume,
even though we cannot see her eye), and thus faces the void directly. Perhaps
her glance brushes over the cold, empty fireplace within the room beyond, or
considers the mantel with its empty, hollowed-out urns, miniature versions of

the hollowness she leans against. What shape does interiority take outside the family? And what is the cost for leaving?

Conclusion

"They learned to negotiate loneliness; it was neither odd nor an enemy but, rather, the basic element of their childhood, which strengthened family ties to near-breaking."[111] Although this was not intended as a description of the Boit portrait, the passage captures the painting's ability to present, simultaneously, isolation and connectedness within the family. The quotation is an observation made by Sargent's biographer about the painter's early life with his sister Emily. Sargent never fully possessed what Gaston Bachelard called the *maison natale*, the childhood home that is longed for but never regained. The painter's elusive primeval home, as he may have imagined it through the Boits' capacious apartment on the avenue de Friedland, was akin to Daly's dreaded house of shadow.[112]

When the spatial envelopes that contain these singular figures are stitched back together, do they form a whole? This is a psychological and social question as well as a formal one, for, in their very figural positions, the Boit sisters incorporate different variants of the conflict between individual female subjecthood and collective family identity. Sargent painted his subjects in a private home, but for public consumption. The unprotective space of the painting anticipates the ruthless exposure the girls will endure as objects of representation.

A delicate connective web knits together these apparently disparate subjects, suggesting their fragile but immutable ties. Here, Sargent emulated the visual axes that bind together the figures in *Las Meniñas*. Velázquez's characters, ambiguously implanted within their own territories, are joined by an ingenious interpenetration of horizontals and verticals. A connective passage knits together on the surface of the canvas multiple levels of depth – the trail of black that begins in Doña Isabella's lace sleeve in the foreground, travels upward to become the contour of her dress, and spills into the door frame many feet behind her to surround Don Nieto's figure in the rear doorway.[113] In Sargent's homage, the line that runs behind Mary Louisa's head at eye level continues, after a slight interruption, into the banding on the vase. The floor behind the eight-year-old's ankles narrows to skim the edge of the rug, intersects Julia's head – which is framed by the same shadow that provides a ground for her two oldest sisters – and then proceeds to float beneath Jane and Florence, ending under the pointed red screen and the vase it neatly surrounds. Near is fused to far, and the impenetrability of each spatial envelope is permanently, though subtly, breached. Also, the visual, and sensual, analogies between the girls'

bodies and the bodylike vases set up a rhythm that arcs across the composition; in fact, one of the smaller vases perched on the shadowy mantel beyond is directly aligned with Julia's head.

The relation between Sargent and his subjects was reciprocal. The child's power to act upon the adult rivaled the authority of the adult to control his subjects and, most importantly, his reactions to them. We actually know very little about the Boit girls. Their mother died twelve years after this painting was made, and the family's only heirs were the children of Edward Boit's second marriage, as none of the sisters Sargent painted were to marry or have children. When Boit commissioned his ambitious young friend to paint his four daughters in 1882, he undoubtedly imagined that the portrait would be both Sargent's ticket to artistic fame and a guarantee of his own immortality. Boit was an artist too, one who abandoned his law practice after being overwhelmed at the sight of Corot's landscapes. In securing Sargent to paint his daughters, he subordinated his own hopes for artistic immortality to those of a more lustrous talent.[114]

This group portrait constitutes Sargent's first major foray into a territory that was to become a crucial aspect of his life's work: the representation of female subjectivity, something he both identified with and feared.[115] His own affinities resonated with the contemporary practice of identifying the female child, or at least an embodiment of feminized qualities, as the quintessential emblem for adult interiority.[116] In this painting, Sargent shows us the stages of the attainment of the interior life, and of its accessibility. Julia is not yet able to articulate her inner life and is oblivious to the need to do so; her sense of self resides entirely in the body. Mary Louisa's figure is finely tuned to the expectations of an external authority. She is responsive but self-protective, perhaps without knowing exactly why. She waits, patiently. Florence is impossibly remote. She cedes authority within the hierarchy of childhood, yet cannot assume her role outside the home.

Then there is Jane, a figure who I suspect caused Sargent some difficulty. Unlike her older sister, she turns toward the viewer, coopting the central position. She is Sargent's "control, his theme, placing her sisters in relation to her variations."[117] But in contrast with her two younger sisters, she refuses to be objectified, constructed from the outside in. She is a fragile but revelatory presence at the core of the painting. Jane resists becoming a mirror for the adult who seeks a safely distant emblem for his own lost childhood. Her painfully apparent discomfort emphasizes that the passage to understanding is fraught with danger. For Sargent, the claims of interiority were perhaps dramatized most intensely in the liminal state of adolescence. Knowledge was terrifying; self-knowledge even more so. Here, interiority opens into a void that threatens the very corporeality of the young girl who stands to greet it.

Chapter Four

The "Surface of Existence"

Edouard Vuillard's *Mother and Sister of the Artist*

Introduction: The Conditional Self

Sargent's *The Daughters of Edward Darley Boit* injected the sensation of ago-raphobia – the fear of open space – into the very domain that was supposed to be fortified against it. Vuillard's much smaller work, *Mother and Sister of the Artist* (Fig. 36 and Plate VII), painted about a decade later, conjures up the inverse spatial fear: claustrophobia.[1] Through a composition nearly cleaved apart by nothingness, Sargent suggested that the potential for the annihilation of the self lurks within every family interior. Vuillard's compact paint strokes link his self-reflexive figures to their setting, forming a variegated tissue that barely masks the void lurking just on the other side.

Vuillard's *Mother and Sister of the Artist,* the most ambitious of the series of images the artist painted of Marie and Madame Vuillard, offers yet another paradigm of the drama of the self so compelling to the nineteenth-century imagination.[2] In Vuillard's interpretation, selfhood is defined by its mutability; a multiplicity of aspects appear to coexist simultaneously. What might seem to be oppositions, or at least inconsistencies, within the self are both marked and married on the surface of the canvas, suggesting that it is possible to discover a variety of personas within the same figure. And if the self was represented by Vuillard as an aggregate of several roles, then the stage for those perfor-mances, the domestic interior, was painted as continuous with, indeed virtually *inseparable* from, that self. These were years in which the borders between self and world were understood to be both pliant and permeable. Vuillard ex-ploited this assumption in *Mother and Sister of the Artist,* yet he also pre-served the distinctions that were usually elided – between self and other, and between self and setting.[3]

Recently, philosophers and psychologists have tried to articulate more pre-cisely the dual structure of bodily experience. "The psychological subject is a spatially extended object," one philosopher has argued, and he concludes that "the basic subject is therefore a mental-and-physical subject-object physically

36. Edouard Vuillard, *Mother and Sister of the Artist*, ca. 1893. New York, Museum of Modern Art. Gift of Mrs. Sadie A. May. Photo: © 2000 The Museum of Modern Art

extended in space."[4] As remote as these terms might seem from the concerns of Vuillard's family portrait, they are actually pertinent to the manner in which the artist staged the figures of his mother and sister in their apartment in Paris. Vuillard was not a philosopher, of course. In fact, he was wary of theories in general – notably those of his close friend Maurice Denis. He feared that close adherence to dogma would blind the artist to the unpredictable richness of daily life.[5] Nevertheless, during the 1890s he was engaged in what Elizabeth Easton has called a "passionate exploration of the self."[6] Vuillard used both his journals and his paintings to understand better how the self could merge conceptually and aesthetically with its surroundings yet still respond to the unforeseeable demands of emotion and incident.[7] In so doing, he was exploring how the self could be both subject and object. In *Mother and Sister of the Artist*, not only do Vuillard's protagonists appear to perform a variety of roles; their very status as human subjects is called into question. Each woman's figure oscillates between a recognizable human presence and an uncanny *other*. And their surroundings have a vitality that threatens to surpass that of the women themselves, refusing to recede as inanimate settings are supposed to do.

The interior Vuillard painted is fraught with inconsistencies, as are the figures of his two actors: his mother, the woman he called "my muse," and his sister Marie, his elder by seven years. In the very year Vuillard painted her, Marie married her brother's best friend, the Nabi painter Ker-Xavier Roussel. Although Marie Vuillard would move out of the family home during 1893, she remained a daily presence because she assisted in the corset- and dress-making business her mother ran from the family dining room. The quietly bustling daily life inside Vuillard's Paris apartment, full of women bent to meditative tasks, inspired the series of domestic interiors that Easton has called his "icons of inwardness."[8]

Mother and Sister of the Artist stands apart from this series, although its setting and cast of characters are the same. Here, Vuillard recognizes the multivalent, conditional nature of selfhood. Through paint, he intimates that there is a role which is assumed for those outside the immediate circle; a character that is adopted, and constantly adjusted, for close relations; and a self that is held within – a self glimpsed in fragments, perhaps, but finally unavailable to anyone outside. Vuillard does not contrast an "authentic" to an "inauthentic" self. Rather, he paints the coexistence of shifting – and equally plausible – surfaces. His achievement correlates with the new theories of mind that emerged at the fin de siècle. These are encapsulated in an observation published in the popular press: "the personality is neither really defined, nor permanent, nor stationary . . . the sense of free will is essentially floating and illusive, memory multiple and intermittent, and . . . character is a function of these variable qualities and can be modified."[9]

The Psychologized Interior

By 1890, a preoccupation with interiority (or "l'intérieur," as it was usually referred to) was commonplace.[10] Artists, playwrights, and theatrical designers experimented with media and forms that would give shape to the ineffable workings of the self; physicians and neurologists wondered about its anatomical structure and tried to pinpoint its external manifestations; novelists and philosophers speculated on the collapse of boundaries between the self and the world. They also explored the perils and seductions of the exaggerated need for containment that had surfaced within the culture (as manifested in the protagonist Des Esseintes's withdrawal into his interiors in Joris-Karl Huysmans's *Against the Grain*) – containment being "one of the most pervasive features of bodily experience."[11] Debora Silverman has argued that the period's characteristic visual form, the Art Nouveau style, represented the projection of a psychic interiority onto the constructed surfaces and assembled objects of the domestic interior. The sensitized, weary "neuropath" of the age found his or

her inner tensions mirrored in the forms that shaped this "domain of supra-historical self-projection." For Silverman, the "interior was no longer a refuge from but a replacement for the external world."[12] These ideas were first advanced in the competing neurological theories of Drs. Jean-Martin Charcot and Hippolyte Bernheim, applied in the novels of Baron Huysmans, and elaborated in the assorted writings of the brothers Edmond and Jules de Goncourt and the critic Paul Bourget.[13] The all-encompassing decorative scheme of Art Nouveau can be seen as the culmination of the thinking that shaped Lecoq de Boisbaudran's "mise ensemble," Duranty's identification of subject and setting, and Daly's advocacy of the interpenetrations of family and habitat. And indeed, Vuillard's early paintings do fit conveniently into this framework to some degree, as they distill the conception that, in representation, figure and setting are as one. Upon closer examination, however, his works embody not only continuity but also rupture, with the so-called psychologized interior of the 1890s.

Vuillard equivocates about the status of a self that is conceived as inseparable from its setting. We know from the artist's journals that the fusion of parts both animate and inanimate into a coherent whole was of paramount importance to him, as it was to his fellow Nabis, who collectively promoted the elevating powers of decorative painting.[14] Yet many of Vuillard's mother and sister figures of the early 1890s incarnate the tensions that emerge when the primacy of the body as a container for the self comes under pressure. If "subjectivity takes place in corporeal space," as Victor Burgin has put it, then where does interiority reside when its most cogent expression is said to be found *outside* the body – on the imaginatively enlivened wall surfaces, textiles, and decorative objects of the modern interior? And if self is subsumed into setting, how are the boundaries between self and other defined, negotiated, and, finally, represented? When inner identity collides with an outer force, the collision is no less profound for being acted out in the mind of the beholder, as Vuillard's own journals attest. In painterly terms, this is cast as a problem of how *difference* is expressed in a pictorial field that stresses parity of emphasis and fusion of parts – the ideological underpinnings of much 1890s painting. In conceptual terms, it is a problem of how the elusive, ever-changing self is represented as a material entity: how the perceiving subject becomes, through paint, a material object. Somehow, through the static form of painting, Vuillard managed to give shape to the inherently changeable, even unstable, character of the boundaries that serve provisionally to distinguish one self from another, the self from the world, and the subject from the object. The artist grafted the ideals and anti-illusionistic techniques of decorative painting to the new staging practices and set designs of the Symbolist theater, with which he was deeply involved in the early 1890s. Vuillard's solutions resonate with a large range of stylizations of the self that were being performed around Paris: in the plays staged at his friend Aurélien Lugné-Poe's Théâtre de l'Oeuvre,

within the Nabis's own marionette theater, in Charcot's amphitheater at the Salpêtrière Hospital, and, according to some critics, on the boulevards of the city and inside its bourgeois drawing rooms.

Subject and Object: Self and Other

As early as 1874, Hippolyte Taine, in his book *De l'Intelligence,* had argued for the unity of the subjective (the mind) and the objective (matter), a premise that Richard Shiff has identified as fundamental to both Impressionist and Symbolist theory and practice. Shiff has demonstrated that the originality of the self was optimally expressed through a considered choice of technique, one that would express simultaneously both the artist's own temperament and his attentiveness to the larger world of material phenomena.[15] The ideas of Vuillard's friend Denis, the leading theorist of the Nabis, emerged within the context of Taine's ideas in psychology and of Albert Aurier's writings on the primacy of the artist's subjectivity. Writing in 1907, Denis reflected on the earlier preoccupations of his own generation. Referring to the "cult of the self" that had motivated them during the 1890s, he summarized their earliest principles: "The symbolist view is that we should consider the work of art as the equivalent of a sensation received: nature could then be, for the artist, only a state of his own subjectivity. And what we call subjective distortion [*la déformation subjective*] is in practice, style."[16]

Vuillard was deeply impressed by Denis (in one journal entry, he seems to sigh at the burden: "always the influence of Denis").[17] And indeed, the seamless integration of body and place remained an ideological goal. Vuillard's journal is full of musings on his efforts to achieve a unified ensemble; he cites his frustrations as he searches for a form that will convey what he feels as well as what he sees – all fused together on the same plane.[18] But his treatment of the female figure and the space that surrounded it was from the outset distinct from that of his Nabi brothers Denis, Paul Ransom, Paul Sérusier, and his future brother-in-law, Roussel. In *Spring (Le Printemps)* (1894; private collection), for example, Denis's ethereal figures float untethered through landscapes whose contours and decorative silhouettes echo the lineaments of the women's bodies. Denis's near-denial of the figure–ground distinction would appeal enormously to Alfred Barr, who later admitted the painter to the pantheon of abstraction's founding fathers.[19] In contrast, during the early 1890s Vuillard painted the body – even the apparently fragile body of his sister – as a persisting, *material* entity that is never entirely subsumed into its surroundings, even when its corporeality is rather aggressively challenged. In *Mother and Sister of the Artist,* Marie's contracted figure displays a visceral strain that seems initially at odds with her pictorial reductiveness. Also reduced, or perhaps instead, condensed, is Vuillard's mother, whose dress is a sharply

contoured silhouette of black. Comfortably erect in her chair, Madame Vuillard is a daunting and stalwart presence. As she is painted, she seems impervious to her daughter's somatic and psychological discomfort. For Marie Vuillard, who worked with, and presumably for, her mother, the family interior does not appear to offer much solace. Madame Vuillard, on the other hand, seems quite at home – as would befit the family's economic and moral authority. The artist's mother had worked as a corset-maker in Paris since the late 1870s, at least five years before she became a widow in 1884. She supported her family until 1898, when Vuillard's commissions began to provide a more reliable income.[20] In *Mother and Sister of the Artist*, Madame Vuillard does not simply inhabit the space her son has constructed for her; she claims it. And because her right arm juts out at precisely the same angle at which Marie's torso contracts, she appears to have elbowed her daughter aside for the privilege.

Mother and Sister of the Artist

Madame Vuillard's sharply edged dress exaggerates the force of her posture. Under her ample skirt, her legs are planted wide apart. Her left hand rests in her lap, and the right is clasped to her thigh, in what is called an "arm akimbo" pose. This is a conventionally masculine bodily configuration, one found in portraits such as Jean-Dominique-Auguste Ingres's *Monsieur Bertin* (1832; Paris, Musée du Louvre), as well as in innumerable other images of authoritative patriarchs presiding over their families. However, the appropriation of such a posture for an uncommonly authoritative matriarch was not unprecedented. Painter Léon Bonnat used it for his mother's portrait in 1893 (*Madame Bonnat*, Paris, Musée d'Orsay), as would Picasso for *Portrait of Gertrude Stein* (1906; New York, Metropolitan Museum of Art).[21] In Vuillard's painting, the floorboards rise up directly to frame the form of his mother, anchoring her even more securely in space. Her implantation on the floor is reinforced by the incongruously large right shoe that thrusts out from beneath her skirt.

The same floorboards that run straight beside Madame Vuillard's figure tilt at an alarming angle under the body of her daughter, undermining what is already a tenuous situation in space. Marie's feet are nearly invisible (a daub of black paint could be her left shoe), and her form is far *too* attached to a wall that seems to surround rather than support her. Her bodily contraction is inexplicable. She bends as if trying to fit into the picture, like a too-tall adult who has been asked to "hunker down" in order to fit into a children's playhouse. A window ledge angles directly up from the bureau and hovers – impossibly – just inches above Marie's head, sustaining the sense of oppression. Some have suggested that Vuillard painted his sister bending to retrieve a dead flower that lies at her feet.[22] This is conceivable, but it is an insufficient explanation for a posture that has been calculated to appear as uncomfortable as possible.

Marie recalls the cramped posture of Lewis Carroll's Alice who, after her spell of shrinking was over, had to fold herself more and more compactly into the White Rabbit's house to accommodate her magically growing body. Instead, Marie Vuillard's body seems to *diminish* as we behold it.

The mahogany bureau behind Madame Vuillard – which doubles both the impact and the shape of her blocklike body – appears in many of Vuillard's paintings of these years. It had a place of honor in the dining-cum-workrooms of the series of apartments the family inhabited on the rue St. Honoré during the 1890s. Usually, the top was covered by a clutter of objects: practical items that were used for family meals. The visual evidence of *Mother and Sister of the Artist* suggests that a meal has just been completed. An empty wine bottle, scraps of leftover food on a plate, and a discarded napkin represent traces of a recent meal – a meal attended, perhaps, by a visitor from the world outside.

"Wallpaper" hardly seems an adequate label for the painted surface that animates the interval between mother and daughter. At first the strokes appear incoherent: sloppily daubed; irregularly spaced; too varied in opacity, tone, and hue. More patient viewing reveals an idiosyncratic but unmistakable sense of order. The larger, lighter strokes that cluster around Marie at the painting's left margin begin to darken, diminish, and cluster more closely together as they approach the figure of Madame Vuillard – a transition whose significance I will discuss below. The rounded daubs of paint just above the bureau, within the corner of the window that is visible, and on top of the tablecloth, are applied more evenly and more closely resemble a conventional pattern.

The interior Vuillard constructed is radically, asymmetrically compressed; the perspective telescopes back to the oversized bureau, which makes an almost comical foil for the composition's elusive vanishing point. Edgar Allan Poe would have applauded Vuillard's construction, for he believed that "a close circumspection of space is absolutely necessary to the effect of insulated incident: it has the force of a frame to a picture . . . of course, [it] must not be confounded with mere unity of place."[23] In this spirit, Vuillard constructed a space that is unmistakably *dis*unified. Consider the implausibility of the rising window ledge, the scale and angle of the bureau, and the discontinuity within the floor's simultaneous – but incompatible – rise in the center and tilt on the left margin. Earlier, both Degas and Sargent had painted volumetric spaces, even as they distorted, distended, or cleaved those spaces apart. Instead, Vuillard offers a series of highly compressed, linked-together surfaces, in which depth is recast into adjacent passages of varying surface tension. Divisions between space and figure are inscribed as variations in the shapes of brushstrokes or tones of pigment.[24] As he suppressed three-dimensional space in painting, Vuillard challenged the convention of the self as an entity that possesses depth concealed by surface. Instead his surfaces are layered and imperfectly knit together. They seem to shift as we behold them, suggesting that the knowledge we seek can be extracted from the surfaces themselves and from the interstices between them – if only we look carefully enough.

Georg Simmel, one of the early theorists of modernity, wrote in 1903 about the expressive importance of the details of daily life: "from each point on the *surface of existence,* however closely attached to the surface alone, one may drop a sounding into the depth of the psyche, so that all the most banal externalities of life finally are connected with the ultimate decisions concerning the meaning and style of life." Vuillard contrives his own "surface of existence," in which he paints, not the place where the self ends and the world begins, but the "points of tangency" where they interpenetrate.[25]

In Vuillard's *Mother and Sister of the Artist,* vitality is no longer concentrated within the body, but is dispersed across a field of enlivened color strokes that link together skin, hair, fabric, wallpaper, and the air that vibrates in the intervals between them. As the strokes recede, translucent green-and-white pigments are replaced by darker, more opaque siennas and ochres, umbers and browns. Strokes become denser and more compact, and comma-like in shape. Unexpectedly, they shift direction; the diagonal strokes that seemed to be loosely applied are reversed to resemble quotation marks. They appear to turn *toward* the figure of Madame Vuillard, who thus appears to generate pattern as well as perspective.

By marking spatial transitions directly on the surface, without recourse to modeling or conventional perspective, Vuillard somehow fashioned two distinct spaces for his subjects to inhabit – a feat remarkable in view of the small scale of the interior. In a period when human relationships were experienced as "space filling," and "space was accorded the power to determine social roles," Vuillard envisioned the spatial and thus, affective, roles of his mother and sister to be both oppositional and interdependent.[26] Here, difference is condensed and embodied: difference of age, sexuality, temperament, social rank, economic power, relation to the beholder, as well as to the artist – the son and brother, respectively. As I suggested earlier, Vuillard's intimate stagecraft presents the self as a kind of performance. This was an idea that much preoccupied the artist in these years and resonated with the thinking around him. Critic Alfred Fouillée, who was steeped in *psychologie nouvelle,* contended in 1891 that the mind was a psychic "theater" in which "a troupe of different, multiple actors enacted an interior drama."[27] The assumption was that subjectivity could be pictured and performed, but not penetrated.

Neurasthenia and the Projected Self

Simmel believed that urban existence at the fin de siècle demanded what he called an "inner barrier between people." Such a mental structure was, quite simply, "indispensable for the modern form of life." He stressed that "metropolitan communication would simply be unbearable without such psychological distance . . . sensitive and nervous modern people would sink completely

into despair if the objectification of social relationships did not bring with it an inner boundary and reserve."[28] Vuillard himself would have qualified easily as one of Simmel's "sensitive and nervous modern people." The artist's friends and colleagues painted a picture of the artist as the consummate neurasthenic, who was riddled "not by doubt, but by self-doubt" and subject to melancholy.[29] Of course, some within Vuillard's circle positively embraced neurasthenia, believing that its sufferers were privileged to experience a whole range of sensations unavailable to those with less refined temperaments.

Edmond and Jules de Goncourt suffered exquisitely for the sake of their art and their home, which they believed to be virtually interchangeable. Their jointly written *La Maison d'un Artiste*, vols. 1 and 2 (1881), an exhaustive description of the works of art, furnishings, and bibelots that filled their eighteenth-century house in Auteuil, testified that their disparate possessions were woven into a "living atmosphere" through the animating force of their personalities. In this atmosphere, the brothers were both perceiving subjects and aestheticized objects.[30] Mentioning the "ennui de coeur" that had prompted their collecting, Edmond de Goncourt conceded that their possessions were more precious – and more *alive* – to them than any human presence.[31] As an apologist for the Goncourts, Paul Bourget explained that the brothers' dispositions defined each as "a kind of oversensitive intellectual, wounded by the slightest sensation, without any defense, without any covering, all bloody."[32] The same attitude of mind would shape Huysmans's contemporary novel, *À Rebours* (*Against the Grain*) (1883), in which the central character of Des Esseintes orchestrates every detail of his fastidiously decorated interiors, to which he retreats in an increasingly hermetic seclusion.

The brothers Goncourt may have been the agents of their sublimely refined living quarters, but at the same time they were trapped within its confines, encased in a beautiful but fragile shell that held the rest of the world at bay. The vulnerability of such an existence was to become the theme of Henry James's *The Spoils of Poynton* (1897). James's protagonist, Mrs. Gereth, talks to her young friend Fleda Vetch about the possessions she so loves – the "spoils" of the title: "There isn't one of them I don't know and love. . . . They're living things to me; they know me, they return the touch of my hand." Later, Fleda reflected on how Mrs. Gereth virtually lost her identity when separated from her objects. "The mind's eye could see Mrs. Gereth, indeed, only in her thick, coloured air; it took all the light of her treasures to make her concrete and distinct."[33]

Vuillard fabricated an analogous "colored air" as he lay in his bed one morning, gazing around him at the architecture and decor of his room:

This morning in my bed upon awakening I was looking at the different objects that surrounded me, the ceiling painted white, the ornament in the middle, vaguely eighteenth-century arabesques, the mirrored armoire opposite, the grooves, the molding of the woodwork, of the window, their proportions, the

curtains, the chair in front of them with its back of carved wood, the paper on the wall, the knobs of the open door, glass and copper, the wood of the bed, the wood of the screen, the hinges, my clothes at the foot of the bed; the four elegant green leaves in a pot, the inkwell, the books, the curtains of the other window, the walls of the court through it, the differences of perspective through the two windows, one with a little patch of sky parallel to the window, in the other, making a perpendicular angle, the impression that results from only that corner.

Vuillard's reverie is suddenly interrupted.

And another thing, in the middle of all these objects, I was astonished to see Mama enter in a blue peignoir with white stripes. To sum up, not one of these inanimate objects had any simple ornamental connection with another, the whole was as disparate as possible. All the same there was a vivid atmosphere, and it gave off an impression that was not at all disagreeable. The arrival of Maman was surprising – *a living person.*[34]

Vuillard's wide-ranging perceptions constructed a mentally unified field. Animate and inanimate presences were conjoined, seemingly without strain. His mother – "a living person" – constitutes an interruption that is quickly incorporated into a field where persons and possessions mingle and merge. As the artist constructs this vivified atmosphere, Madame Vuillard is transmuted from perceiving subject (she has presumably entered the room to wake up her son) to material object (as one part of an allover field): a subject/object whose presence is extended into space – just as the philosopher prescribed. Vuillard, who includes his own clothing in the recitation, is also caught in the veil of his own imaginings; he is both originator of the perceptual field and a facet within the larger ensemble. In his journal, the artist meditated upon how he went about imaginatively transfiguring his setting before casting it into paint: "Man makes objects which are the signs of his thought. They are many, like the moments of thought. *Art is connection,* the order that he follows in the creation of these objects. Purely abstract idea. The mind sees and deciphers the signs, arranges them in accordance with the state that occupies it. All my acts have a shape, only art is in everything. . . . a form, a color, only exists in relation to another."[35]

"Decorative Females and Female Decorators"[36]

Vuillard's musings reflected the aesthetic ideals of decorative painting, which also had an explicit social application. If the borders between art and life could be made more permeable – if art could be placed directly on the walls, infiltrating every aspect of daily life – then the modern home could be elevated. The poet and critic Dom Willibrod Verkade captured the urgency of the Nabis' desire: "a battle cry was fired from one atelier to another: 'No more easel

paintings! Down with useless furniture! Painting should not claim a freedom that isolates it from the other arts! . . . Decorate the walls, the walls! Down with perspective! The wall should stay as the surface, not be penetrated by infinite representations. There are no paintings, there are only decorations!' "[37]

Denis promoted this confluence of the aesthetic and the social in his theoretical writings of 1892: "I would want [the paintings] to have a noble appearance, of rare and extraordinary beauty: they should contribute to the poetry of man's inner being, to the luxurious color scheme and arabesques without soul; and one should find in them a whole world of aesthetic emotions, free of literary allusions and all the more exalting for that."[38] While Vuillard hesitated to embrace all of Denis's theoretical claims, the ideals of decoration were nevertheless ingrained in his thinking. In a journal entry of 1894, he mused, "What danger there is in attaching more importance to ideas than to the cause that gives birth to them."[39]

A largely conservative political movement pursued a different notion about how decoration might change people's lives in fin-de-siècle France, however. During the 1890s, a program of social and artistic reform concentrated attention on the important role women should play in reviving the fortunes of the rather moribund French decorative arts industries. By producing the tapestries, metal ornaments, lacework, embroidery, and fine leatherwork for which women were said to have superior natural talent, and by doing this work *at home*, women could simultaneously infuse life into the French economy (while honoring the national heritage of the rococo) and ensure the stability of the nation.[40] The first, much publicized, Women's Art Exposition was held in 1892. While articles published for the occasion extolled women's achievements, authors were careful to underscore the proper domestic frame of womanly achievement. What appeared to be a celebration of women's talents was actually an ideological program to contain them. The counterpoint for the creative, if dutiful, wifely artisan was the New Woman, who was emerging as both a social force and popular image. In the press, she was "alternatively envisioned as a gargantuan *amazone* or an emaciated, frock-coated '*hommesse*.' "[41] In either instance, her desire for sexual and economic independence presented a dire threat to the bourgeois family. A range of literary and scientific journals reiterated the message, in one form or another: a woman's place is in the home.

A variety of essays suggested various means through which the "decorating woman" should extend her talents to her entire domestic environment, as one house-bound element in a larger design scheme. Writers of the late 1880s and 1890s exhorted women to become "artificers of the interior," adding that they should design themselves with the same nuanced attention they bestowed on their upholstery.[42] One of the most frequent criticisms leveled against the New Woman was her sartorial resistance to being integrated into her setting. She simply wore the wrong clothes, one annoyed critic insisted: "These are no

longer women of pleasure and leisure, but women who study, of very sober comportment. And nothing suits them better than heavy and somber colors."[43]

Was Vuillard's admitted preference for female subjects part of this culturally overdetermined connection between women and their domestic interiors? In his journal, he worried that "I ought to have had a varied multitude of objects represented in my paintings, but I never put men into them, I realize. On the other hand, when my purpose tends to men, I always see terrible caricatures [*d'infames chargés*]; I have the feeling only of ridiculous objects. Never [so] in front of women, where I always find a way to isolate a few elements that satisfy the painter in me."[44] Vuillard's friends seem to have viewed his immersion in the "saturated women's world" of his mother's apartment as confirmation of a generally feminized temperament. Musings about Vuillard's delicate sensibility, his worries, and his preference for female company color many of his friends' accounts. He was described as "deeply sensitive," "highly strung," and "haunted by anxiety," terms identified with women at the turn of the century.[45] Also, Vuillard's acute financial and emotional reliance on his mother was stressed at every turn.[46]

In this light, could Vuillard's pictorial fusion of his sister to the patterned surfaces around her be construed as a visualization of how fluidly a feminine (or feminized) presence might be integrated into its surroundings: the artificer inseparable from the artifice? Or, given her apparent discomfort – her strained posture and tentative expression – is Marie an artisan *too* attached to her surroundings: closely tied to, but not in harmony with, her home? Does Vuillard offer the viewer a commentary on the psychic cost of aesthetic integration, perhaps interrogating his own as he wonders about Marie's? There are close affinities here to Charlotte Perkins Gilman's 1892 short story *The Yellow Wallpaper*, in which a woman in enforced confinement after childbirth – the notorious "rest cure" that deepened, rather than dispelled, the depressions of many nineteenth-century women – imagines that she sees another woman trapped behind the tracery of her wallpaper pattern. Eventually it is clear, to the reader at any rate, that the effigy is none other than a projected self-portrait-self transmuted into *other* to such a degree that the effigy is unrecognizable, at least to the original subject.[47] Marie's near-symbiosis with the wall she presses against in *Mother and Sister of the Artist* seems a nightmarish parody of the cherished dictum that a woman's place is in the home.

The Economy of the Interior

Madame Vuillard and her daughter were artisans, and thus, in their modest way, contributed to the production of fashion goods that was so crucial to the French economy. However, there was a significant class difference between the

artisanal activities that originated in the interior of the Vuillard home and the decorative practices promoted by the Central Union of the Decorative Arts. The Vuillards were members of the *moyenne bourgeoisie,* and until 1898 the family depended on the production of the mother's corsets and dresses for financial sustenance. Most of the women in the Union were of the upper-middle class, and sometimes from the aristocracy. The goods they were encouraged to produce – ivory carvings, silk tapestries, hand-tooled leather book covers, painted china, and lace – were geared for the luxury market and inspired by a fervor to recapture the apogee of France's achievement in the decorative arts: the eighteenth-century rococo.

Charcot's wife was one of the Union's most prominent members. With the help of her daughter, she carried out an ambitious decorative program for the family's palatial residence on the boulevard Saint-Germain – originally the rococo Hôtel de Varengeville.[48] Charcot himself designed the decorative scheme for each room, appropriating motifs from the art of all periods except his own, which he disliked as "vague" and "imprecise."[49] Charcot's colleague Henri Miege described the setting: "nearly every surface was covered with some amalgamation of animal or human personification and encrustations of ornament."[50] More recently, the Charcot family home has been described as "a repository of historically dislocated artifacts, idiosyncratic relics, and emblems of erotic mysticism . . . the emergent pathological interior . . . a possessed apartment."[51]

The rooms occupied by the Vuillard family were, needless to say, very different – albeit perhaps not without their own uncanny qualities. Although the first apartment the family inhabited on the rue St. Honoré has not survived, the paintings and photographs made there suggest a series of small rooms linked to one another in succession without a central hallway. Ceilings were likely to have been fairly low, and most walls were covered with patterned paper. Rooms were furnished simply and flexibly. With a few minor adjustments, a workroom could be transformed into a dining room.[52] Most of Vuillard's sewing paintings of these years seem at first to record a claustral atmosphere in which self-absorbed women work tirelessly, oblivious to the exterior world. In fact, however, both family apartments on the rue St. Honoré were located in the heart of the fashion district amid shops that sold ribbons, hats, fabrics, and the accessories crucial to fin-de-siècle fashionable attire. Easton speculates that Madame Vuillard may even have been active in the corset-makers' union; their headquarters were housed in the same building in which the Vuillards lived.[53] The burgeoning money economy of the late nineteenth century was, quite literally, just outside the walls. The cottage industry run by Madame Vuillard was becoming increasingly anachronistic and impractical. She and her employees (there were usually three, including Marie) were likely to work longer hours and to make less money than their counterparts in larger commercial enterprises.

The commercial world can be understood as both reinforcement and threat to Madame Vuillard's domestic operation. The fragile division between them is distilled in the wall of *Mother and Sister of the Artist,* which is at best an equivocal barrier. But there is another kind of internal wall within the space: the form of Madame Vuillard herself. The inky opacity of her dress, the severity of its contour, and the absolute flatness of the silhouette make her figure a living barricade, a formidable (albeit razor-thin) hedge against encroachment, whose resistance is doubled by the bureau looming behind her.

In ways befitting their different temperaments, ages, and roles within the family structure, mother and sister materialize the contradictions and strains of a self that is forged at home – and in rather close company – in the shadow of the increasingly objectified, impersonal culture outside. Simmel described this process as "the atrophy of individual culture, through the hypertrophy of objective culture." Thus, people were becoming increasingly estranged, not only from the larger cultural milieu, but from "the more intimate aspects of our daily life."[54] Although Charcot believed that most mental disorders possessed an anatomical origin, he did come to believe, with Simmel and others, that the fin-de-siècle populace was reacting with remarkable psychological consistency to the deepening sense of alienation within the modern metropolis. Agoraphobia and claustrophobia alternated as two interdependent facets of modern spatial fear. In 1878, a physician named Legrand de Saulle told a story that exemplified the new "peur des espaces" that he had identified. A certain Madame B "couldn't cross large boulevards or empty squares. . . . Once indoors she was never able to look out of the window onto the courtyard; she filled her rooms with furniture, pictures, statuettes and old tapestries to reduce their spaciousness . . . the void alone frightened her."[55] Another physician, Gilles de la Tourette, described the "neurasthenic vertigo" of the age in explicitly pictorial terms that resonate with the variegated effect of Vuillard's painted wall. A female patient of his with agoraphobia had "a sensation of cerebral emptiness accompanied by a weakness of the lower limbs." Her discomfort was expressed through distorted visual perceptions: "A veil spreads before the eyes, everything is grey and leaden; the visual field is full of black spots, flying patches, close or distant objects are confused on the same plane."[56]

The Second Skin

"Subjective space surrounds us like an envelope, like a second skin," psychoanalyst Arnaud Lévy once wrote: "The notions of front and behind, of right and left, are attached to it."[57] Marie's relation to the encroaching wall in *Mother and Sister of the Artist* is one of the most haunting aspects of the painting. The aggregate of Marie's figure and the wall surrounding her would seem to constitute just such a "second skin." Indeed, skin, wallpaper, hair, and

fabric are linked through increments that visualize Vuillard's own testimony that "art is connection."[58] Marie seems ensnared like a delicate but gawky bird. The surface around her teems with life, while she appears enervated, transfixed – as if her vitality were being sapped by and dispersed into the gyrating strokes around her. These erratic-seeming but deliberate marks of paint impart a sense that the displacement of life is taking place before our eyes. The illusion is heightened by the fact that Marie's left hand is rendered in the same light ochre as the surrounding pattern. Her left arm is bent up and back, as if it has penetrated the wall surface. I will consider the structural manipulations of Marie's anatomy more fully below. For now, I want to concentrate on the significance of the connections and tensions that are generated across the surface of the painting.

In addition to the parity of tone between Marie's left hand and the colors of the wall, her face is painted in shades of a slightly acidic white-green, much like the hues that radiate around her head. Likewise, her hair is constructed out of the same dark greens and siennas that dominate the wall surface. Daubs of the same ochre that Vuillard uses for Marie's left hand are repeated inside the crook of Madame Vuillard's arm. As a formal device, these strokes of bright paint compel the eye to scan the space between mother and daughter repeatedly, reimagining with every glance the shifting boundaries between body and place, boundaries that both strain and define the integrity of the surface.

In her work on ornament and poetry, Rae Beth Gordon identifies what she calls an "Arcimboldo effect" that is found in both fin-de-siècle verse (particularly in that of Vuillard's friend Stephen Mallarmé) and decoration. One sees both the constituent parts and the whole at the same time. Both images are recoverable through a process of "unconscious scanning" – an activity not unlike the one Vuillard set into motion when he gazed about his room one morning, only to have his reverie arrested when his mother suddenly pierced the visual field.[59] In *Mother and Sister of the Artist,* Marie's figure likewise oscillates between resistance and submission to her surroundings. She is both part of the agitated strokes of wallpaper that press around her form and distinct from them. Only her head, a rather well-formed oval, projects out from the wall, as if she is straining to leave behind both her body and the setting that has compromised its autonomy. This formal tension may have captured a biographical fact: Marie was about to marry and thus to leave the family interior.

Unlike those seen in the decorative painting that Denis, Ranson, and Sérusier produced during these years, Vuillard's paint strokes do not effect a seamless transition between figure and ground, a tension-free marriage of equals. Instead he paints a contested topography in which the very limits of the self come under pressure. The body is both delimited and dispersed through paint, a subject/object extended materially into a space that, again, both constricts and refuses to contain it. In Marie's figure, in particular, limits are repeatedly marked and then just as quickly denied. The narrow green column of

her dress – whose integrity as a container is compromised by the presence of the same deep red, browns, and ochres that make up the wallpaper – is gridded by a lattice of yellow squares and white-gold daubs that mark points of intersection. The grid flattens Marie's figure and presses it directly to the wall. Yet it also marks out her body as distinct. She is clearly "a living person," even though the status of her vitality is in doubt. A slash of black paint running up the right side of her dress makes the same point. Unexpectedly, Marie's figure casts a faint shadow. It floats over the wall beside her, more like an accompanying shade than an affirmation that her body is present in space.[60]

Animism and Emptiness

Marie's already equivocal vitality is peremptorily superseded by that of the bureau, which is treated more like a living form than either of the human figures. This oversized bureau belongs in the company of Guy de Maupassant's ambulatory furniture. The author's armchair "went waddling out into the garden one day," or so he claimed, followed by the "low sofas dragging themselves like crocodiles on their short legs."[61] The animism of objects is generally considered a primitive notion, but Scarry believes that the practice is far more common, part of many people's attempt to make the world appear sentient. Scarry writes, "Perhaps no one who attends closely to artifacts is wholly free of the suspicion that they are, though not animate, not quite inanimate." She cites Karl Marx's repeated attribution of the "aliveness" of economic objects, even as he railed against their animism and susceptibility to fetishism. Scarry concludes, "Just as persons are not locked into the private boundaries of fixed sentient attributes, so made objects are not locked into the concrete boundaries of their sensuous attributes."[62]

Similar assumptions colored many 1890s innovations in stage design. Beginning around 1880, the furnishings of the mise-en-scène had begun to assume an importance equivalent to that of the living actors. A new journal called the *Metteur-en-scène* emerged, a tribute to the newly elevated stage designer (a person distinguished from director or actor for the first time) and an affirmation of the expressive agency of the set.[63] Detailed drawings laid out exact locations and explained how and why they were crucial to the meaning and effect of the performance. André Antoine of the Théâtre Libre, the director who spearheaded this development, believed that the objects on the stage were potentially "more human, more intense, more animated in their postures and gestures."[64] As we shall see below, this emphasis on a vivified setting would generate some perplexing dilemmas for the live performers. For example, how does an actor maintain his or her own agency when gestures, pace of speech, and range of motion across the stage are largely subordinated to the demands of an allover, expressive setting?

A similar question could be posed about Marie Vuillard and the restless paint strokes that surround her. Their density, scale, and liveliness seem born of a *horror vacui:* an agitated act of space-filling done to combat the fear of nothingness. In this case, however, signs of nothingness are directly adjacent to what is *present*, for each stroke vibrates in an ether of space. This is no densely woven "tapestry" of color (a phrase that can be applied more accurately to Vuillard's later large panel paintings). Instead, these brushstrokes of lozenge and comma shapes never cohere enough to mask the blankness of the (originally) unvarnished canvas beneath – a "paradoxical interplay between ornamental overburdening and nothingness."[65] Like Mallarmé's intricate prose, Vuillard's wall marries surface to void. "Outside" is continuous with "inside," a duality of presence that distinguishes his human characters as well. *Mother and Sister of the Artist* seems not so much about the relative strength or weakness of boundaries (the question appears beside the point here), but about the fear of *non*containment, of *no* boundaries. Vuillard asks: what is the shape, and the fate, of the insecurely bounded self – of what has come to be called the "decentered" subject?[66]

Perhaps unexpectedly, this same question is posed by the figure of Madame Vuillard as well, although initially the breadth of her body and the masculinity of the pose seem calculated to defy both dissolution and encroachment. Yet unsettling nuances are revealed by a raking light. Some of these discoveries are benign: the thin, dark lines discernible within the apparently uniform opacity of the dress, for instance. These describe the bodice and collar of a mutton-sleeved, close-fitting dress top. This is not the kind of dress that Madame Vuillard would have worn for everyday work, but rather for an occasion – a visit, a funeral, or a ceremonial meal. The discarded dish, napkin, and wine bottle on the right suggest the last event. In fact, both Madame Vuillard and Marie are dressed, not for the intimate life of the interior, but for those who observe that life from without – a self-conscious address to the audience beyond the interior, an exchange that is reenacted by every beholder of the painting. Spectators are met by two rather reluctant hosts: one seems formidably unapproachable, while the other seems to anticipate in her very body the strain of the imminent encounter.

Costume plays a critical role in this work. The dresses worn obviously denote their owners' respective social status and age, but they also determine each woman's bodily relation to her immediate setting. Marie's unstably patterned form is nearly embedded in the wall, while her mother's discrete figure sits apart from the invasive surfaces around it. It seems that the daughter's collapse backward into the wall could continue indefinitely, but the figure of the mother arrests the beholder's gaze. Marie's posture is difficult for the spectator to behold (although arguably easier to empathize with), because there is no logical explanation for a contraction that is stilled but not concluded. On the other hand, Madame Vuillard's black silhouette resembles an expanse of sheet

metal, disallowing spatial projection and deflecting vulnerability, not only of the mother herself, but of the familial interior she commands. Her centrality, along with the rigid black baseboard that connects her body to Marie's, dramatize her as an origin. Vuillard's mother, his "muse," is the origin of the interior's perspective and thus, by extension, of her son's art. But she is also the biological origin of the daughter who hovers beside her and the son who stood apart to paint them both.

Madame Vuillard's indomitability would seem to be unchallenged. But when Vuillard paints his mother's flesh and hair, signs of vulnerability surface. Her hands are almost pink; they seem vital, if aged. But they are laid down in a corrugated impasto that implies decay. The small finger of her right hand is bent – possibly an allusion to the arthritis that was the common lot of any seamstress. Madame Vuillard's hair, rendered in tones of white, gray, and brown, is parted severely; her ears protrude and their interiors are tinged with red. Most disturbing is her face, which Vuillard renders as a mask. Rimmed with lines of gray and brown, it is separated from the rest of her body. Such an act of visual isolation might lead the viewer to anticipate a face with an uncommon clarity of focus. Instead, there is virtually no expression to be found in Madame Vuillard's visage. In fact, there is barely a face at all.

A waxy coat of ivory paint floats eerily over a black underdrawing of Madame Vuillard's features, giving the impression that we are glimpsing skin and bone at the same time. Even the scratchy black lines that do appear to penetrate the surface layer are indistinct. The acuity we might expect to find in Madame Vuillard's eyes – given the aggressiveness of her posture – is absent. Her gaze is unavailable to the beholder; it may be present somewhere, but it is veiled. And the veil of ivory paint is tantalizingly incomplete: raw canvas surrounds the alabaster patches of "face" and the scratchy black lines of "structure." Surface cohesion is compromised, as it is in the wall. Fragmentary layers are sedimented over other layers even less complete; the effect is a bit like a skull floating *over* the ears and hair.[67] Because the hulking bureau is *behind* her (and thus, *behind* her face), the absence of form is disorienting. Vuillard aged his mother; she was in her early fifties when he painted her to look around seventy years old. She would live in good health with her son for another thirty-four years. But in *Mother and Sister of the Artist,* Madame Vuillard is both a figure of uncommonly vivid force and a specter of death.[68]

Performances

Masking and mime are instruments of performance, and in *Mother and Sister of the Artist* they simultaneously define Madame Vuillard and distance her from the beholder. If there is an essential self there, it is irretrievable. Her gaze is too diffuse to be revealing, and the absence of her face is the counterpoint to

37. Edouard Vuillard, *Woman Sweeping,* 1892. Washington, D.C., The Phillips Collection. Acquired 1939. Photo: Courtesy The Phillips Collection

her daughter's not-quite-present body. But Madame Vuillard's role within this space is quite clear, for, to invoke anthropologist Paul Connerton's remark, as I did in the last chapter, "much of the choreography of authority is expressed through the body."[69] This notion had a particular resonance in 1890s Paris in a population made anxious by the potentially subversive force of womanly authority.[70]

In the year before Vuillard painted this double portrait, a writer named Charles Hacks produced a book called *Le Geste* (Paris, 1892). Hacks made the rather startling assertion that gender, age, authority, or sexuality could all be *enacted* through gesture. It is a short leap from the conclusions – if not the reasoning – of this fin-de-siècle "semiologist" (as he called himself) to the present-day view that gender and sexuality are fluid rather than fixed, socially constructed rather than biologically ordained. Hacks railed against what he perceived as a decline in the fluency, the force, and the authenticity of gesture in French society. The most grievous offenders, Hacks contended, were sexually active, middle-class women. In his view, they paraded shamelessly around the boulevards of Paris and through its bourgeois drawing rooms using false, "hysterical" gestures. According to Hacks, malign social training was aided and abetted by the corsets these women wore. The only solution was old age, Hacks proclaimed. Not until a woman set aside her corset and her feminine wiles could she become what he called "a hermaphrodite of gesture," a hybrid of the masculine and the feminine.[71]

38. Edouard Vuillard, *Mother and Sister of the Artist*, 1892. Collection S

Madame Vuillard's masculinized authority is performed only in the presence of her daughter.[72] When alone, as in *Woman Sweeping* (1892) (Fig. 37), she is a benign, self-absorbed presence. But in paintings such as *Mother and Sister of the Artist* (1892) (Fig. 38) and *The Dressmakers* (ca. 1892) (Fig. 39), Marie seems positively reduced by the assertive presence of her mother, as if only one female family member could flourish at a time. Is this the only way to understand Marie's posture in *Mother and Sister of the Artist* – as a sign of her submission to her mother's authority? Does the retrieval of the wilted flower function as a sign of her barely evaded spinsterhood? The familial strains that shape a person's character are undoubtedly suggested here, but Marie's figure also has a more general meaning that is inseparable from the larger concerns of fin-de-siècle culture. Her compromised bodily presence tests the very limits of female subjecthood, at a time when female *object*hood was much in evidence. Critic Camille Mauclair described the woman who sat for a portrait as a "tabula rasa. She waits, like a blank page," he continued, "so that the sensibility of the man can inscribe its dreams there upon her."[73] The objectification of the female body was fundamental to the overall integration of decorative painting, and it was also the presumption that underpinned social critics' pro-

39. Edouard Vuillard, *The Dressmakers*, 1892. Private collection of Jane Forbes Clark, New York

motion of women as "artificers of the interior." In this period of fluctuation from subject to object, Marie preserves traits of both. A parallel expression emerged at the Théâtre de l'Oeuvre, in which objectified figures vied with enlivened settings. New conceptions about the agency of the female actor – in life as well as art – illuminate some of the undeniable oddities of Marie's figure.

The Subject as Object: Body Parts

Marie's disjunct body parts, contracted posture, splayed hands, bobbing head, and lack of fleshiness are not unlike the features of a puppet. In the early 1890s, the Théâtre de l'Oeuvre, with Vuillard as both *metteur-en-scène* and playbill designer, staged a series of plays written explicitly for marionettes. Maurice Maeterlinck, the Belgian playwright who was most identified with Lugné-Poe's theater, outspokenly preferred marionettes to their human counterparts. As Bettina Knapp has explained: "Maeterlinck felt that human actors, because they were restricted by their physical characteristics, were not appropriate vehicles to portray the archetypal figures with which he peopled his stage. Since wooden dolls were complex and ambiguous forces, they infused a super- or extrahuman dimension into the stage happenings."[74]

Vuillard was also an active participant in the world of avant-garde puppetry. With Pierre Bonnard, Ranson, Roussel, and Sérusier, he collaborated in a

puppet theater staged at Ranson's studio. The art of puppetry was appealing to artists and writers associated with the Symbolist circle, not only because of its identification with the naive and the childlike, but also because the puppet offered a generalized, universal type of figure unfettered by the idiosyncrasies of individual psychology. While the Nabis enjoyed shadow puppets at the Chat Noir Café, at Ranson's studio the marionette was the chosen vehicle of expression; its multiple articulated joints offered the most suggestive surrogate for the human figure. The "sculptor Nabi," George Lacombe, carved the marionettes' wooden heads; Denis made their costumes; Ranson wrote the plays; and Sérusier and Vuillard made the sets. This relatively informal enterprise would later develop into the more ambitious "Théâtre de Pantins," for which puppet plays were staged at the apartment of poet Claude Terrasse. This improvised "theater," large enough for only a handful of spectators, was decorated by Vuillard himself.[75]

Perhaps even more relevant to Marie in *Mother and Sister of the Artist* is the fact that the Théâtre de l'Oeuvre became known for productions in which actors performed *as if* they were puppets (critics dubbed it the "théâtre des poupées").[76] Actors' movements were stilted, constrained, and enigmatic; their speech was slow, incantatory, and poetic. These mysterious effects were orchestrated in the service of an acute subjectivism with an ambiguous relationship to the audience. On one hand, viewers were drawn in by the atmospheric effects used by stage designers such as Vuillard, who depended on minimal furnishings, generalized costumes, dim lighting, and the use of colored gauze scrims. At the same time, however, the audience was distanced by the hermetic speech and robotic, self-reflexive gestures of the actors. As actors became perceptually fused to the nearly abstract, atmospheric setting, they grew successively more remote psychologically from the audience.

For years, productions at a variety of theaters had concentrated on eliciting the empathy of the audience with postures and movements that revealed the characters' motivations and states of mind. Stage settings generally located the status and aspirations of their fictive inhabitants without much ambiguity.[77] In the early 1890s, however, audiences were asked to respond to the effects of an abstractly expressive atmosphere, elliptical narratives, and solipsistic gestures. The intent of much Symbolist theater was to create an aesthetics of indirection. The idea was that meaning was never enunciated or indicated directly, but insinuated through allusion and association.

The Théâtre de l'Oeuvre

Aurélien Lugné-Poe, an old school friend of Vuillard's, was the founder of the Théâtre de l'Oeuvre. As an actor and apprentice at Antoine's Théâtre Libre, Lugné had been steeped in the expressivity of the mise-en-scène and was accus-

tomed to treating the stage set as a virtually animate entity that should be fully integrated with living actors.[78] Lugné conceded that there were perils to such an approach. Critics of Antoine's theater thought the director had gone too far in his quest to elevate the importance of the mise-en-scène. The commitment to fidelity ultimately resulted in a surfeit of details that was distracting, rather than revealing, to the audience.

Theater critics such as Louis Becq de Fouquières demanded a change. Becq believed that the key lay in abolishing conventional stage perspective. He advocated a generalized, perspectiveless decor into which figures could be fluidly integrated, a suggestion that is reminiscent of Lecoq de Boisbaudran's advocacy of a "perspective of feeling."[79] Pierre Quillard, another playwright and critic eager for change, defined an idealist decor in explicitly painterly terms: "The decor should be a pure ornamental fiction which completes the illusion through analogies of color and line with the drama."[80] Quillard's statement became a prescription for the idealist stage setting. Details were suppressed for the sake of broad, diffuse effects. Boundaries between actors and settings were deemphasized and, in some cases, deliberately confounded. Individuality of parts was downplayed to construct a unified whole.

Vuillard's 1894 stage design for Henri Régnier's poem-play *La Gardienne* exemplified the new theatrical ideal. At the beginning of the performance, the stage was empty. When the actors appeared, they were seen by the audience through a greenish gauze scrim, which was stretched along the rim of the stage. The performers gestured slowly and stiltedly as the text of Régnier's poem was enunciated – out of synch – by other actors who were secreted in the orchestra pit. Detached from the text, and thus from their customary narrative function, the actors' gestures became nearly opaque.[81] Many critics were outraged and cast the perceived shortcomings in painterly terms: "You have seen the portraits by painters of the new schools, where the figures exhibit no contours, where everything is hazy, as in a fog. Here, when the curtain rose, a transparent greenish gauze covered everything, and so [actors] appeared as shadows moving about and carrying on in the haze. This is purely bizarre."[82]

Surfaces of Existence

The theatrical scrim Vuillard installed for Régnier's *La Gardienne* performed an analogous function to the wall he painted in *Mother and Sister of the Artist*: both are mediating, flexible surfaces that connect disparate parts, nearly dissolving the physical and affective boundaries between them. Both function as fragile screens that divide inside from outside. In Vuillard's painting, private interiority is just barely protected from the outer world. In the theater, the scrim – which is neither opaque nor entirely transparent – acts as an intervening layer between the audience and the accessible, but nonetheless interior,

space of the stage. The division is an ambiguous "fourth wall" materialized by the scrim's presence but subverted by its penetrability.

The veil was a key symbolic figure in the late nineteenth century. Mallarmé, a proponent of both idealist theater and contemporary dance, believed that the luminous colored veils that Loie Fuller used in her choreography symbolized the very interior of her body – specifically, its uterine cavities – drawn out and staged as a spectacle of female embodment. Mallarmé explained that in manipulating her colored veils Fuller was effectively merging female interiority with the space of the stage. She contained that space, Mallarmé believed, "comme son expansion." Felicia McCarren has argued that Fuller's performance links her dancing directly to Charcot's staged performances of the hysterical body during the celebrated "Tuesday lectures" at the Salpêtrière Hospital.[83] As we shall see, Charcot's need to visualize internal disfunction through corporeal disorder is relevant to Vuillard's figurations.

Loie Fuller's veils were an idiosyncratic and highly aestheticized example of a broader paradigm. In the nineteenth century, the veil became a figure for the imagining of scientific, and, in particular, anatomical knowledge. Michel Foucault labeled this the "invisible visible." "Knowledge *develops* in accordance with a whole interplay of *envelopes,*" Foucault wrote; "the hidden element takes on the form and rhythm of the hidden content, which means that, like a *veil,* it is *transparent.*"[84] In other words, the knowing doctor's gaze veritably dissolved (or rendered "invisible") layers of skin and muscle, so that he could see *through* to the anatomy effectively concealed. Think again of Madame Vuillard's face in *Mother and Sister of the Artist*, in which her son seems to conjoin the visible and the invisible, with the exposed canvas marking a rupture in the veil. The partialized veil that Vuillard paints as his mother's face could also function as a sign of his own agency in making a vision of the woman who made him. This is in keeping with Elaine Scarry's notion that the veil can act as a figure of imagination itself. She points out that "our imagined gauze more closely approximates actually perceived gauze than our imagined wall resembles an actually perceived wall." Gauze even looks like a ghost or spirit, its materiality is so reduced.[85]

The Théâtre de l'Oeuvre's repertoire was replete with plays that addressed the unconscious, the irrational, or the simply mysterious. During Vuillard's tenure there, the stage was often populated by ghosts, spirits, demons, and doubles. In Maeterlinck's *Intruder,* which Vuillard both staged and represented, the presence of death is perceived only by a family's aging blind grandfather.[86] In Maurice Beauborg's poem-play *L'Image,* a man falls in love with the spectral double of his new wife and murders the latter in order to be alone with the former. Maeterlinck's *Interior* (also known as *On the Inside*) – a play originally conceived for marionettes – was set in one room that was visible to the audience only through a layer of glass, establishing a mutual sense of entrapment for both actors and audience.[87]

Interior's schematic plot revolves around a family that has just lost one of its daughters by drowning; she is a likely suicide. As the play begins, the girl's body is being carried toward the family's house by the townspeople who found her. The family is not aware of what awaits them. The bearers stop on a rise to look down upon the mother, father, and remaining daughter inside the enclosed, illuminated space of the title. These stilled figures utter the play's rudimentary dialogue, while the mother, father, and sister they gaze upon are the only figures who move – albeit nearly imperceptibly. They gesture and speak with great gravity, "spiritualized by distance."[88] The stilted acting style favored in these plays was not intended to reveal a narrative, but to signal the presence and the potency of the unconscious. Within this context, the actors were not charged with telling a story. Instead, they were archetypes, "primordial images arising from the profoundest layers of man's unconscious."[89]

During the one-act play, a character named The Old Man describes the family's condition to another called The Stranger. He observes that the family has too much faith in its safety simply because a layer of glass separates them from the outside world: "they think that nothing will happen because they have closed the doors and they do not know that it is in the soul that things happen and that the world does not end at the doors to their house. . . . They have the look of lifeless dolls [or puppets, *poupées immobiles*] and yet so many things are taking place in their souls."[90] The Old Man's words sum up not only the effect of Maeterlinck's short play but the hermetic world of Vuillard's family interior.

The Autistic Gesture

Until the early 1890s, actors had relied on a roster of fairly predictable gestures that had been codified explicitly for them. These were collected first in the *Académie Traites d'Expression,* and were later modified and expanded by the acting teacher François Delsarte.[91] Delsarte believed that the truest gestures was the "wise gesture," because it provided an accurate reflection of "that newly furnished entity, the self."[92] In contrast, the gestures favored in the productions staged at the Théâtre de l'Oeuvre were designed to confound transparency of meaning as well as to call into question the unitary nature of the self. Their provocative oddness called attention to the body as a vehicle for conveying a variety of selves. "Self" could not be communicated directly or through a single image. Identity itself was a representation.[93]

Even Hendrik Ibsen's plays – perhaps the most "narrative" of those staged at the Théâtre de l'Oeuvre – generated a new roster of nontraditional gestures, suitable for conveying an assortment of familial and sexual tensions.[94] Ibsen's psychologically rich but minimally eventful plays effectively introduced a new

40. Edouard Vuillard, *The Window,* ca. 1893. New York, Museum of Modern Art. The William S. Paley Collection. Photo: © 1995, The Museum of Modern Art

kind of content into French theater and demanded a new array of gestures to convey, for example, emotional isolation, contempt, anxiety, sexual frustration, and rage. Theater historian Gay Gibson Cima has characterized the kind of movement that was used in Ibsen's plays as the "autistic gesture . . . a subtle

41. Edouard Vuillard, *An Outspoken Dinner Party (Le Dîner Vert),* ca. 1891. Private collection

visual sign of the character's soliloquy
with herself or himself." This added
an additional layer of self-conscious-
ness to the actors' thinking. They
were now aware not only of their
own selves and the characters they
were realizing on the stage; they were
also aware of the *role* being played by
the character.[95] The autistic gesture
that consolidated this treble con-
sciousness was usually something
subtle: a strained way of holding the
body, a slightly asymmetric posture,
an unexpected tilt of the head, or an
unusual movement of the limbs. At
other times, perfectly recognizable
kinds of movements – walking, rising
from a chair, motioning to another
character – were slowed down to
near-imperceptibility, or executed so
stiltedly that they assumed the aspect
of ritual.

42. Edouard Vuillard, *Marie by the Mirror*,
ca. 1892. Private collection

 Marie Vuillard's gesture in *Mother
and Sister of the Artist* could be char-
acterized as "autistic." Her posture is inchoate. For all the possible anecdotal
or psychological explanations, her contraction ultimately demands a different
kind of framework for understanding. Its contrived unnaturalness is consistent
with a variety of representations Vuillard made of his sister during these years.
The poses he chose for her in a series of paintings made between 1890 and
1895 are often too strained and provocative to be simply realistic. Yet they are
too opaque and self-reflexive to admit of easy interpretation. Consider, for ex-
ample, the asymmetric contraction, wrenched head, and slackly hanging left
arm of Marie's figure in *The Dressmakers* (Fig. 39); the overly flexed neck and
flaccid arm in *Marie by the Door* (1891; private collection); and the twice-
twisted figure in *Window* (ca. 1893) (Fig. 40), in which Marie's body seems to
double back upon itself for no apparent reason. There is also the exaggerated
ingratiation of *The Outspoken Dinner Party* (ca. 1891) (Fig. 41); and the un-
gainly hands and floating arms of *Marie by the Mirror* (Fig. 42). These ges-
tures are certainly *related* to conventional bodily movements. The upraised
arms of the last image are not completely unlike the gestures of a woman
about to tend to her hair. However, the point of suspension is awkward, as is
the absence of a reflecting surface, concentrating attention on the visceral
strain of a body arrested rather than at rest.

Staging Hysteria

Gestures very much like those Marie displays in the paintings listed above were being performed not only at the Théâtre de l'Oeuvre but at the amphitheater of the Hospital Salpêtrière, under the direction of Charcot. His Tuesday lectures featured live demonstrations by hypnotized patients. These forums for the display of Charcot's theories about the corporeal signs of neurological (and sexual) disorders captivated "tout Paris," for the audience was filled, not only with physicians and neurologists, but also with writers and artists. Edmond de Goncourt, for instance, attended them religiously to extract empirical data for his fiction. Despite the class differences between Charcot's mostly working-class patients and Goncourt's own rarefied social circle, the writer continued to believe that the aberrant gestures he witnessed at Salpêtrière were simply more concentrated and extreme versions of the "hysterical" comportment he observed every day on the streets and in the drawing rooms of Paris.[96]

On the stage of the Salpêtrière amphitheater, patients "performed" the postures of their particular neurological disorders: "the asymmetry of the features in facial paralysis; the different walks of the patients with bodily paralysis; the contraction and frozen stiffness of Parkinson's patients; the grimaces of chorea, the gesticulations of those with uncontrollable tics, and all the varieties of trembling."[97] This description by Henri Miege suggests that patients were consigned to an identity suspended somewhere between human individual in distress and performing automaton or, to put it another way, between subject and object.

This stance of objectification was especially directed toward Charcot's hysterical patients, who attracted the most attention. These women presented a troubling challenge to the neurologist. Their symptoms were bewilderingly varied and complex, without apparent anatomical origin – other than the general, largely prejudicial association with the uterus, a connection that Freud would later theorize to different effect.[98] Charcot would "guide" his patients through the various stages of hypnosis, from lethargy, to catalepsy, and then to somnambulism. A cataleptic patient would sometimes appear frozen in an incongruous asymmetric posture, with arms awkwardly upraised, much like Marie Vuillard's position in *Marie by the Mirror* (Fig. 42). In the last stage, freedom of movement was supposedly restored to patients whose limbs had been contracted or paralyzed before hypnosis. Patients would be asked to act out an emotion or carry out an action about which they claimed to have no memory later. For Charcot, this lapse testified to a disassociation of personality, a splitting and externalization of states of consciousness normally coordinated and controlled. Not surprisingly, the authenticity of these performances was challenged repeatedly, and Charcot was compelled to respond to his critics at length. Doubt persisted because so many of the patients' gestures were

recognizable as conventional theatrical poses.[99] It was as if the affect of hysteria was ratified through performance, rather than the other way around.[100]

Some social critics saw evidence of hysteria everywhere in middle-class culture. According to Charles Hacks's *Le Geste*, it was the disease of the age, middle-class women being its principal actors. Others – Huysmans, for example – embraced hysteria as a revitalizing force for their art. The hysteric subverted the usual paradigms of feminine behavior. She is, Gordon writes, "all uncontrollable movement, threatening to destroy all that surrounds her, even herself. Her contorted poses and facial grimaces are ugly and ridicule the commonly received concept of female beauty. Then she freezes in a cataleptic pose that is a hyperbolic comment on this concept and role."[101]

Marie Vuillard's bodily configuration offers another "hyperbolic" refutation of her era's conventions of feminine display. Her brother has deprived her form of nearly all signs of female sexuality: she is hipless and waistless, and her torso is compressed so radically as to be nearly absent. The faint signs of feminine identity that Vuillard has preserved – Marie's patterned dress and pinned-up hair – vie with the sensation that her bodily presence seems more object-like than human. Like a marionette, she moves under another's control.[102]

The same equivocal treatment surfaces in the photographs that Charcot published in his journal *Nouvelle Iconographie Photographique de la Salpêtrière*, founded in 1887.[103] In the photography studio at the Salpêtrière, patients were photographed while demonstrating the rigid affect of agitated paralysis; the slack, floating limbs and disoriented gaze identified with hysteria; and the uncomfortably bent spine of Parkinson's disease. Many of Charcot's patients – particularly those with arms upraised – seem to perform like marionettes. Their arms move as if they have been hoisted by invisible strings, or, alternatively, as if they have collapsed as the strings slackened. The much touted freedom of movement that hypnosis was supposed to restore to the hysterical patient was accessible only through the doctor's intervention.

Inside on the Outside: Seeing through the Body

The similarities between some of the *Nouvelle Iconographie* photographs and a number of Vuillard's representations of both his sister and his mother are striking. This is not to say that the artist used such images as sources, but rather that both figured the woman as a performing object whose inner workings were represented on the surface of the body. For example, in Vuillard's *The Dressmakers* (Fig. 39), Marie leans toward her mother in a bodily contraction that is both asymmetric and unstable – a shorthand for internal distress, perhaps, and a posture that Charcot had associated with both hysteria and Parkinson's disease (Fig. 43). Even more startling is a comparison between

43. "Attitude anormale simulant un torticolis dans la maladie de Parkinson" (Abnormal posture simulating stiffness in Parkinson's disease). From *Nouvelle Iconographie Photographique de la Salpêtrière*, no. 5 (1892), plates xxvi, xxvii, and xxviii

44. "Attitude anormale dans la paralysie agitante" (Abnormal posture in agitated paralysis). From *Nouvelle Iconographie Photographique de la Salpêtrière*, no. 2 (1889), plate xxix.

Madame Vuillard's figure in this painting and the Salpêtrière photograph of a woman with agitated paralysis (Fig. 44). Madame Vuillard's stolid, contained silhouette possesses exactly the same rigid immobility and drawn-back head of the patient, whose symptoms were generally confined to those "advanced in age" and may have been caused either by "1st, damp cold, such as arising from a prolonged sojourn in a badly-ventilated apartment, or 2nd, acute moral emotions."[104] Marie's figure in *Marie by the Mirror* (Fig. 42) could be an averted stance of a woman in a cataleptic state, her arms floating incongruously in the air (Figs. 45 and 46), and *Marie by the Door* (1891; private collection) is fixed in the same graceless spinal curve that Charcot identified as the key trope for neurological disorder.[105]

Vuillard may not have represented the depth of personality through three-dimensional illusionism, but he did preserve references to the

45. "Mélancolie cataleptique" (Cataleptic melancholia). From *Nouvelle Iconographie de la Salpêtrière*, vol. 2 (1889), plate ix

46. "Etat cataleptique" (Cataleptic state). From Jean-Martin Charcot, *Oeuvres Complètes* (Paris, 1895), plate xii

body's internal structure. In *Mother and Sister of the Artist*, Marie seems an ever-adjustable marionette whose rigid parts have been strung together to compose an unstable whole. The constricted limbs, splayed hands, and compressed torso suggest that there is an armature – however fragile or distorted – beneath the near-rigid surface of the fabric, an awkward marriage of structure and encasement much like the actual constitution of a marionette.[106] Marie's feet are almost entirely retracted; she appears to skim the surface of the floor. Her body inhabits space only provisionally; she could be yanked up and away at any moment were it not for the window ledge that presses down on her so oppressively. A similar kind of manipulation is at work in the upraised arms of *Marie by the Mirror* (Fig. 42) and in *Marie by the Door* (1891; private collection), in which the rigid curve of her head, neck, and shoulders, and the pliant droop of her arms, make her resemble a puppet whose strings have been loosened abruptly and are about to drop.

Marie is not a puppet, however. She is a hybrid: a recognizably human figure whose body has the awkwardness, the insubstantiality, and the uncanniness of a puppet's.[107] In his essay *The Uncanny*, Freud analyzed the enigmatic

power of Olympia, the lifelike mechanical doll of E. T. A. Hoffman's *Sandman*. His remarks were based on the 1906 writings of Ernst Jentsch, for whom the puppet raised "doubts [about] whether an apparently animate being is really alive; or conversely, whether a lifeless object might not be in fact animate."[108] (Later, Walter Benjamin would go so far as to insist that the automaton Olympia was the ideal Art Nouveau woman.)[109] The questions that Jentsch posed are anticipated by the figure of Marie Vuillard: is she an object or a subject?

Puppets are "subject[s] without interiority," according to Kenneth Gross. "Their capacity for abstractly symbolic gesture runs alongside a relentless materiality."[110] The same is true for Marie. She is a subject with a nearly voided corporeal presence, and she is also an uncannily animated object. The historian and theorist of puppetry, Steve Tillis, claims that the distinction between puppet and human is often more unstable than one might expect. He contends that "the puppet is perceived to be an object, while imagined to have life. The puppet as metaphor of humanity, however, is predicated on an inversion of this formulation. In the metaphorical sense, people are perceived by other people to have life, while, at the same time, they are imagined to be but objects."[111]

Tillis suggests that the marionette has always inspired in the viewer a kind of "double vision." The viewer is well aware that the puppet is "only an object, yet he or she nonetheless projects human emotions onto it." As Tillis writes: "The puppet is and is not that which it seems to be . . . the audience's acknowledgment of the puppet, through perception and imagination, sets up a conflict between the puppet as object and as life. What may be called the ontological status of the puppet is always within the margin of doubt; its place in that margin is its most distinctive characteristic."[112] This equivocation also describes Vuillard's relation to his sister and mother. Objecthood and life came together in these figures. Madame and Mademoiselle Vuillard were cherished members of the artist's intimate life. Yet they were the principal materials of his art.

Conclusion: Identity Is a Representation

If identity is itself a representation, to paraphrase the prescient words of Alfred Fouillée in 1892, then Vuillard made the claustrophobic space of his family interior a character in that performance.[113] He wove together a "surface of existence" that conjoins self and setting but leaves the seams showing. In fact, Vuillard made a positive virtue of the discontinuities, ruptures, and ill-fitting joins that occur, inevitably, when a conceptual or psychological fusion becomes a pictorial one – when body and space become figure and ground. In our post-Freudian age, repression is said to be the hallmark of the domestic in-

terior. But Vuillard refused to bury anything beneath the surface. Surface is where representation is at its truest, he believed, where layers of self shift unpredictably but revealingly for their various circumstances and audiences.

The decorative painting with which Vuillard was allied emphasized continuity. Ethereal, dematerialized figures seamlessly merged with elegantly designed groves of trees or patterned walls. But Vuillard demanded that we acknowledge the "points of tangency" and recognize that they are negotiated with great effort. *Mother and Sister of the Artist* suggests that a woman who merges too closely with her setting may turn into an object for others' manipulations; that authority can be a pose and a mask; that death comes even to the indomitable. He also suggests that the world outside is never entirely excluded from the world within, but seeps through and unsettles the very walls, inflecting the shape, the comportment, and the economic politics of the interior.

Simmel wrote that modern life "makes us more and more sensitive to the shocks and turmoils which we confront in the immediate proximity and contact with people and things . . . the bodily proximity and confined space makes the mental distance all the more readily visible."[114] Vuillard objectified his subjects and vivified his inanimate settings. Formally, this levels the perceptual field for transformation into paint. But there may be a psychological purpose as well. Perhaps the objectification represents an internal withdrawal that makes claustrophobia endurable. Perhaps the internal barriers that Simmel advocated are incorporated in the very bodies of Madame Vuillard and her daughter, Marie, as Vuillard painted them.

Vuillard's contemporary, Fouillée, warned that unless people "selected and projected the form of [their] own self-materializing, they would be swallowed up in the vast, disordered tumultuous ocean that envelops [them]."[115] Vuillard's interior is an attempt to still, if not finally quiet, that tumult. For all the depersonalization of the objective culture that lurked just beyond this fragile wall, Vuillard seems to tell us that nothing is as strained, constricting, or relentless as the confrontations that are acted out inside.

Chapter Five

Walter Sickert's *Ennui*

Interiority without Self, and Place without Body

Introduction

"Around 1910 a certain space was shattered. It was the space of common sense, of knowledge [*savoir*], of social practice, of political power . . . the space, too, of classical perspective and geometry."[1] Henri Lefebvre's pronouncement may seem unduly precise, but it is widely agreed that in the early years of the twentieth century, social and historical change was inseparable from a shift in the very structures of representation. Indeed, what those structures consisted of, and what they should, and could, convey, were rethought. Lefebvre's remark sets the stage for the end of my story: the end of the idea that interiority could be represented through the phenomenal world, through a body's charged juxtaposition to a domestic interior. That end is also the beginning of a new story, one whose outlines I will sketch only briefly. New structures for understanding, theorizing about, and picturing subjectivity arose, transmuted, out of those which collapsed or grew too attenuated to be useful.

For a variety of reasons both historical and visual, Walter Sickert's painting *Ennui* (Fig. 47 and Plate VIII), made in 1914, the first year of World War I, encapsulates this shift from the end to the beginning. So do the observations made by Virginia Woolf that were inspired by Sickert's painting – her first and only venture into art criticism.[2] Woolf's meditations on the psychological changes wrought by the war led her to fashion a new conception of how the inner life was structured, a conception that depended, still, on the animacy of objects and the need to fashion an architecture of intimacy. The early-twentieth-century reconfiguration of self emerged in a variety of domains: literary, psychoanalytic, artistic, and architectural.[3] *Ennui* is interiority as Sickert imagined – or more precisely, deflected – it, at a time when the interior ceased to be a place – even if a metaphorical place – where the construction of self could be attempted.

47. Walter Sickert, *Ennui*, ca. 1914. London, The Tate Gallery. Presented by the Contemporary Art Society, 1924. Photo: The Tate Gallery, London/Art Resource, N.Y.

Performing the Self

Theater has figured in each of the chapters of this book. It has informed my discussions of the spare realism of Degas's *Interior*, the brightly lit proscenium and dark recesses of Sargent's *The Daughters of Edward Darley Boit,* and the posturings of Vuillard's *Mother and Sister of the Artist.* In these artists' paintings, theatrical staging devices, bodily attitudes, and lighting effects were appropriated as metaphors for the conjectural and potentially treacherous enterprise of representing identity. Sickert, however, invoked the practices and assumptions of the theater far more explicitly. His aim was not to present a variety of partial but authentic selves, as Vuillard had done, but to demonstrate that from the outset the very notion of an authentic identity was misguided. For Sickert, identity was not so much fleeting and conditional as duplicitous at its very foundation. He anticipated Walter Benjamin by several decades in insisting that "The house where man is born, and is married and dies, becomes his theater."4 Benjamin would imagine the interior as a refuge, however, a sanctum where private identity could be enacted with some hope of recognition and response. Sickert entertained no such illusions. To him, life was a performance calculated to conceal. He was obsessed all his working life with the instability and "ultimate uncertainty" of identity and with the futility of the search for revelation. He was, in sum, "perennially fascinated by disguise, by misrecognition, by falsity and by pretense."5 Raconteur, actor, social gadfly, Sickert possessed a larger-than-life persona that revealed very little about his inner self. Jacques-Emile Blanche, an artist friend who was at times the victim of Sickert's mercurial temper, wrote in some frustration that "Sickert's need for utter privacy should offer an explanation, an excuse for his moods, his alibis, his extravaganzas. His smiles and friendliness, his intimacy followed by estrangements, are all like a screen that veils, with amusing images, his proud progress through life."6

Sickert's physical appearance varied widely. One day he might present himself as an elegantly attired, aristocratic dandy, complete with top hat and cane. Months later, he would attend a party with a full beard, wearing red plaid pants, a bottle-green coat, and embroidered Chinese slippers.7 As a boy, Sickert loved to organize family musical performances and dramas. As a young man, he briefly pursued a vocation as a professional actor and won a series of walk-on parts in Henry Irving's company at the Lyceum Theatre in London.8 Although Sickert abandoned the theater as a trade after only two years, it provided him with a lifelong model for transforming his environment every time he painted it and immersing himself in the roles of the characters he represented.

Sickert avoided using his family members or friends as models, except when he was executing a commissioned portrait. He preferred to hire working-class men and women, and seems to have been positively drawn to those with unsavory pasts. "Hubby," who was the model for the male protagonist of *Ennui,*

became an all-purpose factotum for Sickert after having been so deeply entrenched in London's underworld that he was questioned about the serial murders committed by Jack the Ripper. Obsessed with the Ripper himself, Sickert seems to have relished Hubby's notoriety. The artist's widely proclaimed insistence that he had special knowledge of the killer's identity led one writer to declare that Sickert was the "third man" who had lured the criminal's victims to their doom (a theory that is now resoundingly dismissed).[9]

Sickert lived for years in Dieppe, France, where he met and befriended Degas, who represented the younger artist, along with a host of mutual friends, in 1885 (Fig. 48). After periods of travel to Venice, Sickert returned to England in 1907 and settled in Camden Town, a shabby quadrant in northwest London.[10] This unlikely neighborhood of run-down terrace houses, crisscrossed by railroad lines, was for Sickert what Paris had been for the young Degas. It was not Camden Town's streets that intrigued Sickert, however, but its hidden interior spaces. *Ennui* is the most celebrated of his series of Camden Town's sequestered, seedy rooms.

48. Edgar Degas, *Six Friends at Dieppe*, ca. 1885. Pastel. Providence, R.I., Museum of Art, Rhode Island School of Design, Museum Appropriation. *Left to right, top to bottom:* Walter Sickert, Daniel Halévy, Ludovic Halévy, Jacques-Emile Blanche, Henri Gervex, and Albert Cavé

Ennui

In *Ennui* (Fig. 47 and Plate VIII), a man and woman are lodged in the corner of a modestly furnished and unpleasantly colored interior.[11] The man is angled toward the viewer but sits gazing away into space, fingering a cigar. His body leans back from behind a large curving table that appears to swell toward the spectator. There is a large half-filled water glass on the table and a box of matches beside it. In her essay on Sickert, Woolf characterized this preoccu-

pied gentleman as a "publican . . . looking out of his shrewd little pig's eyes at the intolerable wastes of desolation in front of him."[12] A woman – the man's wife, perhaps (she was Hubby's real-life mate, Marie Hayes) – is wedged into the corner behind him, with her body turned away from the room. She slumps over the large bureau that fills the corner, while her elbows prop up her languidly tilted head. The woman's attention seems focused on nothing in particular, although it is difficult to discern her features. A framed picture hangs on the wall before her, and stuffed birds perch beneath a decorative glass dome. The only other decorations are a framed illustration of Queen Victoria, on the wall just to the woman's right, and a cut-glass decanter and a small gilded goblet on a mantle that inch into the painting from the right. These objects do little to alleviate the impression that large expanses of the canvas are blank. "There is a great stretch of silent territory in Sickert's pictures," Woolf once commented.[13] She speculated on the nature of the relationship between the man and woman:

[They] are motionless, of course, but each has been seized in a moment of crisis; it is difficult to look at them and not to invent a plot, to hear what they are saying. . . . It is all over with them, one feels. The accumulated weariness of innumerable days has discharged its burden on them. They are buried under an avalanche of rubbish. . . . The grimness of that situation lies in the fact that there is no crisis; dull minutes are mounting, old matches are accumulating and dirty glasses and dead cigars; still on they must go, up they must get.[14]

Sickert professed to enjoy immensely Woolf's words of praise about the painting's literary qualities, written more than twenty years after the painting was made. It is unlikely, however, that this was the effect he was originally after.[15] Sickert worked intently on enhancing the felt *physicality* of the couple's torpor. Their languor, and the seeming impossibility of prying them away from one another or from their uncongenial setting, is a bodily sensation that is enacted by the protagonists and responded to viscerally by the viewer. The numerous preparatory drawings that Sickert made for *Ennui* – many on gridded paper – confirm that the corporeal tensions within the painting were planned as carefully as those in Degas's *Interior,* a painting Sickert appears to have known well.[16] Like Degas, Sickert believed that a formal relationship between human beings *was* a psychological one. As he put it, "If the subject of a picture could be stated in words there had been no need to paint it."[17]

Background

Sickert's emphasis on the interdependence of figure and setting was undoubtedly encouraged by his early training with Whistler and his friendship with Degas. But embracing the "ensemble" was also a family tradition. Sickert's

mother was a former actress; his father, an illustrator and graphic artist who had studied with Otto Scholderer, one of Lecoq de Boisbaudran's students; the senior Sickert may even have benefited from the attentions of the master himself, according to Jacques-Emile Blanche.[18] Sickert remained deeply interested in Lecoq's theories, and one finds frequent allusions to them in the artist's critical writings. As Lecoq had done in 1847, Sickert praised both deformation and distortion as necessary and desirable signs of "hand-made art."[19] When the younger artist emphasized the importance of what he called the "eye-catch" – the "point of movement [which] includes the outline of something living against its immediate surroundings" – he sounded very much like Lecoq entreating his students to capture the expressive ensemble of their models' passages through the architecture of the Palais de Justice.[20]

Sickert's pronouncements were published in a variety of journals and newspapers for which he wrote as a professional art critic: the *Fortnightly Review*, the *Southport Visitor*, the *Whirlwind*, and *New Age*. He was also a gifted teacher, which was fortunate, because he often depended upon his teaching and literary skills to support himself financially.[21] As a man of letters in his own right, Sickert was welcomed in the Bloomsbury Circle. Consider the generations and temperaments that were spanned when the progeny of a man who knew Lecoq de Boisbaudran shared an evening with Virginia Woolf and Roger Fry.

Sickert's relationship with Roger Fry was not an easy one. He considered Fry's beloved Cézanne "overrated" and never understood why Fry had not included either Vuillard or Bonnard in the 1910 Post-Impressionism exhibition at the Grafton Gallery.[22] Fry may have expressed reservations about his friend's work, but Sickert committed a far greater sin by ignoring Fry's painting. The critic retaliated, insisting that

everything about Walter Sickert has to have the same air of paradox. He is so ingrainedly *frondeur* that since his wit, his talent and above all his taste make him the natural associate of the "libertarians," he, by sheer cussedness, has been driven to become the advocate of prussian discipline, of meaningless dexterity and of Victorian sentimentality, and is thereby eternally condemned to practice no single one of the virtues he preaches.[23]

Although Fry was harsh, he was not wrong to link Sickert's work to an earlier time, for the latter's intense concentration on the interior life coincided with its perceived demise as a respectable and challenging theme for painting. The position of the Realist painter at the turn of the century was an ambiguous one. Working in the polemic-filled years of early abstraction, Sickert was among the last major exponents of a nineteenth-century tradition. Consider the manifestos that were issued between the years 1907 and 1917, the years of Sickert's most important paintings. Malevich, Kandinsky, Mondrian, and Boccioni had all published their revolutionary tracts by 1917.[24] Sickert was

an articulate, often acerbic, apologist for Realism in an era when other avant-garde movements were challenging not only its contemporary relevance but its historical legitimacy. He believed, however, that Realism could easily incorporate the radical developments of modernism – pointillism's high-keyed color, for example, or the Impressionists' startling compositions.[25] But opponents of Realism viewed this kind of synthesis as a destructive compromise. One of Sickert's rivals, in print and paint, was Wyndham Lewis, the Vorticist painter who dismissed the former's interior genre paintings as "bedroom realism – cynical and boyish playfulness."[26] The dispute between the two men, which eventually became very bitter, was symptomatic of the larger debate raging in England between the so-called "Formalists," championed by Roger Fry, and the "Realists," a group that included London Impressionists such as Augustus John.[27]

The Somewhere

For Sickert, the literary and pictorial examples of Lecoq, Duranty, Whistler, and Degas continued to possess great potency and relevance. Both Lecoq and Duranty had advocated a psychological and expressive parity between figure and surroundings. Sickert preserved the connection but altered the balance. For him, representing space was more critical than picturing the human subjects who dwelled there. Everything began with what Sickert called "the somewhere."

A picture generally represents *someone, somewhere.* The error of art-school teaching is that students are made to begin with the study of the *someone* and generally *nowhere.* The process should be reversed and the students should be taught to make the *someone* emerge naturally from the already established *somewhere.* . . . I am inclined to think that in good composition, the order of consideration must be from the somewhere, to the figures in it. The opposite order of design, from an incident, backwards, to the chamber in which it takes place, is generally fraught with disaster.[28]

A figure had virtually no interest for Sickert as a subject for painting until he could situate it properly. Sounding much like Duranty in *La Nouvelle Peinture,* the artist described a potential subject for a painting: a slightly down-at-the-heels, middle-aged woman whom he dubbed "Tilley Pullen." He advised the young artist who wanted to paint Tilly to

let her leave the studio and climb the first dirty little staircase in the first shabby little house. Tilly Pullen becomes interesting at once. She is in surroundings that mean something. She becomes stuff for a picture. Follow her into the kitchen, or better still – for the artist has the divine privilege of omnipresence – into her bedroom; and Tilly Pullen is become the stuff of which the Parthenon was made, or

Dürer, or any Rembrandt. She is become a Degas or Renoir, and stuff for the draughtsman.²⁹

After 1907, Sickert's "somewhere" was generally an undistinguished, even sordid, room in a run-down house in Camden Town. His friend William Rothenstein wondered at his taste in settings. He did not understand how a man of such fastidious dress and manners could claim to be comfortable in "the dreariest house and the most forbidding rooms" of London. Rothenstein wondered if Sickert was affecting "a kind of dandyism *à rebours?*"³⁰ But the artist's friend and former student Marjorie Lilly made it clear that the search for the properly seedy room was anything but an affectation. She described the end of a day of searching, when Sickert found his "treasure trove." It was, unsurprisingly, a "crooked room at the top of a crooked house in Warren Street, so rightly named." Lilly remembered that she "failed to appreciate the significance of this grisly chamber." She continued:

All I saw was a forlorn hole, cold, cheerless, the ceiling so black and hammocky that I begged him not to go there, foreseeing mountains of plaster descending on his head at any moment. But we were not looking at the same thing. All he saw was the *contre-jour* lighting that he loved, stealing in through a small single window, clothing the poor place with light and shadow, losing and finding itself again on the crazy bed and floor. Dirt and gloom did not exist for him; these four walls spoke only of the silent shades of the past, watching us in the quiet dusk.³¹

Once he found them, Sickert arranged his interiors as if he were a theatrical director. After procuring a room that was advertised as "furnished" – guaranteeing only the most rudimentary iron bedstead, chair, and commode – he would add elements of his own. These might include a horsehair sofa, a vanity, pictures, or stuffed birds perched under a dome of glass, just like the one that appears in *Ennui*. Transporting items such as horsehair sofas and stuffed birds was undoubtedly inconvenient, a fact that underscores the intensity of Sickert's desire that every interior depicted would be an interior freshly *experienced*. Perceived as extensions of himself, these spaces were not mere background for creative activity: they were the raw material of the activity itself. Sickert relished the traces of human existence that clung to those rooms, which resided largely in the dirt and grime that collected on their unadorned surfaces. Their grittiness was a radical departure from the softening effects of the antimacassars, doilies, and upholstery that adorned the furnishings of a conventional domestic interior – material repositories for the "traces" that Benjamin claimed the bourgeoisie left on their possessions. The stripped-down, reductively decorated interiors Sickert arranged in Camden Town – partly made, partly found – allowed him to paint habitation without possession, and companionship without engagement.³²

Let us recall that while he was lying in bed one morning, Vuillard wove together a seamless perceptual field simply by gazing at the furnishings and surfaces of his bedroom. Sickert's immersion in the settings he depicted was far more visceral. He responded to the suggestibility of a room's broad atmospheric effects more than to the delicate nuances of its internal transitions. While Vuillard (whose work Sickert much admired) could mine the subtleties of the way a wall turned a corner, Sickert seized that corner and pushed his figures into it. Before he could paint a space, the artist had to feel as if he fully *possessed* it, as if it had become part of his own body. This urgency is figured in *Ennui,* where the inert bodies of the man and woman seem to have been absorbed into one another and, in turn, to have incorporated the very space around them. Sickert's former student Lilly described her teacher's process of mental and physical submersion:

Was it not Van Gogh who said in order to paint a pair of boots you must *become* a pair of boots? Indeed Sickert did become his own particular brand of third-floor back. He never used these gaunt interiors for work until they had become a part of him. As time went on he seemed to need a fresh garret for almost every picture, as if each one afforded him a separate sharp experience that must be concentrated on a single canvas.[33]

Earlier, I identified a "rhetoric of embodiment" through which Lecoq de Boisbaudran, César Daly, and later Heinrich Wölfflin projected a corporeal liveliness onto the inanimate world, making that world imaginatively coextensive with the body. This practice signaled that psychological empathy could be activated through spatial projection, and enabled the production of the interiors I have discussed so far in this book. Although Sickert depended on the same assumptions about the expressive fusion of figure and space, he reversed the trajectory of animation. He imagined space and atmosphere as vital, almost material, forces that *disenlivened* the figures they touched, that stilled, even paralyzed, the bodies that came under their influence. Whereas Marie Vuillard resisted the force of her vivified setting in *Mother and Sister of the Artist,* Sickert's figures in *Ennui* are resigned to their fate. They greet their submersion into their surroundings with indifference, even though it seems to deprive them of both life and will. In *Ennui,* body and space are no longer fused into one living, breathing entity; they are conjoined into an impenetrable carapace – a seamless encasement that has itself become a fortification: body has become place. Representing the individual subjectivity of another is of little interest to Sickert. He represents his own subjectivity only indirectly, through the measured style of his application of paint in a slow accretion of thin, scrumbled, layers. He hires his models to perform the external signs of a state of mind – the woman's slump, the man's blank gaze – which he constructed by calibrating their bodies' fit to one another and to the furniture that presses against them. Sickert is mining, still, the expressive possibilities of the body in place that had been set into

motion a half-century earlier. The effect of this dynamic juxtaposition is greater than the sum of its parts, and the implied physicality of the figures' formal relations inspires a visceral response in the spectator. But whatever is behind that shell of self and setting is unavailable to us – perhaps because Sickert was not interested in searching for it in the first place.[34]

Permutations

Before Sickert painted *Ennui,* he had experimented for seven years with the permutations of a man and woman positioned together in a gloomy, sparsely furnished interior. Most of these were related to a central work called *L'Affaire de Camden Town* (1909) (Fig. 49), which was based loosely on the 1907 murder of a local prostitute.[35] In *L'Affaire de Camden Town,* Sickert imagined the scene before the crime took place. A tall, dark-haired man dressed in shirt-sleeves, trousers, and waistcoat stands over a nude woman who cowers on a mattress below him. The bedstead's iron bars dramatize her emotional entrapment, as do the armchair that faces her and the crossbars of the diamond-patterned wallpaper above. With his arms folded across his chest and his head projecting slightly forward from his neck, the man's posture in *L'Affaire de Camden Town* is as menacing as the woman's is vulnerable.[36]

Each of the variations that followed demonstrated how alert Sickert was to the different psychological effects that could be conveyed through subtle shifts of gesture, pose, and placement. In a drawing of 1909, the same woman raises her face up to her companion instead of turning away from him.[37] The effect is less ominous than in *L'Affaire de Camden Town,* as if even this slight contact mitigates the opposition between them. In this version the woman's left arm lies more casually on the bed, as if propping up her head instead of warding off an imminent blow. In *Camden Town Murder: La Belle Gâtée,* or *Persuasion* (ca. 1908) (Fig. 50), Sickert seated the fully dressed man on the bed, while the nude woman looks up at him expectantly from the vantage point of his lap – a very different, almost flirtatious, attitude. In still another experiment, Sickert switched the gender of the standing figure, transforming a scene of submission and fear into one of easy congeniality between two friends – or at least co-workers. In *Camden Town Nude: The Conversation* (ca. 1908–9) (Fig. 51), the nude woman lies on the bed, much as in the drawing just described, though the features of her face are a bit more visible. Slouching by the bed is a female companion dressed in a chemise that falls gracefully down her shoulder. Her back and hips curve in a relaxed posture, one appropriate for a chat between friends. Sickert also changed the angle at which we enter the picture. Instead of presenting the bed directly, he pivoted it slightly to the left, so that the diagonal is stronger and the woman is granted a modicum of dignity and privacy.[38]

49. Walter Sickert, *L'Affaire de Camden Town*, ca. 1908–9. Private collection. Photo: © 2000 Artists Rights Society (ARS), New York/DACS, London

50. Walter Sickert, *Camden Town Murder: La Belle Gâtée* or *Persuasion,*
ca. 1908. Chalk on violet paper. Private collection. Photo: © 2000 Artists
Rights Society (ARS), New York/DACS, London

In shaping these Camden Town variations, Sickert played the role of a di-
rector ordering his performers to adopt different positions so that he could
extract and record the greatest inventory of possible expressions. The artist
himself even occasionally acted out the part of the prostitute's murderer. Lilly
remembered one visit to the studio when she saw that her teacher had as-
sumed "the part of the ruffian, knotting the handkerchief loosely round his
neck, pulling a cap over his eyes and lighting his lantern. Immobile, sunk deep
in his chair, he would meditate for hours on his problem."[39] Each shift in ei-
ther protagonist's position or state of dress forged a new content. And each
image was duly granted a different literary title. Wendy Baron has warned,
however, that Sickert was not in fact really interested in creating narrative
paintings, even though he liked to tease his audience with deceptively "liter-
ary" titles.[40]

51. Walter Sickert, *Camden Town Nude: The Conversation,* ca. 1908–9. Chalk. London, Royal College of Art Collection. Photo: © 2000 Artists Rights Society (ARS), New York/DACS, London

Animating Inactivity

In *Ennui,* anecdote is jettisoned. Instead, Sickert concentrates on one of the most *inactive* animate states possible for a human figure. The sense of the figures' paralysis stems not only from their lassitude; Sickert reinforced their confinement by pushing them back into the corner of the room. Degas had used the corner in a similar fashion to suggest artistic paralysis in his *Portrait of Michel-Lévy* (Fig. 27), another work in which a barrier separates us from the subject (in this case, a paint box), rendering him more remote.[41] When an artist inserts a figure into a corner, the figure's distance from the viewer is exaggerated. The corner acts like a fold backward in the surface of the painting. An increased perceptual distance, even if it is illusory, is felt as a psychological one. When two people are wedged into the corner, the effect is even more complex, especially when they are facing in opposite directions. An image of a solitary person staring into space is understood, at least most of the time, as suggesting something akin to reverie. But when that reverie appears to exclude a companion who is just inches away, what seemed before to be mere self-absorption becomes something more like deliberate alienation. Sickert carefully adjusted the degree of his figures' remoteness from one other, and from the spectator. There is a disturbing incompatibility between the profound psychological disengagement of the figures and their bodily fusion on the surface of the painting. In one early sketch, for example (Fig. 52), the woman's profile was rendered more visible, suggesting that she was amenable to conversation. And the man's face was turned slightly more toward the spectator, as if, with a slight adjustment, the sight lines of the viewer and the viewed could be made to intersect.

Sickert also labored to produce the formal coupling between the man and woman that intensifies their emotional detachment. The woman's dark-brown skirt seems to press down upon, and merge with, the slightly lighter-brown jacket of her companion. Her body could be emerging out of his, so compactly are they fused together. Her taut back is an uninterrupted straight line that creates a sensation of pressure, a tension that was achieved after several experiments with a more naturalistic, sagging posture. In Figure 53, the woman's body is stouter and more curvaceous. The belt seems to constrict her waist as her hips swell slightly outward. Her upper body is too short, as if it is being forcibly compacted as it presses downward. In a subsequent drawing (Fig. 54), Sickert drew a dotted line along the contour of the woman's back, as if he were unsure at which angle he would cause it to curve or straighten. A curvature would have sexualized and sentimentalized the figure. Choosing to straighten the back shores up the woman's resistance to both the curious spectator and her companion and abets her bodily fusion with the mate she so disregards.

As Sickert fortified the edge of the woman's back, he also concentrated on a more succinct and geometricized way to fit the man's head into the triangle of

52. Walter Sickert, *Study for Ennui,* ca. 1913–14. Pen and ink. London, The Tate Gallery. Photo: Tate Gallery, London/Art Resource, N.Y.

her left arm. In most of the early sketches, the man's head just skims the woman's elbow. But in another drawing that isolates just this passage (Fig. 55), Sickert allowed a gap of space to intervene between the two bodies. He also tilted the woman's profile to make her features slightly more visible to the viewer, a move toward anecdote that actually distracts from the eloquence of her bodily slouch. In the final painting, the man's head is thrust directly under

the triangle of the woman's arm. Head and arm fit together like pieces of a puzzle, cementing their respective owners' entrapment. The geometry of this bodily fusion is repeated throughout their married forms. The straightened line of the woman's left arm parallels the angle of her shiny belt, which in turn absorbs the thrust of the man's cigar. The wedge of her brown skirt repeats and enlarges the triangle of her shoulder. These ostensibly organic forms are further compressed by the geometric lines of the structures that press against them: the frame and drawers of the bureau; the demarcation of the corner, which is painted in a bilious yellow-green; the mantle and its shadow; the picture frames; and the rounded table. These geometricized fragments are fitted tightly together to achieve maximum tension.

The table in *Ennui* is arguably more animated than the man who sits behind it, as vivified a piece of furniture as Madame Vuillard's bureau. With a pliancy that is remarkable for a

53. Walter Sickert, *Study for Ennui*, ca. 1914. Pen and ink, with blue and reddish brown chalks. Manchester, The Whitworth Art Gallery, The University of Manchester. Photo: © 2000 Artists Rights Society (ARS), N.Y./DACS, London

wooden object, it springs toward the viewer, sloping slightly at an angle that invites us to slide into the composition. Tension is created by the way the table's ovoid form presses directly on the edge of the canvas, a pressure enhanced after an earlier study that allowed for a sculptural, curving edge that trailed off into space at either end.[42] As the table draws in the spectator, it pushes the protagonists back into the corner, a thrust intensified by the oddly shaped and slightly menacing mass of brown shadow just below the man's right arm. Movement is invited, then arrested; for after being propelled through this triangulated accretion of bodies, the spectator comes to an abrupt stop. The empty corner looms up too quickly. As Degas had done, Sickert distorted the room's perspective in order to dramatize the recession. The younger artist even diminished the scale of the woman's head to make it appear more distant. As with *Interior*'s iron bedstead, Sickert's bureau recedes too sharply in its shallow space. Its left edge seems to expand as it looms toward the viewer.[43]

54. Walter Sickert, *Study for Ennui,* ca. 1914. Pen and ink with black chalk. Oxford, Ashmolean Museum. Photo: © 2000 Artists Rights Society (ARS), N.Y./DACS, London

The artist devoted a number of sketches to the decorative trappings of the painting and to fitting them into the larger structure he wanted to build. One drawing shows that Sickert originally intended that the framed picture above the bureau be more visible. According to Wendy Baron, this is probably an image of Queen Victoria as a demure young woman. She poses regally before a swathe of drapery, clasping her arms to her breast and holding a flower in her hand. Another study is devoted to the decanter on the mantle, the glass, and the framed picture of Victoria on the right. The studies affirm Woolf's observation that "Sickert composes his pictures down to the very castors on the chairs and the fire-irons in the grate just as carefully as Turgenev, of whom he sometimes reminds me, composes his scene."[44] From an author who often described the objects that populated her novels as if they were animate beings, this was recognition of the highest order. Woolf believed that it was the class of Sickert's furnishings that allowed them to be so expressive of, and so inseparable

55. Walter Sickert, *Studies for Ennui* (detail of figures), ca. 1914.
Pen and blue ink over black chalk. Oxford, Ashmolean Museum.
Photo: © 2000 Artists Rights Society (ARS), N.Y./DACS, London

from, their imagined owners: "Diamonds and Sheraton tables never submit to use like that," as she put it.[45]

While Hubby's brown suit marks him as a man of the working class (at least as Sickert portrays him in *Ennui*), his garb does bestow on him a measure of dignity. Leaning back in his chair, he fills the space fairly comfortably, despite the fact that the mantel seems much closer to the table than the span of two bodies should allow. He does not seem disturbed by whatever thoughts have generated his distracted gaze. If he were alone, the image would suggest a reasonably well-off, slightly fatigued, small businessman taking a respite from the day's labors. But he is not alone, and this makes all the difference. The female figure is far more anonymous. It is not difficult to construct a fictive persona for the estimable Hubby – the physiognomic and sartorial details are all laid out before us. But the woman's face is largely unavailable, and her ill-formed

body reveals very little about her age or her sexuality. She has been constructed primarily to fuse with her companion, even as she professes to ignore him. Her force is further diminished by the rather unflattering comparison to the lavishly dressed, conspicuously bare-shouldered effigy on the wall behind her. This is yet another image of Victoria, whose elbows now dip in a fashion very similar to the woman's, as if the royal were mocking her subject's slightly wistful dowdiness. Sickert's female subject is as passive as a figure can be while remaining erect. Her companion seems oblivious of her; yet one senses that she, in contrast, is not oblivious of him. Her back is a measure of refusal, not simply disinterest.

The muddy tones of brown, ochre, and green that dominate the palette of *Ennui* – particularly the table and the large expanse of wall – are strangely mottled. It is as though an atmospheric scrim with a palpable, even oppressive, weight had been laid over the paint surface.[46] The submersion of the human subjects into the atmosphere around them parallels Sickert's psychological immersion into the spaces he chose to paint. The idea that an atmosphere could be given form and made tangible enough to impinge upon the human subjects within its purview was taken up by George Gissing, a contemporary of Sickert's, in his novel *New Grub Street* (1891). Gissing used the metaphor of an invasive, penetrating fog to capture the sensation of a crisis in the family of the writer, Alfred Yule. The patriarch has just learned that his eyes are failing, which will render him unfit to pursue the editorial career that supports his family. In the Yule home: "The thick black fog penetrated every corner of the house. It could be smelt and tasted. Such an atmosphere produced low-spirited languor even in the vigorous hopeful; to those wasted by suffering it is the very reek of the bottomless pit, poisoning the soul."[47]

Sickert's *Ennui* is assuredly not filled with a thick, black fog. But its yellowed tonalities produce an atmosphere that seems positively inimical to human activity or exchange. Could this web of unappealing color represent "the great malady of the dread of the domicile," in the words of Charles Baudelaire?[48] Are the livid tones that Sickert employed a materialization of the poisons that, in Baudelaire's view, eventually seeped into every middle-class interior? Certainly, Sickert's interior is a place in which liveliness has been deliberately extinguished. Here, the strains of sexual or emotional conflict have been set aside for a resigned, companionable isolation.

In his study of the "diseased domicile," Georges Teyssot has argued that the kind of boredom Sickert pictured (he uses *Ennui* as an illustration in his argument) was endemic to the constrained domestic life around which so much of nineteenth-century culture revolved: "Ennui moves beyond the physical limits of the body, to reveal itself in the *interior*, the interior rooms of domesticity, where intimate space cloaks the body with the uncanny shapes of familiarity."[49] Schopenhauer believed that ennui was a "domestic demon," Teyssot points out. Writing in 1903, another author called it a "disease of nothingness." A poet described the state of mind as "daughter of null things – mother of the void."[50]

Psychoanalyst Otto Fenichel devoted an entire tract to the subject and ventured, inconclusively, that boredom was the inability to enjoy pleasure.[51]

It is curious that Sickert devoted four oil paintings, eight drawings, and at least one etching to a state of mind that he professed to despise. According to Lilly, Sickert hated boredom. "It's so stupid to be bored,'' he often complained.[52] But Patricia Meyer Spacks, who has written a book on boredom, is careful to distinguish boredom from ennui. Ennui is closer to *acedia*, she claims, the ancient state of elevated melancholy: a "metaphysical malady" distinct from the ostensibly less important, less complex mental state of, say, the bored housewife. Historically, ennui was a condition in which its sufferers took a certain amount of pride. What could be more gripping than a "state of the soul-defying remedy, an existential perception of life's futility?"[53] Sickert's friend Jacques-Emile Blanche believed that ennui was an affectation of the British temperament that was calculated to hide strong emotion, a "studied camouflage." In his journal, Blanche tried to isolate how to convey this duality of affect in his own portraiture. It was all in the brow and eyes, he believed. If he got that passage of the physiognomy just right – the nearby blank visage that almost, but not entirely, concealed the tensions not quite suppressed beneath – he would be able to capture the quintessentially British "mask of emotional pathology."[54] The conflict between masking and emotion that Blanche ascribed to most Englishmen was, according to him, especially concentrated in the temperament and art of Sickert, who honed a socially agile but psychologically unrevealing persona. Why should that mask – as Sickert fashioned it out of body and place in *Ennui* – become more impenetrable, more obdurate, in 1914? Why were there so many alterations made in the service of greater stasis, suppression of affect, and refusal of engagement? Why this refusal of both the expression of, and access to, *self*?

Sickert once described the significance a seemingly ordinary man could come to possess in a painting: "For the moment [this man's] pose and the lighting conspire to make of his image the quintessential embodiment of life. He is not so much Tom Smith as he is Everyman, in No-man's-land."[55] For Sickert, Hubby was his Everyman, and 1914 was a no-man's-land of the spirit. What was a man of Sickert's restless temperament to do during a war? He was too old to fight, too young to concede his forced passivity without resistance and resentment. That Sickert could not travel to France during this time was a source of great frustration for him. The artist's response to the war is more overt in a work he painted two years after *Ennui*. In *Suspense* (1916) (Fig. 56) a young woman sits on a wooden chair by a fireplace. Behind her is a closed door. Her head is upraised, and her hands clasped around her knee. Sickert's peers considered the painting an image of "a woman waiting for news of her son or lover."[56] Without recourse to anecdote of any kind, Sickert conveys the visceral experience of waiting. The tension in *Suspense* is palpable, and made easily available to the spectator. The young woman's fingers are tensed; her head is uncomfortably thrown back; her back is flexed in anticipation. A large

56. Walter Sickert, *Suspense*, ca. 1916. Belfast, Ulster Museum. Reproduced with the kind permission of the Trustees of the National Museum and Galleries of Northern Ireland. Photo: © 2000 Artists Rights Society (ARS), N.Y./DACS, London

interval of space seems to hover directly, and ominously, above her head. This young woman – a girl, perhaps – betrays all the emotion that the male protagonist of *Ennui* and his female companion refuse to reveal.

It was second nature for Sickert to mask emotion in art, and in life. Blanche cited the artist's tendency toward a "disdainful discretion, a sort of self-

defense, in his attitude toward human contact – *noli me tangere*. . . . All relations with Sickert have an extraordinary, mysterious character."[57] In the no-man's-land of the artist – and his surrogate, the model of late middle age in the England of 1914 – the state of ennui was perhaps the only foil against the unimaginable. The refusal to imagine, to reveal a self, or to engage with another – all of which are encapsulated in *Ennui* – signaled that private life was being experienced and represented elsewhere, and on very different terms.

The End of Private Life

Many writers and artists fervently believed that World War I ended both the conception and the practice of private life as they had known it. For Henry James, this was nothing less than the end of civilization. In a letter to a friend, he lamented, "Black and hideous is the tragedy that gathers and I'm sick beyond cure to have lived on to see it."[58] One of the most riveting and unsettling images of the war was the home rent asunder, its interiors exposed to view. When Edith Wharton traveled in 1915 through the French town of Auve, near the Belgian border, she described a fragmented cityscape dominated by the broken-down structures of domestic life. She wrote of smashed windowpanes, roofless buildings, and house fronts that were, "sliced clean off." Families' most mundane but intimate possessions were cruelly revealed to strangers. Gone was the "poor frail web of things that had made up the lives of a vanished city-full."[59] All too fittingly, a book Wharton organized in 1915 to raise money for the America Hostels association and the Children of Flanders Rescue committee was called *The Book of the Homeless.*[60]

For Woolf, a generation younger than Wharton and James, the war was a menacing presence that lurked just beneath the surface of her most important fiction. Except for some discussion in *Three Guineas,* she rarely dwelt on the war's material devastation.[61] Instead, she described a feeling of life dimming in familiar, beloved objects and conjured a sensation of strain and isolation inside rooms that had previously provided solace. Her novel *The Years* is full of such imagery. One night at dinner, the gallant Eleanor Pargiter understands that an air raid is about to begin.

The Germans, said Eleanor as the door shut. She felt as if some dull bore had interrupted an interesting conversation. The colours began to fade. She had been looking at the red chair. It lost its radiance as she looked at it, as if a light had gone out. . . . The houses opposite were completely curtained. She drew their own curtain carefully.[62]

Later, Eleanor's young friend North has returned from the war and some years in India. He perceives that rooms no longer seem to gather people together, rather they drive them apart into discrete, isolated chambers. Life seems

permanently changed, although the actual domestic structures have been re-built.[63] In Woolf's novel *Jacob's Room,* the sadness of a young soldier's death is expressed by the incongruity of the untidy room he left behind: "Did he think he would come back? [Bonamy] mused, standing in the middle of Jacob's room."[64] In her journals, Woolf speculated on the logical consequences of this kind of isolation and wondered about the advisability of living without do-mestic trappings in a world where they seemed to have lost their meaning: "As I sat in the complete English gentleman's home, I wondered how anybody could tolerate that equipage; and thought how a house should be portable like a snail shell. In future perhaps, people will flirt out houses like little fans; and go on. There'll be no settled life within walls."[65] Woolf, like many others, was imagining a new structure for the interior life. Private subjectivity was more and more internalized – a vision held privately rather than acted out in the do-mestic interior that had once been, in Benjamin's words, "the universe to the private individual." Relying on one's material surroundings to construct, and to represent, a self seemed far too risky an enterprise. If objects, furniture, a fa-vored corner, or a revealing passageway could be taken away, what of the identity that was forged in juxtaposition with those structures and artifacts?

The structure of identity was largely reconfigured in the early years of the twentieth century. As Charles Taylor has put it in his *Sources of the Self,* "The epiphanic centre of gravity begins to be displaced from the self to the flow of experience, to new forms of unity, to language conceived in a variety of ways – eventually even as a 'structure.' " Taylor understands this shift as the dawn of a "decentering subjectivity," which is not, in his view, an "alternative to in-wardness; it is its complement."[66]

In the postwar imagination, the mind assumed a rational structure of its own, one that was often described as a series of rooms or chambers. This met-aphor is commonplace in our time, but a nascent expression of the idea shaped Henry James's *The Jolly Corner* of 1909. Here a man's confrontation with his past is achieved via his passage through the empty rooms and dark corridors of the house of his youth. The force of the actual material structure pales in comparison to the series of memories experienced by the character. Gradually, he gains more skill at negotiating the "dusk of distances and the darknesses of corners ... the treacheries of uncertain light, the evil-looking forms taken in the gloom by mere shadows, by accidents of the air, by shifting effects of perspective."[67]

Freud's reconfiguration of the mind is well beyond the scope of this study. Indeed, the images and conceptions I am concerned with bring us right to the brink of the changes that Freud inaugurated and popularized. It is worth not-ing, however, that in his essay on the unconscious, which was published in two installments toward the end of 1915, Freud tried to construct what he called a "topography of mental acts" and struggled with how to give both a physical and a psychical shape to the "latent states of mental life."[68] These states –

"Consciousness," the "Unconscious," and what Freud called the "Precon-scious" – interpenetrated sometimes (as when a physical act moved from an unconscious to a conscious state, relocating from one mental space to an-other), but remained largely distinct. Freud believed that to understand how these states worked upon one another was to understand the "dimension of the depth of the mind."[69]

Writing thirteen years later, Woolf pictured the mind as possessing a discrete architecture of its own. In *To the Lighthouse* (1927), the painter Lily Briscoe contemplates the magnetic yet elusive Mrs. Ramsay. Though the older woman sits right next to Lily, she seems impossibly remote from her. The painter con-cludes that she is finally unknowable.

[Lily] imagined how in the chambers of the mind and heart of woman who was, physically, touching her, were stood, like the treasures in the tombs of kings, tablets bearing sacred inscriptions, which if one could spell them out, would teach one everything, but they would never be offered openly, never made pub-lic. What art was there, known to love or cunning, by which one pressed through to those secret chambers?[70]

Woolf's words are one sign of the end of the belief that it was possible to pene-trate the inner life of another. In *The Jolly Corner,* James had indicated how difficult it was to simply know oneself.

James's fictive house materialized the disorientation of a nightmare. When Walter Pater remembered his *maison natale,* in "The Child in the House," it had been with longing, and with sadness at the loss. The intensity of Pater's urge to remember transported him, as if bodily, through the rooms of a house that no longer existed. The house seemed more real to him in middle age than it had been at the age of eight.[71] As Pater retained the visceral memories of his childhood home, so the poet Rainer Marie Rilke believed that he had absorbed the experiences and feelings of his youth so deeply that the rooms of his house and his passages through them resided in his body "as blood does in the veins."[72] Instead of the body acting out a self in place, the memory of place had been drawn into the body to become a hidden, but abiding, part of the self.

This idea informs the seventh of Rilke's haunting *Duino Elegies,* written in 1917: "Nowhere, beloved, will world be but within us. / Our life passes in transformation. / And the external shrinks into less and less. / Where once an enduring house was, / now a cerebral structure crosses our path, completely / belonging to the realm of concepts, / as though it still stood in the brain."[73]

Such "cerebral structures," the new dispersal and displacement of self that Taylor described, were manifested in the utopian schemes of the early twenti-eth century. When the interior was implicated in these schemes, it was not as a mediated image of domesticity, but as a three-dimensional "abstract interior" from which the body was largely excluded.[74] In this space, architecture, de-sign, and art coalesced to demonstrate the unity of all the arts and dramatize

the seamless connection between art and life. In cities throughout Europe, the interior became a work of art in its own right, and every surface and every object within its boundaries was integrated into an overarching design scheme, free of figuration and references to history. Some of these interiors descended from the artists' houses of the nineteenth century and represented a variation on the Arts and Crafts tradition. The Red House, by William Morris and Phillip Webb, for example, influenced the more radical and abstract decorative schemes of the Omega Workshop, of which Roger Fry was a principal founder. In Vienna and Brussels, the principles of the Art Nouveau style shaped the collaborations of architect Josef Hoffmann and painter Gustav Klimt. Klimt's mosaic frieze of marble, glass, and semiprecious stones, *Fulfillment* (ca. 1910; Brussels, Palais Stoclet) was one part of a totality that included other abstract murals, Hoffman's geometric tiling design for the floor, and furniture that reiterated their geometry (1905–11; Brussels, Palais Stoclet). An even more austere vision of the abstract interior was produced by the artists of the De Stijl movement in Holland. In their colored abstract environments, they attempted to merge the arts within a fully integrated setting, and the resulting aesthetic harmony was intended to express a new social order. Ideally, a new utopian city would emerge, based on a series of abstract, geometric forms. The idea that collaborative design could be a vehicle for social change also fueled the work of the Russian Constructivists and the Bauhaus.[75]

In representations of the canonic architecture of modernism, the body was also largely excised from place. As Benjamin succinctly observed about the Bauhaus, "They have created spaces in which it is difficult to leave traces."[76] The designs of Le Corbusier were explicitly conceived in opposition to the traditional conceptions and living practices of the bourgeois house. Benjamin proclaimed that "The work of Le Corbusier seems to arise when the 'house' as mythological configuration approaches its end."[77] When Le Corbusier staged his signature photographs of the Villa Savoye, no human figures were included. Only a series of carefully edited objects gendered as masculine – a hat, a pair of gloves, glasses – were placed as if to suggest the presence of an occupant whom the viewer would never overtake. Similarly, only once did Adolph Loos publish a photograph of his interior architecture that included a human figure. And, as Beatriz Colomina points out, he positioned the man at the most vulnerable point in the structure – at the threshold: the man's body is only partially in the room. Loos often confounded the distinctions between inside and outside. He placed a mirror directly next to a window in the dining room of the Steiner House, for instance; in his design for Josephine Baker's house, he enclosed the interior swimming pool with glass, abrogating Baker's privacy to render her an object of display inside her own home. Loos may have called his houses "stages for the theater of the family," but the members of the family were rarely represented. "The subject of Loos's interiors is a stranger, an intruder in his own space."[78]

The influence of high modern architecture – place without body – was potent and wide-ranging. But the impulse to represent subjectivity through intimate space would surface again with a vengeance in the Surrealist designs of Tristan Tzara, whose "intrauterine architecture" was conceived as a radical critique of the reductive abstraction of Le Corbusier.[79] The interdependence of space and self continues to haunt architects and theorists to this day. Much like Rilke, architect Anne Troutman has recently imagined that she is "constructed of the various dwellings I have lived in over the years. . . . I do not believe a house is a safe place. For me, it is a collision of dream, nightmare, and circumstance, a portrait of the inner life."[80]

The need to possess and recognize an interior life has never been eclipsed.[81] The paintings I have discussed in this book visualize, *avant la lettre,* Troutman's lament; they testify that the desire to locate and build a form for subjectivity prompts a state of mind that oscillates between dream and nightmare. The paintings also suggest that the enactment of a self for display is not a comfortable or immediately gratifying experience. Indeed, our own culture demonstrates a great impatience with the meditative, unpredictable, and, not least, unprofitable, aspects of such an enterprise.

The novelist Carol Shields once wrote that "the brave often stay at home and try to make sense of being at home."[82] The act of achieving selfhood – however conflicted, fragmented, constrained, disguised, or repressed that self might be – may not seem like an epic struggle; but it may be one of the most eloquent we have remaining to us. And during the nineteenth century, the competing demands, the mixed alliances, and even the danger inherent in that struggle were encapsulated in the image of a body attempting to establish a fragile equilibrium in place.

Notes

Prologue: The Body in Place

1. The phrase comes from Carolyn Steedman's *Strange Dislocations: Childhood and the Idea of Human Interiority, 1780–1930* (Cambridge, Mass.: Harvard University Press, 1995), ix. Another important source for discussions of modern selfhood is Charles Taylor, *Sources of the Self: The Making of Modern Identity* (Cambridge, Mass.: Harvard University Press, 1989). For a recent collaboration between psychologists and philosophers on the role of the body in the production of the self, see Jose Luis Bermudez, Anthony Marcel, and Naomi Eilan, eds., *The Body and the Self* (Cambridge, Mass., and London, England: MIT Press, 1998).

2. Michel Foucault, *The Care of the Self: The History of Sexuality,* vol. 3, trans. Robert Hurley and Allen Lane (New York: Vintage Books, 1984, 1988). Foucault's ideas are discussed in Steedman, *Strange Dislocations,* p. 12.

3. For a recent, compact collection of Sigmund Freud's writings, see Peter Gay, ed., *The Freud Reader* (New York: W. W. Norton & Co., 1989). The basic reference for the complete works of Freud is *The Standard Edition of the Complete Psychological Works of Sigmund Freud,* trans, and ed. James Strachey, 24 vols. (London: Hogarth Press, 1953–74).

4. Susan Sidlauskas, "A 'Perspective of Feeling': The Expressive Interior in Nineteenth-Century Realist Painting," Ph.D. diss., University of Pennsylvania, 1989.

5. See ibid. for a discussion of these artists' "expressive interiors," and for bibliography on individual works.

6. A key source on the division between public and private realms is Jürgen Habermas, *The Structural Transformation of the Public Sphere: An Inquiry into a Category of Bourgeois Society,* trans. Thomas Burger, with the assistance of Frederick Lawrence (Cambridge, Mass., and London, England: MIT Press, 1989). In the field of nineteenth-century art history, see Griselda Pollock's influential "Modernity and the Spaces of Femininity," reprinted in her *Vision and Difference: Femininity, Feminism and Histories of Art* (London and New York: Routledge, 1988), pp. 50–90. Shiff's phrase comes from the conclusion to his *Cézanne and the End of Impressionism* (Chicago and London, England: University of Chicago Press, 1984), pp. 223–30.

7. Anthony Vidler, *The Architectural Uncanny: Essays on the Modern Unhomely* (Cambridge, Mass., and London, England: MIT Press, 1992).

8. Ibid., p. 167.

9. Kirk Varnedoe, "The Artifice of Candor: Impressionism and Photography Reconsidered," *Art in America,* vol. 68, no. 1 (January 1980): 66–78; and idem, "The Ideology of Time: Degas and Photography," *Art in America,* vol. 68, no. 6 (Summer 1980): 96–109.

10. William Preyer, *The Mind of the Child, Part I: The Senses and the Will* and *Part II: The Development of the Intellect,* trans. H. W. Brown (New York: D. Appleton and Co., 1889); James Sully, *The Human Mind: A Text-Book of Psychology,* vols. 1 and 2 (New York: D. Appleton and Co., 1892).

11. Jean-Martin Charcot, *Lectures on The Diseases of the Nervous System,* trans. George Sigerson (Philadelphia: Henry C. Lea, 1879). For a recent discussion of the relation between Charcot's ideas and the art and architecture of the late nineteenth century, see Debora Silverman, *Art Nouveau in Fin-de-Siècle France: Politics, Psychology, and Style* (Berkeley and Los Angeles: University of California Press, 1989), esp. pp. 75–108.

12. For a collection of essays on the problem and the influence of Dora, see Charles Bernheimer and Claire Kahane, eds., *In Dora's Case: Freud – Hysteria – Feminism* (New York: Columbia University Press, 1985). See also Peter Gay, ed., *The Freud Reader,* "Fragment of an Analysis of a Case of Hysteria ('Dora')," pp. 172–239.

Introduction

1. Walter Benjamin, *Das Passegen-Werk,* p. 281, quoted in David Frisby, *Fragments of Modernity: Theories of Modernity in the Work of Simmel, Kracauer, and Benjamin* (Cambridge, Mass., and London: MIT Press, 1986), p. 248, n. 316, and p. 305. See also Walter Benjamin, *Charles Baudelaire: A Lyric Poet in the Era of High Capitalism,* trans. Harry Zohn (London: Verso Editions, 1982), "Louis-Philippe or the Interior," pp. 167–68.

2. Benjamin, "Louis-Philippe or the Interior," pp. 167–68.

3. One of the first compilations of paintings of interiors was Mario Praz's *An Illustrated History of Furnishing from the Renaissance to the Twentieth Century,* trans. William Weaver (New York: George Braziller, 1964). Also useful is Peter Thornton, *Authentic Decor: The Domestic Interior 1620–1920* (London: Weidenfeld and Nicolson, 1984). On the photographic interior, see Margaret Nesbit, *Eugène Atget: Intérieurs Parisiens,* exh. cat. (Paris: Musée Carnavalet, 1987), and Molly Nesbit, *Atget's Seven Albums* (New Haven: Yale University Press, 1992). For popular illustrations, see Pierre Lavédan, *Histoire de l'Urbanisme à Paris* (Paris: Hachette, 1975). Two examples of pattern books are Antoine Priguot, *Décors Intérieurs* (Paris: Portefeuille, 1869), and Alexander Koch, *Innen Dekoration* (Munich: Darmstadt, 1902). The most influential late-nineteenth-century book on architectural interiors was César Daly, *L'architecture privée aux XIXe siècle urbaine et suburbaine* (Paris: M. Brun, 1864). On Realist theater, see Edith Melcher, "Stage Realism in France," Ph.D. diss., Bryn Mawr, Pa., 1928. See also Emile Zola, *Le Naturalisme au théâtre, Oeuvres Complètes,* vol. 39, ed. Maurice Le Blond (Paris: F. Bernouard, 1974).

4. Victorien Sardou, quoted in Germaine Bapst, *Essai sur l'histoire de théâtre* (Paris: Hachette, 1893), p. 583.

5. Rémy Saisselin, *The Bourgeois and the Bibelot* (New Brunswick, N.J.: Rutgers University Press, 1984). See also Peter Gay, *The Bourgeois Experience: Victoria to*

Freud, vol. 1: *Education of the Senses;* vol. 2: *The Tender Passion* (New York and Oxford: Oxford University Press, 1984, 1986), and Richard Sennett, *The Fall of Public Man* (New York: Vintage Books, 1974).

6. For a survey of interiors in nineteenth-century painting, see Fritz Laufer, "Das Interieur in der europäischen Malerei des 19.Jahrhunderts," Ph.D. diss., University of Zurich, 1960.

7. Susan Stewart, *On Longing: Narratives of the Miniature, the Gigantic, the Souvenir, the Collection* (1984; repr. Durham, N.C., and London: Duke University Press, 1993), p. 104.

8. It was formerly commonplace to identify these anomalies as "photographic." For the best refutation to this argument, see Kirk Varnedoe, "The Artifice of Candor: Impressionism and Photography Reconsidered," *Art in America,* vol. 68, no. 1 (January 1980): 66–78; and idem, "The Ideology of Time: Degas and Photography," *Art in America,* vol. 68, no. 6 (Summer 1980): 96–109.

9. Vidler stresses the importance of Heinrich Wölfflin's writings in establishing the psychological notion of empathy. See Vidler, *The Architectural Uncanny,* pp. 72–73. For relevant documents, see *Empathy, Form, and Space: Problems in German Aesthetics, 1873–1893,* intro. and trans. Harry Francis Mallgrave and Eleftherios Ikonomou (Santa Monica, Calif.: Getty Center for the History of Art and the Humanities, 1994). See especially Heinrich Wölfflin, "Prolegomena to a Psychology of Architecture," pp. 149–92.

10. Benjamin, *Baudelaire,* pp. 167–68.

11. Henri Lefebvre, *The Production of Space,* trans. Donald Nicholson-Smith (Oxford, England, and Cambridge, Mass.: Blackwell Press, 1974). He writes: "And even if there is no general code of space, inherent to language or to all languages, there may have existed specific codes, established at specific historical periods and varying in their effects. If so, interested 'subjects,' as members of a particular society, would have acceded by this means at once to *their* space and to their status as 'subjects' acting within that space and (in the broadest sense of the word) comprehending it" (p. 17).

12. Lefebvre cites the "conceptual triad," which consists of spatial practice, representations of space, and representational space; ibid., p. 33.

13. Nancy Munn, "Excluded Spaces: The Figure in the Australian Aboriginal Landscape," *Critical Inquiry,* vol. 22, no. 3 (Spring 1996): 446–65, 454. Munn quotes Lefebvre, p. 451: "This field can be plotted along a hypothetical trajectory centered in the situated body with its expansive movements and immediate tactile reach, and extendable beyond this center in vision, vocal reach, and hearing (and further where relevant)."

14. Ibid., p. 453.

15. Ibid., pp. 457–58.

16. Walter Benjamin, "Paris: Capital of the Nineteenth Century," in *Reflections,* trans. Edmund Jephcott (New York: Schocken Books, 1986), quoted in Beatriz Colomina, "The Split Wall: Domestic Voyeurism," in Beatriz Colomina, ed., *Sexuality and Space* (New York: Princeton Papers on Architecture, Princeton Architectural Press, 1992), pp. 73–130, 74.

17. César Daly, quoted in Anne Lorenz Van Zanten, "Form and Society: César Daly and the *Revue Générale de l'Architecture,*" *Oppositions,* no. 8 (Spring 1977): 137–45, 140.

18. Heinrich Wölfflin, *Renaissance and Baroque,* trans. Kathrin Simon, intro. by Peter Murray (London: McCallum Sons & Co., 1964), p. 77.

19. Ibid.
20. T. J. Clark, "Freud's Cézanne," *Representations*, no. 52 (Fall 1995): 94–122, 111.

Chapter One: Body into Space

1. Horace Lecoq de Boisbaudran, Archives Nationales, Dossier AN AJ 53 130, Personal dossier. The main source for information on the curriculum of the Ecole Gratuite is the Archives Nationales in Paris, hereafter AN. Archives of principal importance are F 21643, AJ 53 100 and AJ 53 62 to 91. For a useful inventory of the archives, see Brigitte Labat-Poussin, *Inventaire des Archives de l'Ecole National Supérieure des Beaux-Arts et de l'Ecole Nationale Supérieure des Arts Décoratifs, sous série AJ 52 et AJ 53* (Paris: Archives Nationales, 1978). On the "comité d'enseignement" (the curriculum committee of the school's teachers) see AN AJ 53 100; the responsibilities of the comité d'enseignement are also described in the *Revue Générale de l'Architecture et des Travaux Publics*, vol. 6 (1845–46), col. 123. For a sample curriculum, see AN F 21 643, Tableau de Classes.
2. Lecoq is discussed briefly in Albert Boime, "The Teaching Reforms of 1863 and the Origins of Modernism in Painting," *Art Quarterly*, vol. 1, no. 1 (Autumn 1977): 1–39. The Ecole Gratuite is now the Ecole des Arts Décoratifs. In 1847 the school's official name was the Ecole Royale Spéciale Gratuite de Dessin et de la Mathématique, but it was also called the Ecole Impériale de Dessin, or the Ecole Gratuite de Dessin. It was popularly known by two nicknames, "Petite Ecole" and Ecole du Médecine, which referred to the street on which it was located.
3. For a recent application of these ideas in a very different, but illuminating, context, see Nancy Munn, "Excluded Spaces: The Figure in the Australian Aboriginal Landscape," *Critical Inquiry*, vol. 22, no. 3 (1996): 446–65.
4. On Lecoq's memory training, see especially Petra ten-Doesschate Chu, "Lecoq de Boisbaudran and Memory Drawing," in Gabriel Weisberg, ed., *The European Realist Tradition* (Bloomington: University of Indiana Press, 1982), pp. 242–89. Lecoq's drawing theories were known, directly or indirectly, to all of the artists discussed in this book. His best-known formal students included Henri Fantin-Latour, Charles Cazin, and Alphonse Legros, who would later take his teacher's ideas to the Slade School in London. See Susan Sidlauskas, "A 'Perspective of Feeling': The Expressive Interior in Nineteenth-Century Realist Painting" (Ph.D. diss., University of Pennsylvania, 1989), for discussion of these artists and a bibliography.
5. Lecoq de Boisbaudran's best-known publication was *Education de la Mémoire Pittoresque*, first published in Paris in 1847 and reprinted in 1862. Variations and additions followed. In 1872, he published *Coup d'Oeil sur l'Enseignement des Beaux-Arts* (Paris: A. Morel et cie.), a critical survey of drawing instruction in France, and in 1876, *Lettres à un Jeune Professeur* (Paris: A. Morel et cie.). A French edition of his complete writings, *Oeuvres Complètes*, was published in 1879 by A. Morel and cie., Paris. Quotes here come from this edition unless otherwise noted. An English translation by L. Luard, with an introduction by Selwyn Image, was published in London by Macmillan & Co. in 1911. Lecoq taught at the Ecole Gratuite from 1841 until 1866, when he became director for three years. He was widely considered to have been the school's most important instructor. After he left, he taught at the Lycée de St. Louis and then at the Ecole Spéciale d'Architecture. Shortly before his death at the age of ninety-five, he was tutoring privately in his home. The best discussions of Lecoq's importance at the

school are to be found in Anne Wagner, *Jean-Baptiste Carpeaux* (New Haven and London: Yale University Press, 1986), chap. 1, esp. p. 25. For briefer commentaries, see Albert Elsen and J. Kirk T. Varnedoe, *The Drawings of Rodin* (New York: Praeger, 1971), pp. 26–120. The only biography of Lecoq is by his student Félix Régamey, *Horace Lecoq de Boisbaudran et ses élèves* (Paris: Champion, 1903). Lecoq is also listed in Ulrich Thieme and Felix Becker, *Allgemeines Lexikon der Bildenden Kunstler* (Leipzig: W. Engelmann, 1908), vol. 22, p. 528. Lecoq's last publication offered advice on how to combine positivism with idealism, the material world with the spiritual, an ambition that he believed offered the only hope to a disheartened, pessimistic society. Horace Lecoq de Boisbaudran, *Quelques idées et propositions philosophiques* (Paris: n.d.). One of the few surviving copies of the pamphlet is in the Bibliothèque Nationale in Paris.

6. The phrase "la mise en place ou la mise ensemble" comes from Lecoq de Boisbaudran, *Coup d'oeil,* p. 11.

7. Victorien Sardou, quoted in Germaine Bapst, *Essai sur l'histoire de théâtre* (Paris: Hachette, 1893), p. 583: "Régardez votre cabinet, aujourd'hui. Les chaises ne sont pas au mur; les fauteuils sont devant la cheminée; à droite et à gauche, de-ci et de-là, il y a des poufs, des bérgères, des crapauds, des tabourets, éparpilles, disseminés, se régardent se tournant de dos, formant comme des groupes des personnages qui devisent entre eux." On the realist theater in France, see Edith Melcher, "The Realist Stage in France" (Ph.D. diss., Bryn Mawr College, 1928), pp. 16–28. Melcher points out that Dénis Diderot was the first person to criticize the symmetry of the French stage. Also see Martin Meisel, *Realizations: The Narrative, Pictorial and Theatrical Arts in Nineteenth-Century England* (Princeton, N.J.: Princeton University Press, 1983).

8. Louis-Edmond Duranty, *Bric-à-Brac,* originally serialized in *Le Temps,* 21 juin–2 juillet, 1876, later reprinted in *Le Pays des Arts* (Paris: Charpentier, 1881). This moralizing tale of a quest for the perfect "bibelot" that leads a family of collectors astray includes a humorous scene in a collector's salon, in which people are rendered virtually indistinguishable from the clutter of objects around them: "On voyait apparaître une tête entre les panses de deux énormes potiches de Chine; plus loin, deux jambes croisées sortaient d'un enfoncément crée entre un cabinet de la Renaissance et une armoire hollandaise peintre, et une voix haillissait de ce creux moir sans qu'on y distinguat ni corps ni tête" (*Le Pays des Arts,* p. 226). Other interesting examples of this conceptual fusion are found in Poe's "Philosophy of Furniture," in *Complete Tales and Poems of Edgar Allan Poe* (New York: Modern Library, 1938), and in Edmond and Jules de Goncourt, *La Maison d'un Artiste,* vols. 1 and 2 (Paris: G. Chamerot, 1881).

9. Hippolyte Taine, *Lectures on Art,* trans. John Durand (New York: Holt & Co., 1875), vol. 1: *On the Ideal in Art,* pp. 336–37.

10. Lecoq de Boisbaudran, *Oeuvres Complètes,* p. 148. Lecoq wrote, "on subordonne ces figures à l'ensemble du tableau, soit qu'on les considere comme en étant les sujets principaux."

11. Lecoq's influence was not confined to his students. His series of pamphlets and books circulated among the close friends of such artists as Fantin-Latour, Legros, and Cazin. Prominent among them were the critic Louis-Emile Edmond Duranty. See Marcel Crouzet, *Duranty. Un Méconnu du Réalisme* (Paris: Librairie Nizet, 1964).

12. For a useful survey of influential model books, see Daniel Harlé, "Les Cours de dessin gravés et lithographiés du XIX siècle conservé au Cabinet des Estampes de

la Bibliothèque Nationale. Essai critique et catalogue" (Ph.D. diss., Ecole du Louvre, 1975).

13. The Ecole Gratuite played a central role in reforms in the teaching of drawing around this time. For information on the school, see Boime, "The Teaching Reforms of 1863"; the first chapter of Wagner, *Carpeaux*; E. Guillaume, "L'Idée générale d'un enseignement du dessin: Essai sur la théorie du dessin," text of a speech to Union Centrale des Arts, March 23, 1866; F. Ravaisson, *De l'enseignement du dessin dans les lycées* (Paris, 1854); and William Dyce, "Report made by W. Dyce, contingent to his journey on an inquiry into the state of schools of design in Prussia, Bavaria and France, House of Commons Parliamentary Papers," vol. 29, 1840, pp. 25–28. For Daly's comments, see *Revue Générale*, vol. 6 (1845–46), pp. 120–24.

14. Elaine Scarry, *The Body in Pain: The Making and Unmaking of the World* (New York and Oxford: Oxford University Press, 1985), p. 255.

15. Idem, "On Vivacity: The Difference between Daydreaming and Imagining-under-Authorial-Instruction," *Representations*, no. 52 (Fall 1995): 1–26.

16. César Daly, "Du Symbolisme dans l'Architecture," *Revue Générale de l'Architecture*, vol. 7 (1847): 49–69: "Regardez bien, ne semble-t-il qu'un fluide vital circule à travers ces pierres; que ces murs, ces piliers, ces trumeaux, ces voûtes que couvrent de célestes phalanges, s'animent sous le regard mental de celui que sent l'influence d'une foi profonde?" (pp. 50 and 54).

17. Ibid., pp. 50–51: "Ce portique n'est plus pour moi une masse de pierres plus or moins savamment assemblées . . . c'est quelque chose de vivant, d'animé, qui me parle et me traverse d'une émotion indéfinissable."

18. Ibid., p. 53: "Pour un édifice régulier, le corps central est ce qu'est l'épine dorsale pour le squelette, le coeur pour le système de la circulation sanguine, la moelle épinière pour le système nerveux, le tronc pour l'arbre: la condition de son unité, c'est-à-dire de son existence même."

19. César Daly, quoted in Anne Lorenz Van Zanten, "Form and Society: César Daly and the *Revue Générale de l'Architecture*," *Oppositions*, no. 8 (Spring 1977): 137–45, 140.

20. See especially Heinrich Wölfflin, "Prolegomena to a Psychology of Architecture," in *Empathy, Form, and Space: Problems in German Aesthetics, 1873–1893*, intro. and trans. by Harry Francis Mallgrave and Eleftherios Ikonomou (Santa Monica, Calif.: Getty Center for the History of Art and the Humanities, 1994), pp. 149–92. Quotes are from pp. 154, 155, and 153.

21. Hippolyte Taine, *Lectures on Art*, pp. 336–37.

22. On the changes in the social construction of visuality during the nineteenth century, see Jonathan Crary, *Techniques of the Observer: On Vision and Modernity in the Nineteenth Century* (Cambridge, Mass.: MIT Press, 1991), pp. 97–136; quote is from p. 69. Also see idem, "Modernizing Vision," in Hal Foster, ed., *Vision and Visuality*, Discussions in Contemporary Culture, 2 (Seattle: Dia Art Foundation, 1988), pp. 29–50.

23. Crary, *Techniques of the Observer*, p. 72. Crary continues: "Biran used the term 'co-enesthèse' " to describe "one's immediate awareness of the presence of the body in perception" and "the simultaneity of a composite of impressions inhering in different parts of the organism" (pp. 72–73).

24. Ibid., p. 73.

25. Daly, "Du Symbolisme dans l'Architecture," p. 49. See also idem, "Causerie sur l'esthétique," *Revue Générale de l'Architecture*, vol. 25 (1867): 54: "Cette corre-

spondance de la notion de la stabilité avec la ligne droite, et du mouvement avec la ligne courbe, se retrouve partout, dans les organismes naturels ou mécaniques aussi bien que dans les oeuvres d'art. Toutefois, la plupart des symboles réfléchies sont aussi fondés en raison; le symbolisme réfléchi n'est que le symbolisme instinctif passe à l'état de conscience. Je me suis occupé beaucoup à constituer la théorie du symbolisme instinctif, parce que dans cette langue naturelle sont comprises toutes les energies de l'art et que, cette théorie connue, on ne confondra pas plus les combinaisons géometriques du mode majeur avec les combinaisons que sont de mode mineur, qu'on ne confond, dans une partition d'orchestre, les combinaisons majeures et mineures dessous musicaux; qu'on ne confond, dans une partition d'orchestre, les combinaisons majeures et mineures des sous musicaux; qu'on confond les lignes heurtées de l'Hercule avec les ondoyants et gracieux contours de la Venus."

26. The phrase "perspective de sentiment," is from Lecoq de Boisbaudran, *Coup d'oeil*, p. 73. On Lecoq's hostility to measuring tools of any kind, see ibid., pp. 64–65. Lecoq also wrote: "Décomposer systèmatiquement en carrés, en angles et en triangles toutes les formes, de la nature jusqu'à la figure humaine, ne peut manquer d'alterer profondement chez les enfants, si impressionnables, la notion de la forme vraie" (idem, *Oeuvres Complètes*, pp. 10–11). He also contended that "Il n'y a que trop de tendance aujourd'hui, à des direction unitaires, à des systèmes d'enseignements uniformes pour tous, égalément oppressifs pour l'élève et pour le professeur" (*Coup d'oeil*, p. 19). Edgar Allan Poe provides the literary equivalent of Lecoq's anxiety about symmetry in his essay "The Philosophy of Furniture": "A want of keeping is observable sometimes in the character of the several pieces of furniture, but generally in their colors or modes of adaptation. *Very* often the eye is offended by their inartistical arrangement. Straight lines are too prevalent – too uninterruptedly continued – or clumsily interrupted at right angles. If curved lines occur, they are repeated into unpleasant uniformity. By undue precision, the appearance of many a fine apartment is utterly spoiled." Edgar Allan Poe, "Philosophy of Furniture," in *Complete Tales and Poems of Edgar Allan Poe* (New York: Modern Library, 1938), p. 463.

27. Henri Lefebvre, *The Production of Space,* trans. Donald Nicholson-Smith (Oxford, England, and Cambridge, Mass.: Blackwell Press, 1974), quoted in Victor Burgin, *In/Different Spaces* (Berkeley and Los Angeles: University of California Press, 1996), p. 26.

28. The classic discussion of perspective is Renssaeler Lee, "*Ut Pictura Poesis:* The Humanistic Theory of Painting," *Art Bulletin*, vol. 22 (1940): 197–269. Recent studies include Hubert Damisch, *The Origin of Perspective,* trans. John Goodman (Cambridge, Mass.: MIT Press, 1994) and James Elkins, *The Poetics of Perspective* (Ithaca, N.Y.: Cornell University Press, 1994).

29. Thomas Couture's *Romans of the Decadence* (1847; Musée d'Orsay, Paris) is a contemporary example. See Charles Rosen and Henri Zerner, "The Juste Milieu and Thomas Couture," in *Romanticism and Realism: The Mythology of Nineteenth-Century Art* (New York: W. W. Norton and Co., 1984), pp. 113–29, and Albert Boime, *Thomas Couture and the Eclectic Vision* (New Haven: Yale University Press, 1980).

30. Lecoq wrote directly about history painting only once. See *Coup d'oeil, Appendice,* Note R, which is ommitted in the 1879 *Oeuvres Complètes.*

31. On Piranesi, see John Wilton Ely, *The Mind and Art of Giovanni Battista Piranesi* (London: Thames and Hudson, 1973); on Gandy, see Brian Lukacher and John

Summerson, *Joseph Michael Gandy,* exh. cat. (London: Architectural Association, 1982); see also Lukacher's "Phantasmagoria and Emanations: Lighting Effects in the Architectural Fantasies of Joseph Michael Gandy," *Architectural Association Files,* no. 4 (1982): 40–48, 95; and idem, "Joseph Michael Gandy: The Poetical Representation and Mythography of Architecture" (Ph.D. diss., University of Delaware, 1987). See also Patrick Youngblood, "That House of Art: Turner at Petworth," *Turner Studies,* vol. 2, no. 2 (Winter 1983): 16–33; and Susan Sidlauskas, "Creating Immortality: Turner, Soane, and the 'Great Chain of Being,' " *Art Journal,* vol. 52, no. 2 (Summer 1993): 59–65.

32. César Daly, "Causerie sur l'esthétique," p. 58. Daly wrote that "on voit que le sentiment humain s'exprime dans la langue architectonique, par des combinaisons de lignes."

33. Ibid., p. 55. Daly wrote: "L'homme n'est-il pas cerveau, sens et coeur? pensée sensitivité et affection? Eh bien! comment peut-on supposer épuisée l'étude des relations qui existent entre l'homme et la forme, ou, en d'autres termes, entre l'homme et la géométrie (qui contient le principe de toutes les formes), si l'on fait le rapprochement entre la géométrie et une partie de l'homme seulement, et non avec son être tout entier. En étudiant les rapports de la forme avec *l'intelligence* pure (la raison), on a créé la *géométrie abstraite;* en étudiant un certain ordre des rapports qui existent entre la forme et les *sens* de l'homme (les rapports *d'utilité* matérielle), on a créé la *géométrie industrielle,* et on a même éffleuré – mais éffleuré seulement, – dans l'optique et l'acoustique, deux branches de l' *esthétique matérielle* ou *positive;* mais pourquoi s'est-on arrêté là?"

34. In ibid., pp. 55–56, Daly wrote: "Que font donc les savants, du *coeur* de l'homme et de ses rapports avec la forme? Rien! Aussi la science est-elle incomplète et mutilée, comme est mutilée et incomplète la notion de l'homme – exclusivement intellectuel et sensuel – que seule la science a voulu considérer. On a oublié le coeur de l'homme, on a oublié l'art, la poésie, le beau, et, par une juste rétribution, on a été atteint dans la science elle-même, à laquelle manque la geométrie esthétique, la physique esthétique, etc. sciences touchées accidentellement seulement, et dans leurs parties rudimentaires, mais qui sont si peu comprises encore dans leur nature vraie, que les noms mêmes de *géométrie esthétique, acoustique esthétique, optique esthétique,* etc., n'existent pas encore dans la science, bien que les conditions de l'harmonie physique des couleurs et des sons aient été déjà l'objet de travaux importants."

35. Most contemporary drawing instruction depended on copying model books of lithographs or etchings. Some popular examples were Antoine Etex, *Cours élémentaire de dessin* (Paris: Carilian-Loewy, 1851); Marie-Elizabeth Cavé, *Le Dessin sans Maître,* with preface by Eugène Delacroix (Paris: Aubert et Cie., 1852). Other popular tracts included A. Dupuis, *Enseignement du dessin, Méthode* (Paris: Impr. de Mme. de Lacombe, ca. 1850). For an analysis of these manuals, see Harlé, "Les cours de dessin gravés." The Ecole Gratuite was criticized by William Dyce in 1840 for not giving enough attention to technical matters. Hillaire Belloc hired both Lecoq de Boisbaudran and Lecoq's good friend Eugène Viollet-le-Duc in 1841 as instructors of "dessin des plantes et animaux" and "dessin d'ornamentation historique," respectively. Belloc was accountable to the Ministre de l'Intérieure. Viollet originally joined the staff as a "répétiteur," or student assistant, in the mid-1830s and became a full professor in 1844, as did Lecoq. For biographical information on Belloc, see "Hilaire et Louise Swanton

Belloc," in *La Grande Encyclopédie* (Paris: H. Lamirault, 1886–1912), vol. 6, p. 92.

36. Viollet-le-Duc, "Un Cours de Dessin," *L'Artiste*, 2, n.s. 5 (Sept.–Dec. 1858): 154–56. Viollet hailed "l'absence de chic, de poses de convention, d'effets cherchés, la simplicité, la gravité et le coloris solide que donne toujours la nature, la verité sans trivialité."

37. Lecoq de Boisbaudran, *Mémoire Pittoresque*, pp. 57–58. He wrote: "Là seront étudiés, non plus d'une manière abstraite, mais dans leurs realitiés pittoresques, tous les faits, toutes les lois, tous les accidents de la perspective: la dégradation des grandeurs, en raison directe des dégrés d'éloignement, les différences d'aspect suivant les divers points de vue, l'importance des conditions de distance, les raccourcis de la figure humaine et ses rapports de proportion avec les objets qu'ils environnent."

38. Charles Blanc, *Le Temps*, Nov. 2, 1879, 19. "Il a fait un emploi particulièrement heureux de la perspective cavalière pour donner . . . des vues à vol d'oiseau, permettant de fixer sur une surface trés réduite les ensembles les plus étendres."

39. Lecoq de Boisbaudran, *Mémoire Pittoresque*, pp. 71–72. Lecoq believed that students should "non seulement saisir les aspects avec exactitude, mais les modifier à volonté, choisir, diminuer, augmenter, abstraire, accentuer, embellir, greffer." They should, in addition, work toward "interprétations, des équivalents, des abstractions, et exprimer enfin moins la chose que son esprit."

40. Ibid., pp. 62–63: "de se représenter non seulement les choses que l'on a vues, mais encore celles auxquelles on pense et que l'on invente, et à donner ainsi aux conceptions de l'imagination une netteté et une précision qui les mettent, en quelque sorte, sous les yeux et à la disposition de l'artiste."

41. Ibid., pp. 20: "leur propre conception, leur propre idéal." In *Lettres à un jeune professeur*, Lecoq wrote, "Un bon modèle de dessin devrait être correct, et de bon goût simple et naturel, c'est-à-dire sans affectation de carrés ou d'autres formes conventionnelles. Il devrait être d'apparence libre, facile et engageante pour les élèves. Il y faudrait beaucoup de science sans pédantisme, de la verité avec distinction, des effets larges et simplifiés sans monotonie" (pp. 26–27).

42. Lecoq de Boisbaudran, *Oeuvres Complètes*, p. 143: "On a souvent parlé des règles de la composition. Il n'y a pas de règles proprement dites, il y a des convenances, que les élèves accepteront volontiers, sans qu'elles soient érigées en règles absolues et imposées comme telles."

43. See Judith Weschler, "An Apéritif to Manet's *Déjeuner sur l'Herbe*," *Gazette des Beaux-Arts*, vol. 91, no. 2, 6th sér. (1978): 32–34. The relation between the so-called avant-garde and the academic world during this period was far from polarized. Degas, for instance, counted among his closest friends Salon painters like Béraud, Gervex, and Raffaelli. His relationship with Manet, with whom he was closely linked, was difficult but respectful.

44. Lecoq de Boisbaudran, *Mémoire Pittoresque*, p. 52: "Quelques jours après, des aspects d'un autre ordre, des scènes toutes différentes nous offrirent un intérêt non moins vif: l'habile architecte d'un de nos principaux monuments [the Palais de Justice] avait bien voulu mettre à ma disposition, avant de les livrer au public, plusieurs salles d'une sévère architecture. . . . Il est difficile d'imaginer l'effet grandiose produit par des figures noblement drapées se promenant sous ces portiques, s'appuyant sur ces balustrades, ou dèscendant majesteusement les degrés d'un escalier monumental."

45. Lecoq de Boisbaudran, *Coup d'oeil*, p. 73: "Les jeunes gens sentiront alors la rai-son de certaines inexactitudes volontaires, usitées par les plus habiles praticiens. Ils pourront s'essayer, à leur tour, à ces compromis entre le goût et la rigueur des principes, que l'on appelle la perspective de sentiment, et que permettent, seules, la connaissance approfondie des règles et l'observation répétée de la nature."

46. J. J. Gibson, *The Senses Considered as a Perceptual System* (Boston: Houghton Mifflin Co., 1955), p. 202.

47. Ibid., pp. 275–76.

48. Lecoq de Boisbaudran, *Mémoire Pittoresque*, p. 4: "il fallait conserver nettement ses propres idées, ses propres impressions." The principal cause of bad work was "l'absence des facultés intellectuelles indispensables, des plus précieuses connais-sances. Il y a donc ici moins excès de mémoire que manque de jugement, de goût de tact et d'esprit." As for the inevitable distinctions among artists' work: "mais rien n'oblige à appeler constamment l'attention et le travail de la mémoire sur la même manière, sur le même maître . . . c'est la nature, à ce maître-là l'on em-prunte son style, ce sera la plus grande des originalités."

49. Lecoq de Boisbaudran, *Oeuvres Complètes*, p. 24.

50. See Archives Nationales, AN, F 21 643, Tableau de Classes. Although the school was not nearly as preoccupied with prizes as was the Ecole des Beaux-Arts, the di-rector, Hillaire Belloc, did not rule out the publicity advantages of a few acquisi-tions. See AN AJ 53 100 Carton.

51. "L'ornément est l'intervalle entre une chose et une autre. On comble cet intervalle par un rapport entre les deux choses et c'est là la source de l'ornément"; quoted in George Shackelford, *Degas: The Dancers*, exh. cat. (Washington, D.C.: National Gallery of Art, 1984), p. 105, n. 24. Shackelford supplies several words that are missing from Theodore Reff's transcriptions in *The Notebooks of Edgar Degas*, 2 vols. (Oxford: Oxford University Press, 1976), p. 60.

52. Lecoq de Boisbaudran, *Oeuvres Complètes*, p. 69: "Les rapports entre la mémoire et l'imagination sont tellement directs et immédiats, qu'il est admis généralement que l'imagination ne fait que combiner les matériaux que lui fournit la mémoire, produisant ainsi, comme la chimie avec des éléments connus, des composés en-tièrement nouveaux. Combien l'imagination deviendra plus féconde, enrichie par une mémoire cultivée, mettant à sa disposition, des éléments plus nombreux plus variés, plus précis. On peut donc établir avec assurance que la culture de la mé-moire pittoresque, en servant et fortifiant l'imagination, favorise éminémment la composition artistique."

53. Quoted in Elisabeth Bronfen, "Facing Defacement: Degas's Portraits of Women," in *Degas Portraits*, ed. Felix Baumann and Marianne Karabelnik et al. (London: Merrell Holberton, 1994), pp. 226–49, 227. Also see ibid., Jean Sutherland Boggs, "Degas as a Portraitist," and "A Chronology for Degas as a Portraitist," pp. 16–86.

54. Henri Matisse, quoted in John Elderfield, *Pleasuring Painting: Matisse's Feminine Representations* (London: Thames and Hudson, 1996), pp. 23–24. My thanks to Katherine Bourguignon for bringing this essay to my attention.

55. See Marcel Crouzet, *Duranty. Un Méconnu du Réalisme* (Paris: Librairie Nizet, 1964). Duranty was one of Realism's earliest theorists and was later the author of *La Nouvelle Peinture*, which was originally published in 1876 on the occasion of the second Impressionist exhibition at the Durand-Ruel Gallery. It was reprinted in 1946 by Marcel Guérin in Paris, and later, with a complete English translation, in Charles Moffett et al., *The New Painting: Impressionism 1874–1886*, exh. cat.

(San Francisco and Washington, D.C.: The Fine Arts Museums of San Francisco and the National Gallery of Art, 1986), pp. 37–49 and 447–84. Duranty gave a full statement on the goals of Realism in the first issue of the periodical *Réalisme*, Nov. 15, 1856, p. 1.

56. Although this is the first published evidence of his acquaintance with Lecoq, many of Duranty's comments on painting composition in *Réalisme* sound as if they were lifted directly from Lecoq's pamphlets. Duranty owned copies of Lecoq's *Sommaire d'une méthode d'enseignement de dessin,* 1876, and *Coup d'oeil sur l'enseignément des beaux-arts,* 1872; see *Vente Duranty,* Durand-Ruel, January 1881. The review of Cazin's students is "Tours et le dessin moderne," *Paris-Journal,* March 29, 1870: "Les résultats obtenus étant excellents, je suis très heureux de penser que l'application pratique puisse enfin donner gain de cause à des principes d'art auxquelles se sont forément attachés quelques-uns d'entre nous. M. Cazin sort de l'atelier de M. Lecoq de Boisbaudran, le maître le plus intéressant de ce temps-çi, et qui aura forme le plus d'hommes de talent, et d'un talent individuel. Ce qui a été rémarquable chez M. Lecoq, c'est la variété d'allure des artistes qui ont traverse son atelier. Dans tout autre atelier, tout le monde n'apprend qu'une chose, la manière du maître. On avait confié à M. Lecoq l'enseignement à l'école de dessin de la rue de l'Ecole-de-Médecine. On le lui a retiré, uniquement parce qu'il voulait être intelligent." For Duranty's references to Lecoq in *The New Painting,* see Moffett, *The New Painting,* pp. 39 and 41.

Chapter Two: Degas and the Sexuality of the *Interior*

1. Rene König, *Sociologie de la mode* (Paris: Payat, 1969), p. 136, quoted in Rémy Saisselin, *The Bourgeois and the Bibelot* (New Brunswick, N.J.: Rutgers University Press, 1984), p. 40.

2. Degas knew of Lecoq's ideas through his friendships with Legros, Cazin, Fantin-Latour, and Whistler. In addition, Duranty referred to the drawing master fairly often in his own essays for *Réalisme* and, later, in his art reviews and in *The New Painting.*

3. For the use of *Le Viol* as an alternate title, see Marcia Pointon, *Naked Authority* (New York and Cambridge: Cambridge University Press, 1990), p. 119; and Carol Armstrong, "Edgar Degas and the Representation of the Human Body," in Susan Suleiman, ed., *The Female Body in Western Culture* (Cambridge, Mass., and London: Harvard University Press, 1985), pp. 223–42, 225. A detail of the right half of the painting, showing the man and the bed, has been used as the cover illustration to L. A. Higgins and B. R. Silver, eds., *Rape and Representation* (New York: Columbia University Press, 1991).

4. Early comments to this effect came from George Grappe, *Degas. L'art et beau,* vol. 3, no. 1 (Paris: Librairie artistique internationale, 1908), p. 7; and Camille Mauclair, *Degas* (Paris: Editions Hypérions, 1924), p. 31. Other early interpretations of the painting are Arsène Alexandre, "Degas: Nouveaux Aperçus," *L'Art et les artistes,* vol. 29, no. 154 (February 1935): 145–73; and Julius Meier-Graefe, *Degas* (Munich: R. Piper, 1920). The most substantial writings on the painting to date have been by: Theodore Reff, whose original interpretation appeared as "Degas's 'Tableau de Genre,' " in *Art Bulletin,* vol. 54, no. 3 (1972): 316–37, and was later collected in his *Degas: The Artist's Mind* (New York: Metropolitan Museum of Art with Harper and Row, 1976); Carol Armstrong, *Odd Man Out: Readings of the Work and Reputation of Edgar Degas* (Chicago: University of

Chicago Press, 1991), pp. 93–100; and, more recently, by John House, "Degas's 'Tableaux de Genre,' " in Richard Kendall and Griselda Pollock, eds., *Dealing with Degas: Representations of Women and the Politics of Vision* (New York: Universe, 1992), pp. 80–94.

5. See Jean Sutherland Boggs, with Douglas Druick, Henri Loyrette, Michael Pantazzi, and Gary Tinterow, *Degas,* exh. cat. (New York: Metropolitan Museum of Art, 1988), pp. 143–46, for the painting's provenance and exhibition and critical histories. The painting was first exhibited in America at *A Loan Exhibition of Paintings and Pastels by H. G. E. Degas* (Cambridge, Mass.: Fogg Art Museum, April 5–14, 1911). For a complete list of texts on the painting, see Boggs et al., *Degas,* p. 146. The only comment we have about *Interior* while it was being painted is in the form of a few notes written on an envelope. Reff has identified the author as James Tissot (see Reff, *Degas,* pp. 226–27 on Tissot; p. 201 on George Jeanniot, a family friend who watched Degas restore the painting in 1903; and p. 202 on the remarks of Henri Rouart). There is also evidence that Walter Sickert, a protégé of Degas's, knew the painting (see n. 32 below). Degas kept the painting in his studio and reworked it during the 1890s. See Armstrong, *Odd Man Out,* pp. 99 and 267, n. 47.

6. My article on the painting, "Resisting Narrative: The Problem of Edgar Degas's *Interior," The Art Bulletin,* vol. 75, no. 4 (December 1993): 671–96, focuses on the tension between narrative and realist painting around the 1860s. Some of the same material is included in this chapter, but the argument, and the range of evidence, have been significantly expanded.

7. Jean François de Bastide, *The Little House: An Architectural Seduction,* trans. and intro. by Rodolphe El-Khoury, preface by Anthony Vidler (New York: Princeton Architectural Press, 1996); Vidler quote, pp. 16–17.

8. Ibid., p. 33.

9. César Daly, *L'Architecture privée aux XIXe siècle urbaine et suburbaine* (Paris: A. Morel et cie., 1864), p. 10. The home should be "le vêtement de la famille. Elle est en effet destinée à lui servir d'enveloppe, à l'abriter et à se prêter à tous ses mouvements" (p. 22).

10. Idem, p. 12, On Daly's ideas about "aesthetic geometry," see Anne Lorenz Van Zanten, "Form and Society. César Daly and the *Revue Générale de l'Architecture," Oppositions,* no. 8 (Spring 1977): 137–45, esp. 140. For an analysis of *Architecture privée,* see Hélène Lipstadt, "Housing the Bourgeoisie: César Daly and the Ideal Home," *Oppositions* 8 (Spring 1977): 34–47. She quotes Daly: "Suivant que l'aspect de la maison, ses lignes, sa décoration extérieure et intérieure, flattent ou offensent le goût de celui que l'habite, c'est pour lui un plaisir ou une peine de chaque jour; pour certains caractères, c'est une occasion de triomphe ou d'humiliation permanente."

11. César Daly, *Architecture Privée,* p. 12: "Suivant que l'habitation est bien ou mal ordonée, les fonctions domestiques s'accomplissent aisément ou avec peine, le *travail* journalier de chacun, depuis le maître dans sons cabinet ou son atelier, jusqu'au 'cordon-bleu' dans sa cuisine, est facilité ou entrainé, la bonne humeur se maintient ou l'irritation s'éveille, la discretion de la vie intime est respectée ou inconnue, chacun est libre dans son quartier ou soumis a d'intolérables servitudes . . . les relations intérieurs de la famille et les rapports extérieurs d'amitié et de société, s'exercent avec ordre et de grite ou se pratiquent au milieu d'embarras choquants."

12. César Daly, "Villa," *Revue Générale de l'Architecture,* no. 32 (1875): 272–73: "tons doux et harmonieux, lignes et détails sobres, c'est ce qu'a cherché l'artiste et c'est ce qu'il a su merveilleusement trouver et réaliser. Dans ce milieu sympathique et délicat, où tout caresse le regard et satisfait le sentiment esthétique, l'esprit et le coeur s'ouvrent; autour de la table, la fenêtre ouverte sur la vèranda tapissée de glycine et de chèvrefeuille, la parole jaillit et étincelle, et le rire qui ignore les gros éclats en roues n'en est que plus charmant et plus joyeux. . . . Le milieu fait l'homme à son image . . . mais c'est l'art fait homme qui a créé ce milieu."

13. For publications on nineteenth-century decoration, see J. Feray, *Architecture intérieure et décoration en France: Des origines à 1875* (Paris: Berger-Levrault: Caisse Nationale des Monuments Historiques et des Sites, 1988), and T. Lambert, *Décorations et ameubléments intérieurs* (Paris: C. Schmid, 1906).

14. For illustrations that document the relationship between class and urban accommodations, see Edmund Texier, *Tableau de Paris,* vol. 1 (Paris: Paulin et Le Chévalier, 1852), in particular, p. 65.

15. Walter Benjamin, "Paris: Capital of the Nineteenth Century," in *Reflections,* trans. Edmund Jephcott (New York: Schocken Books, 1986), quoted in Beatriz Colomina, "The Split Wall: Domestic Voyeurism," in Beatriz Colomina, ed., *Sexuality and Space* (New York: Princeton Architectural Press, 1992), pp. 73–130, 74.

16. Jürgen Habermas, *The Structural Transformation of the Public Sphere: An Inquiry into a Category of Bourgeois Society,* trans. Thomas Burger, with the assistance of Frederick Lawrence (Cambridge, Mass.: MIT Press, 1989).

17. Some writings in this field that have stimulated my thinking include: Shirley Ardener, *Women and Space* (London: Croom Helm, 1981); Debora Silverman, *Art Nouveau in Fin-de-Siècle France: Politics, Psychology, and Style* (Berkeley and Los Angeles: University of California Press, 1989); Martha Vicinus, *The Widening Sphere* (London: Methuen, 1980); also see Lucy Oakley's excellent overview in *The Exotic Flower: Constructions of Femininity in Late-Nineteenth-Century French Art* (New Brunswick, N.J.: The Jane Voorhees/Zimmerli Museum, Rutgers University, 1998).

18. This point is addressed by Carolyn Steedman, *Strange Dislocations: Childhood and the Idea of Human Interiority, 1780–1930* (Cambridge, Mass.: Harvard University Press, 1995); also, see Part Three ("A Woman's Place") of Suzanne Nash, ed., *Home and Its Dislocations in Nineteenth-Century France* (Albany: State University of Albany Press, 1993); and Carroll Smith-Rosenberg, *Disorderly Conduct: Visions of Gender in Victorian America* (New York and Oxford: Oxford University Press, 1985); and Rachel Bowlby, *Shopping with Freud* (London: Routledge, 1993).

19. The most comprehensive study of intimate life in the nineteenth century is Peter Gay's three-volume series, *The Bourgeois Experience: Victoria to Freud,* esp. vol. 1, *The Education of the Senses* (New York: W. W. Norton, 1984). See Silverman, *Art Nouveau,* esp. 186–206, for an analysis of the feminization of the decorative arts.

20. The most influential argument about the feminization of the spatial strategies employed by artists such as Cassatt and Morisot remains Griselda Pollock, "Modernity and the Spaces of Femininity," in *Vision and Difference: Femininity, Feminism, and the Histories of Art* (London and New York: Routledge, 1988), pp. 50–90. I believe that Degas both exploits and subverts the usual gendered associa-

tions of the domestic interior, and thus serves as a counterexample to Pollock's thesis.

21. For an analysis of the respective status of history and genre painting around 1867, particularly the fluctuating stature of history painting as an "official art," see Patricia Mainardi, *Art and Politics of the Second Empire: The Universal Expositions of 1855 and 1867* (New Haven and London: Yale University Press, 1987). On the status of history painting during the eighteenth century, see Thomas Crow, *Painters and Public Life in Eighteenth-Century Paris* (New Haven and London: Yale University Press, 1985). See Armstrong, "Edgar Degas and the Representation of the Female Body," pp. 73–100, for the relation of Degas's work to earlier painting, both history and genre.

22. For popular imagery on the subject, see Beatrice Farwell, *The Cult of Images: Baudelaire in the 19th Century* (Santa Barbara: Santa Barbara Art Museum, University of California, 1977). A valuable overview of the theme in drama is found in Charles Edward Young, "The Marriage Question in Modern French Drama," *University of Wisconsin Bulletin,* vol. 5, no. 4 (1912). See also Linda Nochlin, "A House Is Not a Home: Degas and the Subversion of the Family," in Kendall and Pollock, *Dealing with Degas,* pp. 43–65. The course of the fallen working girl was charted in many *feuilletons,* which are surveyed in Farwell, as above.

23. See Young, "The Marriage Question," for an overview of the genre of the domestic drama during the nineteenth century.

24. Quoted in Young, "The Marriage Question," p. 410.

25. See Roy McMullen, *Degas: His Life and Time* (Boston: Houghton Mifflin Company, 1984), pp. 151–82, for discussions of the books and ideas Degas was interested in at this time.

26. Jules Michelet, *L'Amour* (Paris: L. Hachette, 1873), p. 47.

27. For a range of these illustrations, see Beatrice Farwell, *French Popular Lithographic Imagery 1815–1870* (Chicago: University of Chicago Press, 1981).

28. On Hogarth, a favorite artist of Degas's, see Lance Bertelson, "The Interior Structures of Hogarth's *Mariage à la Mode,*" *Art History,* vol. 6, no. 2 (1983): 131–42. On Augustus Egg, see T. J. Edelstein, "Augustus Egg's Triptych: A Narrative of Victorian Adultery," *Burlington Magazine,* vol. 135, no. 961 (April 1983): 202–10; and Hilarie Faberman, "Augustus Leopold Egg" (Ph.D. diss., Yale University, 1983). Linda Nead, in *Myths of Sexuality* (Oxford and New York: Oxford University Press, 1988), pp. 71–86, links Egg's *Past and Present* to contemporary changes in England's divorce laws. On the image of women in Victorian painting, see T. J. Edelstein, "They Sang the Song of the Shirt: The Visual Iconology of the Seamstress," *Victorian Studies,* vol. 23, no. 2 (Winter 1980): 183–210, and idem, " 'But Who Shall Paint the Griefs of Those Oppress'd?' The Social Theme in Victorian Painting" (Ph.D. diss., University of Pennsylvania, 1979). See also, Linda Nochlin, "Lost and Found: Once More the Fallen Woman," *Art Bulletin,* vol. 60, no. 1 (March 1978): 139–53; Susan Casteras, *The Substance and the Shadow: Images of Victorian Womanhood,* exh. cat. (New Haven, Conn.: Paul Mellon Center for British Art, 1982); and Linda Nead, "Seduction, Prostitution, Suicide: *On the Brink* by Alfred Elmore," *Art History,* vol. 5, no. 3 (September 1982): 310–22.

29. Richard Sennett, *The Fall of Public Man: On the Social Psychology of Capitalism* (New York: Random House, 1974), p. 183.

30. For Duranty's writing on the absurdity of historical genre, see *Réalisme,* April/May 1857, p. 84. See also Marcel Crouzet, *Un Méconnu du Réalisme: Duranty 1833–1880* (Paris: Librairie Nizet, 1964), p. 249; and Louis-Edmond Du-

ranty, "Sur la Physionomie," *La Revue Libérale,* July 25, 1867, p. 510, for the elaboration of this idea.

31. The original reads: "des séries vastes sur les gens du monde, les prêtres, les sol-dats, les paysans, les ouvriers, les juges, les marchands; en reprenant ces séries de toutes les façons, par exemple en ouvrant une suite de scènes de mariage, de bap-tême, de communion, ou bien d'intérieurs de famille," *Réalisme,* November 1856, p. 11. On Balzac, see *Réalisme,* December 15, 1856, p. 28. Fifty years earlier, for a collection that was to be called the *Pathologie de la vie sociale,* Balzac had writ-ten such fragments as "Théorie de la démarche" and the "Physiologie de la toi-lette." On the implications of this work by Balzac, see Peter Brooks, "The Text of the City," *Oppositions,* no. 8 (Spring 1977): 7–11, and idem, *The Melodramatic Imagination: Balzac, Henry James, Melodrama, and the Mode of Excess* (New York: Columbia University Press, 1985).

32. Walter Sickert owned two copies of Paul Jamot's *Degas* (Paris: Skira, 1924 and 1939), which he copiously annotated. One copy, from which I have quoted, is in the Lugt Collection, Institut Néerlandais, Paris. I thank Ann van der Jagt, curator of the Lugt Collection, for kindly allowing me to see the book, and also Anna Gruetzner Robins for telling me of its existence, and for generously sharing with me her research on Sickert and Degas. Professor Robins will shortly issue an an-notated edition of Walter Sickert's writings, to be published by Oxford University Press. The other copy of the Jamot *Degas* is at the library of the Courtauld Insti-tute, London, along with thirty-four other books, also heavily annotated, origi-nally from Sickert's personal library. I thank Michael Doran, librarian of the Courtauld, for making all these books available to me. Sickert's comment on *Inte-rior,* Lugt Collection Jamot, p. 44, is penciled in the lefthand margin. Sickert dis-agrees with Jamot's discussion of the painting as a representation of an innocent working girl and her employer, and writes, "je crois qu'il n'y a n'en de tout cela/Que Degas fut [illeg] un portrait de famille."

33. Duranty's essay *La Nouvelle Peinture* was originally published in 1876 and was reissued, with an introduction by Marcel Guérin, in Paris, 1946. For a complete annotated transcription of the original pamphlet, and an English translation, see Charles Moffett, *The New Painting: Impressionism 1874–1886,* exh. cat. (San Francisco and Washington, D.C.: The Fine Arts Museums of San Francisco and the National Gallery of Art, 1986), pp. 37–49 and 447–84.

34. Beatriz Colomina, "Domesticity at War," *Assemblage,* no. 16 (December 1991): 15–27. Also see idem, *Privacy and Publicity: Modern Architecture and Mass Me-dia* (Cambridge, Mass.: MIT Press, 1994). A reproduction of Sargent's portrait of *Robert Louis Stevenson and His Wife* can be found in Patricia Hills et al., *John Singer Sargent,* exh. cat. (New York: Whitney Museum of Art in assoc. with Harry Abrams, 1986), p. 79.

35. On the theme of the family's suppression of emotion, see especially Sennett, *The Fall of Man,* pp. 177–83. For the most recent discussions of the Bellelli and Mor-billi portraits, see Félix Baumann and Marianne Karabelnik, eds., *Degas: Por-traits,* with an essay by Jean Sutherland Boggs, exh. cat. (London: Merrell Hol-berton, Kunsthaus, Zurich, and Kunsthalle, Tübingen, 1994–95). See esp. Tobia Bezzola, "Family Portraits," in which both the Bellelli and the Morbilli portraits are discussed, pp. 175–205.

36. Carol Salus, "Degas's *Young Spartans Exercising,*" *Art Bulletin,* vol. 67, no. 3 (September 1985): 501–6. For summaries of the interpretations of Degas's history paintings, see also Boggs et al., *Degas,* pp. 98–100 and 105–11.

37. Nancy Miller, "This Is Not a History Painting: Modernity and Ambiguity in the Development of Degas's *Spartan Youths*" (Ms, University of Pennsylvania, 1995). There are two related full studies, one at the Art Institute of Chicago, 1860–80, the other at the Fogg Museum, Harvard University, Cambridge, Mass. In the Chicago version, the male youth with upstretched arms has significantly larger genitals than appear in the final painting in London. There is an illustration in Richard R. Brettell and Suzanne Folds McCullagh, *Degas in the Art Institute of Chicago* (New York: Harry N. Abrams with the Art Institute of Chicago, 1984), p. 32. See the discussion by Brettell, pp. 32–35.

38. The drawing is illustrated in Boggs et al., *Degas*, p. 106, fig. 56.

39. Laura Mulvey, "Melodrama Inside and Outside the Home," in *Visual and Other Pleasures* (Bloomington: Indiana University Press, 1989), pp. 63–80, 74. Mulvey concludes: "Here the text of muteness is produced not by the material constraints of the law or technology but by a proximity to the mechanisms of repression."

40. Thomas Elsaesser, "Tales of Sound and Fury," in *Movies and Methods*, vol. 2, ed. Bill Nichols (New York: Columbia University Press, 1985), p. 177.

41. César Daly, "Villa," p. 27: "Que pensez-vous, Madame, et vous lecteur, de la 'Maison' que nous venons visiter ensemble? N'avais-je pas bien raison de vous l'annoncer comme un vrai nid de raffinés? Certes, le même nid ne convient pas à l'aigle et au moineau; la même maison ne convient ni à toutes les fortunes, ni à tous les temperaments, ni à tous les lieux, ni à tous les goûts; la maison est essentiellement personnelle, et c'est à ce point de vue surtout que la Maison de Croissy nous offre une page charmante à lire."

42. Wolfgang Kemp, "Death at Work: A Case Study on Constitutive Blanks in Nineteenth-Century Painting," *Representations*, no. 10 (Spring 1985): 102–23, 115–16. For other recent analyses of the phenomenon of response, see David Freedberg, *The Power of Images: Studies in the History and Theory of Response* (Chicago and London: University of Chicago Press, 1989), and H. Jauss, *Toward an Aesthetic of Reception in Theory and History of Literature*, vol. 2 (Minneapolis: University of Minnesota Press, 1982).

43. Heinrich Wölfflin, "Prolegomena to a Psychology of Architecture," in *Empathy, Form, and Space: Problems in German Aesthetics, 1873–1893*, intro. and trans. by Harry Francis Mallgrave and Eleftherios Ikonomou (Santa Monica, Calif.: Getty Center for the History of Art and the Humanities, 1994), pp. 149–90, 153. Here, Wölfflin is summarizing the ideas of Johannes Volkelt, *Der Symbol-Begriff in der neusten Aesthetik* (Jena: Hermann Dufft, 1876).

44. Victor Burgin, "Geometry and Abjection," *AA Files – Annals of the Architectural Association of Architecture*, no. 15 (September 1987): 35–41, 38.

45. Albert Béguin, quoted in Peter Brooks, *The Melodramatic Imagination: Balzac, Henry James, Melodrama, and the Mode of Excess* (New York: Columbia University Press, 1985) p. 125.

46. The contrast between light and dark may have contributed to Julius Meier-Graefe's disparaging perception of *Interior* as a "theatrical" painting. See Julius Meier-Graefe, *Degas* (1920), trans. J. Holroyd Reece (New York: Dover Publications, 1988), pp. 21–22.

47. Degas made a number of remarks in his notebooks of this period about the effects of artificial light. The relevant studies and comments are in Degas's Notebook 23, p. 45. See Theodore Reff, *The Notebooks of Degas*, 2 vols. (Oxford and London: Oxford University Press, 1976).

48. See Sennett, *The Fall of Public Man*, pp. 167 and 174.

49. On how audiences became cued to respond to such subtleties, see ibid., pp. 257–333.

50. See Detroit Institute of Arts, *French Painting 1774–1830: The Age of Revolution* (Detroit: Wayne State University Press, 1975), pp. 345–47, for Robert Rosenblum's discussion on the romantic iconography of melancholy.

51. There are similarities to the kind of passivity that Michael Fried discusses in *Absorption and Theatricality: Painting and Beholder in the Age of Diderot* (Berkeley and Los Angeles: University of California Press, 1980). Degas's protagonist, however, is *intent* upon experiencing a psychological state that remains unknown to us, a quality that imparts more tension to both her figure and our response to it.

52. T. J. Clark, "Freud's Cézanne," *Representations,* no. 52 (Fall 1995): 111.

53. Reff, *Degas,* pp. 208–9, minimizes the connection of this drawing to the final image, pointing out that infrared light shows it is executed with far less finish than the figure of the man alongside. This does not detract from the idea that Degas experimented with, and rejected, a number of conceptions, however. In fact, given the close resemblance between the man in the oil study and the protagonist of the final work, it is possible that Degas remained undecided about his conception until the painting was well under way.

54. Jean Sutherland Boggs, *Drawings by Degas,* exh. cat. (St. Louis and Philadelphia: Philadelphia Museum of Art, 1966), unequivocally relates this study to *Interior* (p. 90).

55. Georges Teyssot, "The Disease of the Domicile," *Assemblage,* no. 6 (June 1988): 73–97, 92.

56. Guy de Maupassant's fanciful "observations" are quoted by Teyssot, ibid., p. 91.

57. Anon., "La Vie de la Forme," *l'Artiste,* no. 2 (1858): 156–57. The entire passage reads: "Les molécules-soeurs, séparées par la force arbitraire de l'homme, ne cèdent spontanément qu'à la douce loi de l'attraction. Mises en liberté, elles se réjoignent et forment entre elles des symphonies plastiques, des groupes mélodieux. Vivant d'une vie indépendante, animée d'une âme personnelle, elles n'obéissent qu'à une seule loi: l'amour; elles ne poursuivent qu'un but, et l'atteignent sans efforts, le beau; et c'est ainsi que, belles et amoureuses, elles s'unissent naturellement dans l'harmonie du vrai."

58. Elaine Scarry, *The Body in Pain: The Making and Unmaking of the World* (Oxford and New York: Oxford University Press, 1985), p. 306.

59. Ibid., pp. 289, 290, and 317.

60. Corsets were not generally worn by working-class women in the mid-nineteenth century. In fact, in *Cousine Bette* (1837), Balzac made a great deal of the moment when the ambitious dress designer dons a corset, the symbol of her entry into the fashionable class. For the passage, see Honoré de Balzac, *Cousine Bette* (Paris: Garnier-Flammarion, 1977), p. 141.

61. Grappe, *Degas,* p. 27.

62. Hollis Clayson has noted that "the abandonment of stays had long been a symbol of female dishonor, of taking leave of social decencies"; "Avant-Garde and Pompier Images of Nineteenth-Century French Prostitutes: The Matter of Modernism, Modernity and Social Ideology," in *Modernism and Modernity: The Vancouver Papers,* ed. Benjamin Buchloch, Serge Guilbaut, and David Solkin (Halifax: The Press of the Nova Scotia College of Art and Design, 1983), pp. 43–64, 56.

63. Degas's remark is quoted in Ambroise Vollard, *Degas: An Intimate Portrait,* trans. Randolph T. Weaver (New York: Crown Publishers, 1937), p. 71. Gervex's *Rolla* is illustrated in S. Hollis Clayson, *Painted Love: Prostitution in French Art*

of the Impressionist Era (New Haven and London: Yale University Press, 1991), p. 89, fig. 43.

64. Clayson, "Avant-Garde and Pompier Images of Nineteenth-Century Prostitutes," p. 56. She writes: "The body, irrespective really of its style, of its precise features, is more or less automatically eroticized by the abandoned, cheap and showy corset."

65. On Degas's preoccupation with dress and undress, see Armstrong, *Odd Man Out*, p. 166. Also see June Hargrove, "Degas's *Little Dancer* in the World of Pantomime," *Apollo*, vol. 147 (February 1998): 15–21; and Richard Kendall, *Degas and the Little Dancer* (New Haven and London: Yale University Press, in assoc. with the Joslyn Art Museum, Omaha, Nebraska, 1997).

66. Marcia Pointon, *Naked Authority: The Body in Western Painting 1830–1908* (Cambridge and New York: Cambridge University Press, 1991), p. 119 and 14.

67. For Armstrong, the man's gaze is the main activity of the painting. See her "Degas and the Female Body," pp. 223–42, 229.

68. Tissot's note is reprinted and illustrated in Theodore Reff, *Degas: The Artist's Mind*, pp. 226–27. Also see Boggs et al., *Degas*, pp. 144–46.

69. For imagery of the seamstress in contemporary prints, see Beatrice Farwell, *The Cult of Images*, and idem, *French Popular Lithographic Imagery 1815–1870*. See Grappe, *Degas*, p. 7, on the man's "bestiality."

70. Camille Mauclair, *Degas* (Paris: R. Piper, 1924), p. 31. Other like-minded interpretations include Arsène Alexandre's in "Degas" (1935); and Meier-Graefe, *Degas* (1920).

71. Armstrong calls the box a valise. See Armstrong, "Edgar Degas and the Representation of the Female Body," p. 228.

72. See Farwell, *The Cult of Images*, for related illustrations.

73. Michael Fried understands the pose of the woman in Greuze's painting as an expression of "absorption." See his *Absorption and Theatricality*, pp. 57–58.

74. An engraving of the painting of *Phryné*, now lost, is illustrated in T. J. Clark's *The Painting of Modern Life: Paris in the Art of Manet and His Followers* (New York: Alfred Knopf, 1985), p. 114.

75. The beleaguered seamstress appears frequently in English narrative painting. The best-known rendition was Richard Redgrave's *The Sempstress* (1846; New York, Forbes Magazine Collection).

76. Nathaniel Hawthorne, *The Marble Faun* (1860; reprint, New York, 1961), p. 246. I thank Molly Gwinn for bringing this passage to my attention.

77. See *The Macchiaioli: Painters of Italian Life 1852–1900*, exh. cat. (Los Angeles: Frederick S. Wight Art Gallery, UCLA, 1986), pp. 74 and 91; and Norma Broude, *The Macchiaioli: Italian Painters of the Nineteenth Century* (New Haven and London: Yale University Press, 1987). Degas knew the painters of this group and was particularly close to the critic within their circle, Diego Martelli. It was Peter Reed who first showed me the Ceccioni painting, and Carole Paul who arranged for it to be photographed in Rome. I thank them both.

78. See Boggs et al., *Degas*, p. 146.

79. See Reff, *Notebooks of Degas*, Notebook 45, p. 17.

80. Degas might have called his sewing box "an accessory symbol," a phrase that appears in his notebooks of this period. See Reff, *Notebooks of Degas*, Notebook 23, p. 44, for "symboles d'accessoire quelquefois." For other remarks along this line, see ibid., Notebook 23, p. 46.

81. Gaston Bachelard, *The Poetics of Space,* trans. Maria Jolas, foreword by Etienne Gilson (Boston: Beacon Press, 1958), p. 85.

82. Ludmilla Jordanova, *Sexual Visions: Images of Gender in Science and Medicine between the Eighteenth and Twentieth Centuries* (Madison: University of Wisconsin Press, 1985), quoted by Laura Mulvey in "Pandora: Topographies of the Mask and Curiosity," in Beatriz Colomina, *Sexuality and Space* (New York: Princeton Architectural Press, Princeton Papers on Architecture, 1992), pp. 53–72, 61, and 96–97.

83. "L'Art, c'est le vice. On ne l'épouse pas légitimement, on le viole. Que dit Art dit Artifice. L'Art est malhonnête et cruel"; quoted in, among other places, F. Sevin, "Degas à Travers Ses Mots," *Gazette des Beaux Arts,* vol. 86, no. 1 (1975): 36.

84. Janet Malcolm, "Reflections; j'appelle un chat un chat," *The New Yorker,* April 20, 1987, pp. 84–102, 98.

85. Sigmund Freud, quoted in Peter Gay, ed., *The Freud Reader* (New York and London: W. W. Norton, 1989), from the "Fragment of an Analysis of a Case of Hysteria ('Dora')," pp. 172–239, 210. Freud wrote: "But a few days later she did something which I could not help regarding as a further step towards the confession. For on that day she wore at her waist – a thing she never did on any other occasion before or after – a small reticule of a shape which had just come into fashion; and, as she lay on the sofa and talked, she kept playing with it – opening it, putting a finger into it, shutting it again, and so on. I looked on for some time, and then explained to her the nature of a 'symptomatic act' " (p. 215).

86. See Charles Bernheimer and Clair Kahane, eds., *In Dora's Case: Freud-Hysteria-Feminism* (New York: Columbia University Press, 1985).

87. "If Freud's countertransference invested Dora with all the seductiveness and dangerousness of Eve, if he saw her not as the messed-up little Viennese teenager she was but as Original Woman, in all her beauty and evil mystery, it is no wonder that he treated her as he did," Janet Malcolm, "Reflections," p. 98.

88. Elaine Showalter, *Sexual Anarchy: Gender and Culture at the Fin de Siècle* (New York: Penguin Books, 1990), p. 137.

89. Laura Mulvey in "Pandora," p. 57.

90. On Degas's unmarried state, see McMullen, *Degas,* pp. 261–83. On Degas and the Goncourts' novel, see idem, pp. 130–31.

91. As Showalter has put it: "There's more than a hint in this language of sexual assault, but also of rational penetration. If Dora's 'case,' like Pandora's box, held the secrets of female sexuality, Freud's key – the new science of psychoanalysis – could unlock it." She quotes Freud: "No one who disdains the key will ever be able to unlock the door" (*Sexual Anarchy,* p. 137).

92. Freud's note to Fleiss is reprinted in Gay, *A Freud Reader,* p. 22. Freud was of course not the first to associate the key or lock with male penetration. See, for instance, *Perspective of a Dutch Interior Viewed from a Doorway (The Slippers)* (ca. 1656; Paris, Musée du Louvre) by Samuel van Hoogstraten, illustrated in Celeste Brusati, *Artifice and Illusion: The Art and Writing of Samuel van Hoogstraten* (Chicago and London: University of Chicago Press, 1995), p. 364, fig. 50. My thanks to Lisa Vergara for bringing this image to my attention.

93. The Gavarni print was in Degas's own collection and was part of the *Lorette* series, but is not illustrated in the catalogue by Ann Dumas, Colta Ives, Susan Alyson Stein, and Gary Tinterow, *The Private Collection of Edgar Degas,* exh. cat. (New York: Metropolitan Museum of Art, 1997).

94. On Degas's social interactions during the 1860s, see McMullen, *Degas,* pp. 165–82.

95. For a discussion of the evolution of the formal suit in all its permutations, see Anne Hollander, *Sex and Suits* (New York: Alfred Knopf, 1994), p. 109.

96. Robert Nye, *Masculinity and Male Codes of Honor in Modern France* (New York and Oxford: Oxford University Press, 1993), p. 167.

97. Walter Ong, *Fighting for Life: Contest, Sexuality, and Consciousness* (Ithaca, N.Y.: Cornell University Press, 1981), p. 98; quoted in Robert Nye, ibid., p. 12. Ong writes that a man is always seeking his masculinity "in some way outside of himself."

98. Stephan Schindler, "What Makes a Man: The Construction of Masculinity in F. W. Murnau's *The Last Laugh,*" *Screen,* vol. 37, no. 1 (Spring 1996): 30–40, 36. Schindler extrapolates here from Klaus Theweleit, *Male Fantasies: Women, Floods, Bodies, History,* vol. 1, trans. Stephen Conway et al. (Minneapolis: University of Minnesota Press, 1987), pp. 3–228. Two intervening studies for the man are closely related to the final painting. For illustrations, see Reff, *Degas: The Artist's Mind,* p. 211, figs. 141 and 142.

99. Anne Hollander, *Sex And Suits,* p. 113. See also Schindler, "What Makes a Man," p. 35. Schindler writes, "The integrity of the male ego seems to rely entirely on the imago of his own intact body, a projection that allows him to deny his own social dependency."

100. Richard Sennett, in *The Fall of Public Man,* writes: "In silence, watching life go by, a man was at last free. . . . Passive silence in public is a means of withdrawal; to the extent that silence can be enforced, to that extent every person is free of the social bond itself," p. 212. See idem, pp. 205–18 on the *flâneur.* Also see Charles Baudelaire, *The Painter of Modern Life and Other Essays* (1863), trans. Jonathan Mayne (Oxford: Phaidon Press, 1964); Walter Benjamin, *Charles Baudelaire: Lyric Poet in the Era of High Capitalism* (London: New Left Books, 1973); and Janet Wolf, "The Invisible Flâneuse: Women and the Literature of Modernity," *Theory, Culture & Society,* vol. 2, no. 3, (1985): 37–46.

101. Sennett, *Fall of Public Man,* p. 195: "it is easily seen that the public man might feel more comfortable as a witness to someone's else's expression than as an active conveyor of expression himself."

102. Nye, *Masculinity,* p. 127. Sennett, in *Fall of Public Man,* writes: "A gentleman at home was an attentive person, especially to the needs of his wife. . . . The perception of a woman's looseness within the family was a perception of her behavior, not of giveaway clues in how she looked or dressed," p. 165.

103. For two brief discussions of this painting, see T. J. Clark, *The Painting of Modern Life,* pp. 257–58; and Susan Sidlauskas, "Contesting Femininity: Vuillard's Family Pictures," *Art Bulletin,* vol. 78, no. 1 (March 1997): 85–111, 103. McMullen, in *Degas,* claims that Michel-Lévy was the model for *Interior* but does not substantiate his claim (p. 160). The resemblance seems convincing, however.

104. See Armstrong, *Odd Man Out,* p. 32, on the domestic look of the *Portraits in an Office,* and pp. 27–38 on both the *Portraits in an Office* and the *Portraits in the Stock Exchange.* On the issue of anti-Semitism and the *Stock Exchange,* see Linda Nochlin, "Degas and the Dreyfus Affair: A Portrait of the Artist as an Anti-Semite," in *Essays on the Politics of Vision in Nineteenth-Century Art and Society* (New York: Harper and Row, 1989), pp. 141–69.

105. Nye, *Masculinity*, p. 67: "As we have seen, male sexual potency was a qualifying feature for full citizenship in the modern state."

106. Armstrong offers a convincing case for Degas's work, especially his later nudes, as evidence of a "structure of celibacy"; see Armstrong, "Edgar Degas and the Female Body," pp. 241–42. The best general discussion of the social context for celibacy among upper-middle-class Parisian males is found in McMullen, *Degas*, pp. 261–83.

107. McMullen recounts Degas's remark to Vollard: "Oh, with me things were different. I was too afraid that after I had finished a picture I would hear my wife say, 'What you've done there is very pretty indeed' " (*Degas*, p. 264).

108. Nye, *Masculinity*, p. 129. Sennett, in *The Fall of Public Man*, points out that "a plunge into the psychic depths was not the purpose of pre-Freudian medicine. 'Mastery' was the purpose. Tension resulting in the family through the fear of involuntary expression of feeling dictated control of surface behavior through self-consciousness" (p. 183).

109. See Reff, *Degas*, pp. 217–20, for a discussion of physiognomic theories relevant to the *Interior*, and p. 329, n. 76, and 82, for references to Caspar Lavater. Cesare Lombroso first issued his classic study *L'Uomo delinquente* in 1876 in Turin. His descriptions of the criminal physiognomy offer to some degree an interesting parallel to Degas's representation, as both Reff in *Degas*, p. 220, and Armstrong in *Odd Man Out*, p. 186, point out. Also see Louis-Edmond Duranty, "Sur Physionomie," *La Revue Libérale*, July 25, 1867, pp. 499–523. Duranty wrote, "la parôle est menteuse, l'action est hypocrite et la physionomie est trompeuse" (523). Reff believes that Degas's *Sulking* (ca. 1869–70; New York: Metropolitan Museum of Art), which portrays a scowling Duranty and an impassive Emma Dobigny, the likely model for *Interior*, was an attempt to visualize modern physiognomies. See Reff, *Degas*, pp. 116–18, for a discussion of the painting.

110. Lombroso's ideas were circulated quite widely before they were published in Italy in 1876. He lectured throughout Europe from the late 1860s on.

111. On the satyr, see Caspar Lavater, *Essays in Physiognomy*, trans. T. Holcroft (London: Ward, Lock, and Bowden, 1880), p. 205.

112. Honoré Daumier, *Intellectuelles (Bas Bleus) et Femmes Sociales*, (orig. 1844; reprint, Paris: Editions Vilo, 1974), p. 12. My thanks to John McCoubrey for pointing this out to me.

113. Nye, *Masculinity*, p. 106.

114. On the "lewd white speck" see Grappe, *Degas*, p. 52, and Reff, *Degas*, pp. 217–18. Delsarte was a professor of music and oratory: *Système de François Delsarte* (Paris: n.d. [before 1877]). In his notebook of this period, Degas made a note to himself: "Etudier les observations de Delsarte sur les mouvements passionnelles de l'oeil," quoted in Reff, *Notebooks of Degas*, Notebook 23, p. 44.

115. On the gaze of the male protagonist, see Armstrong, "Edgar Degas and the Female Body," pp. 228–29. Also see Nye, *Masculinity*, p. 114.

116. It may be relevant that the only recorded note we have of Degas's own apparently limited sexual experience revolves around the sensation of shame: "I cannot say how much I love this girl since she turned me down on Monday, 7 April. I cannot refuse to . . . say it is shameful . . . [illegible] a defenceless girl." This remark is recorded in Reff, *Notebooks of Degas*, Notebook 6, BN, Carnet II, p. 21. It is also quoted in Boggs et al., *Degas*, p. 146.

117. Mark Wigley, "Untitled: The Housing of Gender," in Beatriz Colomina, *Sexuality and Space*, pp. 326–389, 388.
118. Nye, *Masculinity*, p. 10.

Chapter Three: Sargent's Interior Abysses

1. On the history of the commission, see Stanley Olson, *John Singer Sargent: His Portrait* (New York: St. Martin's Press, 1986), pp. 98–99. Also see Albert Boime, in Patricia Hills et al., *John Singer Sargent*, exh. cat. (New York: Whitney Museum of American Art, with Harry N. Abrams, 1986), "Sargent in Paris and London: A Portrait of the Artist as Dorian Gray," pp. 75–109, an account of Sargent's circle in Paris, which included Count Montesquiou and Oscar Wilde. For a biographical sketch of Edward Boit, see Trevor J. Fairbrother, "John Singer Sargent and America" (Ph.D. diss., Boston University, 1981), p. 193. Boit's papers are now in the collection of the Archives of American Art in Washington, D.C. They include letters to his parents from Europe between 1866 and 1867; his diaries from 1885–94 and 1901–8; and three incomplete drafts of a manuscript called "How I Came to Paint." See also the biography of the extended Boit family by Robert Apthorp Boit, *The Boit Family and Their Descendants* (Boston: S. J. Parkhill & Co., 1915). On Sargent's Boit portrait, see James Lomax and Richard Ormond, *John Singer Sargent and the Edwardian Age* (Leeds, Eng.: Leeds Art Gallery, 1979), p. 29, and Richard Ormond and Elaine Kilmurry, *John Singer Sargent: The Early Portraits. Complete Paintings,* vol. 1 (New Haven and London: Yale University Press, The Paul Mellon Centre for Studies in British Art, 1998). I would like to thank Georges Teyssot, who offered some penetrating comments about the material in this chapter at the Buell Center for American Architecture, Columbia University. I appreciate Joan Ockman's invitation to speak there. At Bryn Mawr College, Steven Levine raised very acute questions about this moment of painting in Paris – questions I am still pondering. My thanks to David Cast for extending the invitation to give a colloquium there.
2. John McCoubrey, *The American Tradition in Painting,* 1st ed. (New York: George Braziller, 1963), p. 39, 2d ed. (Philadelphia: University of Pennsylvania Press, 2000).
3. Henry James, "John Singer Sargent," in *The Painter's Eye. Notes and Essays on the Pictorial Arts,* selected by John Sweeney (London: R. Hart-Davis, 1956).
4. Henry James, *The American Scene* (1907; reprint, Bloomington: Indiana University Press, 1968), pp. 15–16. This passage is quoted in Judith Fryer, *Felicitous Space: The Imaginative Structures of Edith Wharton and Willa Cather* (Chapel Hill and London: University of North Carolina Press, 1986), p. 19. James's observation is contemporary with the development of the open-plan in American architecture. See Vincent Scully, *The Shingle Style* (New Haven, Conn.: Yale University Press, 1955). Thanks to David Brownlee for suggesting this connection.
5. I borrow the phrase "spatial envelope" from Edward Hall, as quoted in Judith Fryer, *Felicitous Space,* p. 49. Fryer writes: "Hall believes that each of us has a spatial envelope: an internalization of fixed space learned early in life, a mold into which a great deal of behavior is cast. Linking space and behavior, he sees one's orientation in space as ultimately tied to survival and sanity: to be disoriented in space is to be psychotic." For the seminal study on children and space, see Jean Piaget and Barbel Inhelder, *The Child's Conception of Space* (London: Routledge

and Kegan Paul, 1956). More recent studies on this theme include Christopher Spender, Mark Blades, and Kim Morsley, *The Child in the Physical Environment: The Development of Spatial Knowledge and Cognition* (Chichester, Eng., and New York: John Wiley and Sons, 1989); Susanna Millar, *Understanding and Representing Space: Theory and Evidence from Studies with Blind and Sighted Children* (Oxford: Clarendon Press, Oxford Science Publications, 1994).

6. See Emily Cahan, Jay Mechling, Brian Sutton-Smith, and Sheldon H. White, "The Elusive Historical Child: Ways of Knowing the Child of History and Psychology," in Glenn Elder, John Modell, and Ross D. Parke, *Children in Time and Place: Developmental and Historical Insights* (Cambridge and New York: Cambridge University Press, 1993), pp. 192–223, 192. The authors write: "The ubiquitous presence of children in our everyday worlds and the power of the memories of our own childhoods conspire to make the child deceptively familiar to us. Both the scientific understanding of the 'natural child' inherited from the eighteenth and nineteenth centuries and our twentieth-century commonsensical, folk psychology of the child hold that childhood is a human constant."

7. For a summary of recent research across fields, see Glen Elder, John Modell, and Ross D. Parke, "The Workshop Enterprise," in Elder et al., *Children in Time and Place,* pp. 173–92.

8. Ludmilla Jordanova, "New Worlds for Children in the Eighteenth Century: Problems of Historical Explanation," *History of the Human Sciences,* vol. 3, no. 1 (1990): 69–83, 79.

9. Marcia Pointon, *Hanging the Head: Portraiture and Social Formation in Eighteenth-Century England* (New Haven and London: Yale University Press, Paul Mellon Centre for Studies in British Art, 1993), p. 206. See especially chapter 7, "The State of a Child," pp. 177–217.

10. Carolyn Steedman, *Strange Dislocations: Childhood and the Idea of Human Interiority, 1780–1930* (Cambridge, Mass.: Harvard University Press, 1995), p. 7.

11. Ibid., pp. 170, 172.

12. Karin Calvert, *Children in the House: The Material Culture of Early Childhood, 1600–1900* (Boston: Northeastern University Press, 1992), p. 152. Calvert writes, "Childhood fit nicely into this romantic pattern . . . it was something bright and fleeting to be cherished while it lasted."

13. Steedman, *Strange Dislocations,* p. 172. See also David Lubin, *The Act of Portrayal: Eakins, Sargent, James* (New Haven and London: Yale University Press, 1985). His introduction includes an insightful discussion of the climate after the Civil War, in which what constituted a "masculine" or "feminine" temperament was much debated.

14. On the Venetian paintings, see Marc Simpson, "Away for Venice 1880–1882," in Marc Simpson, with Richard Ormond and H. Barbara Weinberg, *Uncanny Spectacle: The Public Career of the Young John Singer Sargent,* exh. cat. (New Haven and London: Yale University Press, with the Sterling and Francine Clark Art Institute, 1997), pp. 95–110. For a reproduction of Sargent's copy of *Las Meniñas,* see Carter Ratcliff, *John Singer Sargent* (New York and London: Artabras, 1990), p. 77, fig. 108.

15. Robert Alan Mowbry Stevenson, *Velázquez* (1895; repr. London: George Ball, 1899), p. 51.

16. On Sargent's early career, see esp. Marc Simpson, "Sargent and His Critics," in Simpson et al., *Uncanny Spectacle,* pp. 30–69.

17. J. Bertrand's *Marguerite and Faust* is now lost. A wood engraving of the painting is illustrated in *The Chefs d'Oeuvres d'Art of the International Exhibition* (Philadelphia: Gebbie and Barrie, 1878), p. 131.

18. On the portrait of *Mme. Edouard Pailleron,* see Simpson et al., pp. 91–92; on the portrait of *Edouard and Marie-Louise Pailleron,* see Simpson et al., p. 133. Also see Ormond and Kilmurray, *The Early Portraits,* pp. 51–54, for a discussion of the children's portrait, and pp. 45–47 for a discussion of *Madame Edouard Pailleron* and *Edouard Pailleron.*

19. For settings for *cartes de visites* of the second half of the century, see esp. Elizabeth Anne McCauley, *A. A. Disdéri and the Carte de Visite Portrait Photograph* (New Haven and London: Yale University Press, 1985).

20. Sargent may not have known of the Bellelli portrait, as Degas kept it in his studio. The painting was exhibited from April 15 to June 5, 1867, Salon no. 444 or 445, as *Portrait de Famille.* See Jean Sutherland Boggs et al., *Degas* (New York: Metropolitan Museum of Art, 1988), p. 82.

21. For a discussion of child portraits during the eighteenth century, see Pointon, *Hanging the Head,* pp. 177–217. For a more recent appraisal of the representation of childhood, see Anne Higonnet, *Pictures of Innocence: The History and Crisis of Ideal Childhood* (London: Thames and Hudson, 1998). Also see Anne Higonnet and Cassi Albinson, "Clothing the Child's Body," *Fashion Theory,* vol. 1, no. 2 (June 1997): 119–44.

22. Examples include Thomas Eakins's *Baby at Play* (1876; Washington, D.C., National Gallery of Art); and Mary Cassatt's *The Bath* (1910; Paris, Musée du Petit Palais) and *In the Garden* (1893; Baltimore, Baltimore Museum of Art, Cone Collection). Sargent also had the examples of Berthe Morisot's *Hide and Seek* (1873; New York, Collection of Mrs. John Hay Whitney), which was exhibited in Paris in the first Impressionist exhibition of 1874, and Pierre-Auguste Renoir's *Madame Charpentier and Her Children* (1878; New York, Metropolitan Museum of Art), which was shown in 1880.

23. On Tissot, see Russell Ash, *James Tissot* (New York: Harry N. Abrams, 1992); and Christopher Wood, *Tissot: The Life and Work of James-Jacques Tissot, 1836–1902* (Boston: Little, Brown, 1986). Also see *James Tissot,* exh. cat. (London: Phaidon Press, and Barbican Art Gallery, 1984), ed. Krystyna Matyjaszkiewicz, organized by the Barbican Art Gallery in association with the Arts Council of Great Britain and the Musée du Petit Palais, Paris.

24. See Olson, *John Singer Sargent,* p. 5.

25. Ibid., pp. 6–7. On the collective feeling of shame shared by an entire family for the deformity or disability of one member, see Calvert, *Children in the House,* p. 138. Calvert writes: "This, then, was the era when parents hid retarded, deformed, demented, and handicapped children in attics and cellars; this was why the revelation of an imperfect child could destroy wedding prospects for a healthy sibling. A single child's deficiency became the entire family's guilt and shame."

26. Olson, *John Singer Sargent,* p. 6.

27. Edward Darley Boit Papers, Archives of American Art, Washington, D.C. In a letter of October 1, 1867, Boit relates – in great detail – a harrowing tale of his ministrations to his wife (whom he called "Isa") as he attended the birth of their second child. Sadly, neither of these two children would survive. His later diaries are full of references to his children, and to activities he enjoyed with them. For psychological theories about children from the period, see William Preyer, *The Mind of the Child: Part I, The Senses and the Will* and *Part II, The Development of the*

Intellect, trans. H. W. Brown (New York: D. Appleton and Co., 1889); and James Sully, *The Human Mind. A Text-Book of Psychology,* vols. 1 and 2 (New York: D. Appleton and Co., 1892).

28. In a diary entry, Boit worriedly noted the cold of his youngest daughter, Julia, and lamented the protracted illness ("twenty-six days") of her older sister Mary Louisa (who was called "Little Isa"). He then recorded the restorative walks he took with both girls on the Boston Common (diary entries for the week of January 5, 1885). Mrs. Boit's absence from the painting has been much remarked upon. See, for example, Lubin, *Act of Portrayal,* pp. 106–7. Mrs. Boit would die relatively young in 1894, after a long illness. Sargent painted her portrait in 1888 (*Mrs. Edward D. Boit,* Boston, Museum of Fine Arts), and her robustness, modeled after the work of Frans Hals, is in striking contrast to the dark solemnity of her daughters' portraits.

29. Henry James is quoted in Leon Edel, *Henry James: The Middle Years, 1882–1895* (New York: Avon Books, 1978), p. 44. For Robert Apthorp Boit's comments on his aunt, Mary Louisa, see Robert Boit, *The Boit Family,* p. 123.

30. On the family lineage for both the Boits and the Cushings, Mary Louisa's family, see Robert Boit, *The Boit Family,* pp. 119–30. Edward D. Boit graduated from Harvard in 1863 and married Mary Louisa Cushing, daughter of John Peck Cushing of Boston, a year later. Mr. Cushing was a successful merchant who had come "back from the East with a large fortune" (p. 22). The Cushings' estate, called "Belmont," gave the suburban town near Boston its name.

31. From an anonymous etiquette book of 1887, quoted in Mary Cable, *The Little Darlings: A History of Child-Rearing in America* (New York: Scribner's, 1972), pp. 132 and 137.

32. James Mark Baldwin, *Mental Development in the Child and the Race* (1894; reprint, New York: Macmillan, 1906), p. 347.

33. Pointon, *Hanging the Head,* p. 178.

34. On this point, see esp. Lubin, *Act of Portrayal,* pp. 107–17. While I disagree with Lubin's interpretation of *The Daughters of Edward Darley Boit,* I have learned much from his insightful observations about the painting itself and about its relation to nineteenth-century practices of portraiture.

35. Henry James, "John S. Sargent," p. 222.

36. Arthur Baignères, "Première Exposition de la Société Internationale de Peintres et Sculpteurs," *Gazette des Beaux-Arts,* vol. 27, 2d pér. (1883): 187–91, 189: "Imaginez une salle trés grande et trés noire qu'éclaire un jour de côté; pour tout mobilier, deux énormes potiches, et pour habitants quatre petites filles." Henry Houssaye famously disliked the arrangement, insisting that it was "composed according to some new rules, the rules of the four-corners game"; Houssaye, "Le Salon de 1883," *Revue des Deux Mondes,* no. 57 (June 1883): 597. For a full bibliography of contemporary criticism, see Carter Ratcliffe, *John Singer Sargent.* For a discussion of the square format in general, see William Gerdts, "The Square Format and Proto-Modernism in American Painting," *Arts Magazine,* vol. 50, no. 10 (June 1976): 70–75.

37. Baignères, "Première Exposition," p. 9.

38. Anonymous, *Art Amateur,* quoted in Fairbrother, "John Singer Sargent and America," p. 67.

39. Henry James, "John S. Sargent," p. 222.

40. Here I agree with Lubin, who also emphasizes the stages of the girls' development. See Lubin, *Act of Portrayal,* pp. 113–14.

41. As Mrs. Boit's father was a merchant and importer whose fortune had been made in "the East," it is likely that the vases had belonged to him. He died before his daughter married Edward Boit. The family has recently donated the vases to the Museum of Fine Arts, Boston. My thanks to Erica Hirshler and Janet Comey of the Department of American Painting and Decorative Arts at the MFA for sharing their observations about Sargent and the painting with me.

42. Henry James, "John S. Sargent," p. 222.

43. In a letter of June 18, 1866, Boit describes in great detail how the dining room of the Newport house is going to look. He cites the Axminster carpet that has been ordered in the shape of the room, sized to leave a space of eighteen inches between the rug's border and the walls. The rug was to have a dark-blue ground and an arabesque border of blue and red.

44. In his letters, Boit comments often and at length about overcast days (for example, on October 4 and 5, 1868) and notes dark places – a museum gallery, a barbershop – in his diaries (during the first two weeks of January 1885 and February 27, 1890). On Boit's relief at the painting's lighting, see the painting file, Department of American Painting and Decorative Arts, Museum of Fine Arts, Boston. Erica Hirshler of the MFA suggested helpful references on the education of upper-class girls. She also informed me about the career of Julia Boit, who became a watercolorist and illustrator of children's books.

45. James Sully, *Outlines of Psychology* (New York: D. Appleton and Co., 1885), pp. 459 and 486.

46. César Daly, "Villa Choissy," *Revue Générale de l'Architecture*, no. 32 (1875): 274: "Une idée suivie à travers les âges, les races et les pays, c'est une idée sortant des ténèbres et entrant dans la lumière. Le contraste de ces ténèbres et de cette lumière donne la mesure du progres accompli. La Maison du sauvage c'est l'ombre; la Maison de Croissy c'est la lumière, et cette lumière rayonne d'un éclat d'autant plus vif que cette ombre est plus profonde. Etudiez donc la série historique des habitations, et mettez chaque cas particulier à sa place dans la série, ce n'est pas notre illustre ami M. Duc qui aura à s'en plaindre."

47. Here, I am following Anthony Vidler's definition of the "architectural uncanny." Anthony Vidler, *The Architectural Uncanny: Essays in the Modern Unhomely* (Cambridge, Mass., and London: MIT Press, 1992), pp. ix–x. See also ibid., pp. 3–44, for an elaboration of the idea and notes on its earliest manifestations.

48. Ibid., p. 167.

49. Ibid., pp. 169–73, on Boullée's "dark space." On Piranesi's manipulation of space, see Sergei Eisenstein, "Piranesi: Or the Fluidity of Forms," trans. Roberta Reeder, *Oppositions*, no. 2 (Winter 1977): 83–110.

50. Vidler, *Architectural Uncanny*, p. 171. See ibid., p. 166, for a characteristic design by Boullée.

51. Henry James, "The Jolly Corner," in *The Short Stories of Henry James*, ed. Clifton Fadiman (New York: The Modern Library, 1945), pp. 630–31 and 632.

52. Henry James, *What Maisie Knew* (1897; reprint, Harmondsworth: Penguin Books, 1966), pp. 9–10.

53. Edith Wharton, *A Backward Glance* (New York: D. Appleton and Co., 1934), p. 57. Wharton wrote: "The child of the well-to-do, hedged in by nurses and governesses, seldom knows much of its parents' activities. I have only the vaguest recollection of the way in which my father and mother spent their days." The doctor's comment is from Dr. Helen Willison Brown, "The Deforming Influence of

the Home," *Journal of Abnormal Psychology*, vol. 12 (April–May 1917): 49–57, 51–52.

54. On Chase's early training and travels, see Katherine Metcalf Roof, *The Life and Art of William Merritt Chase* (New York: Charles Scribner's and Sons, 1917). See also Ronald Pisano, *William Merritt Chase: In the Company of Friends*, exh. cat. (Southampton, New York, and Detroit: Parrish Art Museum and the Detroit Institute of Arts, 1979); and *The Quest for Unity: American Art between the World's Fairs, 1876–1893*, exh. cat. (Detroit: Detroit Institute of Art, 1983), p. 96, for an excellent discussion of *Hide and Seek* by Kathleen Pryce. Chase's painting also recalls Robert Louis Stevenson's remark that "Children are ever content to forego what we call the realities, and prefer the shadow to the substance," from "Child's Play," in *The Travels and Essays of Robert Louis Stevenson: Virginibus Puerisque. Memories and Portraits* (New York: Charles Scribner's and Sons, 1989), p. 144. Stevenson also believed that hide-and-seek "has so pre-eminent a sovereignty," because "it is the well-spring of romance, and the actions and the excitement to which it gives rise lend themselves to almost any sort of fable" (ibid., p. 146).

55. Wolfgang Kemp, "Death at Work: A Case Study on Constitutive Blanks in Nineteenth-Century Painting," *Representations*, no. 10 (Spring 1985): 102–23, 114–16.

56. Eisenstein, "Piranesi," p. 95. Eisenstein writes, "The play of chiaroscuro – the collision of luminescent projections with the ruins of gaping darkness between them – changes into independent spots no longer of light and dark, but of corporeally applied dark and light colors." Also see Eisenstein, "Montage and Architecture" (intro. by Yve-Alain Bois), *Assemblage*, no. 10 (December 1989): 111–31.

57. Olson, *John Singer Sargent*, pp. 6–7.

58. Ibid., p. 81.

59. Robert Boit, in *The Boit Family*, writes, "There are four living daughters of this marriage and there were several children that died young" (p. 125).

60. Olson, *John Singer Sargent*, p. 83.

61. Boit laments the dullness of his daily life both in an early letter to his parents of October 5, 1868, and in a diary entry for Sunday, January 1885; Archives of American Art, Edward Darley Boit Papers.

62. See Calvert, *Children in the House*, p. 15. Calvert writes: "In both a material and a grammatical sense, children have usually been regarded as objects. Traditionally, they were the possessions of their parents, to be dealt with as parents thought best."

63. David Lubin characterizes the figure of Julia, whom he calls "J," in this way: "She is seated while the other girls are standing. This may signify privilege. She appears to be considered special: she sits enthroned" (p. 86).

64. Lubin, *Act of Portrayal*, p. 88.

65. See Calvert, *Children in the House*, pp. 32–33, on the "standing stool"; see p. 34 for a discussion of "stocks" for infants, and p. 35 for a description of "leading strings," which allowed parents to manipulate their infants as if they were puppets.

66. W. B. Drummond, *Introduction to Child Study* (London: Arnold Press, 1907), p. 85.

67. See Calvert, *Children in the House*, p. 76. Around mid-century, Calvert recounts: "one older woman wondered how young mothers endured their babies' crying. She confided that she herself had relied on gin: 'There's nothing like it for the colic' " (p. 77).

68. On the equivocal nature of dolls, see Calvert, ibid., pp. 6–7, 50–52, 116–19. Lubin, *Act of Portrayal,* interprets the doll very differently, describing it as a "buffer zone" that "protectively blocks from our gaze and the revealing light . . . J's pudendum, as though to disclaim it, deny it, foreswear its existence" (p. 86).

69. On doll funerals, see Miriam Formanek-Brunell, "Sugar and Spite: The Politics of Doll Play in Nineteenth-Century America," in Elliott West and Paula Petrik, eds., *Small Worlds: Children and Adolescents in America, 1850–1950* (Lawrence: University Press of Kansas, 1992), pp. 107–24, esp. 116. See also Mary Lynn Stevens Heininger, Karin Calvert et al., *A Century of Childhood 1820–1920,* exh. cat. (Rochester, N.Y.: The Margaret Woodbury Strong Museum, 1984).

70. Formanek-Brunell, "Sugar and Spite," p. 117.

71. See Calvert, *Children in the House,* pp. 6 and 50–51.

72. Preyer, *Mind of the Child,* vol. 2, pp. 194–95.

73. Sully, *Outlines of Psychology,* p. 204. Sully writes: "A child's body is an object which he can touch and see, like an external thing. The whole of the surface can be explored by the hands, and a good part of it by the eyes as well." He adds, "A knowledge of externality in the sense of detachment from the independence of percipient mind is only attained much later, in connection with that of the permanence of objects."

74. Ibid., p. 182. Sully writes that "the visual perception of depth is developed in conjunction with, and by the aid of tactual perception." He also observed that "a moment's thought will show that the experiences of early life must tend to bring about the closest possible associations between sight and touch, and to favour that automatic interpretation of visual language which we find in later life" (p. 196). See also John Eliot, Neil Salkind, and Charles Thomas, eds., *Children's Spatial Development* (Springfield: University of Illinois Press, 1975). Preyer (*Mind of the Child,* vol. 1, pp. 107–8) writes about how children's consciousness of time comes into being only when "to the original consciousness belonging to sensation is added the experience of succession and with that the consciousness of time; then the simultaneousness of the sensations of contact, and with this the consciousness of space, finally the consciousness of the causal connection of two or more contacts that have come to consciousness in time and space, and with this, the idea of the body touched."

75. Italics added. Henri Lefebvre, *The Production of Space,* trans. Donald Nicholson-Smith (Oxford, Eng., and Cambridge, Mass.: Blackwell Press, 1974). The author continues, "And, once that operation is complete, it must proceed to the perception and conceptualization of space" (p. 294).

76. Today, cognitive psychologists consider the age of eight to mark the stage when children are able to balance on their own in space without visual cues from their surrounding environment. See Millar, *Understanding and Representing Space,* p. 39.

77. Here I note that her usually complacent father had a famous temper when he was not obeyed. As Edward Boit's nephew would later write about him: "He had great self-control and self-possession, but when his indignation was once aroused, the wise kept quiet. My brother John used to say, 'When you see Ned's eyes growing *beady,* look out for yourself' "; Robert Boit, *The Boit Family,* p. 130.

78. Lubin, *Act of Portrayal,* p. 90, makes a similar observation about Mary Louisa, whom he calls "A."

79. Maurice Merleau-Ponty, "Leçons du 1949," *Bulletin de Psychologie,* vol. 18, nos. 2–3 (1964): 109, quoted in Maria D'Alessio, "Social Representations of Childhood: An Implicit Theory of Development," in Gerard Duveen and Barbara

Lloyd, eds., *Social Representations and the Development of Knowledge* (Cambridge and New York: Cambridge University Press, 1990), pp. 70–71.

80. Millar, *Understanding and Representing Space*, p. 39.

81. See Steedman, *Strange Dislocations*, pp. 126, 141, and 147.

82. On Degas's sculpture, see June Hargrove, "Degas's *Little Dancer* in the World of Pantomime," *Apollo*, vol. 147 (February 1998): 15–21; and Richard Kendall, *Degas and the Little Dancer*, exh. cat. (New Haven and London: Yale University Press, with the Joslyn Art Museum, Omaha, Nebraska, 1997). For a discussion of the dancer's physiognomy, see Anthea Callen, *The Spectacular Body: Science, Matter, and Meaning in the Work of Degas* (New Haven and London: Yale University Press, 1995); and George Shackelford, *Degas Dancers*, exh. cat. (Washington, D.C.: National Gallery of Art, 1984).

83. Paul Connerton, *How Societies Remember* (Cambridge and New York: Cambridge University Press, 1989), pp. 87, 73, and 74.

84. D. W. Winnicott, *Playing and Reality* (London: Tavistock, 1971), p. 96. Also see p. 51 for more discussion on the same theme.

85. Dr. Lewis, *Our Girls* (New York: Harpers and Bros., 1871), quoted in Lynne Vallone, *Disciplines of Virtue: Girls' Culture in the Eighteenth and Nineteenth Centuries* (New Haven and London: Yale University Press, 1995), p. 115.

86. Sully, *Outlines of Psychology*, vol. 2, pp. 98–99. He writes: "The feeling attaching to the bodily self, as 'nice' or 'pretty,' is analogous to the tender feeling the child has for its mother. Markedly different from this is the shade of self-feeling attaching to exhibitions of active power. The boy rejoices in his strength, and has in the realisation of his bodily powers a delightful consciousness of self, as expanding."

87. Lubin, *Act of Portrayal*, p. 92, believes that Florence, the fourteen-year-old who leans against the vase, anticipates the narcissism of the subject Sargent would paint a year later, Virginie Avegno Gautreau, in the portrait known as *Madame X* (1883; New York, Metropolitan Museum of Art). While both adolescent and young professional beauties do turn their profiles to the spectator, I believe it is rather Mary Louisa's carriage and sensual self-presentation that best anticipates those of Gautreau.

88. Sarah Cohen, *Art, Dance, and the Body in French Culture of the Ancien Régime* (Cambridge and New York: Cambridge University Press, 2000), p. 264. Cohen writes: "Watteau asks us to scrutinize this life-sized body but gives the body itself no resources with which to present itself. . . . The puffy eyes, reddened nose and slightly parted lips appear vacant and unplanned, and the arms hanging in their oversized sleeves come off as curiously inarticulate."

89. Pierre Mendousse, "L'Âme de l'adolescent," first published in Paris in 1909, quoted in John Neubauer, *The Fin-de-Siècle Culture of Adolescence* (New Haven and London: Yale University Press, 1992), p. 150. The first exhaustive study of adolescence published in English was Granville Stanley Hall's *Adolescence: Its Psychology and Its Relations to Physiology, Anthropology, Sociology, Sex, Crime, Religion and Education*, 2 vols. (New York: D. Appleton and Co., 1904). Hall, who is better known today as the person who brought Freud to America, began lecturing at Clark University in Worcester, Massachusetts, in the 1880s. Whereas Hall was concerned with the evolutionary aspects of adolescence as a symbol for the youth of humanity, French writers were said to be concerned with the "souls" of adolescents; see Neubauer, *The Fin-de-Siècle Culture of Adolescence*, pp. 149–50. Also see Winifred Richmond, *The Adolescent Girl* (New York: Macmillan and Co., 1928).

90. G. S. Hall, *Adolescence*, vol. 1, p. 313, quoted by Neubauer, *Fin-de Siècle Culture of Adolescence*, pp. 148–49. Hall wrote, "Many states that become trancoidal and absorptive are best described as the drunkenness of fancy, a state which may become habitual and passionate, but which, true to its secret nature, is unrevealed to others save in certain katatonic [*sic*] attitudes and a clumsiness to mundane re-actions, such as Plato ascribes to the true philosopher." Hall also wrote *Youth: Its Regimen and Hygiene* (New York: D. Appleton and Co., 1906). Also see E. Leigh Mudge, *Varieties of Adolescent Experience* (New York and London: The Century Co., 1926), p. 67: "Much of adolescent imagination is concerned with the future. It is a dream life, with the very practical end in view of making the dreams reali-ties. . . . In adolescence . . . his dreams and aspirations become more dynamic. They affect his very personality, so that the dream life furnishes dominant motives for his conduct."

91. Mudge, *Varieties of Adolescent Experience*, p. 75.

92. See Calvert, *Children in the House*, p. 123. Also, Vallone, *Disciplines of Virtue*, p. 124: "Around the turn of the century, some boarding schools for girls routinely gave their students a dose of calomel if they were in 'too robust health,' to make them more 'languid and listless' and 'lady-like.' "

93. William Alcott, quoted by Vallone, *Disciplines of Virtue*, p. 124.

94. Sully, *Outlines of Psychology*, vol. 2, p. 477.

95. Ibid.: "Young children are wont to project themselves in infancy to distant regions of space and to transform themselves into other objects. . . . This personifying of objects around him is based on his knowledge of his own double existence, bodily and mental" (pp. 322 and 378).

96. Herman Scheffauer, "The Vivifying of Space," in Lewis Jacobs, *Introduction to the Art of the Movies* (New York: Octagon Books, 1970), p. 77.

97. Ibid., p. 82. Scheffauer is here discussing the "film-play" *From Mourning to Mid-night*.

98. Eugène Minkowski, "Towards a Psychopathology of Lived Space," in *Lived Time: Phenomenological and Psychopathological Studies*, trans. and intro. by Nancy Metzel (Evanston, Ill.: Northwestern University Press, 1970), p. 429. Also see Roger Caillois, "Mimicry and Legendary Psychasthenia," trans. John Shep-herd, reprinted in *October: The First Decade, 1976–1986*, ed. Annette Michel-son, Rosalind Krauss, Douglas Crimp, and Joan Copjec (Cambridge, Mass.: MIT Press, 1987), p. 72. On the schizophrenic's response to dark space, Callois wrote: "to these dispossessed souls, space seems to be a devouring force. Space pursues them, encircles them, digests them in a gigantic phagocytosis. It ends by replacing them. Then the body separates itself from thought, the individual breaks the boundary of his skin and occupies the other side of his senses. He tries to look at *himself from* any point whatever in space. He feels himself becoming space, *dark space where things cannot be put*. He is similar, not similar to something, but just *similar*. And he invents space of which he is the 'convulsive possession.' "

99. On the distinction, see Joseph F. Kett, "Adolescence and Youth," in Theodore K. Rabb and Robert Rotberg, eds., *The Family in History: Interdisciplinary Essays* (New York: Harper and Row, 1971), p. 103. Kett writes: "The propensity of youths toward mental instability – melancholy for males and hysteria for females – was set down by medical writers from the 1830's onward under the rubric 'pu-bertal insanity.' In a sense, youthfulness had acquired a psychological as well as a chronological content." For a contemporary assessment, see C. B. Burr, "The In-sanity of Pubescence," *American Journal of Insanity*, no. 42 (1887): 328–39.

100. Burr, "Insanity of Pubescence," pp. 328 and 338: "In the female this disorder is apt to be associated with menstrual derangement, undue sexual excitation, precocity in matters of love, and causes which are provocative of hysterical excitement. . . . The liability of the female sex to this form of disease is greater than that of the male – a fact attributable to the increased perturbation of the system incident to the establishment of menstruation. As may be inferred, this sexual excitation is apt to give rise to erotic fancies and delusions."

101. This is a phrase from D. W. Winnicott, *Playing and Reality* (London: Tavistock, 1971), p. 144: "[The family] must provide the 'facilitating environment.' . . . In the time of adolescent growth boys and girls awkwardly and erratically emerge out of childhood and away from dependence, and grope towards adult status. If the family is still there to be used, it is used in a big way; and if the family is no longer there to be used, or to be set aside (negative use), then small social units need to be provided to contain the adolescent growth process."

102. Henry James, "John S. Sargent," p. 222. James also describes Florence and Jane as clasping hands (p. 222). He is wrong, for their hands overlap on the surface of the painting, rather than intentionally touch.

103. Margaret Bertha Wright, *Art Amateur,* quoted in Fairbrother, "John Singer Sargent and America," p. 67: "One naturally considers the living objects the chief consideration in portraiture and does not ask for a portrait of fantastic light or for ostentatious proof of the painter's cleverness."

104. Lubin, *Act of Portrayal,* p. 114.

105. Henry James, *The Awkward Age* (1899; reprint, Harmondsworth: Penguin Books, 1966), p. 42.

106. Louis-Emile Edmond Duranty, "Bric-à-Brac," first published in 1876, later collected in *Le Pays des Arts* (Paris: G. Charpentier, 1881).

107. The vases were manufactured in Japan expressly for an American or European clientele. According to Ormond and Kilmurray, in *Sargent: The Early Portraits,* the vases were "made by the potter Hirabayishi or his workshop, in Arita, Japan" (p. 66). Given that Mrs. Boit's father had worked in the China trade out of New England, they may have been in his possession earlier. My thanks to Erica Hirshler for information on the vases.

108. Walter Pater, *The Child in the House* (New York: Thomas Crowell and Co., 1894), orig. in *Macmillan's Magazine,* August 1878, as "Imaginary Portraits I. The Child in the House," p. 6.

109. Jean Baudrillard, *Le Système des Objets,* quoted in Susan Stewart, *On Longing: Narratives of the Miniature, the Gigantic, the Souvenir, the Collection* (first published 1984; reprint, Durham and London: Duke University Press, 1993), p. 146.

110. Stewart, *On Longing,* p. 146.

111. Olson, *John Singer Sargent,* p. 23. On the specific effects of the expatriate life, see p. 84, where Olson calls it an "international fake-life," and 91, where Olson writes: "John was unacquainted with his emotions. He was surprised by them – a reaction that provided a further twist in the complicated oxymoron of his character."

112. Gaston Bachelard, *La Terre et les rêveries du repos* (Paris: Librairie Jose Corti, 1948), pp. 6 and 95.

113. This continuous black line was first pointed out to me by Leo Steinberg in 1983.

114. In his manuscript "How I Came to Paint," Boit tells how he saw the Corot paintings at the Tremont Street Gallery of Soule and Ward in Boston around 1868: "A bit of the real world was before me. The picture as picture was lost sight of and forgotten. The [illegible] gap that had so long puzzled me was filled up and for the

first time I realized the possibility of so representing the world we live in that it should seem reflected on the canvas, that in contemplating the picture we should perceive not only the forms of natural objects but that the light should seem to play about them as in the inner world and the air to envelop them as under the dome of the heavens" (p. 2). Three incomplete drafts of the essay are in the Archives of American Art.

115. Lubin, in *Act of Portrayal,* p. 20, writes, "My own guess, derived from reading between the lines of the biographies and artworks, too, is that James, Eakins, and Sargent all repressed homoerotic tendencies that brought about in each an unusually close identification with women, and, at the same time, a negative reaction to them. I do not mean to suggest that these three men were closet homosexuals or closet misogynists; what I am trying to say is that their personal lives were filled with a deep-seated, deeply hidden sexual ambivalence brought into relief by their lack of participation in the war and in the efficiently businesslike, often self-congratulatory, male culture that followed in its wake." For a different, but complementary, interpretation of Sargent's nervous sensibility, see Simpson, *Uncanny Spectacle,* pp. 130–31.

116. Steedman, *Strange Dislocations,* pp. 155–59.

117. Olson, *John Singer Sargent,* p. 98. Sargent may have perceived something about the two older Boit girls that filtered into his portrait. In Ormand and Kilmurray, *Sargent: The Early Portraits,* the authors write: "None of the girls married, and both Florence and Jane became to some extent mentally or emotionally disturbed. Mary Louisa and Julia remained close as they grew older, and Julia became an accomplished painter in water-colors" (p. 66).

Chapter Four: Vuillard's *Mother and Sister of the Artist*

1. On the so-called spatial fears of the fin de siècle, see Anthony Vidler, "Psychopathologies of Modern Space: Metropolitan Fear from Agorophobia to Estrangement," in Michael S. Roth, ed., *Rediscovering History: Culture, Politics and the Psyche* (Stanford, Calif.: Stanford University Press, 1994), pp. 11–29.

2. On the entire series, see Elizabeth Easton, *The Intimate Interiors of Edouard Vuillard* (Museum of Fine Arts, Houston, with Smithsonian Institution Press, Washington, D.C., 1989). For a discussion of the paintings in terms of the gendered oppositions of mother and sister, see Susan Sidlauskas, "Contesting Femininity: Vuillard's Family Pictures," *Art Bulletin,* vol. 78, no. 1 (March 1997): 85–111. John Russell provides the best overview of the early reception of Vuillard's work; see his *Edouard Vuillard 1868–1940,* exh. cat. (Toronto: Art Gallery of Toronto, 1971), pp. 72–140, for a compilation of various remembrances about the artist. On Vuillard's family life and the profession of his mother, see esp. Easton, *Intimate Interiors,* pp. 25–101, as well as Gloria Groom, *Edouard Vuillard: Painter-Decorator* (New Haven and London: Yale University Press, 1993), pp. 25–34, and Belinda Thomson, *Vuillard* (New York: Abbeville Press, 1988), pp. 9–18. The relation of *Mother and Sister of the Artist* to Vuillard's work in the Symbolist theater is discussed in George Mauner, "Vuillard's Mother and Sister Paintings and the Symbolist Theatre," *Artscanada,* vol. 10 (December 1971/January 1972): 124–26, and in Susan Sidlauskas, "The Expressive Interior in Nineteenth-Century Painting" (Ph.D. diss., University of Pennsylvania, 1989), chap. 4. The importance of the connection between Vuillard and the Symbolist theater is challenged by Nancy Forgione in her "Edouard Vuillard in the 1890s: Intimism, Theater, and

Decoration" (Ph.D. diss., Johns Hopkins University, 1993). The novelist and es-sayist Mary Gordon made some astute observations about Vuillard's paintings of his family in "The Silent Drama in Vuillard's Rooms," *The New York Times*, Sec. 2, May 13, 1990, pp. 1, 38. For a succinct but subtle overview of Vuillard, see Lucy Oakley, *Edouard Vuillard* (New York: Metropolitan Museum of Art, 1981).

3. On the dominant theories of mind of the fin de siècle, with particular relevance to the art and architecture of the time, see Debora Silverman, *Art Nouveau in Fin-de-Siècle France: Politics, Psychology, and Style* (Berkeley and Los Angeles, Calif.: University of California Press, 1989), esp. pp. 75–108.

4. Bill Brewer, "Bodily Awareness and the Self," in José Luis Bermudez, Anthony Marcel, and Naomi Eilan, eds., *The Body and the Self* (Cambridge, Mass., and London: MIT Press, 1995), pp. 291–310, 303.

5. I will cite the first volume of Vuillard's journals, which are in the Bibliothèque de l'Institut de Paris, #5396-1, 2, 1890–1905, as EV I.1 (Journal I, Carnet 1) and the second as EV I.2 (Journal I, Carnet 2). On Vuillard's reluctance to depend too fully on theory, see EV I.2, October 24, 1890, pp. 23–34, and EV I.2, November 4, 1894, pp. 53 and 54. Also see Forgione, "Edouard Vuillard in the 1890s," p. 46, n. 46, and Groom, *Vuillard: Painter-Decorator*, pp. 8–9. There is quite a bit of overlap between Forgione's 1993 thesis and my own 1989 Ph.D. dissertation, par-ticularly on Vuillard's work for the Théâtre de l'Oeuvre. While we agree on many aspects of Vuillard's work in both painting and theater, there are significant de-partures, which I note below.

6. Easton, *Intimate Interiors*, p. 4.

7. See EV I.2, September 8, 1991, pp. 83–88 (loose pages at the back of the journal, numbered and dated appropriately): "Mon seul désir maintenant est la vie de mon âme. Le travail est le signe en même temps le produit de cette vie. Il nous est imposé à cause de nôtre condition d'homme. . . . Il est bien impossible, quelque vert. [illeg.] . . . que l'on soit de ne pas se laisser distraire si le sens m'ont rien qui les occupée . . . un certain temps son régard intérieure repose sur le même objet" (p. 83).

8. Easton, *Intimate Interiors*, p. 25. See esp. pp. 25–102 for information about, and analysis of, the family paintings.

9. Philippe Caryl, "La Suggestion et la personnalité humaine," in *Le Temps*, no. 8970 (November 21, 1885): 3, quoted in Silverman, *Art Nouveau*, p. 89.

10. The term "interiority," as I use it here, encompasses the new conceptions about the unconscious as well; see Silverman, *Art Nouveau*, chap. 5, "Psychologie Nou-velle," pp. 75–108. In her discussions, Silverman emphasizes the importance of the irrational, the unconscious, and the dream state. I do not limit my conception of interiority to the unconscious but include those self-conscious attempts to char-acterize and to represent a "self."

11. Mark Johnson, *The Body in the Mind: The Bodily Basis of Meaning, Imagina-tion, and Reason* (Chicago and London: University of Chicago Press, 1987), p. 21.

12. Silverman, *Art Nouveau*, p. 77.

13. On Charcot and Bernheim, see ibid., pp. 75–108, esp. 83–88; for the same au-thor's analysis of the importance of Jules and Edmond de Goncourts' *La Maison d'un Artiste* (Paris, 1881), see pp. 17–39. On Charcot, see Georges Didi-Huber-man, *L'Invention de l'hystérie: Charcot et l'iconographie photographique de la Salpêtrière* (Paris: Editions Macula, 1982); and Joan Copjec, "Flavit et Dissipati Sunt," *October: The First Decade 1976–1986*, ed. Annette Michelson et al.

(Cambridge, Mass., and London: MIT Press, 1987); and Jan Goldstein, *Console and Classify: The French Psychiatric Profession in the Nineteenth Century* (Cambridge and New York: Cambridge University Press, 1987), esp. chap. 9; and Elaine Showalter, *The Female Malady: Women, Madness and English Culture, 1830–1980* (New York: Pantheon Books, 1985), pp. 155–62.

14. On the Nabis, see Claire Frêches-Thory and Ursula Perucchi-Petri, *Nabis 1888–1900,* exh. cat. (Munich: Prestel-Verlag, 1993); Patricia Eckert Boyer, ed., *The Nabis and the Parisian Avant-Garde,* exh. cat. (New Brunswick, N.J.: Rutgers University Press, with the Jane Voorhees/Zimmerli Art Museum, 1988); George Mauner, *The Nabis: Their History and Their Art 1888–1896* (New York: Garland Publications, 1978), and Ursula Perucchi-Petri, *Die Nabis und Japan* (Munich: Prestel-Verlag, 1976). On Vuillard as a decorator, and the general context for decorative painting, see Groom, *Vuillard: Painter-Decorator.* For more on the theoretical framework around decoration during these years, see Roger Benjamin, *Matisse's 'Notes of a Painter': Criticism, Theory and Context 1891–1908,* Studies in the Fine Arts: Criticism, No. 21 (Ann Arbor: UMI Research Press, 1987), for a discussion of Denis's theories in relation to Matisse and the idea of decoration.

15. See Richard Shiff, *Cézanne and the End of Impressionism: A Study of the Theory, Technique, and Critical Evaluation of Modern Art* (Chicago: University of Chicago Press, 1984), esp. chap. 4, "The Subject/Object Distinction, Critical Evaluation, and Technical Procedure," pp. 27–38. The quotes are from Shiff, pp. 140 and 134.

16. Maurice Denis, "De Gauguin et de Van Gogh au classicisme," *Théories,* first published 1905–6 (Paris: Hermann, 1969), pp. 266–68, 275. Quoted in Shiff, *Cézanne,* pp. 140 and 274, n. 84. On the influence of Vuillard on Matisse, see Yve-Alain Bois, "On Matisse: The Blinding," *October,* no. 68 (Spring 1994): 61–121, esp. 88–91.

17. EV I.1, September 1890, p. 56.

18. See EV I.2, October 23, 1890, pp. 30–31: "l'ouvrage est la partie, l'oeuvre est tout. L'oeuvre n'a qu'une seule méthode, l'ensemble de toutes les actions."

19. Alfred Barr, *Cubism and Abstract Art,* exh. cat. (New York: Museum of Modern Art, 1936), pp. 10, 12, and 19, for discussion of Maurice Denis as one of the founders of the "intuitional and emotional strain" of "abstraction." Barr considered Bonnard and Vuillard "brilliant youngsters"; *Henri Matisse: Retrospective Exhibition* (New York: Museum of Modern Art, 1931), p. 10. Barr emphasized the masculinized "pictorial conquest" of abstraction (*Cubism,* p. 11). For a very different view of the implication of gender in the origins of abstraction, see Carol Duncan, "Virility and Domination in Early Twentieth-Century Vanguard Painting," *Artforum,* vol. 12, no. 4 (December 1973): 30–39.

20. For a discussion of the particulars of Madame Vuillard's business, as well as a brief social and economic history of corset making in the 1880s and 1890s, see Easton, *Intimate Interiors,* pp. 226–29. On Vuillard's family background, see especially Easton, ibid., pp. 7–21, and also Patricia Ciaffa, "The Portraits of Vuillard" (Ph.D. diss., Columbia University, 1985).

21. On the "arm akimbo" pose, see Joaneath Spicer, "The Renaissance Elbow," in Jan Bremmer and Herman Roodenburg, eds., *A Cultural History of Gesture* (Ithaca, N.Y.: Cornell University Press, 1991), pp. 84–128. Spicer concentrates on Renaissance portraiture, but the convention she describes still prevailed in late-nineteenth-century representation. For the connection to Ingres's *Louis-François*

Bertin, see Easton, *Intimate Interiors,* p. 140, n. 31. For an excellent analysis of the social and sexual pressures at work in Picasso's *Portrait of Gertrude Stein,* see Robert Lubar, "Unmasking Pablo's Gertrude: Queer Desire and the Subject of Portraiture," *Art Bulletin,* vol. 79, no. 1 (March 1997): 57–84. Also see Alisa Luxenberg, "Letter to the Editor," *Art Bulletin,* vol. 80, no. 1 (March 1998): 194–95, for the mention of Bonnat's portrait of his mother, *Madame Bonnat* (1893; Paris, Musée d'Orsay). Luxenberg points out that the Ingres Bertin portrait influenced a number of painters around the turn of the century and also notes Léon Bonnat's *Portrait of Ernest Renan* as an example.

22. Anna Chave writes that the "narrative pretext for Marie's stoop is a pitiful wilted flower at her feet." See her "Vuillard's *La Lampe,*" *Yale University Art Gallery Bulletin,* vol. 38, no. 1 (Fall 1980): 12–15.

23. Edgar Allan Poe, "Philosophy of Composition," in *Literary Criticism of Edgar Allan Poe,* ed. Robert Hough (Lincoln: University of Nebraska Press, 1965), p. 21.

24. See Shiff, *Cézanne,* pp. 171–72, on the theoretical implications of the critique of illusionism.

25. Georg Simmel, "The Metropolis and Mental Life" (first published in 1903), quoted in David Frisby, *Fragments of Modernity: Theories of Modernity in the Work of Simmel, Kracauer, and Benjamin* (Cambridge, Mass.: MIT Press, 1986), p. 58. The phrase "points of tangency" is borrowed from Ann Fadiman's *The Spirit Catches You and You Fall Down: A Hmong Child, Her American Doctors, and the Collision of Two Cultures* (New York: Farrar, Straus, and Giroux, 1997).

26. Anthony Vidler, "Psychopathologies of Modern Space: Metropolitan Fear from Agorophobia to Estrangement," in Michael S. Roth, ed., *Rediscovering History: Culture, Politics, and the Psyche* (Stanford, Calif.: Stanford University Press, 1994), pp. 11–29, and also 20 and 22.

27. Alfred Fouillée, "Les Grandes Conclusions de la Psychologie Contemporaine – la Conscience et ses Transformations," *Revue des deux mondes* (1891): 788–816, 798; quoted in Silverman, *Art Nouveau,* pp. 90 and 336, n. 90.

28. Simmel, quoted in Frisby, *Fragments of Modernity,* pp. 56 and 67.

29. For a variety of comments to this effect, see Russell, *Vuillard,* pp. 86, 89, 95, and 109.

30. The phrase "living atmosphere" is in Paul Bourget's essay, "MM. Edmond et Jules de Goncourt," *Nouveau essais de psychologie contemporaine* (Paris: Tourgue-niev-Amiel, 1886), p. 147.

31. Edmond and Jules de Goncourt, *La Maíson d'un Artiste,* Vols. 1 and 2 (Paris: Charpentier, 1881), p. 3.

32. Paul Bourget, "MM. Edmond et Jules de Goncourt," p. 155: "une sorte d'écorché moral et sensitif, blessé à la moindre impression, sans défense, sans enveloppe, tout saignant."

33. Henry James, *The Spoils of Poynton,* first published in 1897 (reprint, Harmondsworth: Penguin Books, 1963), pp. 25 and 105.

34. Italics added. EV. I. 1, October 26, 1894, pp. 52 verso and 52 recto. The original passage is printed in its entirety in Easton, *Intimate Interiors;* the original French is on p. 140, n. 29; the English translation is on pp. 78–79.

35. EV I.1., May 19, 1894, p. 57 recto (I preserve Vuillard's occasional lack of accents): "L'homme fabrique des objets qui sont les signes de sa pensée. Ils sont multiples comme les moments de pensée. *L'art est l'enchaînement,* l'ordre qu'il suit dans la création de ces objets. Idée purement abstraite. L'esprit voit et démêle les

signes, les ordonne conformément à l'état qui l'occupe. Tous mes actes ont une forme, seulement [illeg.] l'art est dans tout . . . une forme, une couleur, n'existe que par rapport à une autre." These ideas may be relevant to the theories of the philosopher Henri Bergson, who elevated the importance of the contemporary artist, for him "the agent of a direct, unmediated access to the unconscious." The artist had the power to dissolve all boundaries between self and other. See Henri Bergson, *Essai sur les données immédiates de la conscience* (Paris: Alcan, 1889) pp. 11–14, 12. This aspect of Bergson is discussed in Silverman, *Art Nouveau,* pp. 89–91.

36. This phrase is from Octave Uzanne, as quoted in Silverman, *Art Nouveau,* p. 71.

37. Dom Willibrod Verkade, *Le Tourment de Dieu: Étapes d'un moine peintre* (Paris: Rouart et Watelin Editeurs, 1923), p. 94, quoted in Forgione, "Vuillard in the 1890s," pp. 57–58: "un cri fut lancé d'un atelier à l'autre: 'Plus de tableaux de chevalet!' A bas les meubles inutiles! La peinture ne doit pas usurper une liberté qui l'isole des autres arts. . . . Des murs, des murs à décorer! A bas la perspective! Le mur doit rester surface, ne doit pas être percé par les representations infinis. Il n'y a pas de tableaux, il n'y a que des décorations!"

38. (Pierre Louis [Maurice Denis]), "Notes sur l'exposition des Indépendants," *La Revue Blanche,* no. 3 (April 1892): 232, quoted in Groom, *Vuillard: Painter-Decorator,* p. 14.

39. Vuillard, quoted in Groom, *Vuillard: Painter-Decorator,* p. 71. The quote is from a journal entry of October 1894.

40. See Silverman, *Art Nouveau,* chap. 6, "The Central Union of the Decorative Arts," pp. 109–33.

41. Silverman, *Art Nouveau,* p. 63.

42. Silverman, *Art Nouveau,* pp. 193–206, for discussion of this idea. For further commentary on this notion, see Octave Uzanne, *L'art et idée: Révue contemporaine du diléttantisme littéraire et de la curiosité,* vols. 1 and 2 (Paris, 1891–92); see esp. vol. 1, pp. 1–3.

43. Marius-Ary Leblond, "Les Peintres de la femme nouvelle," in *La Revue,* no. 39 (1901): 275–76, 289–90.

44. EV I.2., July 24, 1894, p. 46 recto, p. 47 verso. Part of this passage is quoted in Groom *Vuillard: Painter-Decorator,* p. 57.

45. "Deeply sensitive," is from Dom Willibrod Verkade, quoted in Russell, *Vuillard,* p. 86; "haunted by anxiety" is from Romain Coolus, quoted in ibid., p. 89; "highly strung" is from Paul Signac, quoted in ibid., p. 95. That these characteristics were identified with women is made clear by Alfred Fouillée's "La psychologie des sexes," *Revue des Deux Mondes,* vol. 119, no. 3, sér. 3 (September 15, 1893): 397–429, esp. 409.

46. Pierre Veber, a friend of Vuillard's, emphasized the artist's attachment to his mother; see Russell, *Vuillard,* p. 99. Traces of this mythology persist to this day. In a recent homage to the painter called *Vuillard's Sieste* (1990; New York, Marlborough Gallery), Red Grooms shows the napping artist oblivious to, but obviously reliant upon, the ministrations of his mother, who hovers just beyond a protruding folding screen. See *Red Grooms: New Works, exh. cat.* (New York: Marlborough Gallery, 1992), fig. 10.

47. Charlotte Perkins Gilman, "The Yellow Wallpaper" (first published in 1892), in *The Yellow Wallpaper and Other Writings,* ed. and intro. by Lynn Sharon Schwartz (New York: Bantam Books, 1989).

48. Silverman gives a detailed account of Charcot's decorative program in her *Art Nouveau,* pp. 102–6.

49. Henri Miege, "Charcot Artiste," *Nouvelle Iconographie Photographique de la Salpêtrière,* vol. 11, no. 6 (November–December 1899): 509.

50. Ibid., p. 500: "Il excella surtout dans l'art d'approprier les oeuvres des meilleurs maîtres aux motifs d'ornémentation. . . . Il en maissait des sculptures en ronde-bosse ou des bas-reliefs, des ornéments cisèles ou répousses, des services de tables dorés ou peints, des vitraux, des émaux, des meubles aux panneux sculptés, gravés et colories, des réliures delivres, des coffrets, des sièges, des tables, et toute une profusion de bibelots fantaisistes, imités de l'ancien, cirés, patinés, vieillis à dessein, dont le fouillis étrangement composite s'harmonisait encore avec une profusion d'oeuvres d'art parfaitment authentiques-curieux musée de famille où Charcot goutait ses meillures joies et qui réalisait son idéal shakespearien: 'Un peu de trop.' "

51. Emily Apter, "Cabinet Secrets: Fetishism, Prostitution, and the Fin de Siècle Interior," *Assemblage,* no. 9 (June 1989): 6–19, quote on 16–17.

52. See Easton, *Intimate Interiors,* pp. 58–77, for a discussion of the Vuillard family's actual living spaces.

53. Ibid., p. 29: "In 1892, a group of workers in the clothing business . . . banded together to create the only union of the trade, which took the name L'Aiguillée, a name given to an 1893 painting by Vuillard. . . . The headquarters were located at 342, rue St. Honoré, the very building in which Mme Vuillard lived and ran her business in that year."

54. Simmel, quoted in Frisby, *Fragments of Modernity,* pp. 82 and 93.

55. Vidler, "Psychopathologies of Modern Space," describing Le Grand's 1878 account, pp. 15–16.

56. Ibid., pp. 17–18.

57. Arnaud Lévy, "Devant et derrière soi," *Nouvelle revue de psychoanalyse,* no. 15 (Spring 1977): 93–94, quoted in Victor Burgin, *In(Different) Spaces: Place and Memory in Visual Culture* (Berkeley and Los Angeles: University of California Press, 1996), p. 213. Burgin also reminds us of Freud's provocative but unexplored comment "The ego is a mental projection of the surface of the body" (p. 129). Interestingly, Vuillard wrote in his journal that "les petites sensations" corresponded to "points différentes de ce corps" in representation; EV.I. 1, p. 12.

58. EV I.1., May 19, 1894, p. 57 verso.

59. Rae Beth Gordon, *Ornament, Fantasy and Desire in Nineteenth-Century French Literature* (Princeton, N.J.: Princeton University Press, 1992), pp. 148–49. On the "Arcimboldo effect" she writes, "Rather than constructing a system of oppositions or a simple play of contrasts, the tight interlacing of ornament and void produces a sort of Arcimboldo painting where the eye grasps quasi-simultaneously the vegetables with the portrait of a man." "Unconscious scanning" is a phrase Gordon adopts from Anton Ehrenzweig, quoted on p. 168.

60. On the meaning of shadows, see Michael Baxandall, *Shadows and Enlightenment* (New Haven and London: Yale University Press, 1995).

61. Guy de Maupassant, *Contes et Nouvelles,* vol. 2 (Paris: Gallimard, 1979), p. 1229; quoted in Georges Teyssot, "The Disease of the Domicile," *Assemblage,* no. 6 (June 1988): 91. The passage, as Teyssot translates it, reads: "And then, all of a sudden, I saw, in the doorway, an armchair, my large reading chair, which went waddling out. It went off through the garden. Others followed it, those from my salon, then the low sofas dragging themselves like crocodiles on their short

legs, then all my chairs with goatlike leaps and the little footstools trotting out like rabbits."

62. Elaine Scarry, *The Body in Pain: The Making and Unmaking of the World* (Oxford and New York: Oxford University Press, 1985), pp. 286, 306, and 317.

63. *Metteur en Scène*, February 10, 1881. Collection Rondel, Rj 254, Bibliothèque de l'Arsenal, Paris. Three issues were published in 1881. The editor was Jules Payen. In general, the term *metteur-en-scène* came into wider usage. Edith Wharton even published a short story entitled "Les Metteurs-en-Scène," in 1908, which her biographer has described as "a bitterly ironic tale about a young American woman who makes her living arranging marriages between rich American ladies and the nobility of the Fauborg," in R. W. B. Lewis, *Edith Wharton: A Biography* (New York: Harper and Row, 1975, 1985), p. 234. Wharton's story was originally published in *Revue des Deux Mondes* (September 1908): 696–708.

64. André Antoine, "Causerie sur la mise en scène," *La Revue de Paris* (April 1, 1903): 569–612, and 608: "plus humain, plus intense, plus vivant d'attitudes et des gestes."

65. Gordon, *Ornament, Fantasy and Desire*, p. xvii.

66. In his *Sources of the Self: The Making of Modern Identity* (Cambridge, Mass.: Harvard University Press, 1989), p. 465, Charles Taylor writes: "As a result of [a profound breach in the received sense of identity and time], the epiphanic centre of gravity begins to be displaced from the self to the flow of experience, to new forms of unity, to language conceived in a variety of ways – eventually even as a structure. An age starts of 'decentering' subjectivity, which reaches its culmination, or perhaps its parody, in certain recently fashionable doctrines from Paris. . . . Decentering is not the alternative to inwardness; it is its complement."

67. Marcus Doel writes that "the material fabric of the body may frustrate the passage towards the place of the universal and abstract subject. Hence the fact that flesh and bodies are always sedimented, stratified and traversed by the double movement of universalisation and individuation which envelopes them with skin and stamps them with face." From Doel, "Bodies without Organs: Schizoanalysis and Deconstruction," in Steve Pile and Nigel Thrift, eds., *Mapping the Subject: Geographies of Cultural Transformation* (London and New York: Routledge, 1995), pp. 226–40, 230.

68. The fragmentary structure of Madame Vuillard's face suggests that the body possesses secret recesses, or "internal organs and other body parts, which only come into view in special circumstances, such as illness or injury," Quassim Cassam, "Introspection and Bodily Self-Ascription," in Bermudez et al., *The Body and the Self,* pp. 311–36, 330. For a discussion of the tension between the idea of the mother who gives life but cannot give immortality, see Simone de Beauvoir, *Le Deuxième Sexe* (Paris: Librairie Gallimard, 1949); Luce Irigaray, *Ce sexe qui n'en est past un* (Paris: Les Editions de Minuit, 1977); and Julia Kristeva, *Pouvoirs de l'horreur: Essai sur l'abjection* (Paris: Editions du Seuil, 1980).

69. Paul Connerton, *How Societies Remember* (Cambridge and New York: Cambridge University Press, 1989), p. 74.

70. See Susan Sidlauskas, "Contesting Femininity: Vuillard's Family Pictures," *Art Bulletin,* vol. 78, no. 1 (March 1997): 91–93, for additional discussion of the implications of women appropriating a pose recognized as masculine.

71. Charles Hacks, *Le Geste: De la signification du mot geste – Définition du geste origine et localisation cérébrale du geste* (Paris: E. Flammarion, 1892). The author writes, "La vieille fille est à la fois homme et femme; elle a les mauvais côtés

et les mauvais gestes de tous les deux. C'est l'hermaphrodite du geste. Comme la femme, elle est sèche, étriquée, coquette, vaniteuse, au point de vue du geste; comme l'homme, elle est violente, exagérée, sans pondération, jusqu'à ce que l'age arrive qui, au point de vue du sexe, de l'acte comme du geste, mélange homme et femme, mère et vieille fille dans un même affaiblissement, dans un même tremblement" (p. 71). The issue of gesture and gender is touched upon briefly in recent studies of cross-dressing. See, for instance, Marjorie Garber, *Vested Interests: Cross-Dressing and Cultural Anxiety* (New York and London: Routledge, 1992). Also see Andrew Perchuk and Helene Posner, eds., *The Masculine Masquerade: Masculinity and Representation,* exh. cat. (Cambridge, Mass.: MIT List Visual Arts Center, 1995). For an overview of seventeenth- and eighteenth-century applications of gestural codes to representation, see Dorothy Johnson, *Jacques-Louis David* (Princeton, N.J.: Princeton University Press, 1993), pp. 11–69.

72. Here, I adapt Judith Butler's argument in "Performative Acts and Gender Constitution: An Essay in Phenomenology and Feminist Theory," in Sue-Ellen Case, ed., *Performing Feminisms* (Baltimore: Johns Hopkins University Press, 1990), p. 270, in which the author contends that gender is a performative act, a series of stylized gestures repeated over time. See also idem, *Bodies That Matter: On the Discursive Limits of 'Sex'* (New York and London: Routledge, 1993).

73. Camille Mauclair, "La Femme devant les peintres modernes," *La Nouvelle Revue,* n.s. 21 (November 1, 1899): 190–213, quoted in Silverman, *Art Nouveau,* p. 69.

74. Bettina Knapp, *Maurice Maeterlinck* (New York: Twayne Publishers, 1975), pp. 77–78. On Vuillard's involvement in the theater, see esp. Forgione, "Vuillard in the 1890s," chap. 1, "Early Theatrical Involvement," pp. 17–90; and chap. 3, "Vuillard and the Avant-Garde Theater," pp. 132–215. Forgione stresses rightly that Vuillard was interested in, and involved with, the theater before he worked with the Théâtre de l'Oeuvre. However, later she downplays the direct influence of Lugné-Poe's theater on the painter and argues against the association of Vuillard and Maeterlinck. Also see Guy Cogéval, "Le Célibataire, mis à nu par son théâtre, même," in Ann Dumas and Guy Cogéval, *Vuillard,* exh. cat. (Lyons: Musée des Beaux-Arts, 1990), pp. 105–36.

75. On the Nabis' involvement in puppetry, see esp. Geneviève Aitken, "Les Nabis, dans un foyer au théâtre," in Frèches-Thory and Perucchi-Petri, *Nabis,* pp. 399–406.

76. This is from a review of the Théâtre de l'Oeuvre's production of Henri Régnier's *La Gardienne,* signed by G. V. [G. Visinet], "Théâtre de Paris," *Journal de Rouen,* June 22, 1894, Paris, Bibliothèque de l'Arsenal, Collection Rondel, Rt. 3695, vol. 1.

77. On the history of stage design, see Arthur Pougin, *Dictionnaire Historique et Pittoresque du Théâtre et des Arts* (Paris: Firmin Didot, 1885), and also Alfred Bouchard, *La Langue Théâtrale: Vocabulaire Historique, Descriptif et Anecdotique des Termes et des Choses du Théâtre* (Paris: Arnaud et Labat, 1878). Also see Edith Melcher, "Stage Realism in France: Between Diderot and Antoine" (Ph.D. diss., Bryn Mawr College, 1928).

78. See Aurélien Lugné-Poe's two-volume autobiography, *La Parade: Acrobaties* (Paris: Librairie Gallimard, 1931), and *La Parade: Sous Les Etoiles* (Paris: Librairie Gallimard, 1933). On the Symbolist theater in general, see Frantisek Deak, *Symbolist Theater: The Formation of an Avant-Garde* (Baltimore and London: Johns Hopkins University Press, 1993). Lugné called the mise-en-scène "un relief

qui bouge," a phrase that he apparently borrowed from Hippolyte Taine; undated clipping from Collection Rondel, Carnet, Rt. 12266, "Les Deux Ecoles dans l'art du décor." Also see William Speth, "La Sincerité du Théâtre," *L'Oeuvre* (Paris, 1913), pp. 57–59, a publication of the Théâtre de l'Oeuvre.

79. Louis Becq de Fouquières, *L'Art de la mise en scène. Essai d'aesthétique théâtrale* (Paris: Charpentier, 1884). The critic wrote, "Il faut donc la traiter comme un peintre traite les masses, c'est-à-dire sacrifier le détail particulier à l'ensemble. Si le metteur en scène se préoccupe à juste titre des places relatives que doivent occuper, individuellement les personnages du drame, il a aussi à s'occuper de grouper la figuration de la diviser en parties harmoniques de telle sorte qu'elle produise un effet général où s'éface toute individualité" (p. 164). Vuillard had a genuine interest in Lecoq de Boisbaudran's theories. See Claude Roger Marx, *Vuillard: His Life and Work* (London: Paul Elek, 1946), chap. 5: "Visual Memory and Organization of the Picture," pp. 171–96.

80. Pierre Quillard, "De l'inutilité absolue de la mise en scène exacte," *La Revue d'Art Dramatique*, May 1891 (pp. 180–83, 183): "Le décor doit être une pure fiction ornementale qui complète l'illusion par des analogies de couleur et de lignes avec le drame." Critics and theorists of the idealist theater took to heart the idea that the stage setting was a living thing. In England, Edward Gordon Craig published an essay in his journal *Mask* that described what he called the "Scene." "I have said of this Scene that it is a living thing, that it is capable of expression, and I must here warn you, from personal experience in its use, that it is so living that, unless treated as a living thing, it is quite likely not to respond to the will of the manipulator or arranger." Craig patented the design for the Scene, which was essentially a group of free-standing moveable screens.

81. The setting is described in Deak, *Symbolist Theater,* p. 226. Deak speculates that Vuillard also applied makeup to the actors' faces, as they too were criticized for their bizarre range of colors. Interestingly, Lecoq's students at the Ecole Gratuite used a scrim stretched over a moveable frame as a device to relate correctly figures or objects and surrounding spaces. See AN F21 497, Dossier: Procedé du dessin pour faciliter l'étude des arts, par N. Rouillet.

82. G. V. [G. Visinet], "Théâtre de Paris," *Journal de Rouen,* June 26, 1894. Visinet continues: "Mais ce n'est pas tout-comme singularité. Les héros du drame vus sur la scène ne parlent pas. Ils font des gestes. Le poème est déclamé par des artistes placés à l'orchestre. . . . Vous avez vu ces portraits de peintres des nouvelles écoles, où les figures ne présentent aucun contour, où tout est flou comme dans un brouillard. Ici, quand la toile se lève, une gaze transparente verdâtre couvre toute la scène. On ne voit les personnages qu'à travers ce voile; ils paraissent ainsi comme des ombres se remuant et agissant dans le vague. . . . C'est de la pure bizarrerie."

83. Mallarmé is quoted in Felicia McCarren, "The 'Symptomatic Act' circa 1900: Hysteria, Hypnosis, Electricity, Dance," *Critical Inquiry,* no. 21 (Summer 1995): 748–74, esp. 757–58. Also see idem, "Stephane Mallarmé, Loie Fuller, and the Theater of Femininity," in *Bodies of the Text: Dance as Theory,* ed. Ellen W. Goellner and Jacqueline Shea Murphy (New Brunswick, N.J.: Rutgers University Press, 1995), pp. 217–30. Mallarmé's writings on the theater are collected in his *Crayonné au théâtre* in *Oeuvres Complètes,* ed. Henri Mondor (Paris: Gallimard, 1984). On Mallarmé's involvement with the Symbolist theater, see Mary Lewis Shaw, *Performance in the Texts of Mallarmé: The Passage from Art to Ritual* (University Park: Pennsylvania State University Press, 1993), and Haskell M.

Block, *Mallarmé and the Symbolist Drama* (Detroit: Wayne State University Press, 1963).

84. Michel Foucault, *Birth of the Clinic: An Archaeology of Medical Perception,* trans. A. M. Sheridan Smith (New York: Vintage Books, 1973), pp. 165–66, quoted in McCarren, "The Theater of Femininity," p. 770.

85. Elaine Scarry, "On Vivacity: The Difference Between Daydreaming and Imagin-ing-under-Authorial-Instruction," *Representations,* no. 52 (Fall 1995): 1–25, 13. Scarry writes: "It is not hard to successfully imagine a ghost. What is hard is suc-cessfully imagining an object, any object, that does *not* look like a ghost."

86. There is an ink drawing and a gouache, both illustrated in Belinda Thomson, *Vuillard* (New York: Abbeville Press, 1988), p. 79, figs. 62 and 63.

87. For a description of the staging of Maeterlinck's play, see Bettina Knapp, *Maurice Maeterlinck,* p. 83. Maeterlinck's essay *The Treasures of the Humble* has often been linked to Vuillard (trans. Alfred Sutro, with intro. by A. B. Walkey [New York: Dodd, Mead, and Co., 1916]). On the theme of entrapment, see Gail Finney, "Dramatic Pointillism: The Examples of Holz and Schlaf's *Die Familie Selicke* and Maeterlinck's *L'Intruse,*" *Comparative Literature Studies,* vol. 30, no. 1 (1993): 1–15.

88. Knapp, *Maurice Maeterlinck,* pp. 77–78.

89. Ibid., pp. 42–43.

90. This scene is quoted in Harold B. Segel, *Pinocchio's Progeny: Puppets, Mari-onettes, Automatons, and Robots in Modernist and Avant-Garde Drama* (Bal-timore and London: Johns Hopkins University Press, 1995), pp. 53–54. For a short summary of a recent conference on puppetry, see Sarah Boxer, "Pulling Strings: The Gepetto Effect," *New York Times,* Sec. B, January 17, 1998, pp. 9 and 11.

91. On Delsarte, see Genevieve Stebbins, ed., *Delsarte's System of Expression,* first published in 1885 (New York: E. S. Werner, 1902). For a critique of the eigh-teenth-century gestural conventions of oratory, see Michael Fried, *Absorption and Theatricality: Painting and Beholder in the Age of Diderot* (Berkeley and Los Angeles: University of California Press, 1980), pp. 77–82, 95–97, 101–4.

92. François Delsarte, quoted in Hillel Schwartz, "Torque: The New Kinaesthetic of the Twentieth Century," in Jonathan Crary and Sanford Kwinter, eds., *Incorpora-tions* (Zone Books 6, distributed by MIT Press, 1995), pp. 70–127, 77. Schwartz continues, "Like Diderot, Rousseau and Goethe, Delsarte meant to reinvigorate theatrical – especially operatic – convention so that, as in the very best of political and pulpit oratory, voice and movement would together become an integral ex-pression of that newly furnished entity, the self."

93. This paraphrases a remark by Alfred Fouillée, "Les Grandes Conclusions de la Psychologie Contemporaine – la Conscience et ses Transformations," *Revue des Deux Mondes,* vol. 107 (1891): 788–816, 815.

94. Vuillard worked on at least two of the Ibsen productions: *Rosmersholm,* for which he designed both the stage setting and the playbill, and *Solness le Construc-teur* (or *The Master Builder,* as we know it).

95. Gay Gibson Cima, *Performing Women, Female Characters, Male Playwrights, and the Modern Stage* (Ithaca, N.Y., and London: Cornell University Press, 1993); on the "autistic gesture," see p. 52; on the notion of a treble consciousness, see pp. 42–43.

96. On the connection between the Goncourts and Charcot, see Silverman, *Art Nou-veau,* p. 37. Recent applications of the Charcot material to representation are

found in Carol Armstrong, *Odd Man Out: Readings of the Work and Reputation of Edgar Degas* (Chicago and London: University of Chicago Press, 1991), pp. 186–87, and Anthea Callen, *The Spectacular Body: Science, Method, and Meaning in the Work of Degas* (New Haven and London: Yale University Press, 1995), pp. 50–59. Sigmund Freud, who studied briefly with Charcot at the Salpêtrière, dubbed his mentor a "*visuel,* one who sees," a testament both to Charcot's faith in empirical evidence and to his acute eye for the corporeal signs of disorder. This is quoted in Peter Gay, *Freud: A Life of Our Time* (New York: W. W. Norton, 1988), p. 51. For Freud's comments on his six-week stay in Paris, see ibid., pp. 48–53.

97. Miege, "Charcot Artiste," pp. 489–516. Quotations are from pp. 493 and 509.

98. On hysteria, see Mark S. Micale, *Approaching Hysteria: Disease and Its Interpretation* (Princeton, N.J.: Princeton University Press, 1995); Jann Matlock, *Scenes of Seduction: Prostitution, Hysteria, and Reading Difference in Nineteenth-Century France* (New York: Columbia University Press, 1994); Janet Beizer, *Ventriloquized Bodies: Narratives of Hysteria in Nineteenth-Century France* (Ithaca, N.Y.: Cornell University Press, 1994), esp. chap. 1; A. R. G. Owen, *Hysteria Hypnosis, and Healing: The Work of J.-M. Charcot* (London: Dobson, 1971); Elaine Showalter, *The Female Malady: Women, Madness and English Culture 1830–1898* (London: Pantheon Books, 1980), esp. pp. 155–62. On the history of the "uterine" theory of hysteria, see Helen King, "Once upon a Test: Hysteria from Hippocrates," and Sander Gilman, "The Image of the Hysteric," both in *Hysteria beyond Freud,* ed. Sander Gilman et al. (Berkeley and Los Angeles: University of California Press, 1993), pp. 3–90, and 345–452. Charcot's own writings are collected in *Charcot the Clinician: The Tuesday Lessons,* trans. and ed. Christopher G. Goetz (New York: Raven Press, 1987). The advent of the "talking cure" for hysteria is detailed in Sigmund Freud and Joseph Breuer, *Studies on Hysteria* in the Standard Edition of the Complete Psychological Works of Sigmund Freud, trans. and ed. James Strachey, 24 vols. (London: Hogarth Press, 1953–74), 2:30. For the connection between Charcot and Freud, see William J. McGrath, *Freud's Discovery of Psychoanalysis: The Politics of Hysteria* (Ithaca, N.Y.: Cornell University Press, 1986).

99. Charcot himself responded to the accusation that his patients were not truly under hypnosis: "This leads me to say a word on *simulation.* You will meet with it at every step in the history of hysteria, and one finds himself sometimes admiring the amazing craft, sagacity and perseverance which women, under the influence of this great neurosis, will put in play for the purposes of deception – especially when a physician is to be the victim. As to the case in point, however, it does not seem to me demonstrated that the *erratic paruria* of hysteria has ever been wholly simulated, and, as it were, created by these patients. On the other hand, it is incontestable that, in a multitude of cases, they have taken pleasure in distorting, by exaggerations, the principal circumstances of their disorder, in order to make them appear extraordinary and wonderful"; Jean-Martin Charcot, *Lectures on the Diseases of the Nervous System,* trans. George Sigerson (Philadelphia: Henry C. Lea, 1879), p. 189. Although Charcot came to believe that men were also susceptible to hysteria, they never performed at the Salpêtrière. See Mark S. Micale, "Charcot and the Idea of Hysteria in the Male: Gender, Medical Science, and Medical Diagnosis in Late Nineteenth-Century France," *Medical History,* no. 34 (October 1990): 363–411.

100. This is indeed the central argument of Georges Didi-Huberman's book, *Invention de l'Hystérie*. On the significance of gesture in assessing hysteria, see ibid., pp. 127–54 and 173–252.

101. Rae Beth Gordon, *Ornament, Fantasy and Desire*, p. 221. Gordon writes, "As [the hysteric] 'decomposes' her face and body, from which various bodily fluids escape, she approaches the status of pure matter."

102. For a discussion about the objectification of the woman's body as being fundamental to abstraction in film, see Janet Bergstrom, "Sexuality at a Loss: The Films of F. W. Murnau," in *The Female Body in Western Culture: Contemporary Perspectives*, ed. Susan Suleiman (Cambridge, Mass., and London: Harvard University Press, 1985), pp. 242–61.

103. Didi-Huberman, 1982, provides a history of the journal and appendices on the work of individual photographers at Salpêtrière. See *Invention de l'hystérie*, pp. 113–205, for a discussion of the photographic imagery, and pp. 275–88 for the appendices.

104. Charcot, *Lectures*, pp. 109–10.

105. Silverman discusses and illustrates the trope of the spinal curve (*Art Nouveau*, p. 94–95). In collaboration with Paul Richer, Charcot made a large inventory of the artistic images of pathology, which were first introduced in the pages of the *Nouvelle Iconographie*. See Jean-Martin Charcot et Paul Richer, *Les Démoniaques dans l'art*, ed. Pierre Fedida and Georges Didi-Huberman (Paris: Editions Macula, 1984). Vuillard's *Marie by the Door* (also called *Girl by the Door*), ca. 1891, private collection, is illustrated in Easton, *Intimate Interiors*, p. 31, fig. 12. Vuillard's *Marie by the Mirror* (also known as *Figure at a Window*), ca. 1892, private collection, is illustrated in color in ibid., p. 97, fig. 74.

106. For all his emphasis on flattening the body for representation, Vuillard seems to have been both interested in, and knowledgeable about, the internal structure of the human body – its skeletal and muscular structures. See EV. I.1, p. 15 recto and verso.

107. The classic essay on the puppet is Heinrich von Kleist's "On the Marionette Theater," in which the author celebrated both the superior gracefulness of the performing marionette and its lack of soul, which he felt acted as a pull on the gravitational field of the human actor. Kleist emphasized the weightlessness of the puppet and wrote, "The puppet uses only the ground like elves, to *skim* it and reactivate the swinging of their limbs through an instantaneous pause; we use it to *rest* upon and recover from the effort of the dance"; Heinrich von Kleist, "On the Marionette Theater," first published as "Über das Marionettentheater," in *Berliner Abendblatter*, December 12–14, 1810, trans. Roman Paska; *Fragments for a History of the Human Body*, Zone Books 3, Part One, ed. Michel Feher et al. (New York: Urzone, dist. by MIT Press, 1989), pp. 415–20, 417. In the same volume, see Roman Paska, "The Inanimate Incarnate," pp. 410–14, esp. 412, where Paska illustrates "Marionette Lilith," by W. A. Diggins, a marionette whose form is comparable to Marie Vuillard's, as her brother represents her. Also see ibid., Jean-Claude Beaune, "The Classical Age of Automata: An Impressionistic Survey from the Sixteenth to the Nineteenth Century," pp. 430–80. For more recent studies on the use and symbolism of the puppet, see Scott Cutler Shershow, *Puppets and Popular Culture* (Ithaca, N.Y., and London: Cornell University Press, 1995); Harold B. Segel, *Pinocchio's Progeny* (Baltimore: Johns Hopkins Press, 1995); John Bell, "Puppets and Performing Objects in the Twentieth Century," *Perform-*

ing Arts Journal, no. 56 (1997): 29–46; Jeffrey Cox, "The Parasite and the Puppet: Diderot's *Neveu* and Kleist's *Marionettentheater,*" *Comparative Literature,* vol. 38, no. 3 (Summer 1986): 256–69.

108. Sigmund Freud, "The Uncanny," in *Collected Works,* vol. 17, pp. 244 and 226. The paper Freud refers to is Ernst Jentsch, "Zür Psychologie des Unheimlichen," *Psychiatrische-neurologie Wochenschrift,* no. 8 (1906): 195–202.

109. See Anthony Vidler, *The Architectural Uncanny* (Cambridge, Mass., and London: MIT Press, 1992), pp. 156–57.

110. Kenneth Gross, "Love among the Puppets," *Raritan,* vol. 17, no. 1 (Summer 1997): 67–82, 71 and 77.

111. Steve Tillis, *Toward an Aesthetics of the Puppet: Puppetry as Theatrical Art,* Contributions in Drama and Theatre Studies, no. 47 (New York and Westport, Conn.: Greenwood Press, 1992), p. 83. This same duality is discussed in philosophy. Bill Brewer writes: "The properties of which we are immediately aware in bodily awareness are spatially located properties of the body that are also necessarily properties of the subject of that very awareness. Therefore, the subject is a material object" (Brewer, "Bodily Awareness and the Self," p. 308).

112. Tillis, *Toward an Aesthetics of the Puppet,* pp. 64–65.

113. Alfred Fouillée, "Les Grandes Conclusions de la psychologie contemporaine – la conscience et ses transformations" (1891), quoted in Silverman, *Art Nouveau,* pp. 90 and 336, n. 90.

114. Georg Simmel, "Soziologische Aesthetik," *Die Zukunft,* vol. 17 (1896): 206, quoted in David Frisby, *Fragments of Modernity,* p. 67; and Simmel, "Die Grosstadte und das Geistesleben," *Jahrbuch der Gehe-Stiftung zu Dresden,* no. 9 (1903): 187, quoted in Frisby, ibid., p. 81.

115. Alfred Fouillee (1891), quoted in Silverman, *Art Nouveau,* p. 91.

Chapter Five: Walter Sickert's *Ennui*

1. Henri Lefebvre, *The Production of Space,* pp. 25–26, quoted in Victor Burgin, *In/Different Spaces* (Berkeley and Los Angeles: University of California Press, 1996), p. 144.

2. Virginia Woolf, *Walter Sickert: A Conversation,* in *The Captain's Bed and Other Essays* (New York: Harcourt Brace, 1950).

3. I would add dance to this list, although I will not be addressing choreographic innovations here. For relevant discussion, see Hillel Schwartz, "Torque: The New Kinaesthetic of the Twentieth Century," in *Incorporations,* ed. Jonathan Crary and Sanford Kwinter, Zone Books 6 (New York: Urzone, distributed by MIT Press, 1992), pp. 70–127. Also see Peggy Phelan, "Dance and the History of Hysteria," in *Corporealities: Dancing Knowledge, Culture, and Power,* ed. Susan Leigh Foster (London: Routledge, 1996), pp. 90–105.

4. Walter Sickert, "A Stone Ginger," in Sickert's collected writings, *A Free House! Or, the Artist as Craftsman,* ed. Osbert Sitwell (London: Macmillan, 1947), p. 336. The major work on Sickert has been done by Wendy Baron, first in her *Sickert* (London: Arts Council of Great Britain, 1977), pp. 6–35; Wendy Baron and Malcolm Cormack, *The Camden Town Group,* exh. cat. (New Haven: Yale Center for British Art, 1980); Wendy Baron and Richard Shone, eds., with additional contributions by Anna Gruetzner Robins and Patrick O'Connor, *Sickert: Paintings* (New Haven and London: Yale University Press, with the Royal Academy of Arts, 1992). Baron's dissertation also contains much valuable information and

analysis. Wendy Baron, "Walter Sickert: A Chronological and Critical Study of His Development" (Ph.D. diss., University of London, 1966). More recently, Anna Gruetzner Robins has published an excellent book on Sickert's drawings, *Walter Sickert: Drawings. Theory and Practice: Word and Image* (Aldershot, Hants.: Scolar Press, 1996).

5. David Peters Corbett, " 'Gross Material Facts': Sexuality, Identity and the City in Walter Sickert," *Art History,* vol. 21, no. 1 (March 1998): 45–64, esp. 55 and 54. I thank Maria Gindhart for first drawing my attention to this article. For a different approach to Sickert's work, see Stella Tillyard, "W. R. Sickert and the Defence of Illustrative Painting," in Brian Allen, ed., *Studies in British Art I: Towards a Modern Art World* (New Haven and London: Yale University Press, with Mellon Centre for Studies in British Art, 1995), pp. 189–206.

6. Jacques-Emile Blanche, *Portraits of a Lifetime,* trans. Walter Clement (New York: J. M. Dent and Sons, 1938), pp. 117–18.

7. For a first-person account of Sickert's habits, see Quentin Bell, "Some Memories of Sickert," *Burlington Magazine,* vol. 129, no. 1009 (April 1987): 226–31.

8. The high point of his theatrical career was his appearance as Demetrius in *A Midsummer Night's Dream.* For discussion of Sickert's theatrical career, see the introduction to Richard Shone's *Walter Sickert* (London: Thames and Hudson, 1988).

9. On the history of Hubby (whose real name is unknown), see Baron and Shone, *Sickert,* pp. 7 and 216. Sickert's model was an old school friend who had fallen on bad times, become an alcoholic, run away to sea, and lived the life of a petty criminal. In 1914, Sickert had to dismiss Hubby because he had reverted to his old habits. Wendy Baron summarizes and refutes the stories about the alleged connection between Sickert and Jack the Ripper, in Baron and Shone, *Sickert: Paintings,* p. 213. Sickert confided to his friend Osbert Sitwell that he had learned the identity of Jack the Ripper from a former landlady; see Sickert, *A Free House,* pp. xxxviii–xl.

10. See Anna Gruetzner Robins, "Degas and Sickert: Notes on Their Friendship," *The Burlington Magazine,* vol. 130, no. 1020 (1988): 225–29. Robins also discusses Degas and Sickert in her essay " 'Drawing Masters' and the Mastery of Drawing," in Robins, *Sickert: Drawings.* See W. R. Sickert, "Degas," *The Burlington Magazine* vol. 31, no. 176 (1917): 190. In the pastel of 1885 in which Degas memorialized his Dieppe friends (Fig. 48), he included, along with Sickert, J.-E. Blanche, Ludovic Halévy, Daniel Halévy, Henri Gervex, and J.-L. Cavé.

11. There are actually four painted versions of *Ennui,* eight drawings, and one etching. For a full explanation, see Wendy Baron, *Sickert* (London: Phaidon, 1973), pp. 143–52, and Baron and Shone, *Sickert,* pp. 230–33. Also see Aimée Troyen, *Walter Sickert as Printmaker,* exh. cat. (New Haven and London: Yale Center for British Art, 1979), pp. 54–55, for an analysis of the related etching. The Tate version is generally considered to be the canonic one. It was, however, the more decorative half-scale version in the Ashmolean Museum that inspired Virginia Woolf's essay.

12. Woolf, "Walter Sickert: A Conversation," pp. 192–93.

13. Ibid., p. 200.

14. Ibid., pp. 192–93. In the half-scale version of *Ennui,* illustrated in Baron and Shone, *Sickert: Paintings,* p. 232, Sickert conveyed the same immobility that defines the earlier work, but by slightly different means. The postures of the figures are generally the same, although the woman's form is stouter and the man's head leans back at a slightly more relaxed angle. Instead of using blankness to suggest

ennui, Sickert fills every surface with a decorative pattern, creating a kind of *horror vacui* that is decidedly claustrophobic.

15. Sickert was very enthusiastic about the idea of Woolf writing an essay when it was first proposed to him, and wrote to her: "I would suggest that you *sauter par dessus* all paint-box technical twaddle about art which has bored & bored everybody stiff. I have always been a literary painter, thank goodness, like all the decent painters. Do be the first to say so"; undated note from Sickert to Woolf, quoted in Quentin Bell, *Virginia Woolf: A Biography* (New York and London: Harcourt Brace, 1972), 2:174. Although we cannot be absolutely certain, it appears that Sickert's *Portrait of a Woman* (n.d.; Collection St. Felix School, Southold) shows Virginia Woolf. Bell, Woolf's nephew and biographer, described a dinner that Sickert enjoyed with her before she wrote *A Conversation*. "Sickert kissed the ladies' hands, sang a French song, told the story of his life, made jokes about Roger [Fry], repeated that he was a literary painter – a romantic – and assured Virginia that she was the only person who understood him" (see ibid., pp. 173–74).

16. Baron, in Baron and Shone, *Sickert: Paintings,* p. 208, states that Sickert surely would have seen Degas's *Interior* at the Galérie Durand-Ruel in Paris between 1905 and 1909. Also, it is possible he would have seen it in the artist's studio years earlier. Sickert's citations on the painting in his two copies of Paul Jamot, *Degas* (Paris: Editions de la Gazette des Beaux-Arts, 1924), suggest that he may even have discussed the painting with Degas. See Chapter 2, n. 32.

17. The full caption reads: "The real subject of a picture or a drawing is the plastic facts it succeeds in expressing, and all the world of pathos, of poetry, of sentiment that it succeeds in conveying, is conveyed by means of the plastic facts expressed, by the suggestion of the three dimensions of space, the suggestion of weight, the prelude or the refrain of movement, the promise of movement to come, or the echo of movement past. If the subject of a picture could be stated in words there had been no need to paint it"; from Walter Sickert, "The Language of Art," *New Age,* July 28, 1910, p. 300.

18. Oswald Adalbert Sickert (1820–79), Sickert's father, worked as an artist for the Munich-based humor magazine *Fliegende Blätter.* Before his marriage to Elinor Sheepshanks, an actress and musician, he spent several years in France as a member of the Parisian circle surrounding Horace Lecoq de Boisbaudran. Jacques-Emile Blanche believed that Oswald himself had been a student of Lecoq's. See Jacques-Emile Blanche, *La Pêche aux Souvenirs* (Paris: Flammarion, 1949), p. 149. The eldest of six children, Walter was born in Munich in 1860, but the family emigrated to London in 1868 to avoid German citizenship. For Sickert's family background, see Denys Sutton, *Walter Sickert: A Biography* (London: Michael Joseph, 1976); and also H. Swanwick, *I Have Been Young* (London: V. Gollancz, 1935). Swanwick, the painter's younger sister, was an interesting woman in her own right. She authored several tracts on feminism and socialism. Sickert married the wealthy Ellen Cobden in 1885; their marriage ended in divorce a decade later. He married Christine Angus in 1911 and was bereft at her death in 1920. Sickert's third wife, whom he married in 1926, was the painter Thérèse Lessore.

19. Sickert wrote: "Deformation or distortion in drawing is a necessary quality in hand-made art. Not only is this deformation or distortion not a defect. It is one of the sources of pleasure and interest. But it is so on one condition: that it result from the effort for accuracy of an accomplished hand, and the inevitable degree of human error in the result." Walter Sickert, "Post-Impressionism," *Fortnightly Review* (January 1911), p. 89.

20. Ibid. Quentin Bell emphasized the importance of Lecoq to Sickert's thinking in his "Some Memories of Sickert," p. 227.

21. Sickert's writings are collected in Sickert, *A Free House*, ed. Osbert Sitwell. Sickert's skills as a teacher are discussed in a book by his friend and former student Marjorie Lilly, *Sickert: The Painter and His Circle* (London: Elek, 1971), p. 43. On his teaching philosophy, see Walter Sickert, "The Teaching of Art and the Development of the Artist," in *English Review*, vol. 2 (July 1912): 645.

22. Roger Fry's writings are collected in *Transformations: Critical and Speculative Essays on Art* (New York: Brentano's, 1927). Richard Shiff, in *Cézanne and the End of Impressionism* (Chicago: University of Chicago Press, 1984), discusses Fry's theories of art extensively and explores the influence of his criticism on Cézanne. Also see *A Roger Fry Reader*, ed. and intro. by Christopher Reed (Chicago and London: University of Chicago Press, 1996).

23. Quoted in Denys Sutton, *Sickert*, p. 219.

24. F. Tommasso Marinetti, "Manifesto del Futurismo," orig. 1909, reprinted. In Umberto Boccioni, *Pittura, Scultura Futurista, Dinamismo Plastico* (Milan: Poesia, 1914); Wassily Kandinsky, *Über das Geistege in der Kunst*, orig. 1910–12, reprinted as "Concerning the Spiritual in Art" (London: Constable and Co., 1914); Kasimir Malevich, *Essays on Art 1915–1933*, trans. Xenia Glowacki-Prus and Arnold McMillan, ed. Troes Andersen (London: Rapp and Whiting, and Ulster Springs, Pa.: Dufour Editions, 1969); also Kasimir Malevich, "O Poezii," *Same*, no. 1 (1919): 31–35. Piet Mondrian, *Le Neo-Plasticisme* (Paris: L. Rosenberg, 1926). For a discussion of early geometric abstraction, see Magdalena Dombrowski, *Contrasts of Form: Geometric Abstract Art 1910–1980*, exh. cat. (New York: Museum of Modern Art, 1985). Also see *Towards a New Art: Essays on the Background to Abstract Art 1910–1920*, exh. cat. (London: Tate Gallery, 1980).

25. The annotations in Sickert's two copies of Paul Jamot's *Degas* shed much light on his thoughts on modern painting. Also see his essay on Realism for the book on Bastien-Lepage, "Modern Realism in Painting," in *Jules Bastien-Lepage and His Art*, ed. André Theuriet (New York: Macmillan, 1892), pp. 139–40.

26. Quoted in Denys Sutton, *Sickert*, p. 168.

27. See Anna Gruetzner Robins, "British Impressionism: The Magic and Poetry of Life around Them," in Norma Broude, ed., *World Impressionism: The International Movement 1860–1920* (New York: Harry Abrams, 1990). Also see idem, "Degas and Sickert: Notes on Their Friendship." I thank Professor Robins for generously sharing her research on Sickert with me.

28. Walter Sickert, "On the Conduct of a Talent," *New Age*, June 11, 1914, p. 131.

29. Walter Sickert, "The Study of Drawing," *New Age*, June 16, 1910, p. 156.

30. William Rothenstein, *Men and Memories: Recollections of William Rothenstein, 1872–1900* (New York: Coward-McCann, 1931), 1:167. Rothenstein wrote: "I had known many poor studios in Paris, but Walter Sickert's genius for discovering the dreariest house and the most forbidding rooms in which to work was a source of wonder and amusement to me. He himself was so fastidious in his person, in his manners, in his choice of his clothes; was he affecting a kind of dandyism *à rebours*?"

31. Lilly, *Sickert*, p. 43.

32. Here I borrow Richard Shiff's characterization of the task of the modern artist: to "make a find." Shiff writes: "In effect, the modern artist learns how to *make a find*, how to represent a find or an origin. He need not actually discover an origin or a final truth, for he knows how to give the appearance of doing so, he knows

how to represent the original without ever comprehending or attaining it;" from *Cézanne and the End of Impressionism,* p. 229.

33. Lilly, *Sickert,* p. 42.
34. In his recent article on Sickert, David Peters Corbett discusses the larger social dimensions of the artist's enterprise. He writes that "Sickert's works address the revision of male identity through a catalogue of its own gendered and classed anxieties. Tension is generated from Sickert's skepticism about the imposition of control, coupled with his continuing attempts to recoup the gains of the *flâneur* and to make those systems of control and enjoyment function again in commanding the dissolute and threatening city of modernity to order." See Corbett, "Gross Material Facts," p. 58 and passim, for a discussion of the changes in contemporary London that inflected Sickert's work and point of view. For a discussion of the urban social context of late-nineteenth- and early-twentieth-century London, see Judith R. Walkowitz, *City of Dreadful Delight: Narratives of Sexual Danger in Late Victorian London* (Chicago: University of Chicago, and London: Virago Press, 1992).
35. *L'Affaire de Camden Town* is discussed in Baron and Shone, *Sickert: Paintings,* pp. 210–13. On the entire series of Camden Town paintings, see: ibid., pp. 206–13; Corbett, "Gross Material Facts," passim; Gruetzner Robins, *Sickert: Drawings,* pp. 31–34; Baron and Cormack, *Camden Town Group,* pp. 62–63; Baron (1977), pp. 21–22; and Tillyard, "W. R. Sickert." Lisa Tickner has lectured on the series in "Walter Sickert, the *Camden Town Murder* and Tabloid Crime," unpublished Paul Mellon Lecture on Early-Twentieth-Century British art, National Gallery, London, November 6, 1996.
36. Degas's *Interior* is the most obvious precedent for a scene of a fully dressed man and a nude, or partially nude, woman. It is worth asking whether Sickert's numerous depictions of beleaguered women was a sign of sympathy for their plight. Many of his models were women – and men – who had fallen on hard times and became part of the entourage around him. We know that Sickert had read George Gissing's book *The Odd Women,* whose central character works tirelessly to found a school to educate women. However, Sickert was actually quite conventional in his perception of the role of women, although he was instrumental in including their work in the London Group exhibition of 1913. His writings are full of deprecating comments about women, although it is difficult to know whether he was giving vent to his true feelings or being deliberately provocative. By and large, his stature within the group of women who gathered around him was that of adored impresario. As Jacques-Emile Blanche wrote, "Dans son atelier, de demoiselles amateurs, Sickert joue son rôle d'Amadis" (Blanche, *La Pêche aux Souvenirs,* p. 216).
37. This 1909 drawing in black crayon on hot-pink paper was given by Sickert to Paul Signac. It is inscribed "À Signac, Sickert." It is described in detail, along with all related studies, in Baron, *Sickert* (1973), p. 349.
38. In many works, Sickert used either an iron or a wooden bed shown from a variety of angles. In *The Prevaricator* (1920–22; private collection), a high footboard almost entirely blocks our view of a woman's body and face. A slim, nattily dressed man with his back to the viewer peers over a high wooden bedstead toward his companion below.
39. Lilly, *Sickert,* p. 15.
40. See Baron, *Sickert,* p. 22.

41. Another variation is found in Edouard Vuillard's portrait of his friend *Félix Vallotton* (ca. 1900; Paris, Musée d'Orsay), in which the subject is seated on a table top that is pushed toward the right corner of the room. Though Vallotton is parallel to the rear wall and not shoved into the corner, Vuillard exaggerated the recession back into space, putting Vallotton farther out of reach. With his arms crossed against his chest, he is the image of remote self-containment. Another example is Alfred Stevens, *Emotionnée* (ca. 1870; Brussels, Collection Mme. Janssens), in which a young woman's distress is conveyed by pinning her into a corner of a folding screen.

42. Sickert drew a table whose edges end in midair in *Study for l'Ennui, Hubby and Marie*, ca. 1914, pen and brown ink over pencil, Oxford, Ashmolean Museum. The drawing is illustrated in *Sickert: Paintings, Drawings and Prints of Walter Richard Sickert 1860–1942*, exh. cat. (London: Arts Council of Great Britain, 1977–78), p. 44. In *Ennui*, Sickert's table is a smaller version of a large round table that commandeers the foreground of R. S. Tait's *Thomas and Jane Carlyle in the Drawing Room of Their House in Cheyne Row, Chelsea* (1857–58; Collection of the Marquess of Northampton, on loan to Carlyle House, Chelsea). Jane Carlyle seems similarly wedged into the corner, while her husband stands meditatively by the mantle. An illustration of the painting serves as the cover illustration to Phyllis Rose, *Parallel Lives: Five Victorian Marriages* (New York: Alfred A. Knopf, 1984).

43. Woolf wrote that one of the keys to *Ennui*'s particular beauty was to be found "in the relation of the chest of drawers to the woman's body"; Woolf, "A Conversation," p. 193.

44. Ibid., p. 195. The study of the small picture and glass dome is illustrated in *Sickert: Paintings, Drawings, and Prints of Walter Richard Sickert, 1860–1942*, The Arts Council of Great Britain, p. 45, cat. no. 79. The second study is illustrated in *W. R. Sickert: Drawings, Paintings 1890–1942*, exh. cat. (Liverpool: Tate Gallery of Art, 1988), p. 25.

45. Ibid., p. 195. Woolf writes: "Merely by process of use and fitness the cheap furniture has rubbed its varnish off; the grain shows through; it has the expressive quality that expensive furniture always lacks; one must call it beautiful, though outside the room in which it plays its part it would be hideous in the extreme."

46. Baron discusses Sickert's painting technique in detail in the first two chapters of her book *Sickert* (London: Phaidon and Praeger, 1973). She cites the change from impasto to layering of thin applications of color. Baron believes that Sickert fought against the influence of Whistler, even though he was naturally drawn to thinner paint and pretty colors. Because so many of Sickert's works remain in private collections, they are usually reproduced in black and white, making it difficult to appraise the application of paint.

47. George Gissing, *New Grub Street* (1891; reprint, Harmondsworth: Penguin Books, 1968), p. 458.

48. Charles Baudelaire, *Mon coeur mis à nu,* in *Oeuvres Complètes* (Paris: Editions du Seuil, 1968), p. 1284. Quoted in Georges Teyssot, "The Disease of the Domicile," *Assemblage*, vol. 6 (June 1988): 73–97 and 95.

49. Georges Teyssot, "Boredom and Bedroom: The Suppression of the Habitual," *Assemblage*, vol. 30 (August 1996): 44–61 and 47. This article and the one noted above are part of Teyssot's forthcoming book, *The Diseased Domicile*.

50. Arthur Schopenhauer, quoted in Teyssot, "Boredom and Bedroom," p. 48; the second quote is by Emile Tardieu, from his *L'Ennui: Etude psychologique,* 2d ed. (Paris: Alcan, 1913), p. 136, quoted in Teyssot, "Boredom," p. 48; the third quote is by poet Giacomo Leopardi, *Zibaldoni,* fragment of 1815, September 13, 1821, quoted by Teyssot, "Boredom," p. 48.

51. Otto Fenichel, "On the Psychology of Boredom," in *The Collected Papers of Otto Fenichel* (New York: Norton, 1953), quoted by Teyssot, "Boredom," p. 49.

52. Quoted in Lilly, *Sickert,* p. 46.

53. Patricia Meyer Spacks, *Boredom: The Literary History of a State of Mind* (Chicago and London: University of Chicago Press, 1995), pp. 180 and 27.

54. Blanche wrote: "Le flegme britannique n'est qu'un camouflage etudié, enseigné de l'enfance, le masque d'une emotivité pathologique. L'adulte redevient enfant sous la pression de quelque désir impérieux qu'il lui faut satisfaire à tout prix. Je me suis très particuliérement exerce, comme portraitiste, à l'étude des yeux, du regard, de l'expression dans la partie du visage qu'ils appellent *brow.* L'âge du sujet n'en modifie guère les constantes qui sont raciales. On a trop parlé du *spleen.* L'Anglais a besoin d'amusement, quoiqu'il soit plûtot leger de pensée, je dirais gai." Blanche, *La Pêche aux Souvenirs* (Paris: Flammarion, 1949), p. 370.

55. Walter Sickert, "A Stone Ginger," *New Age,* March 19, 1914, p. 631.

56. Lilly, *Sickert,* p. 18.

57. Jacques-Emile Blanche, *More Portraits of a Lifetime,* trans. Walter Clement (New York: J. M. Dent and Sons, 1939), p. 117.

58. Quoted in Leon Edel, *Henry James: The Master (1901–1916)* (New York: Lippincott, 1972), 5:512. James also wrote: "Everything is blackened over for the time blighted by the hideous Public situation. This is a (Monday) the August Bank holiday but with horrible suspense and the worst possibilities in the air" (ibid., p. 511).

59. Quoted in Cynthia Wolff, *A Feast of Words: The Triumph of Edith Wharton* (Oxford and London: Oxford University Press, 1972), pp. 263–64. See R. W. B. Lewis, *Edith Wharton: A Biography* (New York: Harper and Row, 1975), pt. 5, "The War Years: 1913–1918," for a full account of Wharton's activities during these years and their impact on her life and art.

60. *The Book of the Homeless* (1915) contained a short tribute to the British soldier by Henry James and poems by William Butler Yeats, Thomas Hardy, George Santayana, Paul Claudel, and Jean Cocteau. Artists contributed pictures of other contributors: John Singer Sargent sent a replica of his portrait of Henry James; Jacques-Emile Blanche, his photographs of Hardy, George Moore, and Igor Stravinsky. Paul Bourget and Maurice Maeterlinck also contributed short pieces; Rudyard Kipling declined, saying that he found it impossible to write about the war.

61. The exception is *Three Guineas,* in which Woolf discusses photographs that show the devastation of the war. Virginia Woolf, *Three Guineas* (1938; reprint, New York: Harcourt Brace, 1966), pp. 10–11.

62. Virginia Woolf, *The Years* (1937; reprints, New York: Harcourt Brace, 1965), pp. 288–89. Jacques-Emile Blanche wrote: "*Jacob's Room, Mrs. Dalloway, To the Lighthouse, The Years, The Waves,* sont dominés par le cauchemar de la guerre – une sort de hantise de l'avenir du monde, l'horreur de la politique bolchévisante dont Mr. Leonard Woolf est le porte-drapeau. La neuropathe évite le mot guerre dans ces romans qui n'en experiment qu'allusivent les échos dans son être" (Blanche, *La Pêche aux Souvenirs,* pp. 378–79).

63. "The girl [who answered the door for him] had been sucked down into the lower portion of the house. The door stood open. . . . He felt an outsider. After all these years, he thought, everybody was paired off; settled down, busy with their own affairs. You found them telephoning, remembering other conversations; they went out of the room; they left one alone" (Woolf, *The Years,* p. 317).

64. "Listless is the air in an empty room, just swelling the curtain; the flowers in the jar shift. One fibre in the wicker arm-chair creaks, though no one sits there." Virginia Woolf, *Jacob's Room* (1922; reprint, New York: Harcourt, Brace, 1959), p. 176.

65. Virginia Woolf, "Tuesday, September 12, 1935," from *A Writer's Diary,* ed. Leonard Woolf (New York: Harcourt Brace, 1953), p. 246.

66. Charles Taylor, *Sources of the Self: The Making of Modern Identity* (Cambridge, Mass.: Harvard University Press, 1989), p. 465.

67. Henry James, "The Jolly Corner" (1909; reprinted in the *Short Stories of Henry James,* selected and edited with intro. by Clifton Fadiman [New York: The Modern Library, 1945]), pp. 630–31. The passage reads: "It seemed to him that he had waited an age for some stir of the great grim hush; the life of the town was itself under a spell – so unnaturally, up and down the whole prospect of known and rather ugly objects, the blankness and the silence lasted. Had they ever, he asked himself, the hard-faced houses, which had begun to look livid in the dim dawn, had they ever spoken so little to any need of his spirit? Great builded voids, great crowded stillnesses put on, often, in the heart of cities, for the small hours, a sort of sinister mask, and it was of this large collective negation that Brydon presently became conscious – all the more that the break of day was, almost incredibly, now at hand, proving to him what a night he had made of it."

68. Sigmund Freud, "The Unconscious," in Peter Gay, ed., *The Freud Reader* (New York and London: W. W. Norton and Co., 1989), pp. 574 and 578.

69. Ibid., p. 579.

70. Virginia Woolf, *To the Lighthouse* (1927; reprint, New York: Harcourt Brace, 1955), p. 79.

71. Walter Pater, "The Child in the House," first published 1878, in Harold Bloom, ed., *Selected Writings of Walter Pater* (New York: Columbia University Press, 1974), pp. 1–16. The phrase "maison natale" is from Gaston Bachelard, *La Terre et les rêveries du repos* (Paris: Librairie Jose Corti, 1948), and is discussed in Anthony Vidler, *The Architectural Uncanny* (Cambridge, Mass., and London: MIT Press, 1992), pp. 64–65.

72. Rainer Maria Rilke, *Die Aufzeichnungen des Malte Laurids Brigge,* first published 1910, English ed., *The Notebooks of Malte Laurids Brigge,* trans. M. D. Herter (New York: W. W. Norton and Co., 1949), pp. 30–31; quoted in Georges Teyssot, "The Disease of the Domicile," p. 92. The entire passage reads: "As I recover it in recalling my child-wrought memories, it is no complete building; it is all broken up inside me; here a room, there a room, and here a piece of hallway that does not connect these two rooms but is preserved, as a fragment, by itself. In this way it is all dispersed within me – the rooms, the stairways that descended with such ceremonious deliberation, and other narrow, spiral stairs in the obscurity of which one moved as blood does in the veins; the tower rooms, the high-hung balconies, the unexpected galleries onto which one was thrust out through a little door – all that is still in me and will never cease to be in me. It is as though the picture of this house had fallen into me from an infinite height and had shattered against my very ground."

73. Rainer Maria Rilke, from the seventh of the *Duino Elegies,* quoted in Taylor, *Sources of the Self,* p. 501.

74. This is the phrase of Jane Becket, "The Abstract Interior," in *Towards a New Art,* exh. cat. (London: Tate Gallery of Art, 1980), pp. 90–124.

75. On the Stoclet House in Brussels, 1906–11, see Kirk Varnedoe, *Vienna 1900: Art, Architecture, and Design,* exh. cat. (New York: Museum of Modern Art, 1986), where the Palais Stoclet is illustrated on pp. 64–75. See p. 70 for a view of the dining room and p. 71 for Gustave Klimt's *Fulfillment.* Also see Becket, "The Abstract Interior," pp. 92–115. On De Stijl, see Nancy Troy, *The De Stijl Environment* (Cambridge, Mass., and London: MIT Press, 1983); Mildred Friedman, ed., *De Stijl: 1917–1931: Visions of Utopia* (New York: Abbeville Press, 1982); and *Mondrian: Nature to Abstraction,* with essay by Bridget Riley, exh. cat. (The Hague: Gemeente Museum, and London: Tate Gallery, 1997), and also Yve-Alain Bois, *Piet Mondrian 1872–1944* (Boston: Little, Brown, 1995). On the Russian Constructivists, see Arts Council of Great Britain, *Art in Revolution: Soviet Art and Design since 1917,* exh. cat. (London: Hayward Gallery, 1971), and *The Great Utopia: The Russian and Soviet Avant-Garde 1915–1932,* Solomon Guggenheim Museum, exh. cat. (New York: Guggenheim Museum, distributed by Rizzoli, 1992). On the Bauhaus, see Hans Wingler, trans. Wolfgang Jobs and Basil Gilbert, ed. Joseph Stein, *The Bauhaus: Weimar, Dessau, Berlin, Chicago* (Cambridge, Mass., and London: MIT Press, 1978).

76. Walter Benjamin, "Erfahrung und Armut," first published 1933, in *Gesammelte Schriften,* ed. R. Tiedemann and H. Scheppenhauser, vol. 2 (Frankfurt: Suhrkamp, 1977), pp. 213–19; quoted in Teyssot, "Disease of the Domicile," p. 93.

77. Walter Benjamin, "Das Passagen-Werk," in *Gesammelte Schriften,* ed. Rolf Tiedemann and Hermann Schweppenhauser, 7 vols. (Frankfurt am Main: Suhrkamp Verlag, 1982), 5:513; quoted in Vidler, *Architectural Uncanny,* p. 147. Vidler (p. 217) also cites Benjamin on transparency: "In the imprint of this turning point of the epoch, it is written that the knell has sounded for the dwelling in its old sense, dwelling in which security prevailed. Giedion, Mendelssohn, Le Corbusier, have made the place of abode of men above all the transitory space of all the imaginable forces and waves of air and light. What is being prepared for is found under the sign of transparency." Benjamin, "Die Wiederkehr des Flaneurs," in *Gesammelte Schriften* (1972), 3:168.

78. Beatriz Colomina illustrates both Loos's and Le Corbusier's interiors in "The Split Wall: Domestic Voyeurism," in Colomina, ed., *Sexuality and Space* (New York: Princeton Architectural Press, 1992), pp. 72–128. Quotations are taken from pp. 83 and 95. See p. 87, fig. 13, for illustrations of Loos's Muller House; fig. 12 for the Steiner House; and p. 89, fig. 14, for his design for Josephine Baker's house. See pp. 99–101, figs. 19–23, for photographs of Le Corbusier's Villa Savoye. Also see idem, "On Adolf Loos and Josef Hoffmann: Architecture in the Age of Mechanical Reproduction," *9H,* no. 6 (1983): 52–58, and idem, *Privacy and Publicity: Modern Architecture as Mass Media* (Cambridge, Mass., and London: MIT Press, 1994). For a recent study that connects the austerity of early modern architecture to ideas about gender, costume, and health, see Mark Wigley, *White Walls, Designer Dresses: The Fashioning of Modern Architecture* (Cambridge, Mass., and London: MIT Press, 1995). The literature on both Le Corbusier and Loos is vast. Recent studies include *Le Corbusier: Architect of the Century,* ed. Michael Raeburn and Victoria Wilson (London: Arts Council of Great Britain, 1987); and

Jane Newman and John H. Smith, trans. and eds., *Adolph Loos, Spoken in the Void: Collected Essays 1897–1900* (Cambridge, Mass., and London: MIT Press, 1982), and Wilfred Wang, *The Architecture of Adolph Loos* (London: Arts Council of Great Britain, 1985).

79. Tzara believed that the fundamental forms of architecture were the cave, the grotto, and the tent: "From the cave (for man inhabits the earth, 'the mother'), through the Eskimo yurt, the intermediary form between the grotto and the tent (remarkable example of uterine construction which one enters through cavities with vaginal forms), through to the conical or half-spherical hut furnished at its entrance with a post of sacred character, the dwelling symbolizes prenatal comfort." Tristan Tzara, "D'incertain automatisme du Goût," *Minotaure*, no. 9 (October 1936): 62. Quoted in Vidler, *Architectural Uncanny*, pp. 151–52.

80. Anne Troutman, "Inside Fear: Secret Places and Hidden Spaces in Dwellings," in Nan Ellin, ed., *Architecture of Fear* (New York: Princeton Architectural Press, 1997), pp. 143–57, esp. 157 and 143.

81. Recently, a photograph by Elliot Erwitt of a young boy striding determinedly through a harshly lit, empty space was used to illustrate an article that examined the oddness – the positive *unhomeliness* – of recent photographs of domestic interiors as contemporary architectural magazines such as *House and Garden* and *Elle Decor* had conceived them. "Could *House and Garden* be channeling Diane Arbus?" the author asked. Experts attempted to explain the eeriness of the images by, variously, the breakdown of the traditional family, the end of "authoritarian rule" about how people should dress and live, and the generally provocative mandate of a commercial magazine. See Julie V. Iovine, "Helter-Shelter: New Look for Dream Books," *New York Times,* The Home Section, August 22, 1996, pp. C1 and C8.

82. Carol Shields, in a review of Richard Bausch, *Rare and Endangered Species, The New York Times Book Review,* August 14, 1994, p. 6.

Bibliography

Alexandre, Antoine. "Degas." *L'art et les artistes*, vol. 29, no. 154 (February 1935): 145–73.

Antoine, André. "Causerie sur la Mise en Scène." *La Revue de Paris* (April 1, 1903): 569–612.

Apter, Emily. "Cabinet Secrets: Fetishism, Prostitution and the Fin de Siècle Interior." *Assemblage*, no. 9 (June 1989): 6–19.

Ardener, Shirley. *Women and Space*. London: Croom Helm, 1981.

Armstrong, Carol. "Edgar Degas and the Representation of the Human Body." In Susan Suleiman, ed., *The Female Body in Western Culture*, pp. 223–42. Cambridge, Mass., and London: Harvard University Press, 1985.

Armstrong, Carol. *Odd Man Out: Readings of the Work and Reputation of Edgar Degas*. Chicago and London: University of Chicago Press, 1991.

Arts Council of Great Britain. *Art in Revolution: Soviet Art and Design since 1917*. Exh. cat. London: Hayward Gallery, 1971.

Bachelard, Gaston. *The Poetics of Space*. Trans. Maria Jolas, foreword by Etienne Gilson. Boston: Beacon Press, 1958.

Bachelard, Gaston. *La Terre et les Rêveries du Repos*. Paris: Librairie Jose Corti, 1948.

Baldwin, James Mark. *Mental Development in the Child and the Race*. 1894. Reprint, New York: Macmillan, 1906.

Balzac, Honoré de. *Cousine Bette*. 1837. Reprint, Paris: Garnier-Flammarion, 1977.

Bapst, Germaine. *Essai sur l'Histoire de Théâtre*. Paris: Hachette, 1893.

Baron, Wendy. *Sickert*. London: Arts Council of Great Britain, 1977.

Baron, Wendy. "Walter Sickert: A Chronological and Critical Study of His Development." Ph.D. diss., University of London, 1966.

Baron, Wendy, and Malcolm Cormack. *The Camden Town Group*. Exh. cat. New Haven: Yale Center for British Art, 1980.

Baron, Wendy, and Richard Shone, eds., with contributions by Anna Gruetzner Robins and Patrick O'Connor. *Sickert: Paintings*. New Haven and London: Yale University Press, with the Royal Academy of Arts, 1992.

Barr, Alfred. *Cubism and Abstract Art*. Exh. cat. New York: Museum of Modern Art, 1936.

Barr Alfred. *Henri Matisse: Retrospective Exhibition*. Exh. cat. New York: Museum of Modern Art, 1931.

Bastide, Jean François de. *The Little House: An Architectural Seduction*. Trans. and intro. by Rodolphe El-Khoury, preface by Anthony Vidler. New York: Princeton Architectural Press, 1996.

Baudelaire, Charles. *Oeuvres Complètes*. Paris: Editions du Seuil, 1968.

Becq de Fouquiéres, Louis. *L'Art de la Mise en Scène. Essai d'Aesthétique Théâtrale*. Paris: Charpentier, 1884.

Beizer, Janet. *Ventriloquized Bodies: Narratives of Hysteria in Nineteenth-Century France*. Ithaca, N.Y.: Cornell University Press, 1994.

Bell, John. "Puppets and Performing Objects in the Twentieth-Century." *Performing Arts Journal*, no. 56 (1997): 29–46.

Bell, Quentin. "Some Memories of Sickert." *Burlington Magazine*, vol. 129, no. 1009 (April 1987): 226–31.

Bell, Quentin. *Virginia Woolf: A Biography*. Vol. 2. New York and London: Harcourt Brace, 1972.

Benjamin, Roger. *Matisse's 'Notes of a Painter': Criticism, Theory and Context 1891–1908*. Studies in the Fine Arts: Criticism, no. 21. Ann Arbor, Mich.: UMI Research Press, 1987.

Benjamin, Walter. *Charles Baudelaire: A Lyric Poet in the Era of High Capitalism*. Trans. Harry Zohn. London: Verso Editions, 1982.

Benjamin, Walter. *Gesammelte Schriften*. Ed. R. Tiedemann and H. Schweppenhauser. Vol. 2. Frankfurt: Suhrkamp Verlag, 1977.

Bergson, Henri. *Essai sur les Données Immédiates de la Conscience*. Paris: Alcan, 1889.

Bergstrom, Janet. "Sexuality at a Loss: The Films of F. W. Murnau." In Susan Suleiman, ed., *The Female Body in Western Culture: Contemporary Perspectives*, pp. 275–88. Cambridge, Mass., and London: Harvard University Press, 1985.

Bermudez, José Louis, Anthony Marcel, and Naomi Eilan, eds. *The Body and the Self*. Cambridge, Mass., and London: MIT Press, 1995.

Bernheimer, Charles, and Claire Kahane, eds. *In Dora's Case: Freud – Hysteria – Feminism*. New York: Columbia University Press, 1985.

Bertelson, Lance. "The Interior Structures of Hogarth's *Mariage à la Mode*." *Art History*, vol. 6, no. 2 (1983): 131–42.

Blanche, Jacques-Emile. *La Pêche aux Souvenirs*. Paris: Flammarion, 1949.

Blanche, Jacques-Emile. *Portraits of a Lifetime*. Trans. Walter Clement. New York: J. M. Dent and Sons, 1938.

Block, Haskell, M. *Mallarmé and the Symbolist Drama*. Detroit: Wayne State University Press, 1963.

Bloom, Harold, ed. *Selected Writings of Walter Pater*. New York: Columbia University Press, 1974.

Boggs, Jean Sutherland. "Degas as a Portraitist." In Felix Baumann, Marianne Karabelnik et al., eds., *Degas Portraits*. Exh. cat. London: Merrell Holberton, 1994.

Boggs, Jean Sutherland. *Drawings by Degas*. Exh. cat. St. Louis and Philadelphia: Philadelphia Museum of Art, 1966.

Boggs, Jean Sutherland, with Douglas Druick, Henri Loyrette, Michael Pantazzi and Gary Tinterow. *Degas*. Exh. cat. New York: Metropolitan Museum of Art, 1988.

Boime, Albert. "Sargent in Paris and London: A Portrait of the Artist as Dorian Gray." In Patricia Hills et al., eds., *John Singer Sargent*. Exh. cat. New York: Whitney Museum of American Art with Harry N. Abrams, 1986.

Boime, Albert. "The Teaching Reforms of 1863 and the Origins of Modernism in Painting." *Art Quarterly*, vol. 1. no. 1 (Autumn 1977): 1–39.

Boime, Albert. *Thomas Couture and the Eclectic Vision*. New Haven: Yale University Press, 1980.

Bois, Yve-Alain. "Introduction" to Sergei Eisenstein, "Montage and Architecture." *Assemblage*, no. 10 (December 1989): 111–31.

Bois, Yve-Alain. "On Matisse: The Blinding." *October*, no. 68 (Spring 1994): 61–121.

Boit, Edward Darley. Personal Papers, Archives of American Art, Washington, D.C.

Boit, Robert Apthorp. *The Boit Family and Their Descendants*. Boston: S. J. Parkhill & Co., 1915.

Bouchard, Alfred. *La Langue Théâtrale: Vocabulaire Historique, Descriptif et Anecdotique des Termes et des Choses du Théâtre*. Paris: Arnaud et Labat, 1878.

Bourget, Paul. *Nouveaux Essais de Psychologie Contemporaine*. Paris: Tourgueniev-Amiel, 1886.

Bowlby, Rachel. *Shopping with Freud*. London: Routledge, 1993.

Boxer, Sarah. "Pulling Strings: The Gepetto Effect." *New York Times*, Section B, January 17, 1998, pp. 9 and 11.

Boyer, Patricia Eckert, ed. *The Nabis and the Parisian Avant-Garde*. Exh. cat. New Brunswick, N.J.: Rutgers University Press with the Jane Voorhees Zimmerli Art Museum, 1988.

Bronfen, Elisabeth. "Facing Defacement: Degas's Portraits of Women." In Felix Baumann, Marianne Karabelnik et al., eds. *Degas Portraits*. Exh. cat. London: Merrell Holberton, 1994.

Brooks, Peter. *The Melodramatic Imagination: Balzac, Henry James, Melodrama, and the Mode of Excess*. New York: Columbia University Press, 1985.

Broude, Norma. *The Macchiaioli: Italian Painters of the Nineteenth Century*. New Haven and London: Yale University Press, 1987.

Brown, Helen Willison, M.D. "The Deforming Influence of the Home." *Journal of Abnormal Psychology*, vol. 12 (April 1917): 49–57, 51–52.

Burgin, Victor. "Geometry and Abjection." *AA Files – Annals of the Architecture Association of Architecture*, no. 15 (September 1987): 35–41.

Burgin, Victor. *In(Different) Spaces: Place and Memory in Visual Culture*. Berkeley and Los Angeles: University of California Press, 1996.

Burr, C. B. "The Insanity of Pubescence." *American Journal of Insanity*, no. 422 (1887): 328–39.

Butler, Judith. *Bodies That Matter: On the Discursive Limits of "Sex."* New York and London: Routledge, 1993.

Cable, Mary. *The Little Darlings: A History of Child-Rearing in America*. New York: Scribner's, 1972.

Cahan, Emily, Jay Mechling, Brian Sutton-Smith, and Sheldon H. White. "The Elusive Historical Child: Ways of Knowing the Child of History and Psychology." In Glenn Elder, John Modell, and Ross D. Parke, *Children in Time and Place: Developmental and Historical Insights*. Cambridge and New York: Cambridge University Press, 1993.

Callen, Anthea. *The Spectacular Body: Science, Method, and Meaning in the Work of Degas*. New Haven and London: Yale University Press, 1995.

Callois, Roger. "Mimicry and Legendary Psychasthenia." Trans. John Shephard. Reprinted in *October: The First Decade, 1976–1986*, ed. Annette Michelson, Rosalind Krauss, Douglas Crimp, and Joan Copjec. Cambridge, Mass.: MIT Press, 1987.

Calvert, Karin. *Children in the House: The Material Culture of Early Childhood, 1600–1900*. Boston: Northeastern University Press, 1992.

Caryl, Philippe. "La Suggestion et la Personnalité Humaine." *Le Temps, no. 8970, November 21, 1885, p. 3.*

Case, Sue Ellen, ed. *Performing Feminisms.* Baltimore: Johns Hopkins University Press, 1990.

Casteras, Susan. *The Substance and the Shadow: Images of Victorian Womanhood.* Exh. cat. New Haven: Paul Mellon Centre for British Art, 1982.

Cavé, Marie-Elizabeth. *Le Dessin sans maître.* Preface by Eugène Delacroix. Paris: Aubert et Cie., 1852.

Charcot, J.-M. *Charcot the Clinician: The Tuesday Lessons.* Trans. and ed. Christopher Goetz. New York: Raven Press, 1987.

Charcot, J.-M. *Lectures on the Diseases of the Nervous System.* Trans. George Sigerson. Philadelphia: Henry C. Lea, 1879.

Charcot, J.-M., and Paul Richer. *Les Démoniaques dans l'Art.* Ed. Pierre Fedid and Georges Didi-Huberman. Paris: Editions Macula, 1984.

Chave, Anna. "Vuillard's *La Lampe.*" *Yale University Art Gallery Bulletin,* vol. 38, no. 1 (Fall 1980): 12–15.

Chu, Petra ten-Doesschate. "Lecoq de Boisbaudran and Memory Drawing." In Gabriel Weisberg, ed., *The European Realist Tradition,* pp. 242–89. Bloomington: University of Indiana Press, 1982.

Ciaffa, Patricia. "The Portraits of Vuillard." Ph.D. diss., Columbia University, 1985.

Cima, Gay Gibson. *Performing Women, Female Characters, Male Playwrights and the Modern Stage.* Ithaca, N.Y., and London: Cornell University Press, 1993.

Clark, T. J. "Freud's Cézanne." *Representations,* no. 52 (Fall 1995): 94–122.

Clark, T. J. *The Painting of Modern Life: Paris in the Art of Manet and his Followers.* New York: Alfred Knopf, 1985.

Clayson, Hollis. "Avant-Garde and Pompier Images of Nineteenth-Century French Prostitutes: The Matter of Modernism, Modernity and Social Ideology." In *Modernism and Modernity: The Vancouver Papers,* ed. Benjamin Buchloch, Serge Guilbaut, and David Solkin, pp. 43–64. Halifax: The Press of the Nova Scotia College of Art and Design, 1983.

Clayson, Hollis. *Painted Love: Prostitution in French Art of the Impressionist Era.* New Haven and London: Yale University Press, 1991.

Cogéval, Guy. "Le Célibataire, Mis à Nu par son Théâtre, Même," pp. 105–36. Exh. cat. Lyons: Musée des Beaux Arts, 1990.

Cohen, Sarah. *Art, Dance, and the Body in French Culture of the Ancien Régime.* New York and Cambridge: Cambridge University Press, 2000.

Colomina, Beatriz. "On Adolf Loos and Josef Hoffman: Architecture in the Age of Mechanical Reproduction." *9H,* no. 6 (1983): 52–58.

Colomina, Beatriz. *Privacy and Publicity: Modern Architecture as Mass Media.* Cambridge, Mass., and London: MIT Press, 1994.

Colomina, Beatriz. "The Split Wall: Domestic Voyeurism." In Beatriz Columina, ed., *Sexuality and Space,* pp. 73–130. New York: Princeton Papers on Architecture, Princeton Architectural Press, 1992.

Connerton, Paul. *How Societies Remember.* Cambridge and New York: Cambridge University Press, 1989.

Copjec, Joan. "Flavit et Dissipati Sunt." In Annette Michelson et al., eds., *October: The First Decade 1976–1986.* Cambridge, Mass., London: MIT Press, 1987.

Corbett, David. " 'Gross Material Facts': Sexuality, Identity and the City in Walter Sickert." *Art History,* vol. 21, no. 1 (March 1988): 45–64.

Cox, Jeffrey. "The Parasite and the Puppet: Diderot's *Neveu* and Kleist's *Marionettentheatre*." *Comparative Literature*, vol. 38, no. 3 (Summer 1986): 256–69.

Crary, Jonathan. *Techniques of the Observer: On Vision and Modernity in the Nineteenth Century*. Cambridge, Mass.: MIT Press, 1991.

Crary, Jonathan, and Sanford Kwinter, eds. *Incorporations*. Zone Books 6, distributed by MIT Press, 1995.

Crouzet, Marcel. *Duranty. Un méconnu du Réalisme*. Paris: Librairie Nizet, 1964.

Crow, Thomas. *Painters and Public Life in Eighteenth-Century Paris*. New Haven and London: Yale University Press, 1985.

D'Alessio, Maria. "Social Representations of Childhood: An Implicit Theory of Development." In Gerard Duveen and Barbara Lloyd, eds., *Social Representations and the Development of Knowledge*. Cambridge and New York: Cambridge University Press, 1990.

Daly, César. *L'Architecture privée au XIXe siècle urbaine et surburbaine*. Paris: M. Brun, 1964.

Daly, César. "Causerie sur esthétique." *Revue Générale de l'Architecture*, vol. 25 (1867): 50–58.

Daly César. "Du symbolisme dans l'architecture." *Revue Générale de l'Architecture*, vol. 7 (1847): 49–69.

Daly, César. "Villa Choisy." *Revue Générale de l'Architecture*, no. 32 (1875): 274.

Damisch, Hubert. *The Origin of Perspective*. Trans. John Goodman. Cambridge, Mass.: MIT Press, 1994.

Daumier, Honoré de. *Intellectuelles (Bas Bleus) et Femmes Sociales*. 1844. Reprint, Paris: Editions Vilo, 1974.

Deak Frantisek. *Symbolist Theater: The Formation of an Avant-Garde*. Baltimore and London: Johns Hopkins University Press, 1993.

Delsarte, François. *Système de François Delsarte*. Paris: n.d. (before 1877).

Denis, Maurice. *Théories*. 1905–6. Reprint, Paris: Hermann, 1969.

Detroit Institute of Art. *French Painting, 1774–1830: The Age of Revolution*. Detroit: Wayne State University Press, 1975.

Detroit Institute of Art. *The Quest for Unity: American Art between the World's Fairs, 1876–1893*. Exh. cat. Detroit: Detroit Institute of Arts, 1983.

Didi-Huberman, Georges. *L'Invention de l'hystérie: Charcot et l'iconographie photographique de la Salpêtrière*. Paris: Editions Macula, 1982.

Dombrowski, Magdelena. *Contrasts of Form: Geometric Abstact Art 1910–1980*. Exh. cat. New York: Museum of Modern Art, 1985.

Drummond, W. B. *Introduction to Child Study*. London: Arnold Press, 1907.

Duncan, Carol. "Virility and Domination in Early Twentieth-Century Vanguard Painting." *Artforum*, vol. 12, no. 4 (December 1973): 30–39.

Dupuis, André. *Enseignement du Dessin, Méthode*. Paris, ca. 1850.

Durand-Ruel. *Vente Duranty*. Paris, January 1881.

Duranty, Louis-Emile Edmond. "Bric-à-Brac." 1876. Reprinted in *Le Pays des Arts*. Paris: Charpentier, 1881.

Duranty, Louis-Emile Edmond. "Sur Physionomie." *La Revue Libérale* July 25, 1867, pp. 499–523.

Duranty, Louis-Emile Edmond. "Tours et le dessin moderne." *Paris-Journal*, March 29, 1870, p. 36.

Dyce, William. *Report made by W. Dyce, contingent to his journey on an inquiry into the state of schools of design in Prussia, Bavaria and France*. House of Commons Parliamentary Papers, vol. 29, 1840.

Easton, Elizabeth. *The Intimate Interiors of Edouard Vuillard*. Exh. cat. Houston: Museum of Fine Arts, and Washington, D.C.: Smithsonian Institution Press, 1989.

Edel, Leon. *Henry James: The Master, 1901–1916*. Vol. 5. New York: Lippincott, 1972.

Edel, Leon. *Henry James: The Middle Years, 1882–1895*. Vol. 3. New York: Avon Books, 1978.

Edelstein, T. J. "Augustus Egg's Triptych: A Narrative of Victorian Adultery." *Burlington Magazine*, vol. 135, no. 961 (April 1983): 202–10.

Edelstein, T. J. "But Who Shall Paint the Griefs of Those Oppressed?" Ph.D. diss., University of Pennsylvania, 1979.

Edelstein, T. J. "They Sang the Song of the Shirt: The Visual Iconology of the Seamstress." *Victorian Studies*, vol. 23, no. 2 (Winter 1980): 183–210.

Eisenstein, Sergei. "Piranesi: Or, the Fluidity of Forms." Trans. Roberta Reeder. *Oppositions*, no. 2 (Winter 1977): 83–110.

Elder, Glenn, John Modell, and Ross D. Parke, eds. *Children in Time and Place: Developmental and Historical Insights*. Cambridge and New York: Cambridge University Press, 1993.

Elderfield, John. *Pleasuring Painting: Matisse's Feminine Representations*. London: Thames and Hudson, 1996.

Elkins, James. *The Poetics of Perspective*. Ithaca, N.Y.: Cornell University Press, 1994.

Elsaesser, Thomas. "Tales of Sound and Fury." In Bill Nichols, ed., *Movies and Methods*, vol. 2. New York: Columbia University Press, 1985.

Elsen, Albert, and J. Kirk T. Varnedoe. *The Drawings of Rodin*. New York: Praeger, 1971.

Ely, John Wilton. *The Mind and Art of Giovanni Battista Piranesi*. London: Thames and Hudson, 1973.

Etex, Antoine. *Cours élémentaire de dessin*. Paris: Carilian-Loewy, 1851.

Faberman, Hilarie. "Augustus Leopold Egg." Ph.D. diss., Yale University, 1983.

Farwell, Beatrice. *The Cult of Images: Baudelaire in the Nineteenth Century*. Santa Barbara: Santa Barbara Art Museum, University of California, 1977.

Farwell, Beatrice. *French Popular Lithographic Imagery 1815–1870*. Chicago: University of Chicago Press, 1981.

Feray, J. *Architecture intérieure et décoration en France: Des origines à 1875*. Paris: Berger-Levrault: Caisse Nationale des Monuments Historiques et les Sites, 1988.

Finney, Gail. "Dramatic Pointillism: The Examples of Holz and Schlaf's *Die Familie Selicke* and Maeterlinck's *L'Intruse*." *Comparative Literature Studies*, vol. 30, no. 1 (1993): 1–15.

Forgione, Nancy. "Edouard Vuillard in the 1890's: Intimism, Theatre and Decoration." Ph.D. diss., Johns Hopkins University, 1993.

Formanek-Brunell, Miriam. "Sugar and Spite: The Politics of Doll Play in Nineteenth-Century America." In Elliot West and Paula Petrik, eds., *Small Worlds: Children and Adolescents in America, 1850–1950*, pp. 107–24. Lawrence: University Press of Kansas, 1992.

Foster, Hal, ed. *Vision and Visuality*. Discussions in Contemporary Culture, no. 2. Seattle: Dia Art Foundation, 1988.

Foucault, Michel. *Birth of the Clinic: An Archaeology of Medical Perception*. Trans. A. M. Sheridan Smith. New York: Vintage Books, 1973.

Foucault, Michel. *The Order of Things: An Archaeology of the Human Sciences*. Translation of *Les Mots et les choses*. London: Tavistock, 1966.

Fouillée, Alfred. "Les Grands Conclusions de la Psychologie Contemporaine – la Conscience et ses Transformations." *Revue des Deux Mondes* (1891): 788–816.

Fouillée, Alfred. "La Psychologie des sexes." *Revue des Deux Mondes*, vol. 119, no. 3, ser. 3 (September 15, 1893): 397–429.

Frèches-Thory, Claire, and Ursula Perucchi-Petri. *Nabis 1888–1900*. Exh. cat. Munich: Prestel-Verlag, 1993.

Freedberg, David. *The Power of Images: Studies in the History and Theory of Response*. Chicago: University of Chicago Press, 1989.

Freud, Sigmund. *The Standard Edition of the Complete Psychological Works of Sigmund Freud*. Trans. and ed. James Strachey. 24 Vols. London: Hogarth Press, 1953–74.

Fried, Michael. *Absorption and Theatricality: Painting and Beholder in the Age of Diderot*. Berkeley and Los Angeles: University of California Press, 1980.

Friedman, Mildred, ed. *De Stijl: 1917–1931. Visions of Utopia*. New York: Abbeville Press, 1982.

Frisby, David. *Fragments of Modernity: Theories of Modernity in the Work of Simmel, Kracauer, and Benjamin*. Cambridge, Mass.: MIT Press, 1986.

Fry, Roger. *Transformations: Critical and Speculative Essays on Art*. New York: Brentano's, 1927.

Fryer, Judith. *Felicitous Space: The Imaginative Structures of Edith Wharton and Willa Cather*. Chapel Hill and London: University of North Carolina Press, 1986.

Garber, Marjorie. *Vested Interests: Cross-Dressing and Cultural Anxiety*. New York and London: Routledge, 1992.

Gay, Peter. *The Bourgeois Experience: Victoria to Freud*. Vol. 1, *Education of the Senses;* Vol. 2, *The Tender Passion*. New York and Oxford: Oxford University Press, 1984, 1986.

Gay, Peter. *Freud: A Life of Our Time*. New York: W. W. Norton and Co., 1988.

Gay, Peter. *The Freud Reader*. New York and London: W. W. Norton and Co., 1989.

Gerdts, William. "The Square Format and Proto-Modernism in American Painting." *Arts Magazine*, vol. 50, no. 10 (June 1976): 70–75.

Gibson, J. J. *The Senses Considered as a Perceptual System*. Boston: Houghton Mifflin Co., 1955.

Gilman, Charlotte Perkins. "The Yellow Wallpaper." 1892. In *The Yellow Wallpaper and Other Writings*, ed. Lynn Sharon Schwartz. New York: Bantam Books, 1989.

Gilman, Sander, et al., eds. *Hysteria Beyond Freud*. Berkeley and Los Angeles: University of California Press, 1993.

Gissing, George. *New Grub Street*. 1891. Reprint, Harmondsworth: Penguin Books, 1968.

Goellner, Ellen W., and Jacqueline Shea Murphy. *Bodies of the Text: Dance as Theory*. New Brunswick, N.J.: Rutgers University Press, 1995.

Goldstein, Jan. *Console and Classify: The French Psychiatric Profession in the Nineteenth Century*. Cambridge and New York: Cambridge University Press, 1987.

Goncourt, Edmond de, and Jules de Goncourt. *La Maison d'un Artiste*. Vols. 1 and 2. Paris, 1881.

Gordon, Rae Beth. *Ornament, Fantasy and Desire in Nineteenth-Century French Literature*. Princeton, N.J.: Princeton University Press, 1992.

Groom, Gloria. *Edouard Vuillard: Painter-Decorator*. New Haven and London: Yale University Press, 1993.

Gross, Kenneth. "Love among the Puppets." *Raritan*, vol. 17, no. 1 (Summer 1997): 67–82.

Guillaume, E. *L'Idée générale d'un enseignement du dessin: Essai sur la théorie du dessin*. Text of speech to Union Central des Arts, March 23, 1866. Archives Nationales, Paris.

Habermas, Jürgen. *The Structural Transformation of the Public Sphere. An Inquiry into a Category of Bourgeois Society.* Trans. Thomas Burger, with the assistance of Frederick Lawrence. Cambridge, Mass.: MIT Press, 1989.

Hacks, Charles. *Le Geste: De la Signification du Mot Geste – Definition du Geste Origine et Localisation Cérébrale du Geste.* Paris: E. Flammarion, 1892.

Hall, Granville Stanley. *Adolescence: Its Psychology and Its Relations to Physiology, Anthropology, Sociology, Sex, Crime, Religion and Education.* 2 vols. New York: D. Appleton and Co., 1904.

Hall, Granville Stanley. *Youth: Its Regimen and Hygiene.* New York: D. Appleton and Co., 1906.

Hargrove, June. "Degas's *Little Dancer* in the World of Pantomime." *Apollo,* vol. 147 (February 1998): 15–21.

Harlé, Daniel. "Les Cours de dessin gravés et lithographiés du XIX siècle conservé au Cabinet des Estampes de la Bibliothèque Nationale. Essai Critique et Catalogue." Ph.D. diss., Ecole du Louvre, 1975.

Hawthorne, Nathaniel. *The Marble Faun.* 1860. Reprint, New York, New American Library of World Literature, Signet Classics, 1961.

Heininger, Mary Lynn Stevens, Karin Calvert et al. *A Century of Childhood: 1820–1920.* Exh. cat. Rochester, N.Y.: The Margaret Woodbury Strong Museum, 1984.

Higonnet, Anne. *Pictures of Innocence: The History and Crisis of Ideal Childhood.* London: Thames and Hudson, 1998.

Higonnet, Anne, and Cassi Albinson. "Clothing the Child's Body." *Fashion Theory,* vol. 1., no. 2 (June 1997): 119–44.

Hills, Patricia, et al., eds. *John Singer Sargent.* Exh. cat. New York: Whitney Museum of American Art, with Harry N. Abrams, 1986.

Hollander, Anne. *Sex and Suits.* New York: Alfred Knopf, 1994.

House, John. "Degas's 'Tableau de Genre.'" In Richard Kendall and Griselda Pollock, eds., *Dealing with Degas: Representations of Women and the Politics of Vision.* New York: Universe, 1992.

Houssaye, Henri. "Le Salon de 1883." *Revue des Deux Mondes,* no. 57 (June 1883): 597.

James, Henry. *The American Scene.* 1907. Reprint, Bloomington: Indiana University Press, 1968.

James, Henry. *The Awkward Age.* 1889. Reprint, Harmondsworth: Penguin Books, 1966.

James, Henry. *The Jolly Corner.* In *The Short Stories of Henry James,* ed. Clifton Fadiman. New York: The Modern Library, 1945.

James, Henry. *The Painter's Eye: Notes and Essays on the Pictorial Arts.* Selected by John Sweeney. London: R. Hart-Davis, 1956.

James, Henry. *The Spoils of Poynton.* 1897. Reprint, Harmondsworth: Penguin Books, 1963.

James, Henry. *What Maisie Knew.* 1897. Reprint, Harmondsworth: Penguin Books, 1966.

Jamot, Paul. *Degas.* Paris: Editions de Gazette des Beaux Arts, 1924.

Jauss, Hans. *Toward an Aesthetic of Reception in Theory and History of Literature.* Minneapolis: University of Minnesota Press, 1982.

Jentsch, Ernst. "Zur Psychologie des Unheimlichen." *Psychiatrische-Neurologie Wochenschrift,* no. 8 (1906): 195–202.

Johnson, Dorothy. *Jacques-Louis David.* Princeton, N.J.: Princeton University Press, 1993.

Johnson, Mark. *The Body in the Mind: The Bodily Basis of Meaning, Imagination and Reason*. Chicago and London: University of Chicago Press, 1987.

Jordanova, Ludmilla. "New Worlds for Children in the Eighteenth Century: Problems of Historical Explanation." *History of the Human Sciences,* vol. 3, no. 1 (1990): 69–83.

Jordanova, Ludmilla, *Sexual Visions: Images of Gender in Science and Medicine between the Eighteenth and Twentieth Centuries*. Madison: University of Wisconsin Press, 1985.

Kandinsky, Wassily. *Über das Geistege in der Kunst (Concerning the Spiritual in Art)*. Munich: R. Piper, 1910, 1912.

Kemp, Wolfgang. "Death at Work: A Case Study on Constitutive Blanks in Nineteenth-Century Painting." *Representations,* no. 10 (Spring 1985): 102–23.

Kendall, Richard. *Degas and the Little Dancer*. Exh. cat. New Haven and London: Yale University Press, 1995.

Kett, Joseph F. "Adolescence and Youth." In Theodore Rabb and Robert Rotberg, eds., *The Family in History: Interdisciplinary Essays*. New York: Harper and Row, 1971.

Kleist, Heinrich von. "On the Marionnette Theatre." Originally "Über das Marionettentheater," *Berliner Abendblatter*, December 12–14, 1810. Trans. Roman Paska, in *Fragments for a History of the Human Body*. Zone Books 3, Part One, ed. Michel Feher et al., pp. 415–17. New York: Urzone, distributed by MIT Press, 1989.

Knapp, Bettina. *Maurice Maeterlinck*. New York: Twayne Publishers, 1975.

Koch, Anton. *Innen Dekoration*. Munich: Darmstadt, 1902.

König, René. *Sociologie de la mode*. Paris: Payat, 1969.

Labat-Poussin, Brigitte. *Inventaire des Archives de l'Ecole National Supérieure des Beaux-Arts et de l'Ecole Nationale Supérieure des Arts Décoratifs*. Paris: Archives Nationales, 1978.

Lambert, T. *Décoration et ameublements intérieurs*. Paris: C. Schmid, 1906.

Laufer, Fritz. "Das Interieur in der Europäischen Malerei des 19. Jahrhunderts." Ph.D. diss., University of Zurich, 1960.

Lavater, Caspar. *Essays in Physiognomy*. Trans. T. Holcroft. London: Ward, Lock and Bowden, 1880.

Lavédan, Pierre. *Histoire de l'urbanisme à Paris*. Paris: Hachette, 1975.

Leblond, Marius-Ary. "Les Peintres de la Femme Nouvelle." *La Revue,* no. 39 (1901): 275–76, 289–90.

Lecoq de Boisbaudran, Horace. Archives Nationales, Paris, Dossier AN AJ 53 130, Personal dossier.

Lecoq de Boisbaudran, Horace. *Coup d'Oeil sur l'Enseignement des Beaux Arts*. Paris: A. Morel et cie., 1872, 1879.

Lecoq de Boisbaudran, Horace. *Education de la Mémoire Pittoresque*. 1847. Reprint, Paris: Laurens, 1862.

Lecoq de Boisbaudran, Horace. *Lettres à un Jeune Professeur*. Paris: A. Morel et Cie., 1876.

Lecoq de Boisbaudran, Horace. *Oeuvres Complètes*. Paris: A. Morel et Cie. 1879.

Lecoq de Boisbaudran, Horace. *Quelques Idées et Propositions Philosophiques*. Paris: n.d.

Lecoq de Boisbaudran, Horace. *The Training of the Memory in Art and the Education of the Artist*. Trans. L. D. Luard, intro. by Selwyn Image. London: Macmillan, 1911, 1914.

Lefebvre, Henri. *The Production of Space*. Trans. Donald Nicholson-Smith. Oxford and Cambridge, Mass.: Blackwell Press, 1974.

Lewis, R. W. B. *Edith Wharton: A Biography.* New York: Harper and Row, 1975.

Lilly, Marjorie. *Sickert: The Painter and His Circle.* London: Elek, 1971.

Lipstadt, Helene. "Housing the Bourgeoisie: César Daly and the Ideal Home." *Oppositions* (Spring 1977): 34–47.

Lomax, James, and Richard Ormond. *John Singer Sargent and the Edwardian Age.* Leeds, Eng.: Leeds Art Gallery, 1979.

Lubar, Robert. "Unmasking Pablo's Gertrude: Queer Desire and the Subject of Portraiture." *Art Bulletin,* vol. 79, no. 1 (March 1997): 57–84.

Lubin, David. *Act of Portrayal: Eakins, Sargent, James.* New Haven and London: Yale University Press, 1985.

Lugné-Poe, Aurélien. *La Parade: Acrobaties.* Paris: Librairie Gallimard, 1931.

Lugné-Poe, Aurélien. *La Parade: Sous les étoiles.* Paris: Libraire Gallimard, 1933.

Lukacher, Brian. "Joseph Michael Gandy: The Poetical Representation and Mythography of Architecture." Ph.D. diss., University of Delaware, 1987.

Lukacher, Brian. "Phantasmagoria and Emanations: Lighting Effects in the Architectural Fantasies of Joseph Michael Gandy." *Architectural Association Files,* no. 4 (1982): 40–48, 95.

Lukacher, Brian, and John Summerson. *Joseph Michael Gandy.* Exh. cat. London: Architectural Association, 1982.

Luxenberg, Alisa. "Letter to the Editor." *Art Bulletin,* vol. 80, no. 1 (March 1998): 194–95.

Maeterlinck, Maurice. *The Treasures of the Humble.* Trans. Alfred Sutro, intro. by A. B. Walkey. New York: Dodd, Mead, and Co., 1916.

Mainardi, Patricia. *Art and Politics of the Second Empire: The Universal Expositions of 1855 and 1867.* New Haven and London: Yale University Press, 1987.

Malevich, Kasimir. *Essays on Art 1915–1933.* Trans. Xenia Glowacki-Prus and Arnold McMillan, ed. Troes Andersen. London: Rapp and Whiting, and Ulster Springs, Penn.: Dufour Editions, 1969.

Mallarmé, Stephane. "Crayons au théâtre." In *Oeuvres complètes,* ed. Henri Mondor. Paris: Gallimard, 1984.

Mallgrave, Harry Francis, and Eleftherios Ilonomou, eds. *Empathy, Form and Space: Problems in German Aesthetics, 1873–1893.* Santa Monica: Calif.: Getty Center for the History of Art and the Humanities, 1994.

Marinetti, F. Tommasso. *Manifesto del Futurismo.* 1909. Reprinted in Umberto Boccioni, *Pittura, Scultura Futuriste, Dinamismo Plastico.* Milan: Poesia, 1914.

Matlock, Jann. *Scenes of Seduction: Prostitution, Hysteria and Reading Difference in Nineteenth-Century France.* New York: Columbia University Press, 1994.

Mauclair, Camille. *Degas.* Paris: Editions Hyperions, 1924.

Mauclair, Camille. "La Femme Devant les Peintres Modernes." *La Nouvelle Revue,* n.s. 21 (November 1, 1899): 190–213.

Mauner, George. *The Nabis: Their History and Their Art 1888–1896.* New York: Garland Press, 1978.

Mauner, George. "Vuillard's Mother and Sister Paintings and the Symbolist Theatre." *Artscanada,* vol. 10 (December 1971/January 1972): 124–26.

McCarren, Felicia. "The 'Symptomatic Act' circa 1900: Hysteria, Hypnosis, Electricity, Dance." *Critical Inquiry,* vol. 21, no. 4 (Summer 1995): 748–74.

McCauley, Elizabeth Anne. *A. A. Disdéri and the Carte de Visite Portrait Photograph.* New Haven and London: Yale University Press, 1985.

McCoubrey, John. *The American Tradition in Painting.* 1st ed. New York: George Braziller, 1963; 2d ed. Philadelphia: University of Pennsylvania Press, 2000.

McGrath, William J. *Freud's Discovery of Psychoanalysis: The Politics of Hysteria.* Ithaca, N.Y.: Cornell University Press, 1986.

Meier-Graefe, Julius. *Degas.* Munich: R. Piper, 1920; *Degas,* rendered into English by J. Holroyd-Reece. London: Dover, 1923.

Meisel, Martin. *Realizations: The Narrative, Pictorial and Theatrical Arts in Nineteenth-Century England.* Princeton, N.J.: Princeton University Press, 1983.

Melcher, Edith. "Stage Realism in France: Between Diderot and Antoine." Ph.D. diss., Bryn Mawr College, 1928.

Metteur-en-Scène. Periodical. 1881. Collection Rondel, Rj254, Bibliothèque de l'Arsenal, Paris.

Micale, Mark. *Approaching Hysteria: Disease and Its Interpretation.* Princeton, N.J.: Princeton University Press, 1995.

Micale, Mark. "Charcot and the Idea of Hysteria in the Male: Gender, Medical Science and Medical Diagnosis in Late Nineteenth-Century France." *Medical History,* no. 34 (October 1990): 363–411.

Miege, Henri. "Charcot Artiste." *Nouvelle Iconographie Photographie de la Salpêtrière,* vol. 11, no. 6 (November–December 1899).

Millar, Susanna. *Understanding and Representing Space: Theory and Evidence from Studies with Blind and Sighted Children.* Oxford: Clarendon Press, Oxford Science Publications, 1994.

Minkowski, Eugène. "Towards a Psychopathology of Lived Space." In *Lived Time: Phenomenological and Psychopathological Studies.* Trans. and intro. by Nancy Metzel. Evanston, Ill.: Northwestern University Press, 1970.

Moffett, Charles. *The New Painting: Impressionism 1874–1886.* Exh. cat. San Francisco and Washington, D.C.: The Fine Arts Museum of San Francisco and the National Gallery of Art, 1986.

Mondrian, Piet. *Le Néo-Plasticisme.* Paris: L. Rosenberg, 1926.

Mudge, E. Leigh. *Varieties of Adolescent Experience.* New York and London: The Century Co., 1926.

Mulvey, Laura. "Melodrama Inside and Outside the Home." In *Visual and Other Pleasures,* pp. 63–80. Bloomington: Indiana University Press, 1989.

Mulvey, Laura. "Pandora: Topographies of the Mask and Curiosity." In Beatriz Colomina, *Sexuality and Space,* pp. 53–72. New York: Princeton Architectural Press, Princeton Papers on Architecture, 1992.

Munn, Nancy. "Secluded Spaces: The Figure in the Australian Aboriginal Landscape." *Critical Inquiry,* vol. 22, no. 3 (Spring 1996): 446–65.

Nash, Suzanne, ed. *Home and Its Dislocations in Nineteenth-Century France.* Albany: State University of Albany Press, 1993.

Nead, Lynda. *Myths of Sexuality.* Oxford and New York: Oxford University Press, 1988.

Nead, Lynda. "Seduction, Prostitution, Suicide: *On the Brink* by Alfred Elmore." *Art History,* vol. 5., no. 3 (September 1982): 310–22.

Nesbit, Margaret. *Eugène Atget: Intérieurs Parisiens.* Exh. cat. Paris: Musée Carnavalet, 1987.

Nesbit, Molly. *Atget's Seven Albums.* New Haven and London: Yale University Press, 1992.

Neubauer, John. *The Fin-de-Siècle Culture of Adolescence.* New Haven and London: Yale University Press, 1992.

Newman, Jane, and John H. Smith, eds. *Adolph Loos. Spoken into the Void: Collected Essays, 1897–1900.* Cambridge, Mass., and London: MIT Press, 1982.

Nochlin, Linda. "Degas and the Dreyfus Affair: A Portrait of the Artist as an Anti-Semite." In *The Politics of Vision: Essays in Nineteenth-Century Art and Society,* pp. 141–69. New York: Harper and Row, 1989.

Nochlin, Linda. "A House Is Not a Home: Degas and the Subversion of the Family." In Richard Kendall and Griselda Pollock, *Dealing with Degas: Representations of Women and the Politics of Vision.* New York: Universe, 1992.

Nochlin, Linda. "Lost and Found: Once More the 'Fallen Woman.'" *Art Bulletin,* vol. 60, no. 1 (March 1978): 139–153.

Nye, Robert. *Masculinity and Male Codes of Honor in Modern France.* New York and Oxford: Oxford University Press, 1993.

Oakley, Lucy. *Edouard Vuillard.* New York: Metropolitan Museum of Art, 1981.

Oakley, Lucy. *The Exotic Flower: Constructions of Femininity in Late Nineteenth-Century French Art.* New Brunswick, N.J.: The Jane Voorhees/Zimmerli Museum, Rutgers University, 1998.

Olson, Stanley. *John Singer Sargent: His Portrait.* New York: St. Martin's Press, 1986.

Ong, Walter. *Fighting for Life: Contest, Sexuality and Consciousness.* Ithaca, N.Y.: Cornell University Press, 1981.

Ormond, Richard, and Elaine Kilmurray. *John Singer Sargent: The Early Portraits. Complete Paintings, Vol. 1.* New Haven and London: Yale University Press, The Paul Mellon Centre for Studies in British Art, 1998.

Owen, A. R. G. *Hysteria, Hypnosis and Healing: The Work of J.-M. Charcot.* New York: Garrett Publications, 1971.

Pater, Walter. *The Child in the House.* New York: Thomas Crowell and Co., 1894. Originally published in *Macmillan's Magazine,* August 1878, as "Imaginary Portraits I: The Child in the House."

Perchuk, Andrew, and Helene Posner, eds. *The Masculine Masquerade: Masculinity and Representation.* Exh. cat. Cambridge, Mass.: MIT List Visual Arts Center, 1995.

Phelan, Peggy. "Dance and the History of Hysteria." In Susan Leigh Foster, ed., *Corporealities: Dancing Knowledge, Culture and Power,* pp. 90–105. London: Routledge, 1996.

Piaget, Jean, and Barbel Inhelder. *The Child's Conception of Space.* London: Routledge and Kegan Paul, 1956.

Pile, Steve, and Nigel Thrift. *Mapping the Subject: Geographies of Cultural Transformation.* London and New York: Routledge, 1995.

Pisano, Ronald. *William Merritt Chase: In the Company of Friends.* Exh. cat. Southampton, New York, and Detroit: Parrish Art Museum and the Detroit Institute of Arts, 1979.

Poe, Edgar Allan. *Complete Tales and Poems of Edgar Allan Poe.* New York: Modern Library, 1938.

Poe, Edgar Allan. "Philosophy of Composition." In *Literary Criticism of Edgar Allan Poe,* ed. Robert Hough. Lincoln: University of Nebraska Press, 1965.

Pointon, Marcia. *Hanging the Head: Portraiture and Social Formation in Eighteenth-Century England.* New Haven and London: Yale University Press, Paul Mellon Centre for Studies in British Art, 1993.

Pointon, Marcia. *Naked Authority.* New York and Cambridge: Cambridge University Press, 1990.

Pollock, Griselda. "Modernity and the Spaces of Femininity." *Vision and Difference: Femininity, Feminism and the Histories of Art.* London and New York: Routledge, 1988.

Pougin, Arthur. *Dictionnaire Historique et Pittoresque du Théâtre et des Arts*. Paris: Firmin Didot, 1885.

Praz, Mario. *An Illustrated History of Furnishing from the Renaissance to the Twentieth Century*. Trans. William Weaver. New York: George Braziller, 1964.

Preyer, William. *The Mind of the Child: Part I, The Senses and the Will,* and *Part II, The Development of the Intellect*. Trans. H. W. Brown. New York: D. Appleton, and Co. 1889.

Priguot, Antoine. *Décors Intérieurs*. Paris: Portefeuille, 1869.

Quillard, Pierre. "De l'Inutilité Absolue de la Mise en Scène Exacte." *La Revue d'Art Dramatique* (May 1891): 180–83.

Raeburn, Michael and Victoria Wilson, eds. *Le Corbusier: Architect of the Century*. London: Arts Council of Great Britain, 1987.

Ratcliffe, Carter. *John Singer Sargent*. New York: Abbeville Press, 1982.

Ravaisson, F. *De l'enseigenment du dessin dans les lycées*. Paris, 1854.

Reed, Christopher, ed. and intro. *A Roger Fry Reader*. Chicago and London: University of Chicago Press, 1996.

Reff, Theodore. *Degas: The Artist's Mind*. New York: Metropolitan Museum of Art with Harper and Row, 1976.

Reff, Theodore, ed. *The Notebooks of Edgar Degas*. 2 vols. Oxford: Oxford University Press, 1976.

Régamey, Felix. *Horace Lecoq de Boisbaudran et ses élèves*. Paris: Champion, 1903.

Richmond, Winifred. *The Adolescent Girl*. New York: Macmillan and Co., 1928.

Rilke, Rainer Maria. *Die Aufzeichnungen des Malte Laurids Brigge*. 1910. English ed., *The Notebooks of Malte Laurids Briggs*. Trans. M. D. Herter. New York: W. W. Norton and Co., 1949.

Robins, Anna Gruetzner. "British Impressionism: The Magic and Poetry of Life Around Them." In Norma Broude, ed., *World Impressionism: The International Movement 1860–1920*. New York: Harry Abrams, 1990.

Robins, Anna Gruetzner. "Degas and Sickert: Notes on Their Friendship." *Burlington Magazine*, vol. 130, no. 1020 (1988): 225–29.

Robins, Anna Gruetzner. *Walter Sickert: Drawings. Theory and Practice, Word and Image*. Aldershot, Hants: Scolar Press, 1996.

Roger-Marx, Claude. *Vuillard: His Life and Work*. London: Paul Elek, 1946.

Roof, Katherine Metcalf. *The Life and Art of William Merritt Chase*. New York: Charles Scribner's and Sons, 1917.

Rosen, Charles, and Henri Zerner. *Romanticism and Realism: The Mythology of Nineteenth-Century Art*. New York: W. W. Norton and Co., 1984.

Rothenstein, William. *Men and Memories: Recollections of William Rothenstein 1872–1900*. Vol. 1. New York: Coward-McCann, 1931.

Russell, John. *Edouard Vuillard 1868–1940*. Exh. cat. Toronto: Art Gallery of Toronto, 1971.

Saisselin, Rémy. *The Bourgeois and the Bibelot*. New Brunswick. N.J.: Rutgers University Press, 1984.

Salus, Carol. "Degas's *Young Spartans Exercising*." *Art Bulletin*, vol. 67, no. 3 (September 1985): 501–6.

Scarry, Elaine. *The Body in Pain: The Making and Unmaking of the World*. Oxford and New York: Oxford University Press, 1985.

Scarry, Elaine. "On Vivacity: The Difference between Daydreaming and Imagining-Under-Authorial-Instruction." *Representations*, no. 52 (Fall 1995): 1–25.

Scheffauer, Herman. "The Vivifying of Space." In Lewis Jacobs, *Introduction to the Art of the Movies*. New York: Octagon Books, 1970.

Schindler, Stephan. "What Makes a Man: The Construction of Masculinity in F. W. Murnau's *The Last Laugh*." *Screen,* vol. 37, no. 1 (Spring 1996): 30–40.

Schwartz, Hillel. "Torque: The New Kinaesthetic of the Twentieth Century." In Jonathan Crary and Sanford Kwinter, *Incorporations*, pp. 70–127. Zone Books 6, distributed by MIT Press, 1995.

Scully, Vincent. *The Shingle Style*. New Haven: Yale University Press, 1955.

Segal, Harold B. *Pinocchio's Progeny: Puppets, Marionettes, Automatons, and Robots in Modernist and Avant-Garde Drama*. Baltimore and London: Johns Hopkins University Press, 1995.

Sennett, Richard. *The Fall of Public Man*. New York: Vintage Books, 1974.

Shackelford, George. *Degas Dancers*. Exh. cat. Washington, D.C.: National Gallery of Art, 1984.

Shaw, Mary Lewis. *Performance in the Texts of Mallarmé: The Passage from Art to Ritual*. University Park: Pennsylvania State University Press, 1993.

Shershow, Scott Culter. *Puppets and Popular Culture*. Ithaca, N.Y., and London: Cornell University Press, 1995.

Shiff, Richard. *Cézanne and the End of Impressionism: A Study of the Theory, Technique and Critical Evaluation of Modern Art*. Chicago and London: University of Chicago Press, 1984.

Shone, Richard. *Walter Sickert*. London: Thames and Hudson, 1989.

Showalter, Elaine. *The Female Malady: Women, Madness and English Culture 1830–1898*. New York: Pantheon Books, 1985.

Showalter, Elaine. *Sexual Anarchy: Gender and Culture at the Fin de Siècle*. New York: Penguin Books, 1990.

Sickert, Walter. "Degas." *The Burlington Magazine,* vol. 31., no. 176 (1917): 190.

Sickert, Walter. *A Free House! Or, the Artist as Craftsman*. In *Collected Writings,* ed. Osbert Sitwell. London: Macmillan, 1947.

Sickert, Walter. "The Language of Art." *New Age,* July 28, 1910, p. 300.

Sickert, Walter. "On the Conduct of a Talent." *New Age,* June 11, 1914, p. 131.

Sickert, Walter. "Post-Impressionism." *Fortnightly Review* (January 1911): 89.

Sickert, Walter. "The Study of Drawing." *New Age,* June 16, 1910, p. 156.

Sickert, Walter. "The Teaching of Art and the Development of the Artist." *English Review,* vol. 2 (July 1912): 645.

Sidlauskas, Susan. "Contesting Femininity: Vuillard's Family Pictures." *Art Bulletin,* vol. 78, no. 1 (March 1997).

Sidlauskas, Susan. "Creating Immortality: Turner, Soane and the 'Great Chain of Being.' " *Art Journal,* vol. 52, no. 2 (Summer 1993): 59–65.

Sidlauskas, Susan. "A 'Perspective of Feeling': The Expressive Interior in Nineteenth-Century Painting." Ph.D. diss., University of Pennsylvania, 1989.

Sidlauskas, Susan. "Resisting Narrative: The Problem of Edgar Degas's *Interior*." *Art Bulletin,* vol. 75, no. 4 (December 1993): 671–96.

Silverman, Debora. *Art Nouveau in Fin-de-Siècle France: Politics, Psychology and Style*. Berkeley and Los Angeles: University of California Press, 1989.

Simmel, Georg. *The Sociology of Georg Simmel*. Ed., trans., and intro. by Kurt H. Wolff. Glencoe, Ill.: Free Press, 1950.

Simpson, Marc, with Richard Ormond and H. Barbara Weinberg. *Uncanny Spectacle: The Public Career of the Young John Singer Sargent*. Exh. cat. New Haven and

London: Yale University Press, with the Sterling and Francine Clark Art Institute, 1997.

Smith-Rosenberg, Carroll. *Disorderly Conduct: Visions of Gender in Victorian America*. New York and Oxford: Oxford University Press, 1985.

Solomon Guggenheim Museum. *The Great Utopia: The Russian and Soviet Avant-Garde 1915–1932*. Exh. cat. New York: Guggenheim Museum, distributed by Rizzoli, 1992.

Spacks, Patricia. *Boredom: The Literary History of a State of Mind*. Chicago and London: University of Chicago Press, 1995.

Spender, Christopher, Mark Blades, and Kim Morsley, eds. *The Child in the Physical Environment: The Development of Spatial Knowledge and Cognition*. Chichester, England, and New York: John Wiley and Sons, 1989.

Speth, William. "La Sincerité du Théâtre." *L'Oeuvre* (Paris, 1913): 57–59.

Spicer, Joneath. "The Renaissance Elbow." In Jan Bremmer and Herman Roodenburg, eds., *A Cultural History of Gesture*, pp. 84–128. Ithaca, N.Y.: Cornell University Press, 1991.

Stebbins, Genevieve, ed. *Delsarte's System of Expression*. Translated from an unpublished manuscript. 1887. New York: E. S. Werner, 1902.

Steedman, Carolyn. *Strange Dislocations: Childhood and the Idea of Human Interiority, 1780–1930*. Cambridge, Mass.: Harvard University Press, 1995.

Stevenson, Robert Alan Mowbry. *Velázquez*. 1895. Reprint, London: George Ball, 1899.

Stevenson, Robert Louis. *The Travels and Essays of Robert Louis Stevenson. Virginibus Puerisque: Memories and Portraits*. New York: Charles Scribner and Sons, 1989.

Stewart Susan. *On Longing: Narratives of the Miniature, the Gigantic, the Souvenir, the Collection*. 1984. Reprint, Durham, N.C., and London: Duke University Press, 1993.

Sully, James. *The Human Mind. A Text-Book of Psychology*. Vols. 1 and 2. New York: Appleton and Co., 1892.

Sully, James. *Outlines of Psychology*. New York: D. Appleton and Co., 1885.

Sutton Denys. *Walter Sickert: A Biography*. London: Michael Joseph, 1976.

Swanwick, H. *I Have Been Young*. London: V. Gollancz, 1935.

Taine, Hippolyte. *Lectures on Art*. Trans. John Durand. New York: Holt & Co., 1875.

Tate Gallery. *Towards a New Art: Essays on the Background to Abstract Art 1910–1920*. Exh. cat. London: Tate Gallery, 1980.

Taylor, Charles. *Sources of the Self: The Making of Modern Identity*. Cambridge, Mass.: Harvard University Press, 1989.

Texier, Edmund. *Tableau de Paris*. Vol. 1. Paris: Paulin et Le Chevalier, 1852.

Teyssot, Georges. "Boredom and Bedroom: The Suppression of the Habitual." *Assemblage*, no. 30 (August 1996): 44–61.

Teyssot, Georges. "The Disease of the Domicile." *Assemblage,* no. 6 (June 1988), 73–97.

Theweleit, Klaus. *Male Fantasies: Women, Flood, Bodies, History*. Vol. 1. Trans. Stephen Conway et al. Minneapolis: University of Minnesota Press, 1987.

Thomson, Belinda. *Vuillard*. New York: Abbeville Press, 1988.

Thomson, Richard. *The Private Degas*. Exh. cat. London: Arts Council of Great Britain, 1987.

Thornton, Peter. *Authentic Decor: The Domestic Interior 1620–1920*. London: Weidenfeld and Nicolson, 1984.

Tillis, Steve. *Toward an Aesthetics of the Puppet: Puppetry as Theatrical Art.* Contributions in Drama and Theatre Studies, no. 47. New York, Westport, Conn.: Greenwood Press, 1992.

Tillyard, Stella. "W. R. Sickert and the Defence of Illustrative Painting." In Brian Allen, ed., *Studies in British Art I: Towards a Modern Art World,* pp. 189–206. New Haven and London: Yale University Press, with the Mellon Centre for Studies in British Art, 1995.

Troutman, Anne. "Inside Fear: Secret Places and Hidden Spaces in Dwellings." In Nan Ellin, ed., *Architecture of Fear,* pp. 143–57. New York: Princeton Architectural Press, 1997.

Troy, Nancy. *The De Stijl Environment.* Cambridge, Mass., and London: MIT Press, 1983.

Troyon, Aimée. *Walter Sickert as Printmaker.* Exh. cat. New Haven and London: Yale Center for British Art, 1979.

Uzanne, Octave. *L'Art et l'Idée: Revue Contemporaine du Diléttantisme Littéraire et de la Curiosité.* Vols. 1 and 2. Paris, 1891–92.

Vallone, Lynne. *Disciplines of Virtue: Girls' Culture in the Eighteenth and Nineteenth Centuries.* New Haven and London: Yale University Press, 1995.

Van Zanten, Ann Lorenz. "Form and Society: César Daly and the *Revue Générale de l'Architecture.*" *Oppositions,* no. 8 (Spring 1977): 137–45.

Varnedoe, Kirk. "The Artifice of Candor: Impressionism and Photography Reconsidered." *Art in America,* vol. 68, no. 1 (January 1980): 66–78, and "The Ideology of Time: Degas and Photography," *Art in America,* vol. 68. no. 6 (Summer 1980): 96–109.

Verkade, Dom Willibrod. *Le Tourment de Dieu: Etapes d'un Moins Peintre.* Paris: Rouart et Watelin Editeurs, 1923.

Vicinus, Martha. *The Widening Sphere.* London: Methuen, 1980.

Vidler, Anthony. *The Architectural Uncanny.* Cambridge, Mass., and London: MIT Press, 1992.

Vidler, Anthony. "Psychopathologies of Modern Space: Metropolitan Fear from Agorophobia to Estrangement." In Michael S. Roth, ed., *Rediscovering History: Culture, Politics and the Psyche.* Stanford, Calif.: Stanford University Press, 1994.

Viollet-le-Duc, Eugène. "Un Cours de Dessin." *L'Artiste,* vol. 2, n.s. 5 (Sept.–Dec. 1858): 154–56.

Visinet, G. "Théâtre de Paris." *Journal de Rouen,* June 26, 1894.

Vollard, Ambroise. *Degas. An Intimate Portrait.* Trans. Randolph T. Weaver. New York: Crown Publishers, 1937.

Vuillard, Edouard. Journals. Bibliothèque de l'Institut de Paris, #5396-1, 2, 1890–1905.

Wagner, Anne. *Jean-Baptiste Carpeaux.* New Haven and London: Yale University Press, 1986.

Wang, Wilfred. *The Architecture of Adolph Loos.* London: Arts Council of Great Britain, 1985.

Weschler, Judith. "An Apéritif to Manet's *Déjeuner sur l'Herbe.*" *Gazette des Beaux-Arts,* vol. 91, no. 2, 6th ser. (1978): 32–34.

Wharton, Edith. *A Backward Glance.* New York: D. Appleton and Co., 1934.

Wigler, Hans. *The Bauhaus: Weimar, Dessau, Berlin, Chicago.* Trans. Wolfgang Jobs and Basil Gilbert; ed. Joseph Stein. Cambridge, Mass., and London: MIT Press, 1978.

Wigley, Mark. "Untitled: The Housing of Gender." In Beatriz Colomina, ed., *Sexuality and Space,* pp. 326–89. New York: Princeton Papers on Architecture, Princeton Architectural Press, 1992.

Wigley, Mark. *White Walls, Designer Dresses: The Fashioning of Modern Architecture.* Cambridge, Mass., and London: MIT Press, 1995.

Winnicott, D. W. *Playing and Reality.* London: Tavistock, 1971.

Wolf, Janet. "The Invisible Flâneuse: Women and the Literature of Modernity." In *Theory, Culture and Society,* vol. 2, no. 3 (1985): 37–46.

Wolff, Cynthia. *A Feast of Words: The Triumph of Edith Wharton.* Oxford and London: Oxford University Press, 1972.

Wölfflin, Heinrich. "Prolegomena to a Psychology of Architecture." In *Empathy, Form and Space: Problems in German Aesthetics, 1873–1893,* intro. and trans. Harry Francis Mallgrave and Eleftherios Ikonomou, pp. 149–92. Santa Monica, Calif.: Getty Center for the History of Art and the Humanities, 1994.

Wölfflin, Heinrich. *Renaissance and Baroque.* Trans. Kathrin Simon, intro. by Peter Murray. London: McCallum Sons & Co. 1964.

Woolf, Virginia. *Jacob's Room.* 1922. Reprint, New York: Harcourt Brace, 1959.

Woolf, Virginia. *Three Guineas.* 1938. Reprint, New York: Harcourt Brace, 1966.

Woolf, Virginia. *To the Lighthouse.* 1927. Reprint, New York: Harcourt Brace, 1955.

Woolf, Virginia. "Walter Sickert: A Conversation." In *The Captain's Bed and Other Essays.* New York: Harcourt Brace, 1950.

Woolf, Virginia. *A Writer's Diary,* ed. Leonard Woolf. New York: Harcourt Brace, 1953.

Woolf, Virginia. *The Years.* 1937. Reprint, New York: Harcourt Brace, 1965.

Young, Charles. "The Marriage Question in Modern French Drama." *University of Wisconsin Bulletin,* vol. 5, no. 4 (1912).

Zola, Emile. *Le Naturalisme au théâtre. Oeuvres complètes.* vol. 39. Ed. Maurice Le Blond. Paris: F. Bernouard, 1974.

Index

adolescence: behavior in, 84–6; growth in, 86, 181n101; physical changes in, 84–6; space in 84–5

adolescent: body of, 83–6; moods of, 85–6; perceptions of, 84–6; psychological development of, 85–6, 180n99, 181n100

animism: of furnishings, 25, 43–4, 106, 123, 139, 140, 187–8n61; of objects, 7, 9–11, 25, 43–4, 106, 124, 181n103; of spatial environment, 5, 7, 9–12, 43, 92, 100, 105, 123, 132

Antoine, André, 106, 112–3, 188n64

architecture: animation of, xv, 10–11; "cerebral structures," 147; domestic, 23–4, 63; drawing, 10, 13–14, 15; geometry in, 12, 13–15, 156–7n25, 158n32; of intimacy, 124; "intrauterine", 149, 203n79; of the mind, 147; modern, 147–9; and social class, 23–4, 62; writings on, 3, 10–11, 156n17, n18; *see also* uncanny, architectural; Vidler, Anthony, on uncanny space

Armstrong, Carol, 46, 58, 161n3, n4, 164n21, 168n65, n67, n71, 170n104, 171n109, n115, 191–2n96

Art nouveau, 93, 148; and the interior, 93

arts, unity of, 147–9

Aurier, Albert, 95

Bachelard, Gaston, *The Poetics of Space*, 49–51, 89, 169n81, 181n112

Baldwin, James Mark, 70, 175n32

Balzac, Honoré de, 37–8, 165n31, 167n60; *Eugène Grandet*, 7; *Père Goriot*, 7

Baron, Wendy, 135, 194n4, 195n9, n11, 196n16, 198n35, n37, n40, 199n46

Barr, Alfred, 95, 184n19

Bastide, Jean-François, *The Little House*, 22, 162n7

Baudelaire, Charles, 44, 142, 170n100, 199n48

Bauhaus, 148, 202n75

Beauborg, Maurice, 114

Becq de Fouquières, Louis, 113, 190n79

Bell, Quentin, 195n7, 196n15, 197n20

Bellelli, Baron Gennaro, 33, 55

Bellelli, Laura, 33

Benjamin, Walter, 122, 148, 152n1, 153n10, n16, 163n15, 170n100, 202n77; on furnishings, 25, 184n14; on the interior, 1, 3, 4, 23, 126, 131, 152n2

Bernheim, Hippolyte, 94, 183n13

Bertrand, J., *Marguerite of Faust*, 66, 174n17

Biran, Maine de, 12

Blanc, Charles, 14

Blanche, Jacques-Emile, 126, 129, 143, 195n6, 196n18, 198n36, 200n54, n57, n60, n62

Bloomsbury circle, 129

Boggs, Jean Sutherland, 160n53, 162n5, 165n35, n36, 167n54, 168n78, 171n116, 174n20

Boime, Albert, 154n2, 156n13, 157n29, 172n1

Boit, Edward Darley, 69–70, 71, 72–3, 76, 90, 172n1, 174n27, 175n28, n30, 176n43, n44, 177n61, 178n77, 181n114

Boit, Florence, pl. VI, 66, 71, 86–90, 179n87, 182n117

Boit, Jane, pl. VI, 66, 71, 72, 83–6, 89–90, 182n117

Boit, Julia, pl. IV, 66, 71, 77–9, 175n28, 176n44, 177n63, 182n117

223